Gothic Art

Vampires, Witches, Demons, Dragons, Werewolves & Goths

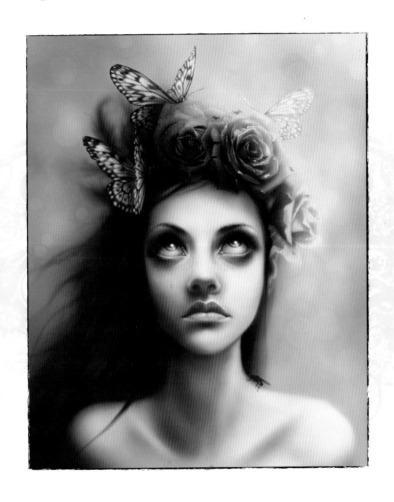

D1348641

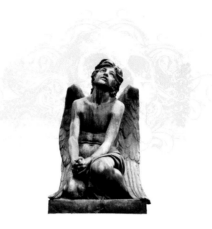

For Mum and Dad – I wouldn't know half of this stuff if it weren't for you.

This is a **FLAME TREE** book
First published 2013

Publisher and Creative Director: Nick Wells
Senior Project Editor: Catherine Taylor
Picture Research: Catherine Taylor, Emma Chafer and Esme Chapman
Art Director and Layout Design: Mike Spender
Copy Editor: Anna Groves
Proofreader: Dawn Laker
Indexer: Helen Snaith

Special thanks to Chris Herbert, Frances Bodiam, Helen Crust and, most importantly, all the artists who made this book what it is.

13 15 17 16 14
1 3 5 7 9 10 8 6 4 2

This edition first published 2013 by
FLAME TREE PUBLISHING
Crabtree Hall, Crabtree Lane
Fulham, London SW6 6TY
United Kingdom

www.flametreepublishing.com

ISBN 978-0-85775-994-8

Gothic Art

Vampires, Witches, Demons, Dragons, Werewolves & Goths

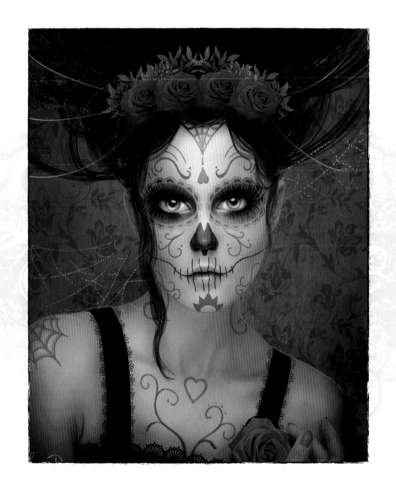

Nicola Henderson

Foreword by: Mick Mercer

FLAME TREE
PUBLISHING

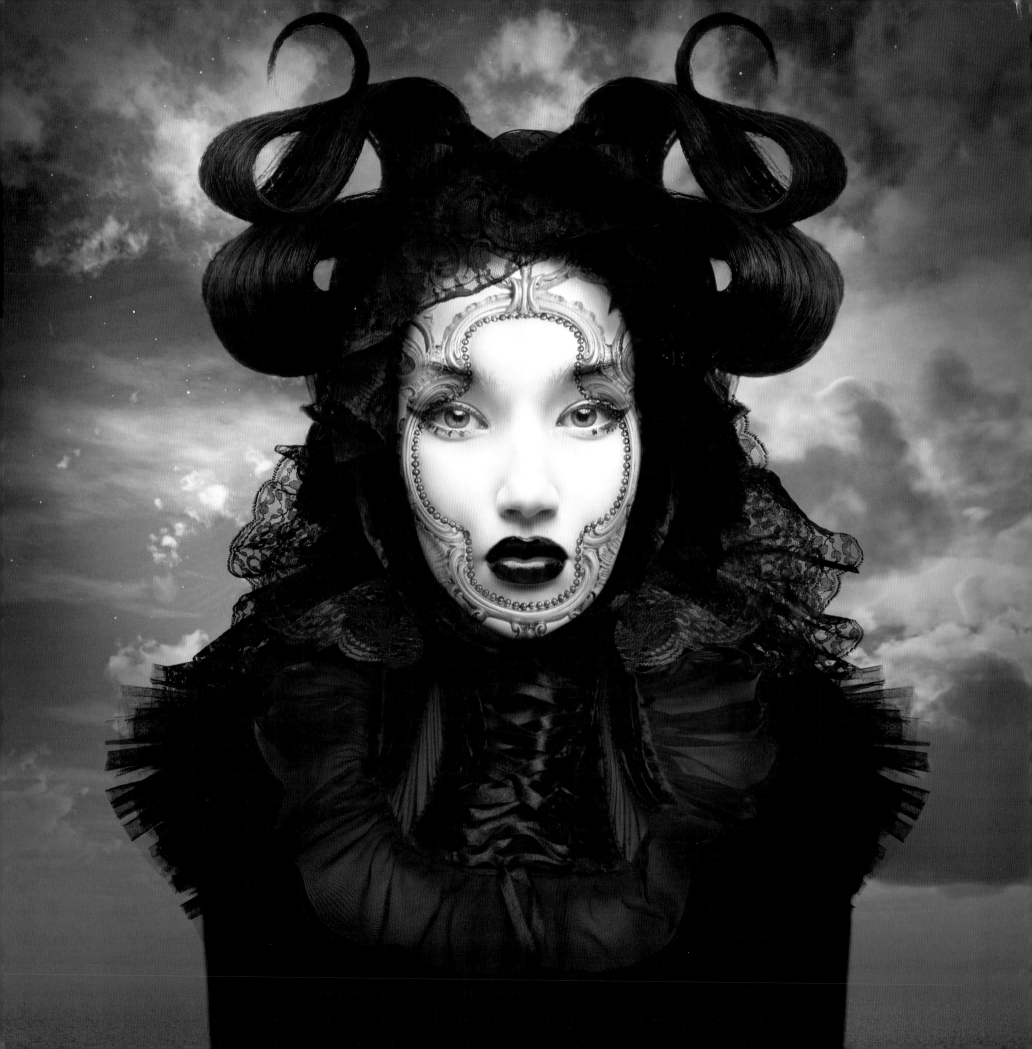

Contents

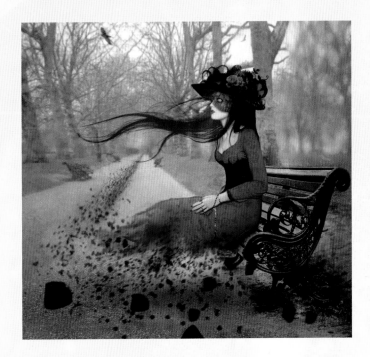

Desolation by Natalie Shau
© Natalie Shau
Digital media: 3D, drawing, photography
natalie-shau.com

Carmine by Natalie Shau
© Natalie Shau
Digital media: 3D, drawing, photography
natalie-shau.com

Foreword

With modern Gothic art, beauty is in the eye of the beholden, for most work satiates the thrilling nocturnal interests of devotees; we need it more than it needs us, as its appeal becomes evermore populist. Where once such dark, eclectic imagery was rare and required diligent searching, now there is a whole industry acknowledging the popularity of such visual versatility, pushing it towards common acceptance.

Early Imaginings

The lineage isn't complicated. Historical purists will enjoy Gothic art of the medieval period, but it has little relevance to our modern appreciation. The nineteenth century gave birth to horror fiction, coupled with the Pre-Raphaelites twisting myth into beautiful shapes on canvas, and romantic poets best represented by long-haired geezers with a neat sideline in debauchery.

Shelley, Stoker, Poe, Stevenson, Lovecraft… and on to Mervyn Peake. The initial impact of compelling and unsettling narratives was mirrored by the earliest cinema with flickering finesse, boosted by Hollywood and its seismic suspense, exploited brilliantly by later genre-specific providers such as the Hammer films and their darker Italian counterparts, out into comics and graphic novels. Now internet outlets for photoshop-wielding artists level the playing field and the subjects of the images have gone from scary to gritty and from the fantastical to urban legend.

Books to Comics to Games… to Art

When I was growing up there was no 'Gothic art' to be appreciated unless you visited libraries. The 1950s had given us EC Comics, but these were banned. During the 1960s TV provided 'The Addams Family' and 'The Munsters'. Then, later, 1970s imagery surfaced in tandem with written themes through comics that unsettled: *Tomb of Dracula*, *Werewolf-by-Night*, *Man-Thing*, *Vampirella*. Everyone read *Gormenghast*. *Dungeons & Dragons* gave way to a plethora of fantasy-based video and computer games, which has led to an important outlet for artists who are then able to unleash their creativity. That's why you'll see the work of popular artists Aly Fell, Anne Stokes, Bob Kehl, Jason Engle and Jon Hodgson within these pages.

On the music scene, when Punk spawned Goth, running parallel with a groundswell of horror and fantasy fiction, the emerging Gothic lifestyle (with female involvement more noticeable than on any other scene) became the catalyst for an entry-level artistic output happening across various visual media, ensuring that the Gothic was reborn, remodelled, reinvigorated. When established, it naturally looked backwards as much as it looked forwards and you hold the evidence of this in your tasteful hands.

The 1980s saw an old favourite like Batman given a darker edge in the Dark Knight (Gene Colan's work was a regular feature of the Detective Comics). *V For Vendetta* and *Watchmen* had a Gothic atmosphere, *Love & Rockets* by Gilbert Hernandez and Jaime Hernandez had actual Gothic characters. Then came Neil Gaiman and *The Sandman*. Game on! We also had the Powergoth Girls of 'As Meninas Gothikas' by the enigmatic .nagash, and the delightful comic *Lenore* ('the cute little dead girl'). Some comic-flavoured art is shown here from Alex Horley.

Moonlight Lady by Natalie Shau
© Natalie Shau
Digital media: 3D, drawing, photography
natalie-shau.com

Beautiful Visions

The modern era has also seen an explosion of Faery-related material, with artists to match, offering the softer side of Gothic fantasy: Mina Meslin, Cris Ortega, Brooke Gillette, Elena Dudina, Marc Potts, Omar Diaz and Selina Fenech. The darker side is represented by Demetris Robinson and Fernanda Suarez, a lighter flair coming from Jasmine Becket-Griffith and the kitsch fun of Marcus Jones.

Some artists are multi-visionary, offering the scary solo character, the apocalyptic cityscape, the sensual outsider as found in the works of Brom, Yefim Kligerman, Dave Oliver, Jason Juta, Joana Shino Dias, Leos Okita Ng, Markus Lovadina, Mike Sebalj and Susanne Radermacher. Two of my real favourites, Mark Ryden and Natalie Shau, have a wickedly inventive, humorous and glamorous approach. Dead centre of all this is the classic Gothic art of Anne Sudworth, the one woman managing modern works that also embrace the classic traditions of British art. One of my proudest possessions is a Sudworth original, albeit very small!

Gothic Whirlwind

The 1990s Gothic scene itself enjoyed a Fetish crossover, as well as absorbing much of the fanzine culture serving the vampire scene, all imagery represented here, because the new artists have lived through this. This was followed by 'Cybergoth' and 'Gothic Lolita' as the internet exploded and focus was dispersed; Deathrock clawed Goth back from polite romantic fields, bestowing a punkier energy, and new scenes were exposed through the internet, most noticeably the Russian and South American arena. During this time art sites proliferated (deviantART the best known). Hundreds of new bands come and go each year, artists flood out.

Death and horror have found a natural beauty. What was once grotesque and shocking drama can now also embrace small-town affectation or insidious melodrama; the very stuff of everyday living. A circle has been completed and now spins at differing speeds. The fact the Gothic scene continues to develop where other scenes have died out is *because* it has outside outlets such as art, poetry, fashion, cinema

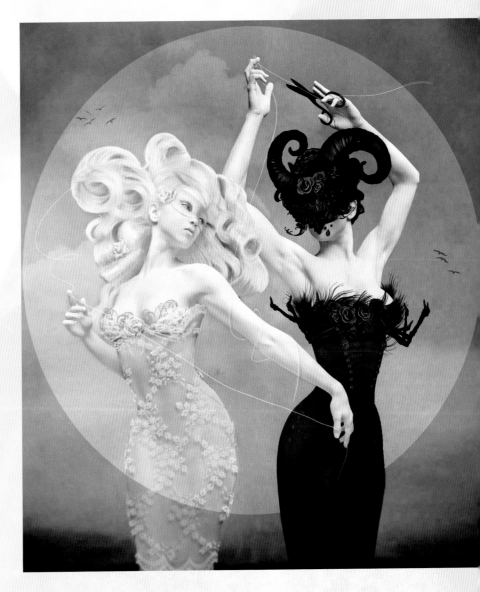

and comics to rival its own creativity and feed back into the central hub – the essence of Gothic, where the unimaginable becomes the focus of artistic imagination. *The Crow*, Anne Rice, Buffy/Angel, Tim Burton and *Twilight* hit home in the upper echelons. Hundreds of music videos, dozens of TV series occupy the middle ground. Steampunk is rattling the basement. There will be many more yet to come.

Mick Mercer

White Thread by Natalie Shau
© Natalie Shau
Digital media: 3D, drawing, photography
natalie-shau.com

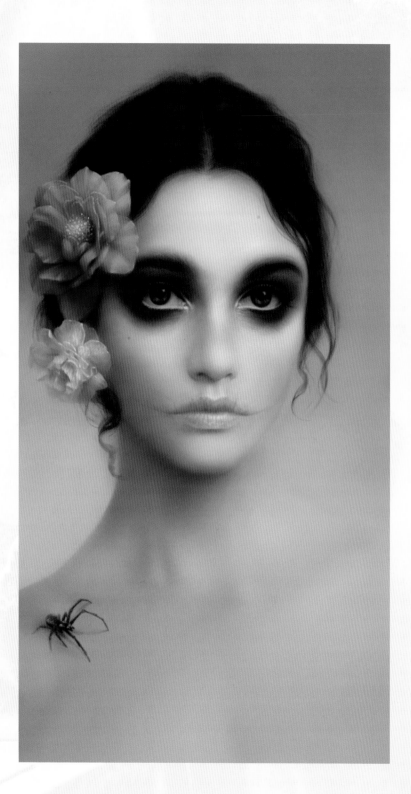

Introduction

Many may not realize it, but Gothic art is an incredibly versatile style of aestheticism. We all have our own ideas of what it means and how to harness it, but in truth, it is a much more transient genre than many give it credit for. One of the most fascinating aspects of its nature is that, no matter what kind of visual style it is applied to or how little or much it is emphasized, its meaning remains the same. There are very few stylistic disciplines that can take on so many different forms and yet remain irrevocably powerful; the Gothic sensibility is a truly unique sight to behold.

A Dark & Diverse Universe

When applied to art, whether visually, musically or theatrically, the style takes on a mind of its own and transports us into worlds we never thought possible. By a dizzying concoction of antiquated mystery, supernatural romance and darker realities, Gothic art presents us with a unique glimpse into a past that never truly was, an alternate reality where anything could crawl out of the shadows and into our beds.

This book gathers together an eclectic showcase of artists who explore the darker side of the tracks, each with their own unique approach to capturing the essence of romantic fantasy and dark drama. Whether you're already initiated into Gothic culture or not, we hope that the art discussed, and the artworks presented, over the following pages will reflect the astonishing level of creativity and thematic exploration that Gothic artists embrace with open arms. Likewise, we hope that you find the diversity of visual styles and mediums demonstrated here just as inspiring as the themes they explore.

Origins & Tales

In our first section, we set out to define the traits that are most widely associated with the Gothic aesthetic, briefly examining how medieval architecture inspired later generations to explore the mysteries of the

Juliet by Mélanie Delon
© Mélanie Delon 2011
Digital media: Photoshop & Painter
melaniedelon.com

past. We identify the important role that contrast plays in the style, along with how the expansion of Victorian culture inspired the themes and styles of the genre.

Next, we take a closer look at how the origins of eighteenth-century supernatural fiction paved the way for the expansion of the Victorian Gothic literature movement. In section two, we explore how the innovative creations of the likes of Horace Walpole, John William Polidori, Mary Shelley and Bram Stoker have solidified the Gothic sensibility into what we recognize today and how modern literature continues to uphold its laws.

Dark Divas & Femmes Fatales

In section three, we examine the role of the quintessential Gothic female enigma, exploring the various iconic character archetypes that remain connected to feminine ideologies. Here, we delve into vampire mythology and explore why it remains such a fascinating creature, along with taking a look at why witches remain so intrinsic to Gothic style and art.

Death is Beautiful

Later, in section four, we collect ourselves and take a moment to reflect on why death is so pivotal to Gothic art, examining the many ways it is personified and represented. Following on from this, we face the strange and fascinating creatures of the underworld, such as demons, malicious spirits and lost souls trapped between the realms of the living and the

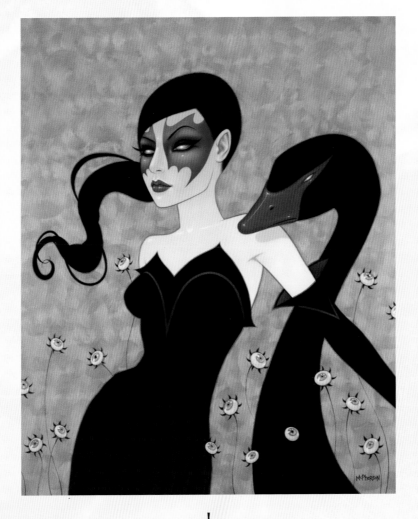

dead, along with getting to grips with occult symbolism used in contemporary art. It may keep you up at night, but it'll be worth it.

Gothic Howls

Moving from the grim to the grisly, section five takes a look at the many kinds of monsters associated with the Gothic tradition, ranging from iconic creatures such as dragons and werewolves to those more closely attached to folklore and mythology. We explore why forms and symbolic value can make monsters so engaging, scouring the lands and seas for inspiring and mystifying creatures.

Cute or Creepy?

As a welcome change of pace, the cuter side of Gothic art is explored in chapter six, in which the likes of Tim Burton and Tara McPherson are championed for their unique creative visions that cross genres and styles whilst retaining authentic Gothic qualities. Cult style movements including Gothic Lolita, Steampunk and Pin-Up are analysed alongside the gritty realism of Cyberpunk and Biomechanicalism.

Landscapes & Gothic Imaginings

And finally, in chapter seven, we take a good look at how the wider elements of Gothic art unite to form eerie visions and evocative scenes. The emotional resonance of landscapes and environments are dissected along with contemporary abstraction, surrealism and overriding themes that make Gothic art so unique.

Isolated Metronomes by Tara McPherson
© Tara McPherson
Traditional media: oil on birch, 76 × 91 cm (30 × 36 in)
taramcpherson.com

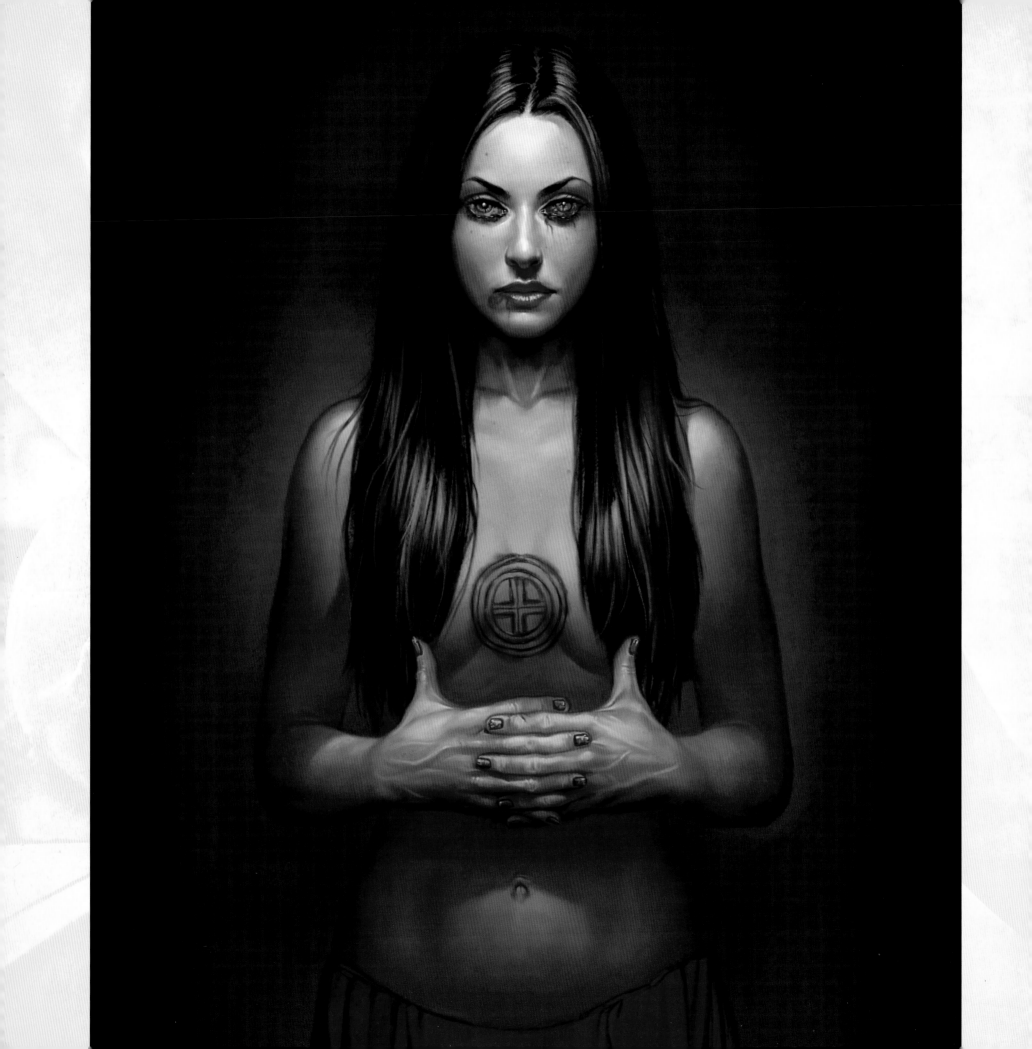

What Is Gothic?

The word 'Gothic' is a powerful little vessel. As soon as you hear it, your mind is immediately transported to somewhere mysterious, dark and imposing; a realm with infinite possibility, where beauty can be found in the strangest of places. It's also a word with many diverse meanings and implications. What was once used to describe ancient tribesmen and architecture can now be used to define a generation of artists who aren't afraid to let their darker sides take hold. There's no escaping its influence; Gothic sensibilities have now outreached their humble beginnings and filtered through into mainstream culture, with an ever-growing list of subgenres and variants adding to its seductive framework.

Defining the Unfathomable

The nature of what can be traditionally perceived as Gothic has evolved over time, and can mean entirely different things to different people. It can be used to describe the most decadent celebrations of the macabre and monstrous, or, at the other end of the spectrum, delicate moments of melancholia and internal reflection.

Whatever shape or form, it seems that thematic contrast lies at the heart of the Gothic aesthetic. Opposing forces – darkness and light, beauty and decay, life and death – are united in spectacular fashion, with each half of the equation amplifying the other. Even the most horrifying of visions can possess extraordinary elegance and poetic resonance, which is why Gothic artwork remains so compelling.

It's not all doom and gloom though; while the more cynical onlookers may assume that there's nothing more to Gothic art than morbid fancy, the truth is that there are plenty of shining examples of Gothic art that take a more whimsical stance, using the grand aesthetic style in a playful and even comical manner.

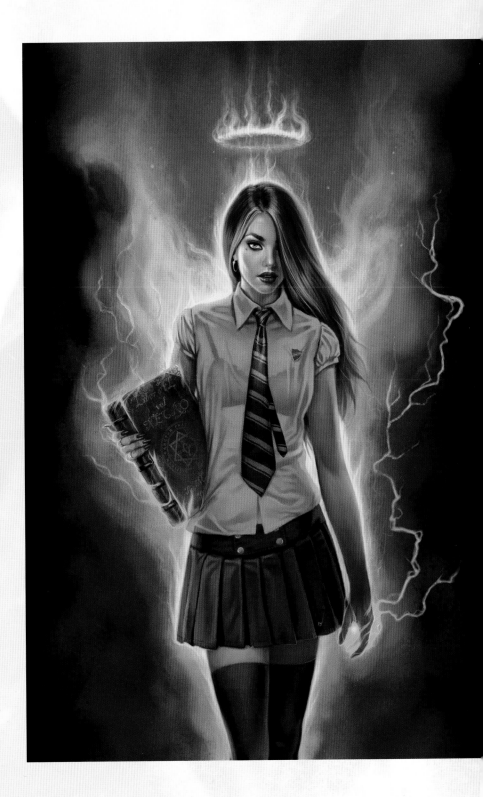

Beast by Aly Fell © Aly Fell
Digital media: Photoshop
Inspired by one of Aleister Crowley's muses.
darkrising.co.uk

The Necromancer by Aly Fell © Aly Fell
Digital media: Photoshop
A character developed for an online challenge, a schoolgirl necromancer.
darkrising.co.uk

Common Themes of Gothic Art

Gothic art tends to focus on the more dramatic and theatrical elements of what can be considered as romanticism; themes that evoke the senses and dance on sublime territory, such as mortality, fear, loss, love and human nature. Many pieces of Gothic art build on the medieval concept of the memento mori, which is a way of using the finite nature of life to heighten transient concepts such as beauty and youth.

By contrasting light themes with dark, an artist is able to create striking imagery that encompasses two sides of a theme, with each aspect telling its own story. The thematic contrast is often made visible too, especially in terms of using colour and shade to enhance atmosphere and tone. Rich colour palettes feature prominently in Gothic artwork, with artists making striking use of the darker ends of the spectrum. However, it's the ability to balance such strong colours against their more delicate and pale counterparts that define the masters of the genre, as you will come to see through the pages of this book.

Gothic Symbolism

Symbolism plays an important role in Gothic art, as it is employed to express the underlying meanings that the artist set out to explore. Symbolism can be found in every ancient culture, with many signs possessing universal connotations that everyone can identify with. In the case of Gothic art, intermixing romantic symbolism with those associated with mortality, temperament and religion can yield fascinating results. Traditional signs can also be experimented with to further explore their meaning, with many artists merging the classical and modern worlds to inject deeper meanings into their work.

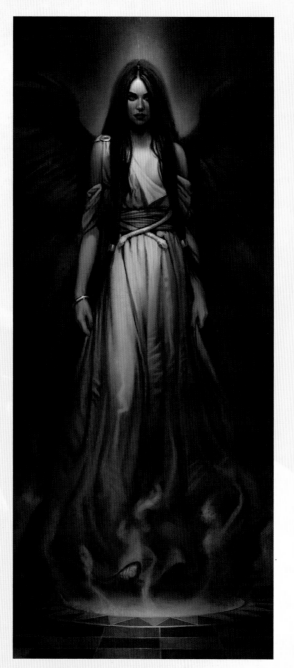

Modern Masters

Like any art movement or style, Gothic art has a definite circle of masters from a variety of disciplines and backgrounds, whose works continue to inspire others to pick up their paintbrushes and explore their darker sides.

Three of the most innovative figures of modern dark fantasy and horror are Gerald Brom, H.R. Giger and Yoshitaka Amano. In Brom, we find an intoxicating blend of horror, mysticism, intrigue and beauty, with works often delving into counterculture themes such as the occult and fetishism. The renowned biomechanical artist H.R. Giger follows suit, with many of his works exploring the dark interplay between man and machine, breaking down the nature of the human condition and deconstructing it into mechanical impulses. Like Brom, Giger often incorporates sexuality into his work, exploring the dark and surreal depths it can lead to. At the other end of the spectrum, the Japanese artist Yoshitaka Amano is renowned for his elegant and visually poetic Gothic artwork, where even a simple line can evoke extraordinary expression and atmosphere.

A Dark and Diverse Ensemble

Of course, there are many, many more artists out there who have helped to shape the Gothic art movement and continue to amaze with their dark ingenuity. The mesmerizing works of digital artists like Anne Stokes, Jason Chan, Dave Rapoza, Marta Dahlig and Mélanie Delon sit happily alongside the atmospheric landscape paintings of Anne Sudworth, the emotional, dark pop of Tara McPherson, the textured experiments of Dave McKean or the intricate sculptures of Kris Kuksi. Despite what many may assume, Gothic art is an exceptionally vibrant genre that plays with expectation and subtext in many surprising ways.

Ligeia by Aly Fell © Aly Fell
Digital media: Photoshop
Inspired by the Edgar Allan Poe tale, Ligeia was one of the Sirens.
darkrising.co.uk

The Vampire Queen by Aly Fell © Aly Fell
Digital media: Photoshop
Inspired by Rosie Lugosi, burlesque host and performer.
darkrising.co.uk

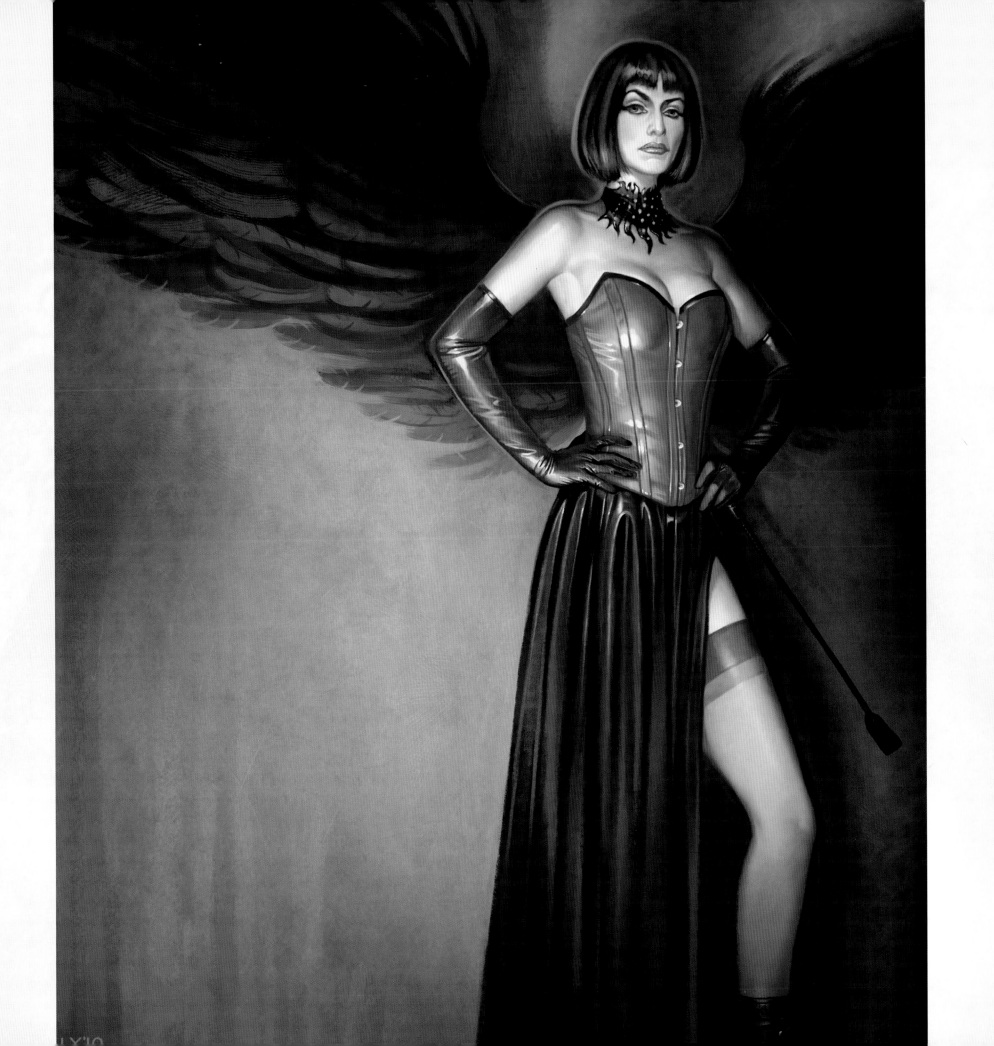

Ancient Origins

Before the term 'Goth' had anything to do with black-clad purveyors of dark fantasy, the name belonged to an ancient East Germanic tribe of Scandinavian origin. By the second century AD the Goths, a nomadic people, had spread across Eastern Europe and southern Russia, and had developed a reputation for their fighting skills on horseback. The tribe eventually split into two main factions, the Ostrogoths and Visigoths, falling respectively into eastern and western territories. After the Huns invaded Goth territory in the fourth century AD, the subjugated Ostrogoths eventually joined their ranks, with the Visigoths settled in Roman territory.

Eventually the Ostrogoths broke away from the Huns in 454 AD, going on to create their own kingdom before falling to the Eastern Roman Empire. Meanwhile, the Visigoths had been somewhat luckier against the Roman Empire after successfully establishing their own kingdoms, which would eventually become modern Spain and Portugal.

Though the Goth tribe may have parted in different ways, the foundations built by both factions helped bring an end to the Roman Empire and lay the early building blocks of what would quickly become medieval Europe.

Medieval Gothic Art

It was not until the sixteenth century that the word 'Gothic' was used to describe art and architecture created before the Renaissance, but the term held a drastically different meaning compared to our modern view. The label was initially used in a derogatory sense to refer to 'barbaric' aesthetics that preceded the refinement of the Italian Renaissance.

Hailing from medieval France, the style of art and architecture that we now refer to as Gothic established itself throughout the twelfth to the mid-sixteenth centuries. After the continental shift from paganism to Christianity, churches became the powerhouses of medieval culture and the heart of society. The visual presence of the church had to be just as powerful as its emotional resonance, and so Gothic architecture and design was deliberately crafted to satisfy the senses. Other significant places of power, such as universities and civil centres, were

Immortality by Mélanie Delon
© Mélanie Delon/ImagineFX 2010
Digital media: Photoshop & Painter
melaniedelon.com

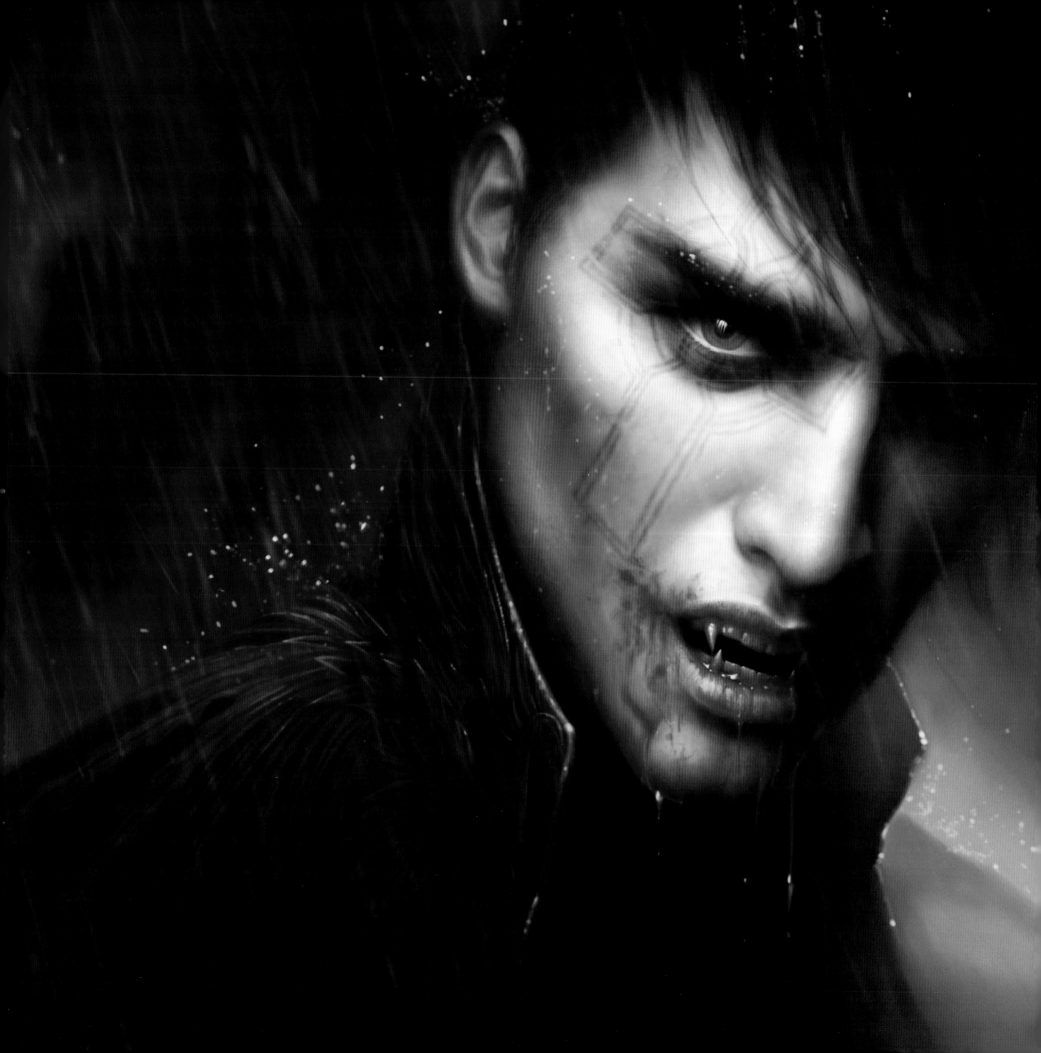

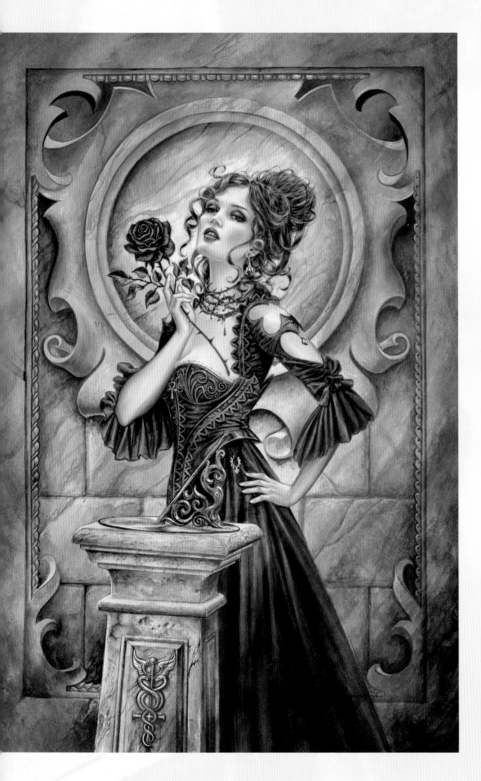

also fashioned in this style, characterized by its grand vaulting, pointed archways and elaborate allegorical sculpture and painting.

The ability to read and write was generally limited to wealthy and noble families, which made the inclusion of symbolic imagery into art a necessary practice for both religious and social purposes.

Gothic Revival

Thankfully, the term fell back into favour in the eighteenth century, as Gothic styles of the past were rediscovered with new appreciation and intrigue. The neogothic movement saw a stylistic return to medieval aesthetics, the revival typified by the building of Strawberry Hill, the residence of the poet Horace Walpole, who felt that the past contained hidden promises and romanticism that had been lost in the overbearing shadow of the Italian Renaissance.

Along with building his very own medieval citadel, Walpole channelled his love for historical mystery into the novel *The Castle of Otranto* (1764), a supernatural tale full of ancient terror and dynastic sin. The dark romanticism of the novel became so popular that it sparked the Gothic literature movement that flourished well into the Victorian era, and further beyond.

The Victorian Gothic Movement

Although supernatural stories enjoyed success well into the 1800s, it was not until the latter half of the century that Gothic fiction really took hold, with the likes of Mary Shelley's *Frankenstein* (1818), R.L. Stevenson's *Strange Case of Dr Jekyll and Mr Hyde* (1886), Bram Stoker's *Dracula* (1897) and the melancholic works of Egdar Allen Poe, all of which skillfully demonstrated that supernatural tales could explore earthbound psychological and social themes in more ways than engendering superficial terror.

The overall Gothic aesthetic also owes much to the Pre-Raphaelite Brotherhood, which saw a group of artists revisiting the mysteries of the past in order to explore their own modern culture. The deeply

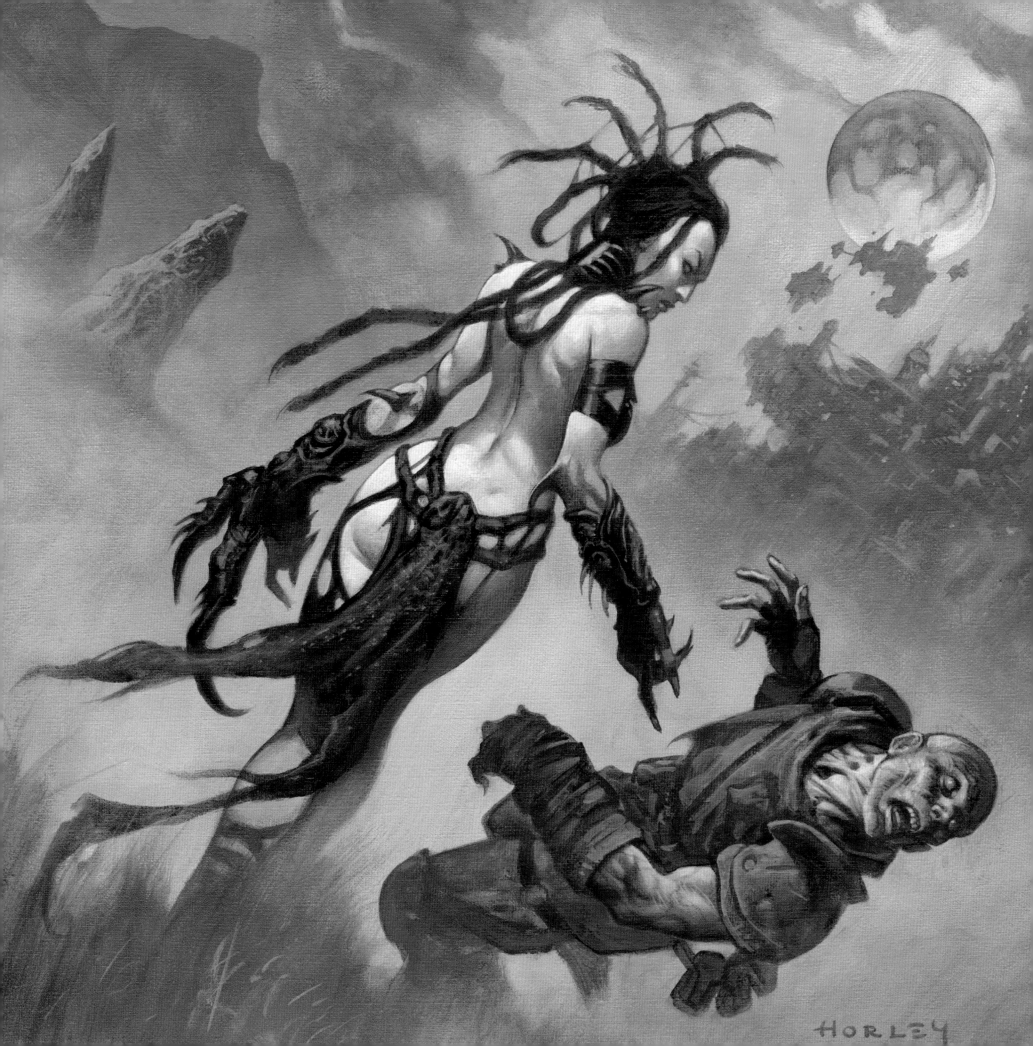

Witch by Pete Thompson

© Atomhawk Design; **Digital media:** Photoshop; atomhawk.com

Step 2: (below) At this point I started adding in the background using a couple of layers with different properties, multiply for the sky and colour dodge for the moon. I also used a custom smudge tool to get some extra texture into her skirt and the grass.

Step 1: This stage was all about making sure the anatomy was correct and the sketch was going to convey the feeling I wanted. I usually use a flat brush for my initial sketch stages with the opacity set at 100% and the flow knocked down to about 50–60%.

Finishing Touches: (right) Adding the colour took a little more time using a number of different layers with different property types to achieve the best result. I also used some photo texture on the moon and for the trees and graveyard. I spent time detailing using a selection of brushes until finally I used an overlay layer with a blue hue and a low fill to pull all of the parts of the painting together.

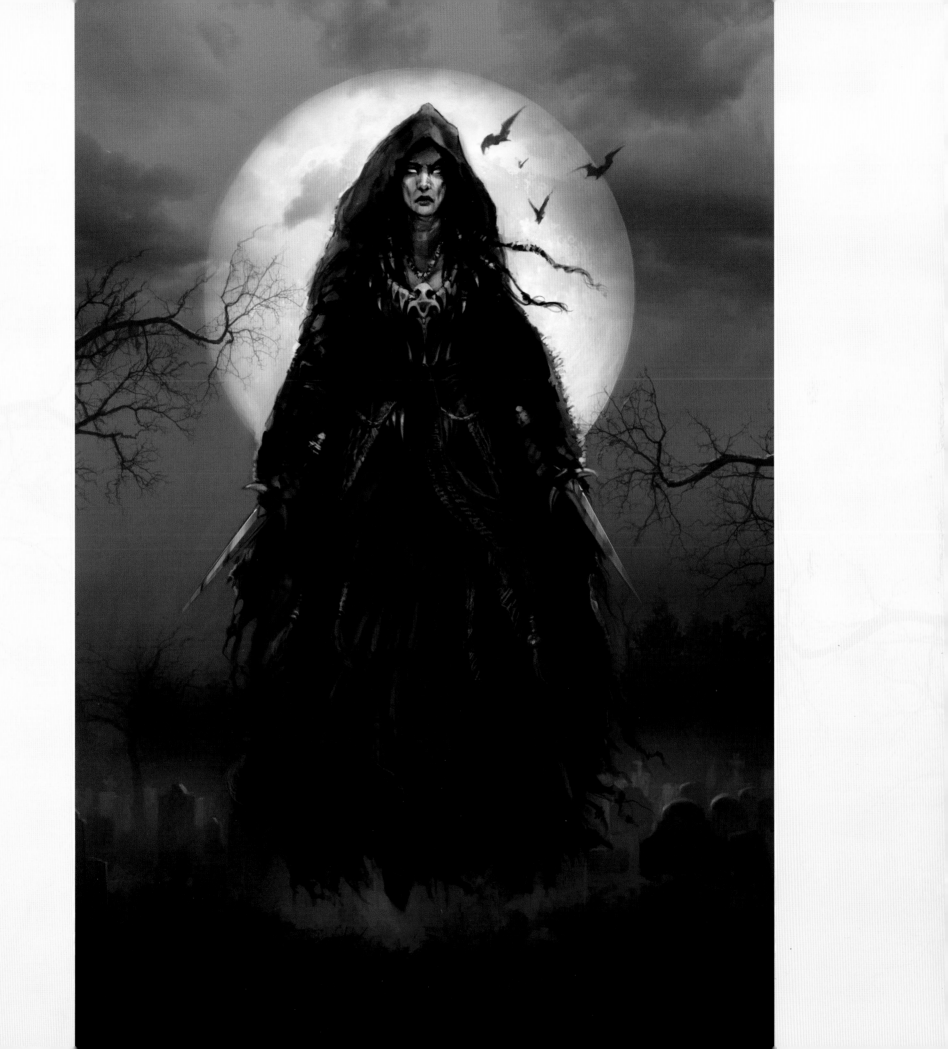

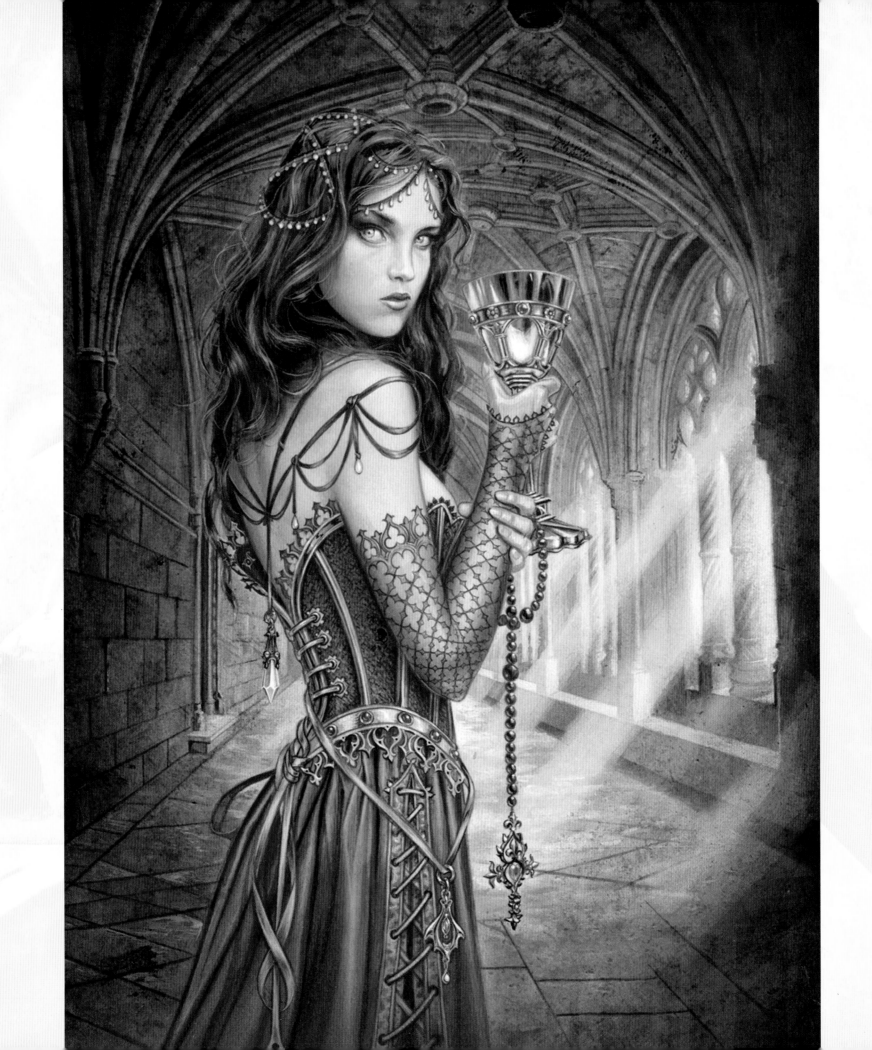

romanticized works of Dante Gabriel Rossetti, John Everett Millais and company saw the creation of haunting paintings that evoked the supernatural and mystic sensibilities of Classical myth and put them into a more modern context, often incorporating darker themes such as death and the cruelty of beauty.

The Cult of Mourning

The Victorians embraced the cult of mourning in a truly fascinating form, especially in the aftermath of Queen Victoria losing her husband, Prince Albert. As is well known, Queen Victoria insisted on wearing nothing but black clothing until her dying day, in memory of her late husband. The Victorians became fascinated by the mourning process, which filtered into fashion and social etiquette. Elaborate black clothing and macabre accessories (such as rings created from locks of hair from the deceased) became an essential part of grieving, turning the private process into a visual spectacle for all to see.

Modern Gothic

These days, Gothic influence is everywhere. What started out as a rebellious music scene in the late 1970s (it was born out of the more experimental strands of British punk rock) is now embraced and explored by all manner of art forms, both as a thriving subculture and a mainstream flight of fancy.

In whatever shape or form, the dark heart of the Gothic sensibility remains the same: to translate light and dark themes into things of beauty, mystery, intrigue and terror, looking back to the past for inspiration and guidance. With such a rich cultural history, it's no surprise that the modern Gothic sensibility continues to build on the themes that have been so vividly expressed in literature and art, even incorporating them into fashion and style. Victorian fashion is as big now as it ever was in the 1800s, with corsets, lace-up boots and billowing skirts making regular appearances on the catwalks as well as the alternative markets of Camden. From *Twilight* to Tim Burton, Gothic art and ideals can inspire us all to look beyond the realms of general perception and embrace the mysterious unknown.

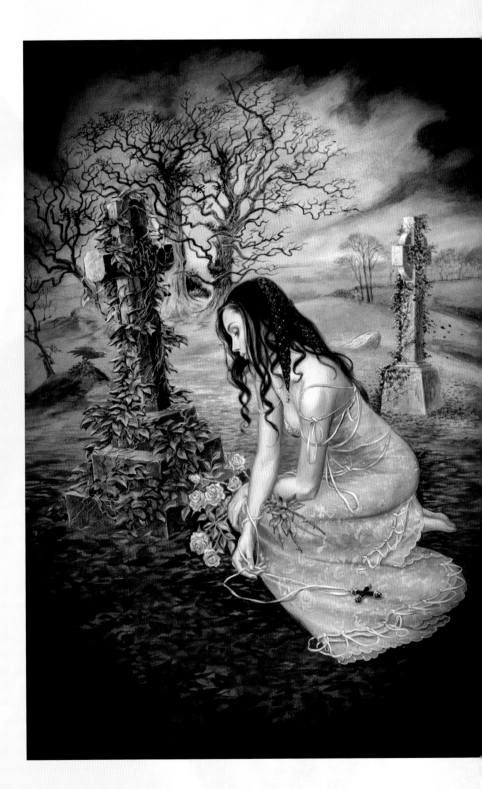

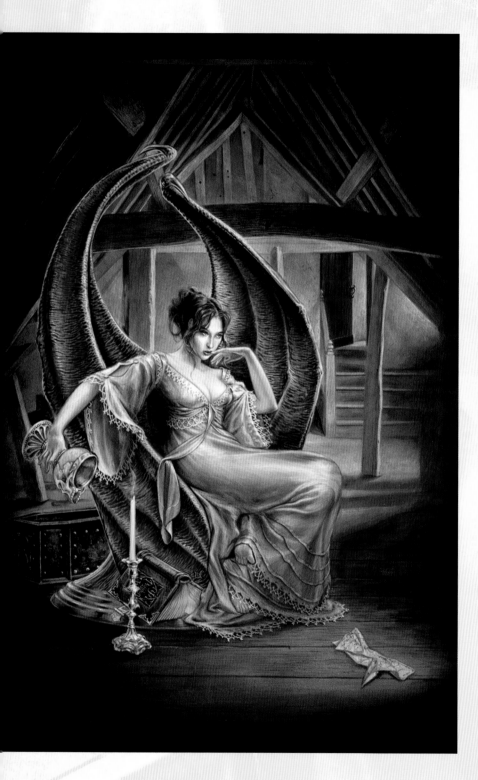

Dark Tales

The landscape of dark fantasy was shaped by those with the curiosity and courage to look into the shadows of the past for creative inspiration. Many of the defining elements of the Gothic sensibility first appeared in the supernatural literature that emerged during the Age of Enlightenment, breaking new ground by merging the worlds of romance and fear.

It all began with Horace Walpole, the father of the modern Gothic novel. Originally published under the guise of a newly discovered medieval manuscript, *The Castle of Otranto* (1764) tells the story of a noble family who finds itself in the clutches of an ancestral curse after a wedding takes an unexpected supernatural turn. Walpole's novel introduced many narrative tropes that would become staple parts of fantasy fiction: family crisis resulting in tragedy, hidden lineage, ancestral sin, power struggles, unrequited lust, forced marriage, forlorn love and vengeful supernatural forces.

What made Walpole's novel stand out was the unusual combination of the ordinary with the supernatural and experimenting with how the two opposing worlds would interact. Light and dark romances underpin and intercept an already bizarre series of events, leaving much to the imagination while fully satisfying the senses.

Otranto's Legacy

The theatrical cast and twisting plot of *The Castle of Otranto* established a framework for subsequent Gothic fiction, especially in the thematic purposes of its core characters: the scheming Lord Manfred driven mad by lust and power and his ostracized wife Hippolita; the vulnerable princess Isabella, who only moments after the death of her fiancé finds herself the unwilling object of Manfred's dynastic plan; the virtuous but doomed daughter Matilda, who prepares to lose the man she loves in favour of helping Isabella, before falling victim to her father's rage; and the chivalrous Theodore, a young man who, after charming (and losing) Matilda, discovers his true noble heritage and saves Isabella from her grim fate.

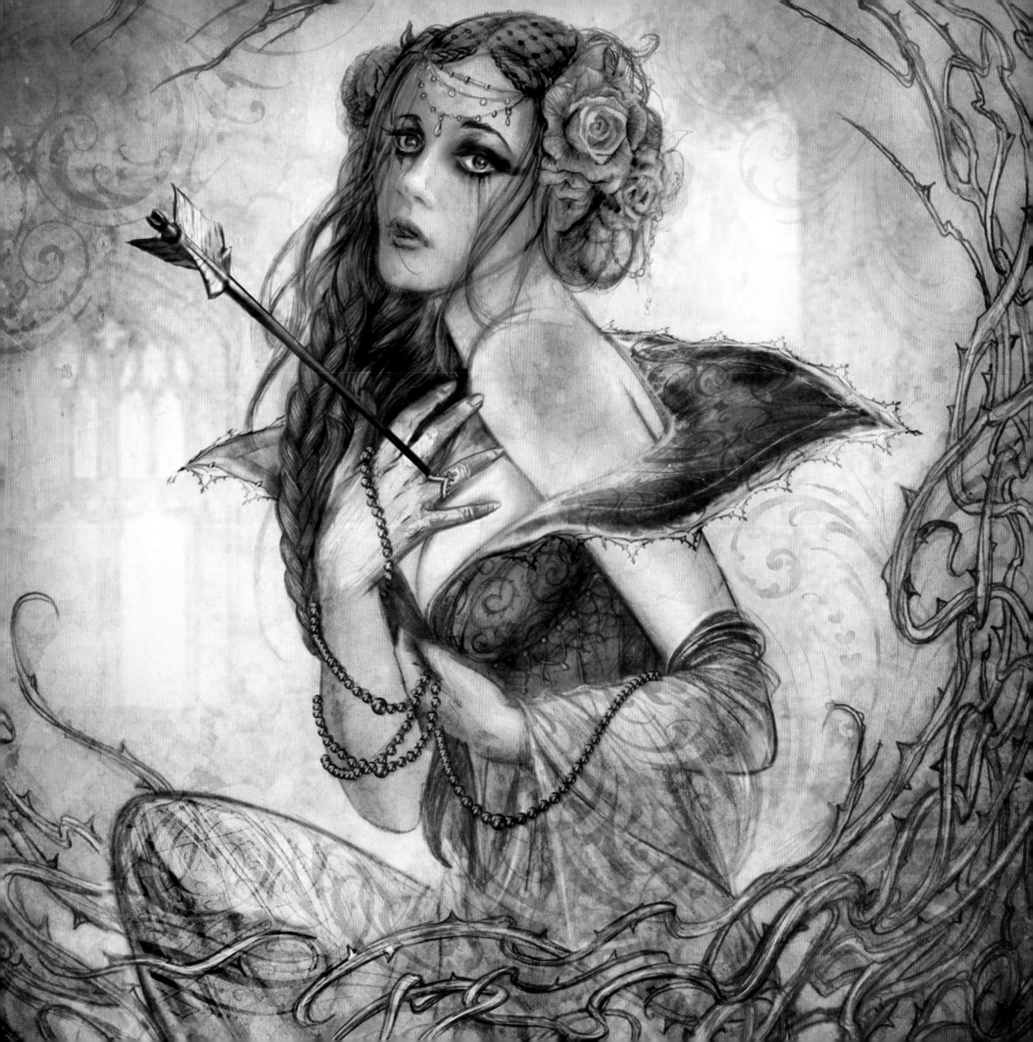

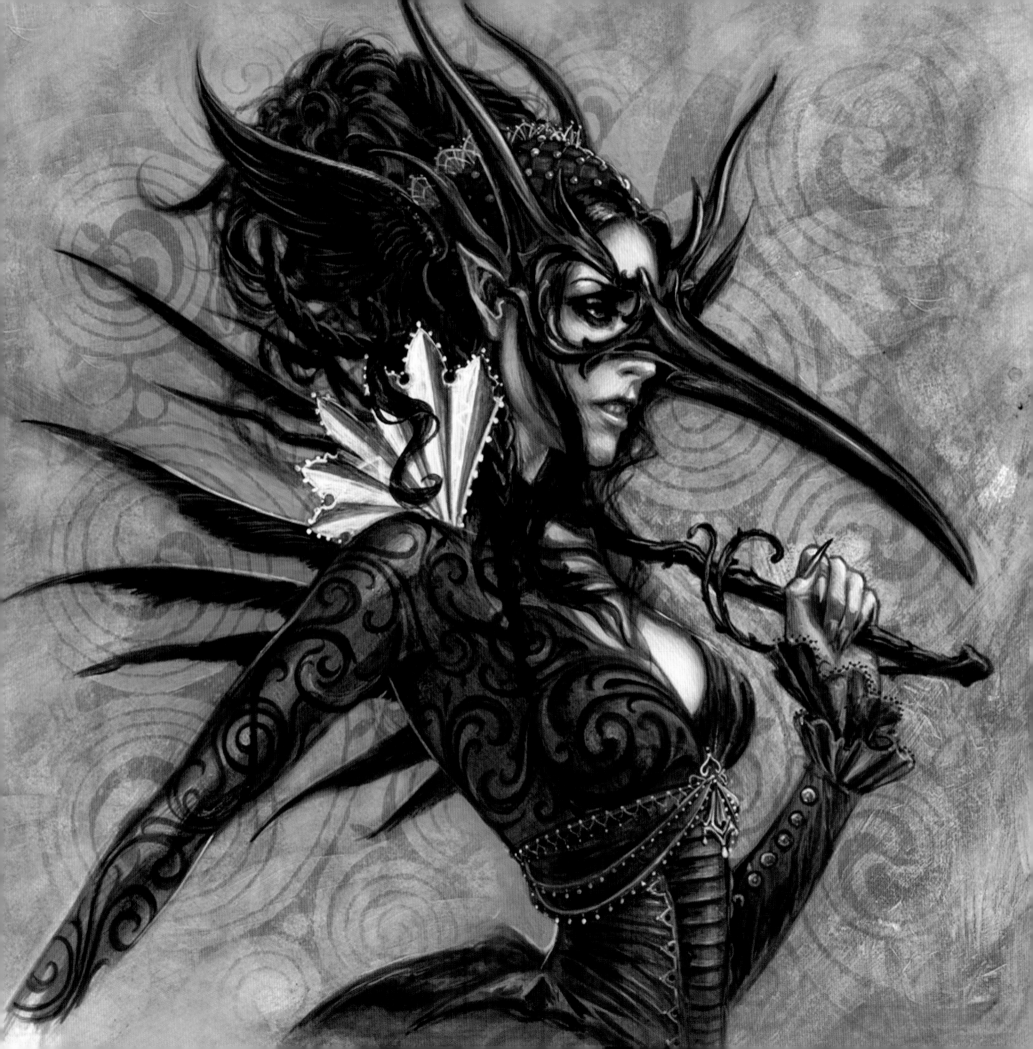

There are many elements to the novel that set the scene for the Gothic aesthetic, especially in terms of gender roles and elaborate settings. We find the Gothic female burdened with loss and fear, at the mercy of older and power-hungry men, while darkness surrounds and consumes every last hope. Meanwhile, the imposing backdrop of ancient castles, secret passages and ominous churches both enchants and mystifies the reader, with the added sensationalism of unfolding ancient prophecies and spectral activity.

Lines of Succession

The success of *The Castle of Otranto* ushered in a new age of Gothic melodrama, which encouraged writers to follow in Walpole's footsteps and explore themes of the supernatural, noble ancestry and family drama. Clara Reeve's *The Old English Baron* (1778) merged paranormal happenings with a righteous battle for the throne, but borrowed less from the inexplicable elements of Walpole's work; while *The Mysteries of Udolpho* (1794) by Ann Radcliffe offered realistic explanations for supposed paranormal occurrences, much to the delight of readers who preferred the rational over the strange. In many ways, Radcliffe's *Udolpho* surpassed *Otranto*, as it built on the themes and tone of Walpole's work while tightening the formula and refining its weaknesses. There's a more unified connection between its gloomy settings and the inner turmoil felt by the heroine Emily St Aubert, along with a highly convincing and menacing Gothic villain in the nobleman Montoni.

Sins of the Flesh

Another significant addition to the genre was the sacrilegious *The Monk* (1796) by Matthew Lewis, which caused outrage by not only ramping up the dark sexual aspects of Gothic fiction, but implicating the Catholic Church in acts of sadistic torture and extreme depravity.

The way in which *The Monk* explores and brutalizes its themes has much to do with why sexuality and fetish-driven violence play such an important visual role in Gothic art. Figures of perceived responsibility are capable of the most deviant acts, with female characters flitting between the roles of virgin, victim and whore at a moment's notice.

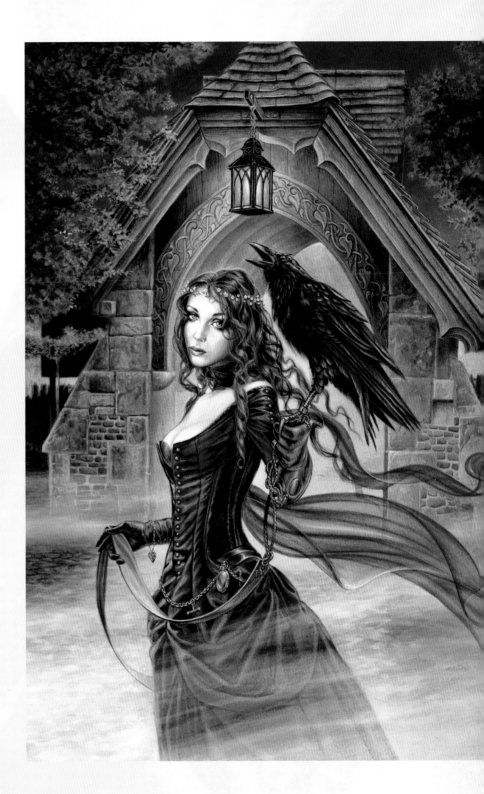

Raven Etiquette by The Alchemist
© 2012 Alchemy Carta Ltd
Traditional media: acrylic on watercolour board
alchemygothic.com

Vespertide by The Alchemist
© 2010 Alchemy Carta Ltd
Traditional media: acrylic on watercolour board
alchemygothic.com

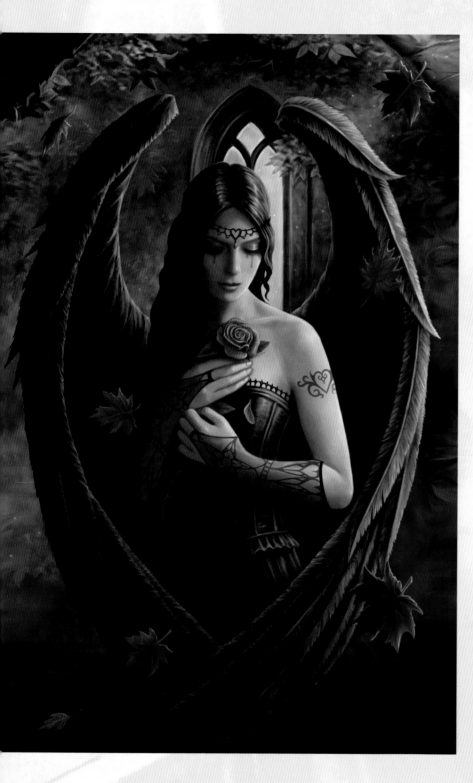

Much of the tale examines the relationship between guilt and sex, or the line between sin and satisfaction. The tale even explores cross-dressing and the sexualization of religious figures. It's no wonder it caused such an outrage upon its original release. The use of black magic also features heavily, adding to the controversial treatment of religion.

The Marquis de Sade

The Monk also presents the connection between Gothic style and the infamous sexual deviant, the Marquis de Sade. In his 1791 novel *Justine: The Misfortunes of Virtue*, Sade presented a tale about a very young girl who finds herself in the most pitiful of situations as she travels through France. One of the most shocking plot points is the way in which she is forced to become a sex slave for a debauched group of monks, which may have provided inspiration for Lewis's graphic tale.

Unlike Sade's other works, *Justine* integrates the Gothic narrative tradition into the novel, often experimenting wildly with the role of submissive female heroine and the limits of the terrors to which she can be subjected. It's also fascinating to note how the notoriety that Sade would leave behind would create a lasting impression on the dark Gothic consciousness, with his own acts of depravity inspiring artists and authors alike for generations to come.

Goethe's Faust

Although not strictly a Gothic tale, the legend of Dr Faustus, the alchemist who strikes a deal with the Devil in order to find true fulfilment in life, has been a constant source of creative inspiration since it first appeared in written form in the sixteenth century. While the general premise of the myth has been incredibly influential, it's perhaps Johann Wolfgang von Goethe's two-part play *Faust* that has become regarded as the definitive version of the story, especially *The First Part of the Tragedy* (1808). Whether due to its fascinating scholarly insight into alchemy and the occult, its portrayal of the playful devil Mephisto, or the tragic downfall of Faust's lover Gretchen, the popularity of Goethe's *Faust* was another important milestone in the rise of supernatural fiction.

Angel Rose by Anne Stokes
© Anne Stokes
Digital media: Photoshop
annestokes.com

Crystal Ball by Anne Stokes
© Anne Stokes
Digital media: Photoshop
annestokes.com

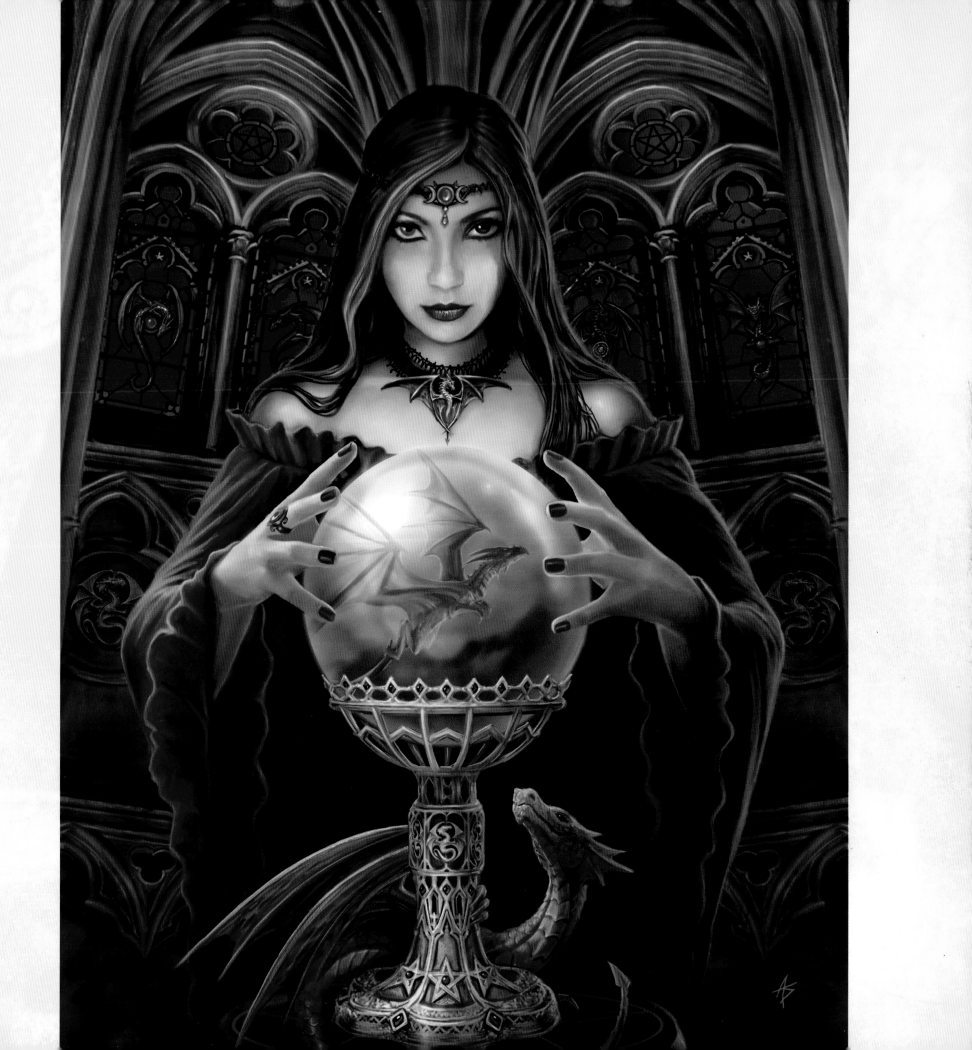

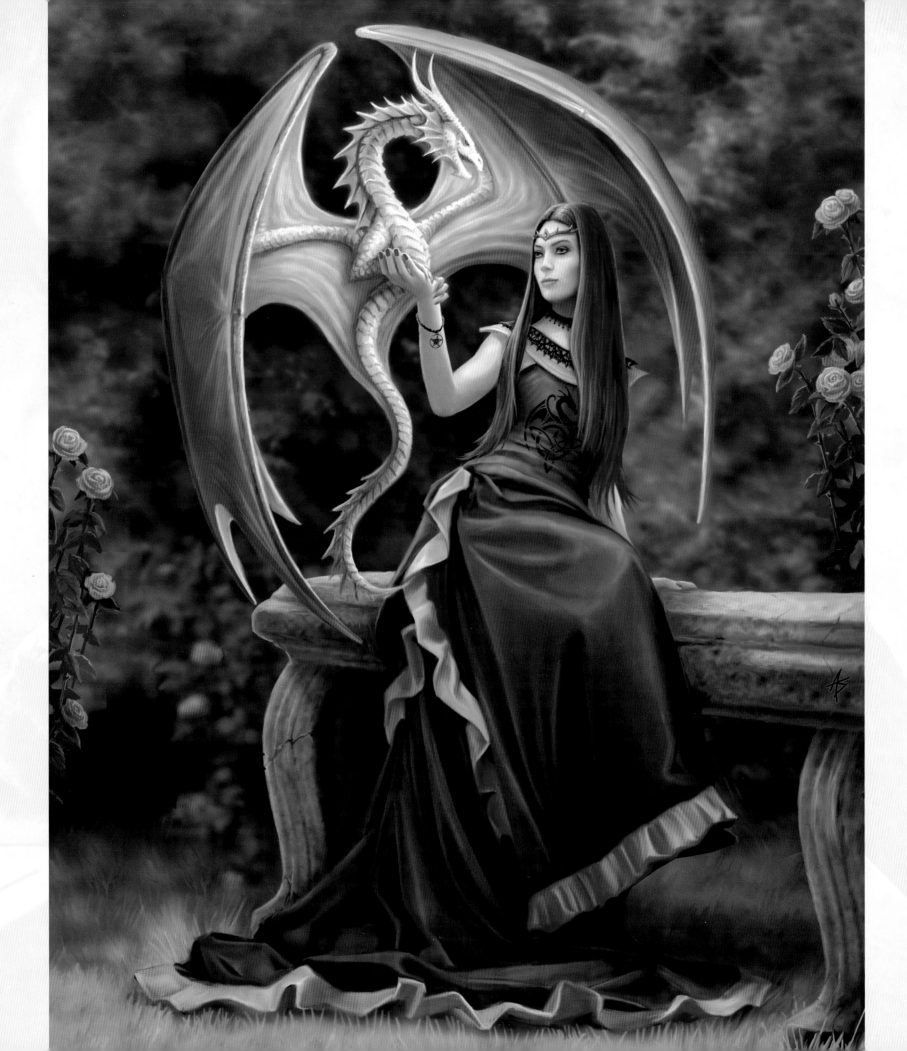

The Dark Romantics

As the end of the Age of Enlightenment approached, the poetic cult of Romanticism had firmly taken hold of European literature, led by Samuel Taylor Coleridge, John Keats, Lord Byron and married couple Percy Bysshe Shelley and Mary Shelley. The Romantics explored the sublime forces of nature and the mysteries of the unknown, tapping into otherworldly imagery and evocative concepts that often veered into darker territory. The dramatic personal lives of the poets became as fascinating as their own works, especially in the case of the libertine Lord Byron; his wanton behaviour and sexual reputation even spawned the birth of a new character archetype, the Byronic Hero, possessing his famed selfishness, coldness and seductive tendencies.

One Dark Night in Switzerland

The night that Lord Byron, the Shelleys and John William Polidori held their ghost story competition at the Villa Diodati on the banks of Lake Geneva is as legendary as the stories that followed. Two of the most famous works of Gothic fiction, Mary Shelley's *Frankenstein* (1818) and John William Polidori's *The Vampyre* (1819) were created during that summer vacation, both resulting in their own subgenres. What made these tales so alarming (and popular) was the fact that, although each novel followed the romanticized Gothic tradition, they added something new and decidedly realistic to dark fantasy, instilling a far greater fear in their readers – the threat of a plausible supernature.

The Dangers of Playing God

In *Frankenstein*, Shelley pursued an innovative line of enquiry that highlighted the darker side of science, exploring the limits men will go to attain the power of creation. Many cite the novel as one of the pioneers of the science-fiction genre, with the reader following the downfall of the scientist Victor Frankenstein as he brings to life a monstrous being assembled from fresh corpses. Shelley's novel was unique in the sense that it not only played on the fears of where science and desire could lead to, but also with the fragile line between man and monster.

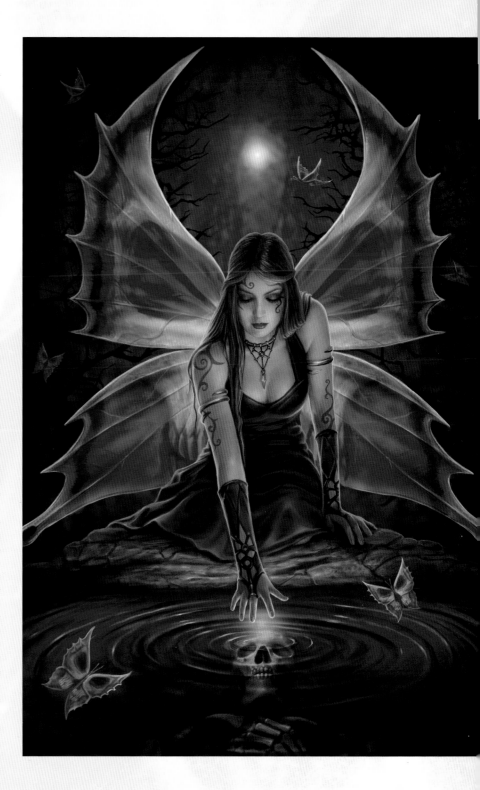

Elegant Dragon by Anne Stokes
© Anne Stokes
Digital media: Photoshop
annestokes.com

Immortal Flight by Anne Stokes
© Anne Stokes
Digital media: Photoshop
annestokes.com

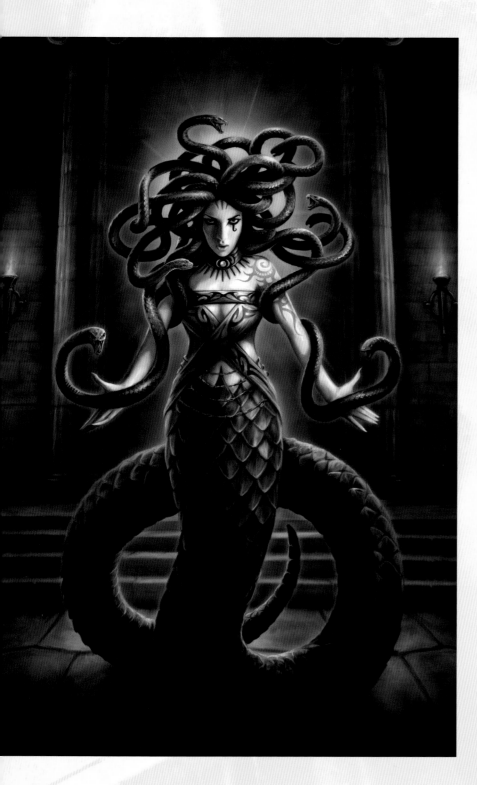

A Dangerous Man to Know

Meanwhile, in *The Vampyre*, Polidori took the growing popularity of the vampire myth and created the first vampire novel, the aftermath of which can be seen today in the extensive selection of vampire literature available to us. Polidori typified the vampire as a seductive and powerful socialite, very much in the mode of his fellow poet Lord Byron. In fact, the name of the vampire, Lord Ruthven, was used as a malicious allusion to Byron in *Glenarvon* (1816), a melodramatic Gothic novel by Byron's spurned lover, Lady Caroline Lamb.

The American Nightmare

By the mid-Victorian era, Gothic fiction had enjoyed its heyday and had lost some of its dark appeal due to an influx of 'penny dreadful' titles. However, this was by no means the end of the line for the genre. The American master of psychological horror, Edgar Allen Poe, reinvigorated Gothic fiction by shifting the balance from the inexplicable and paranormal to the terrors of the mind, with many of his works exploring the progressive descent into madness and self-destruction.

Poe's tales were often self-contained slices of brooding decay, such as the *Otranto*-like *The Fall of the House of Usher* (1839), the guilt-ridden *The Tell-Tale Heart* (1843), the sensory terror of *The Pit and the Pendulum* (1842) and the melancholic lament of lost love in *The Raven* (1845). Although supernatural forces do indeed come out to play, Poe presents a unique kind of terror that is driven by the actions of mankind, with many of his narrators subjecting themselves to their own kinds of internal torture.

While on the subject of Poe, it would be a crime not to mention the captivating work of the Irish illustrator Harry Clarke for the 1923 edition of Poe's collected works, *Tales of Mystery and Imagination*; a must-see for fans of Poe and Gothic visual style alike.

The New Age of Gothic Fiction

The welcome addition of psychology and science to fantasy fiction prompted a new wave of authors of different styles and genres to

Serpent's Spell by Anne Stokes
© Anne Stokes
Digital media: Photoshop
annestokes.com

Spellbound by Anne Stokes
Digital media: Photoshop
© Anne Stokes
annestokes.com

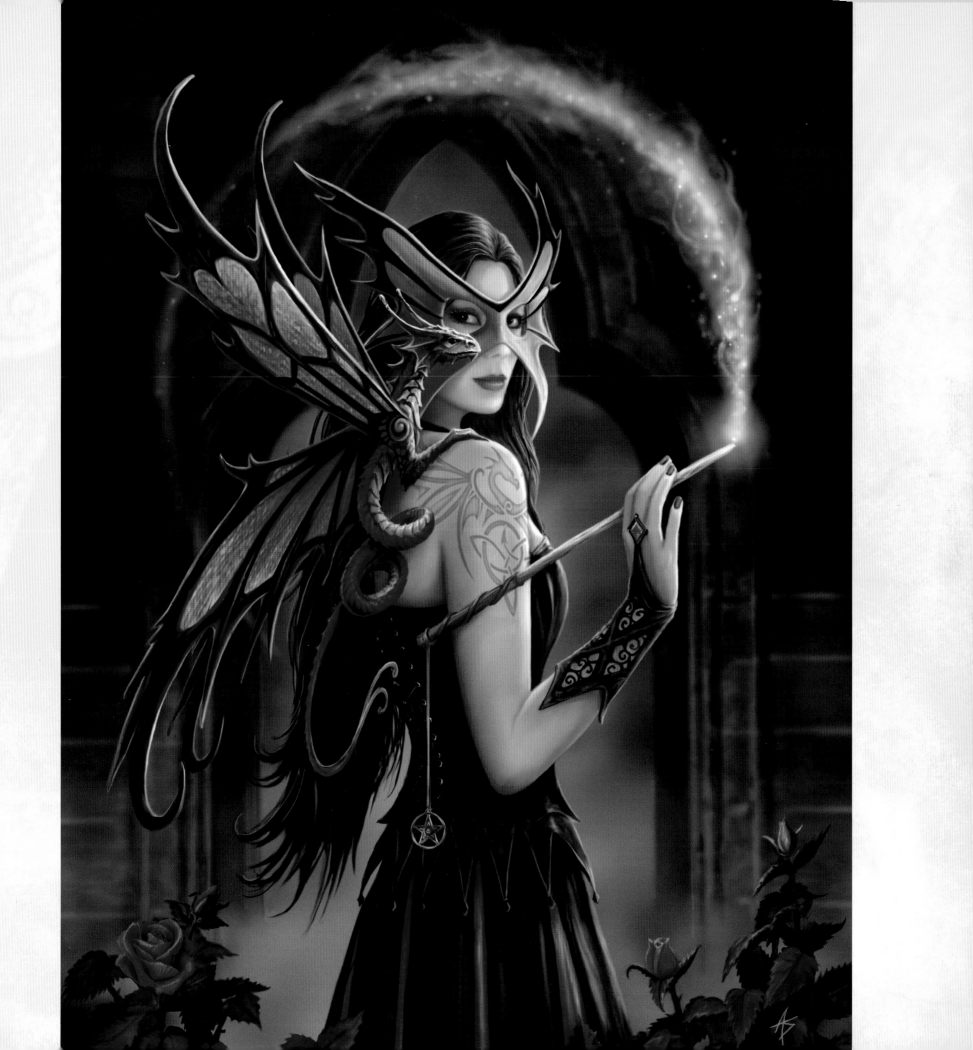

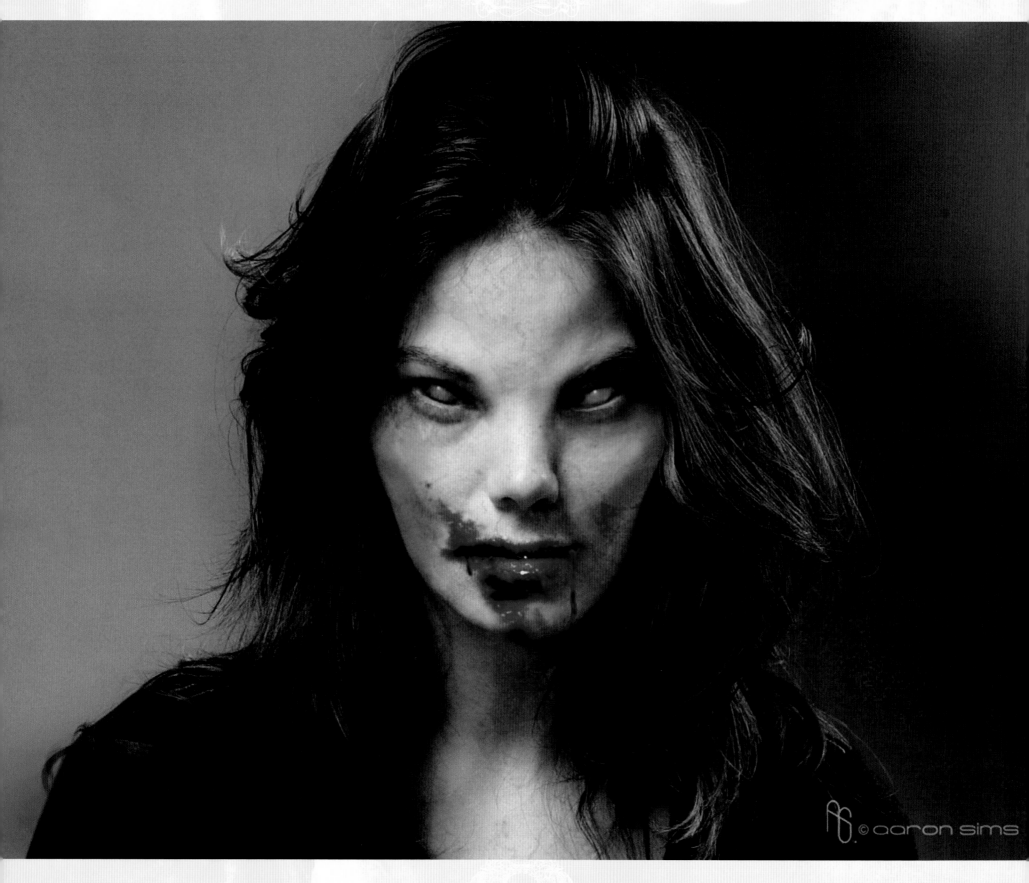

© aaron sims

incorporate Gothic tendencies into their work, as we see in Emily Brontë's sprawling romance *Wuthering Heights* (1847), and the eerie atmosphere in many of the works of Charles Dickens.

Meanwhile, dedicated Gothic literature started to take itself a little more seriously, using romantic themes and social fears to create truly horrifying and thought-provoking works. By the late Victorian period, the industrialization of Britain and Europe brought new fears to the streets of London, with popular literature becoming an outlet to speculate on and understand the prospects of the unfolding future. The birth of modern life challenged virtually every aspect of society, from concerns over commerce, immigration and the reach of the British Empire to the inner workings of the mind and how it would respond to these rapidly changing times. Human nature, sexuality, madness and hysteria were topics of academic speculation, which is why it was inevitable that such subjects would find themselves woven into the fabric of Gothic narrative.

Urban Terrors

Out of the many fears born in the furnaces of the Industrial Revolution, social degeneration was extremely high on the list, and consequently became a core theme in three of the most significant Gothic novels of the latter part of the nineteenth century. Robert Louis Stevenson's *The Strange Case of Dr Jekyll and Mr Hyde* (1886) explored the duality and repression of human nature in spectacular fashion with the struggle between the respectable Dr Jekyll and his grotesque alter ego; a theme which Oscar Wilde explored further in *The Picture of Dorian Gray* (1890). In Wilde's tale, the eponymous Dorian is able to avoid paying the price for his debauched lifestyle through an enchanted portrait that absorbs his sins and ageing appearance – for a while, at least. The novel plays on the duality of beauty and morality, as well as the overriding Gothic tradition of the eventual penalty for past sin.

Then, of course, there's Bram Stoker's *Dracula* (1897), the vampire at its very finest. Along with becoming the apex of the vampire myth, Stoker's novel used the legendary creature as an allegory for all that was wrong with Victorian Britain: a force of immense power capable of consuming all in its path, mocking tradition and morality as it hungrily envelops and devours all.

Victorian Legacy

As the Victorian literary tradition began to wane and modern fiction waxed, the Gothic tradition began to filter into other genres, such as fantasy, horror, romance and science fiction. The success of

Female Vampire for 30 Days of Night by Aaron Sims
© Aaron Sims 2006
Digital media: Photoshop
asc-vfx.com

Water Dragon by Anne Stokes
© Anne Stokes
Digital media: Photoshop
annestokes.com

pulp magazines during the 1920s kept the masters of the past alive alongside upcoming acolytes of dark fiction, such as H.P. Lovecraft and Robert Bloch.

The works of H.P. Lovecraft have been particularly influential to the modern strand of Gothic narrative, with menacing tales such as *The Call of Cthulhu* (1926) and the occult-driven *The Case of Charles Dexter Ward* (1941, published posthumously) fuelling fascinations with fate, higher life forms and apocalyptic entities. Along with Lovecraft, innovative authors such as Anne Rice, Stephen King, Angela Carter and Neil Gaiman have allowed the Gothic tradition to thrive in the most imaginative and compelling of ways.

The Visual Narrative of Comics

With the international success of comics and graphic novels, the Gothic narrative tradition has also found a happy home in such publications all over the world. The pulp-inspired EC Comics franchises such as *Tales from the Crypt* (1950–55) led the way in telling strange and unsettling tales, much to the disapproval of the growing number of academics and health bodies that accused EC comics of promoting violence.

Many titles picked up the gauntlet as the underground comic-book scene explored more mature content, with Warren Publishing's *Vampirella* series (1969) breaking into the mainstream with the help of Frank Frazetta's legendary first-issue cover. DC Comics have long since embraced Gothic themes and styles with many of their comics, most notably in the *Batman* franchise (1939) and Neil Gaiman's seminal *The Sandman* series (1989–96).

Gothic tales are also very popular in Japanese manga, with the likes of the renowned ensemble Clamp integrating subtle influences into their work, like the innovative reinterpretation of the Gothic damsel in *Magic Knight Rayearth* (1993–95) and the grim apocalyptical *X* (1992–2003). Manga offers a fascinating glimpse into how the European Gothic tradition has been applied to Asian folklore, such as in Narumi Kakinouchi's delicate *Vampire Princess Miyu* (1988–2002).

Vampirella by Corlen Kruger
© Atomhawk Design
Digital media: Photoshop
atomhawk.com

Sculpture relief at
Staglieno cemetery,
Genoa, Italy.
Medium: stone

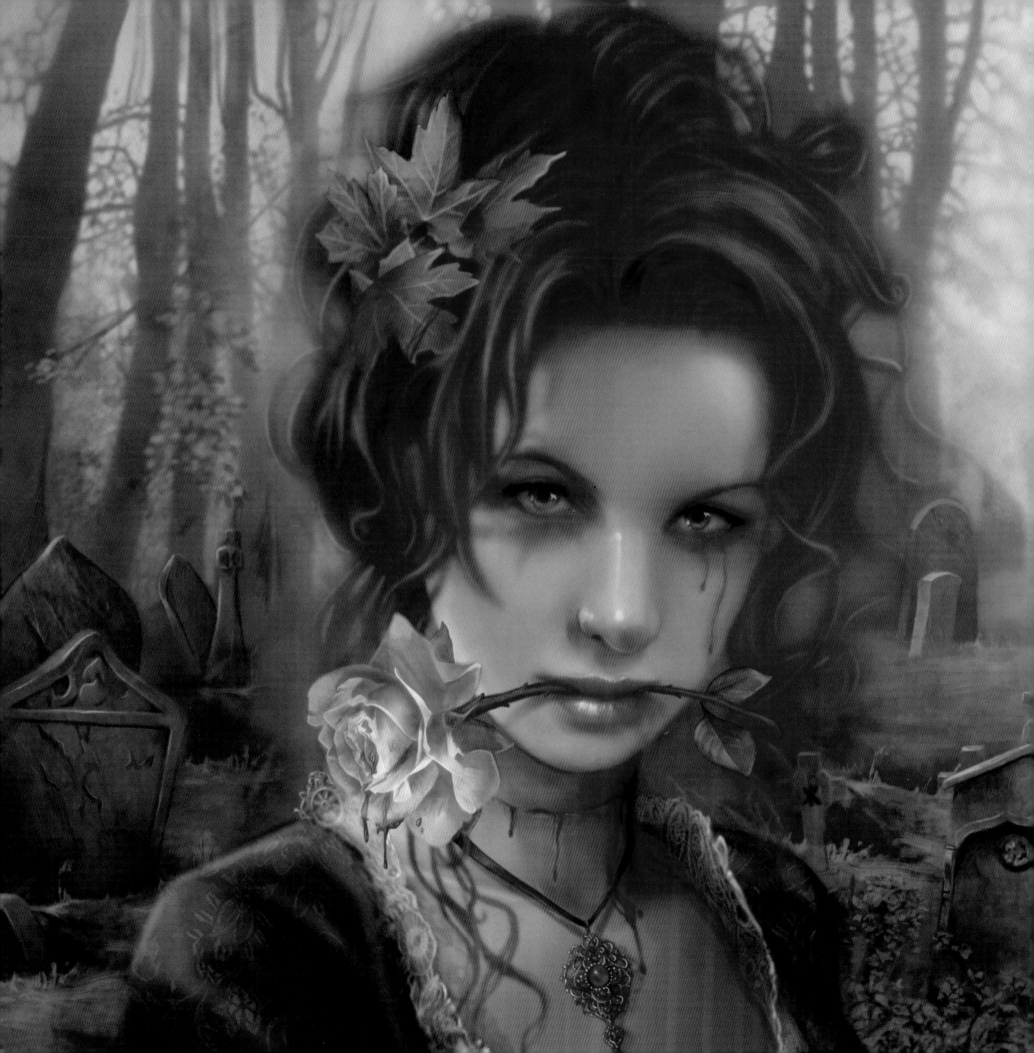

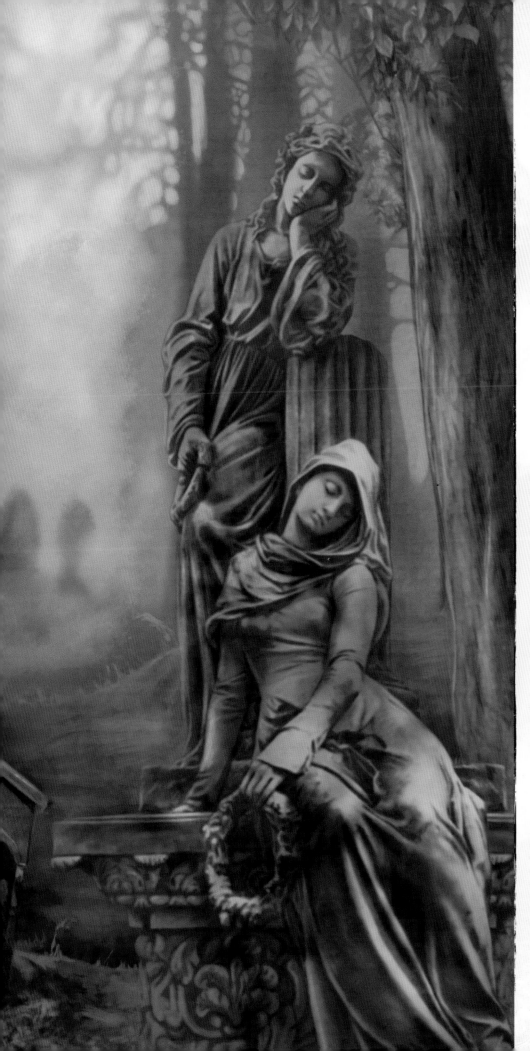

Vampires, Witches & Enigmas

One of the first observations you might make about Gothic artwork is that it favours the female over the male form. However, this is hardly surprising. When you look back over the many styles and movements throughout art history, the symbolic values of the female form have been interpreted over and over by scholars and artists alike.

Much to the displeasure of many, the female is typically depicted in terms of the kind of classical beauty that is openly objectified. Put bluntly, the female form is considered to be more appealing than that of the male. The very personification of beauty, if you will. Along with these physical characteristics, a vital element of feminine beauty is the heightened emotionality that women are considered to possess. Therefore, traditionally, an artist will use the female form as a vessel to amplify emotional themes or concepts that would not carry as much weight if depicted through a male character. Naturally, there are many who actively oppose the objectification of the female in art, who defy convention and challenge gender stereotyping.

The Gothic Female

Fantasy art regularly finds itself under fire for promoting the sexualization of its female characters, and it's easy to see why. But then for those exact reasons, there are many female artists who rebut claims of sexualization and extol the use of femininity as a means of empowering their characters.

In Gothic art, the theatrical tone and emotional attachments of the style and subject matter must be expressed as strongly as possible, which is why the female often appears as the main focal point. She becomes a conduit for a darker purpose, to be explored and savoured, challenged

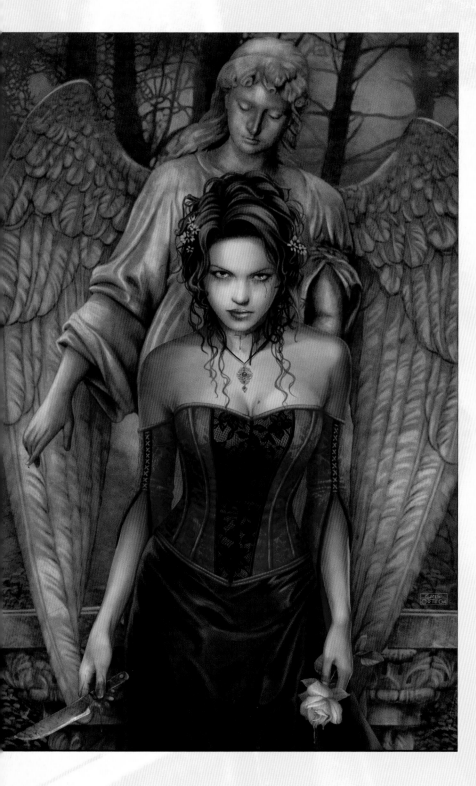

and opposed, feared and worshipped, loved and lost. She can be whatever an artist may choose, or may transform into something entirely different in the eyes of her viewers.

Enchanting Features

The heart of Gothic beauty is romanticized contrast: visual traits that complement nearby physical features whilst retaining a unique characteristic of their own. Pale complexions are often the base on which other emotive qualities can become theatrically enhanced, such as startling eyes, expressive lips and luscious hair. Make-up is often a prominent feature, with darker shades adding extra drama and definition, especially around the eyes.

Clothing is often ornate, elaborate and of historical origin, which can add an extra layer of emotional narrative with expressive fabrics and colours. Fine details, such as embroidery, textured materials and intricate tailoring can dramatically enhance mood and tone. Jewellery serves an important function that can not only add visual interest to a character, but also bring extra symbolic weight to enhance atmosphere, tone and narrative.

The works of celebrated fantasy artists Marta Dahlig, Jason Chan and Mélanie Delon typify the ethereal Gothic aesthetic as a kind of poetic beauty that balances elegance with brooding melancholia. Jason Chan's *White Flower* (2005) is a particularly stunning example of the evocative use of contrasting elements, with its striking use of colour, selective texture definition and haunting symbolism.

Plays on Femininity

The complex duality of traditional female values (seductive physical form verses emotional frailty) has become increasingly associated with Gothic aestheticism, with artists of all disciplines using bold and graphic imagery to explore the nature of femininity, such as Darren Aronofsky's *Black Swan* (2010), a Gothic take on the ballet Swan Lake.

It's the acceptance of the darkness that other styles try to hide that makes Gothic artwork all the more compelling, as we see in the many

Queen of Ghouls by Cris Ortega
© Cris Ortega/Norma Editorial 2006
Digital media: Photoshop
Originally published in Forgotten I art book.
crisortega.com

Nightmare by Cris Ortega
© Cris Ortega 2008
Digital media: Photoshop
crisortega.com

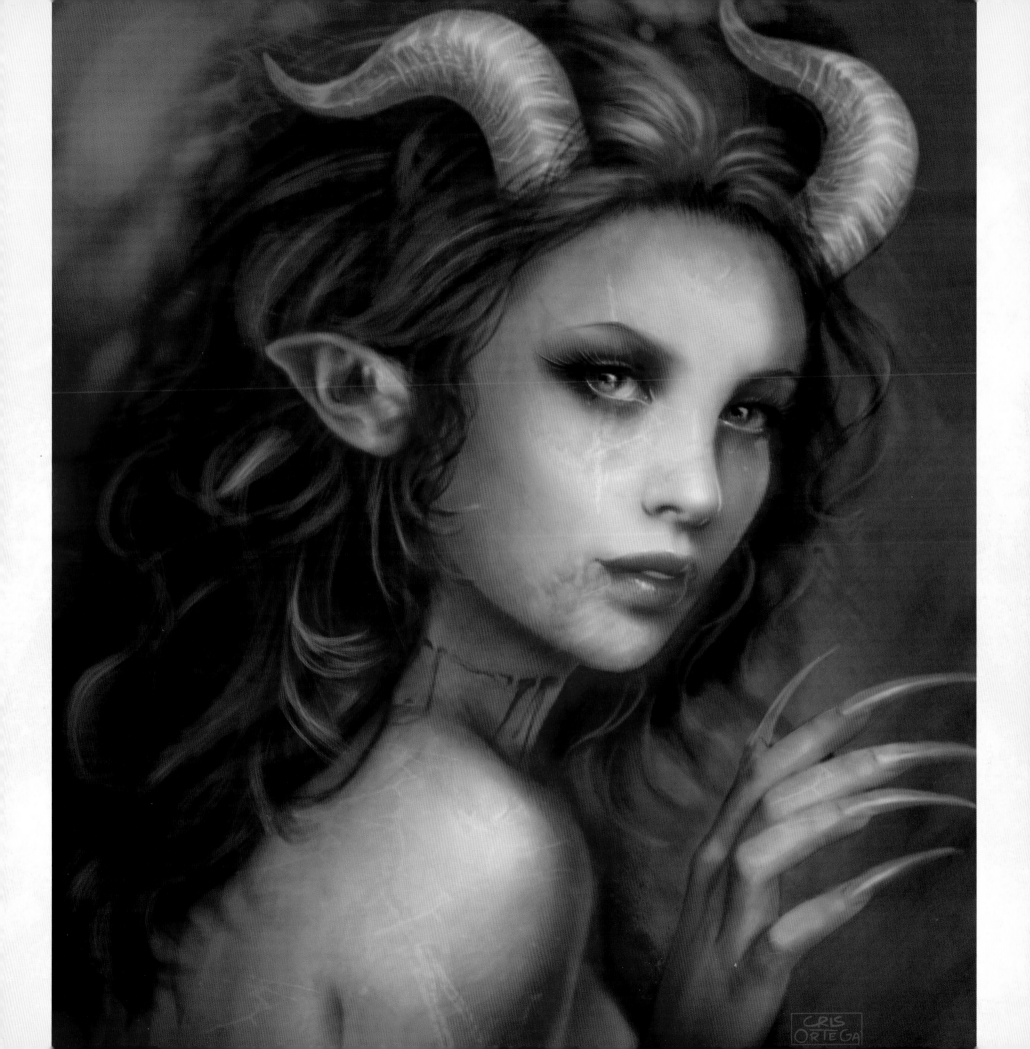

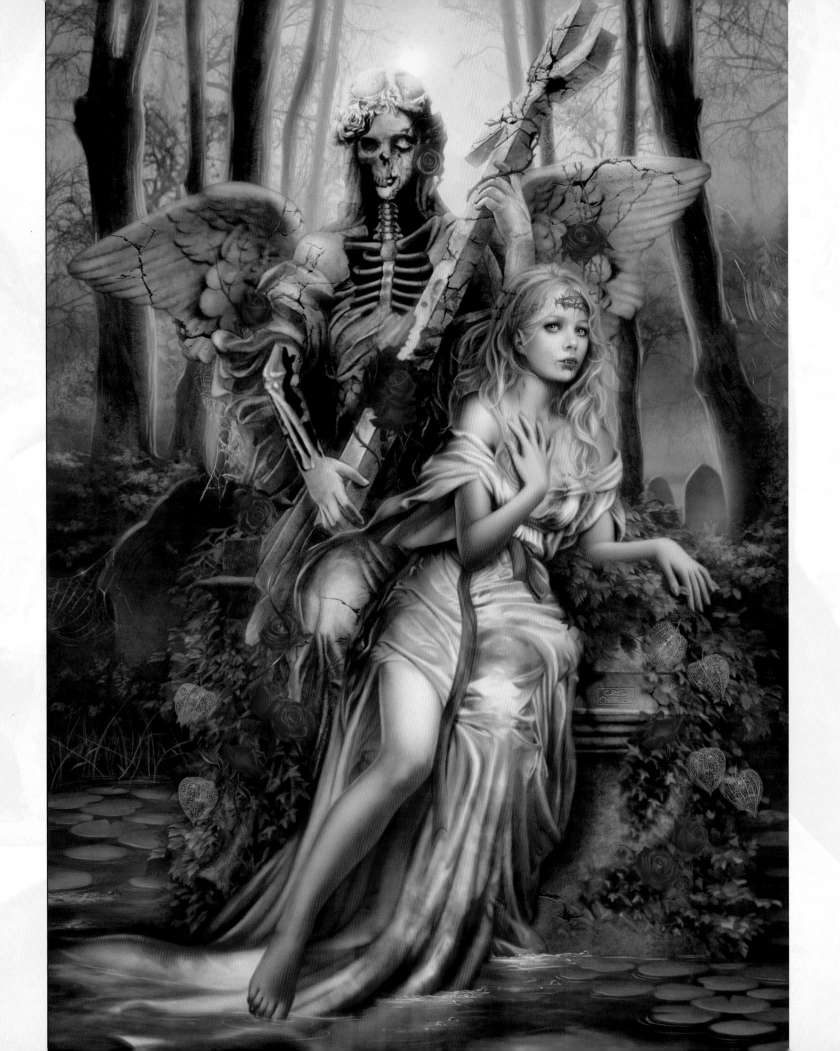

figures that reappear time and time again: the tragic figure of the Gothic bride, the lovelorn maiden waiting patiently and silently, the sadistic harlot who toys with her victims, or the fallen angel who seeks one last chance of retribution. Gothic art often casts a darker spin on traditionally virtuous female archetypes, which in turn plays with our reactions: the dark fairy art of Marc Potts, for instance, examines some of the more adult connotations that were associated with fairy folk before the age of censorship that followed the publication of *Grimm's Fairy Tales* in 1812.

Horrors of the Past

History plays such an important role in the Gothic aesthetic that it's no wonder that figures from Classical mythology, literature and bygone times are frequently seen in the realm of Gothic art. Many artists choose to explore the darker sides of history, selecting evocative stories and characters they can really sink their teeth into. Classical mythology and literature from ancient cultures, such as the Romans, Greeks and Egyptians, continue to be extremely popular, as do notorious figures from history such as Elizabeth Báthory, Lucrezia Borgia, Cleopatra and Anne Boleyn.

Twisted Fairy Tales

Another popular strand of Gothic art is the subversion of popular tales, casting dark shadows over iconic characters or stories. Dark and twisted fairy tales are especially popular when it comes to examining female nature, with brutal reimaginings of Little Red Riding Hood, Alice in Wonderland and Sleeping Beauty following in the footsteps of Angela Carter, the acclaimed (and dearly missed) purveyor of dark feminist fantasy, who published her seminal collection of dark fairy tales *The Bloody Chamber and Other Stories* in 1979.

Video-game designer American McGee transformed Alice's exploits into nightmarish and bloody encounters in the cult adventure game *American McGee's Alice* (2000), followed by the beautifully designed sequel *Alice: Madness Returns* eleven years later. Both titles turned the familiar concept of Alice's adventures through Wonderland on its head, with Alice recast as a troubled young woman plagued by madness.

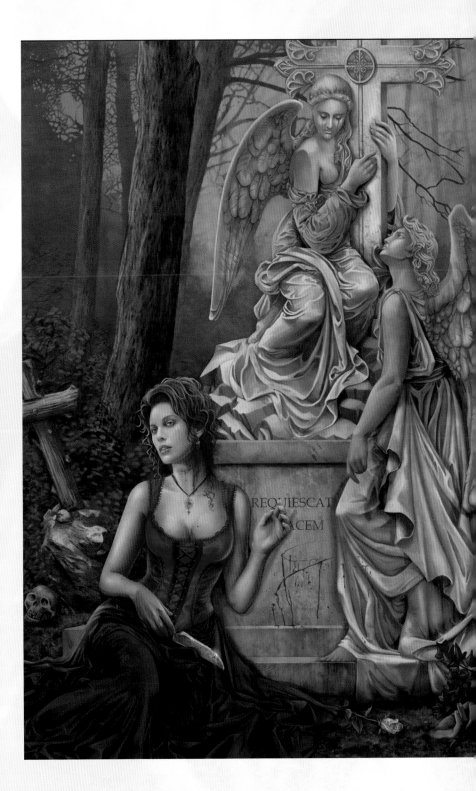

The Thorn of Every Rose by Cris Ortega
© Cris Ortega 2010
Digital media: Photoshop
Originally published in Nocturna art book.
crisortega.com

Wild Rose II by Cris Ortega
© Cris Ortega/Norma Editorial 2006
Digital media: Photoshop
Originally published in Forgotten 1 art book.
crisortega.com

Spirit of the Night by Cris Ortega

© Cris Ortega/Norma Editorial, 2009; **Digital media:** Photoshop; Originally published in *Forgotten 3* art book; www.crisortega.com

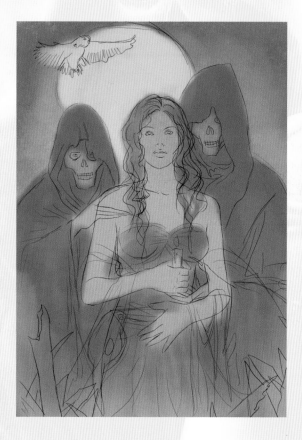 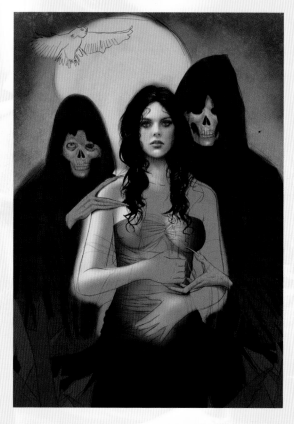 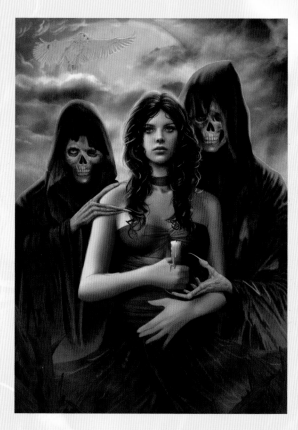

Step 1: I began with a rough sketch of characters and setting, working out where the strong points of focus would be. The sketch is not highly defined, but helps to provide a clear idea of the elements in the painting.

Step 2: With the sketch on a different layer as a guide, I kept on painting the basic tones of the picture. As I wanted to focus on the girl, I chose lighter and warmer tones for her to stand out, keeping the grim figures behind her in the shadows. I worked with several soft- and hard-edged brushes, and also with some texturized ones for a more natural effect.

Step 3: Then I worked in full detail, taking special care on the girl. I used mostly blue tones for the environment, adding some warmer ones on her skin. I also added detail to the death skin of the reapers and their ripped clothes. The background is going to be bright with lighter tones, to make the characters stand out. I began working on the basic lines of the owl in the background.

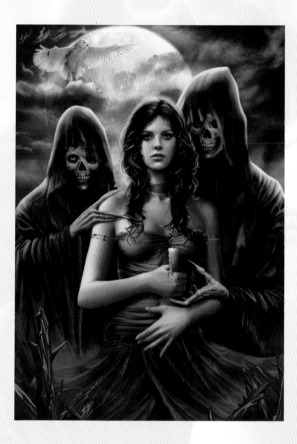

Step 4: By this stage I was almost finished with the image. I worked futher on the details, adding several medium and light tones and varying the colours, seeking a more polychromatic look. I worked on the transparency of the clothes, adding some jewels. I used the same light blue colours in the background to create a clear outline where the moonlight shines on the characters.

Finishing Touches (right): Finally, I worked more on the contrast and brightness of the image, adding some mist and smoke for a mystical feeling. I also retouched the colours to make it all stand together, mixing the background and foreground tones for a better result.

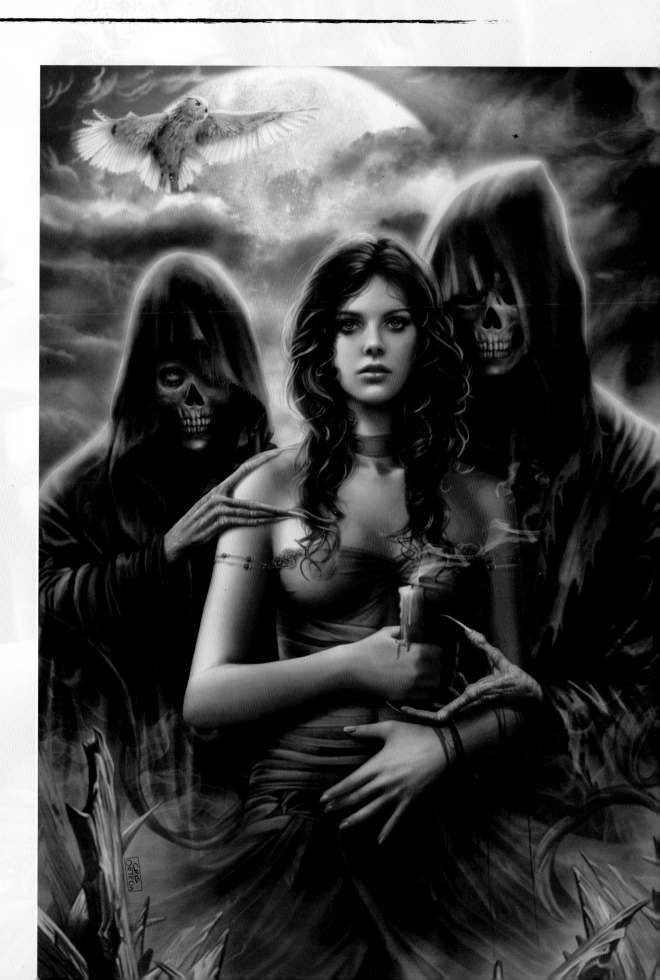

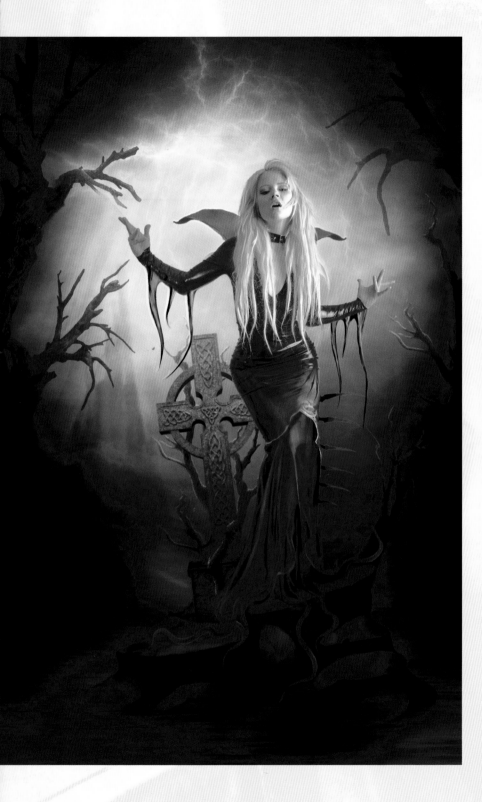

Restraint and Disobedience

Themes of feminine restraint are also a common theme of Gothic art, with some of the most provoking examples using sadomasochistic imagery to create nightmarish scenes of brutality and surreal beauty. The master of dark fantasy Gerald Brom often toys with the concept of restraint on many levels, with his masked characters wearing outfits that look like they have been clamped on to their skin by some kind of hellish contraption, such as the deadly *Sister Mercy* and *Sister Compassion* (both 2010).

Likewise, rebellion also plays an important role in Gothic creations, whether in a fantastical or modern-day setting. The recurring motif of the femme fatale is a celebration of females who choose to stray from the path or challenge expected and appropriate behaviour, using their looks to foil their adversaries and to get what they want.

The Gothic Vampire

In many ways, the vampire is the very embodiment of Gothic culture. Ferocious, predatory, seductive and tragic, the vampire has become one of the most enduring creatures to spring from folklore and mythology, and has had a lasting impact on not only Gothic fiction, but also the wider realm of popular culture.

The most distinctive sign of the vampire are its fangs, along with an unnaturally pale complexion, piercing eyes and luscious, inviting lips. If not on their own grounds, a vampire can only feed on those who invite them into their homes, making the ability to charm – and if necessary, seduce – an absolute necessity.

The vampire has become an icon of Gothic art, and can be explored in a limitless number of ways: from the dark romance of Anne Stokes, Joana Dias and Mélanie Delon to the wayward nocturnal sirens of Serge Birault, Matt Dixon and Avelina de Moray, there are different kinds of vampires for every taste, style and artistic discipline. The most revered masters of fantasy art, including Frank Frazetta, Dorian Cleavenger, Yoshitaka Amano, Boris Vallejo and partner in paint Julie Bell, have taken on the vampire and created evocative and haunting images of immortal beauty.

Tormenta by Elena Dudina
© elenadudina
Digital media: Photoshop
elenadudina.com

Pasaje Secreto by Elena Dudina
© elenadudina
Digital media: Photoshop
elenadudina.com

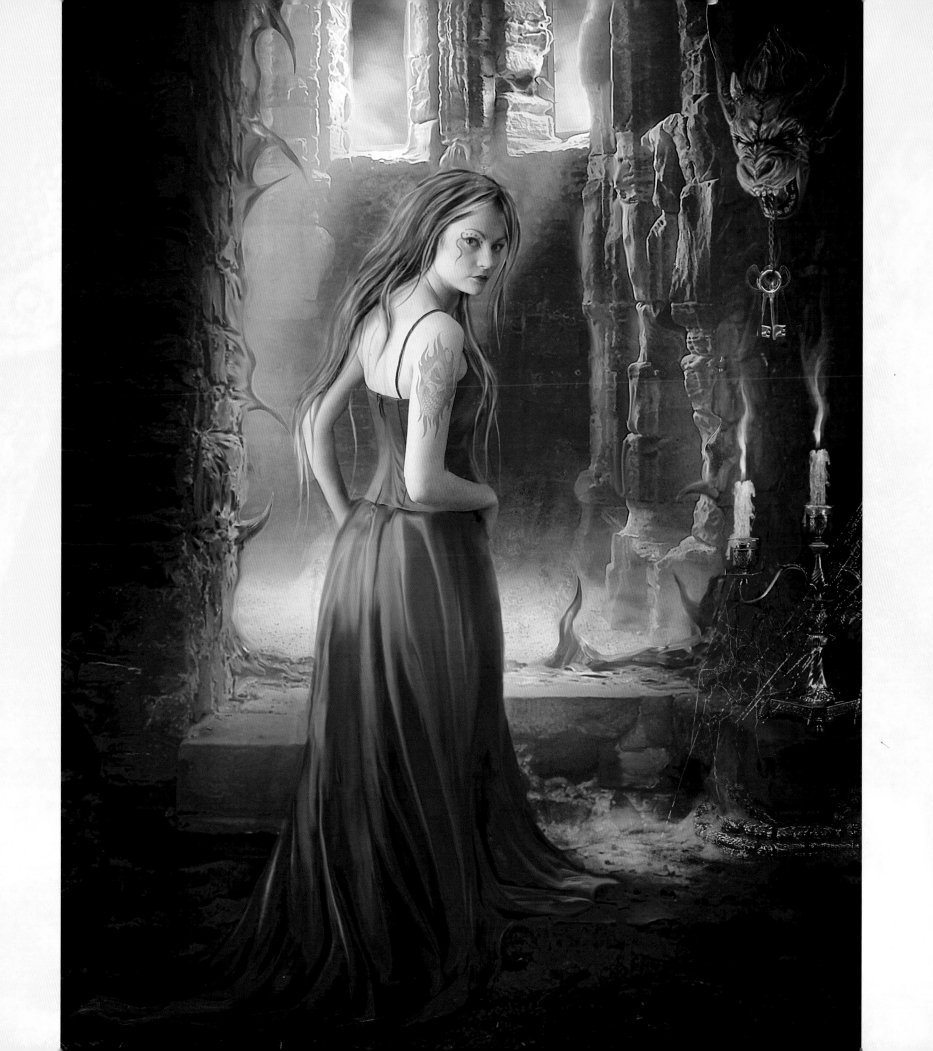

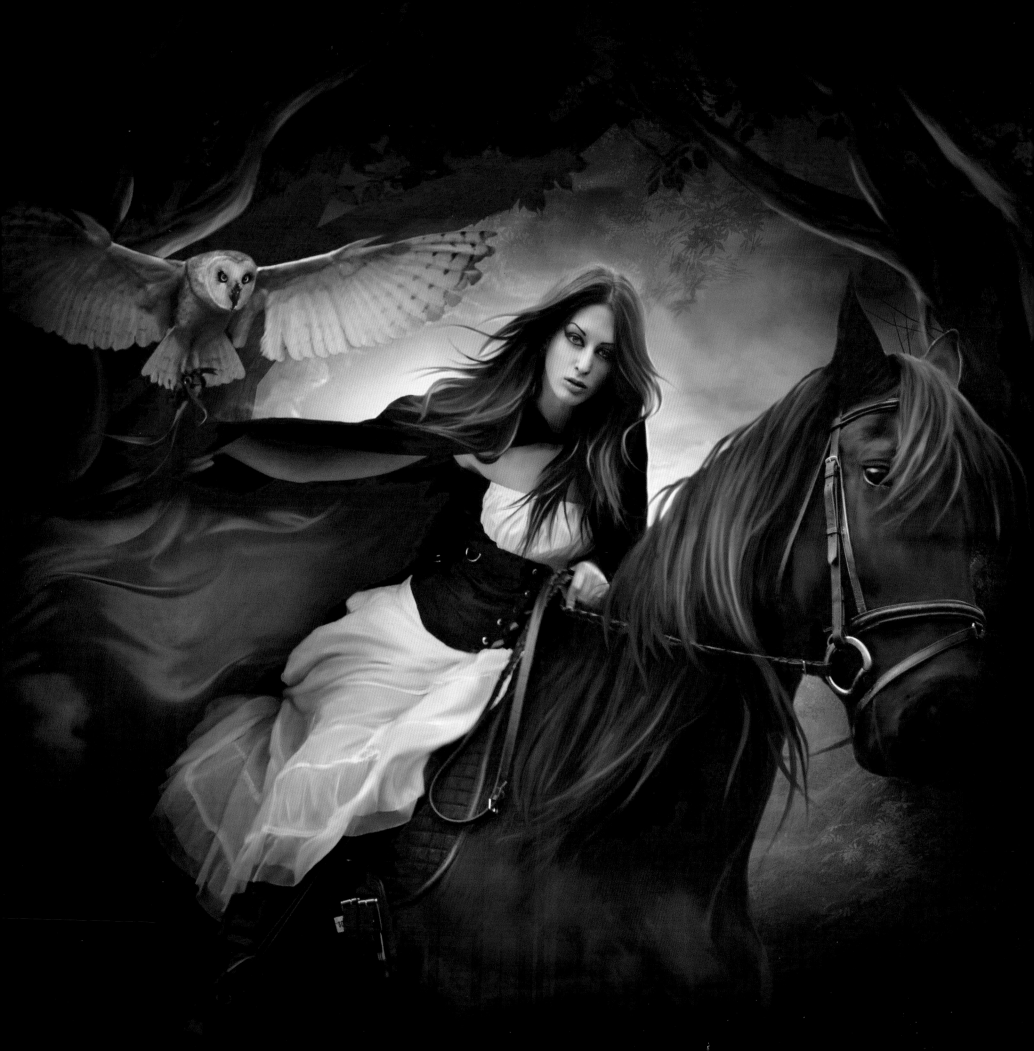

Vampiric Origins

We generally think of vampires as elegant and noble beings who are as cunning as they are deadly, but the roots of the creature paint a very different picture. Tales of blood-sucking entities can be found in almost every ancient culture throughout world history, although the vampire was generally believed to be more beast-like and savage than their modern brethren.

One of the most ancient vampires was believed to be the demon Lilith, whose roots can be traced back to the same Jewish mythology that the Bible is founded on. The 1892 painting *Lilith* by the Pre-Raphaelite artist and writer John Collier has inspired many modern Gothic artists with its evocative use of symbolism. Brom, for instance, paid homage to Collier's composition and symbolism in his demonic piece *Inferno* (1997).

Changing Faces

Although there are many fascinating variants of the vampire myth to be found in traditional folklore and mythology, it is perhaps the tales that originate in medieval south-eastern Europe that have had the most influence in shaping our notion of a vampire, such as those of the Romanian strigoi, troubled spirits that return from the grave to feed on human blood. However, it wasn't until the emergence of supernatural poetry in the eighteenth century that the nature of the vampire began to evolve, shifting from the primitive ghoul of folklore into a more sophisticated and threatening adversary.

The Birth of the Modern Vampire

Many of the staple characteristics of vampire fiction made their literary debut in *The Vampyre* by John William Polidori. Published in 1819, the short novel tells the story of a young English gentleman named Aubrey, who finds himself in the company of the mysterious Lord Ruthven. After a series of strange and violent events, it soon becomes clear that Lord Ruthven is not as he seems, with Aubrey eventually learning that he is in fact a vampire. It may have had its share of issues (its authorship was heavily disputed as it emerged that the plot was stolen from

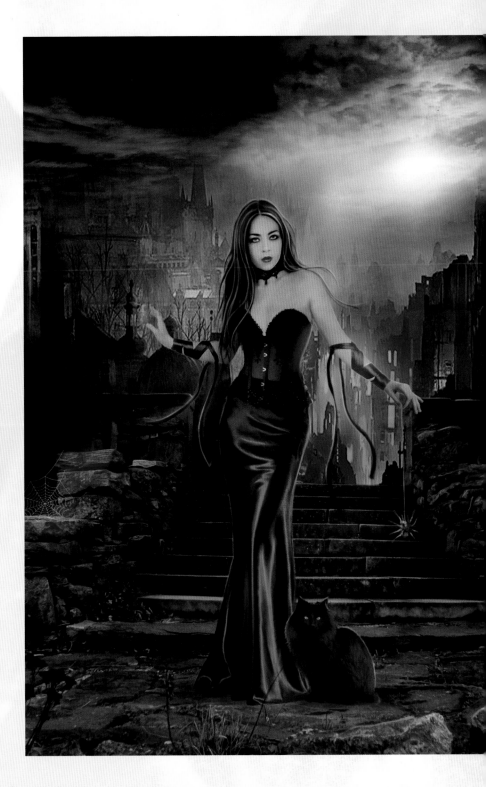

Tres en la Noche by Elena Dudina
© elenadudina
Digital media: Photoshop
elenadudina.com

Una Noche Más by Elena Dudina
© elenadudina
Digital media: Photoshop
elenadudina.com

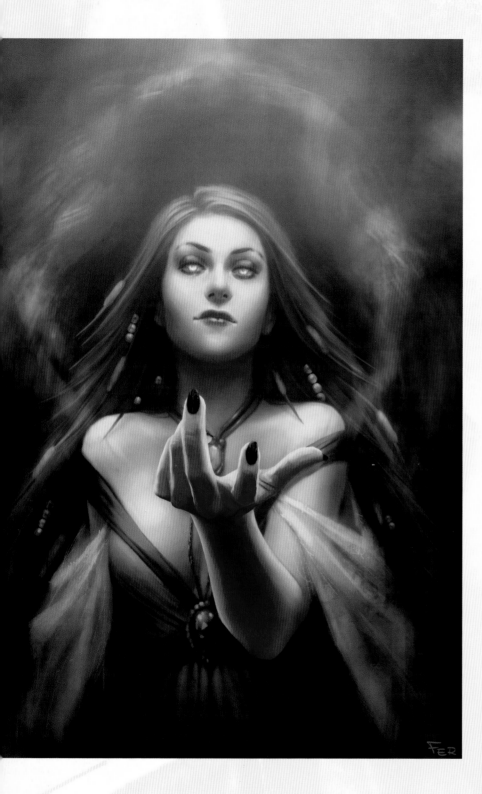

Polidori's former employer, the poet Lord Byron), but the success of *The Vampyre* set in motion the first stages of the vampire novel movement.

Countess Carmilla

Later, in 1872, Joseph Sheridan Le Fanu's *Carmilla* posed the idea of a tragic vampire who, while calculating and predatory, enjoyed the friendship of her young female victims as much as the chase itself. The novel explores the growing friendship between our heroine Laura and her guest Carmilla, a young girl who finds herself in the care of Laura's father. Laura soon suspects that there is something unusual about her guest, whose actions and affection are both welcomed and unsettling. The novel takes us closer to the concept of the romanticized vampire, with every new victim born from a much-coveted friend.

Dracula, Vampire Incarnate

By the late Victorian period, popular literature had become a means by which to speculate upon and understand the changing nature of society. Bram Stoker's *Dracula*, the quintessential vampire tale, was written during this period. Stoker's dark creation, Count Dracula, personified the fears of Victorian Britain, which is why he has become as legendary as the vampire myth itself.

To many, Dracula is the ultimate vampire: an icon of Gothic sensibility, with a persistent influence on many art forms. Outside the novel, several film adaptations of Stoker's Count Dracula have further influenced Gothic aesthetics, such as F.W. Murnau's 1922 silent movie *Nosferatu* and Universal Studios' *Dracula* (1931) starring Bela Lugosi, whose distinctive looks defined the classic vampire aesthetic, along with more recent adaptations like Francis Ford Coppola's sumptuous *Bram Stoker's Dracula* (1992).

The Contemporary Vampire

There are now more vampires lurking on our bookshelves and gracing our screens than ever before, not to mention the gripping comic books

Die Out by Fernanda Suarez
© 2013 Fernanda Suarez
Digital media: Photoshop CS5 and Wacom Bamboo tablet
fdasuarez.deviantart.com

Alise by Fernanda Suarez
© 2013 Fernanda Suarez
Digital media: Photoshop CS5 and Wacom Bamboo tablet
fdasuarez.deviantart.com

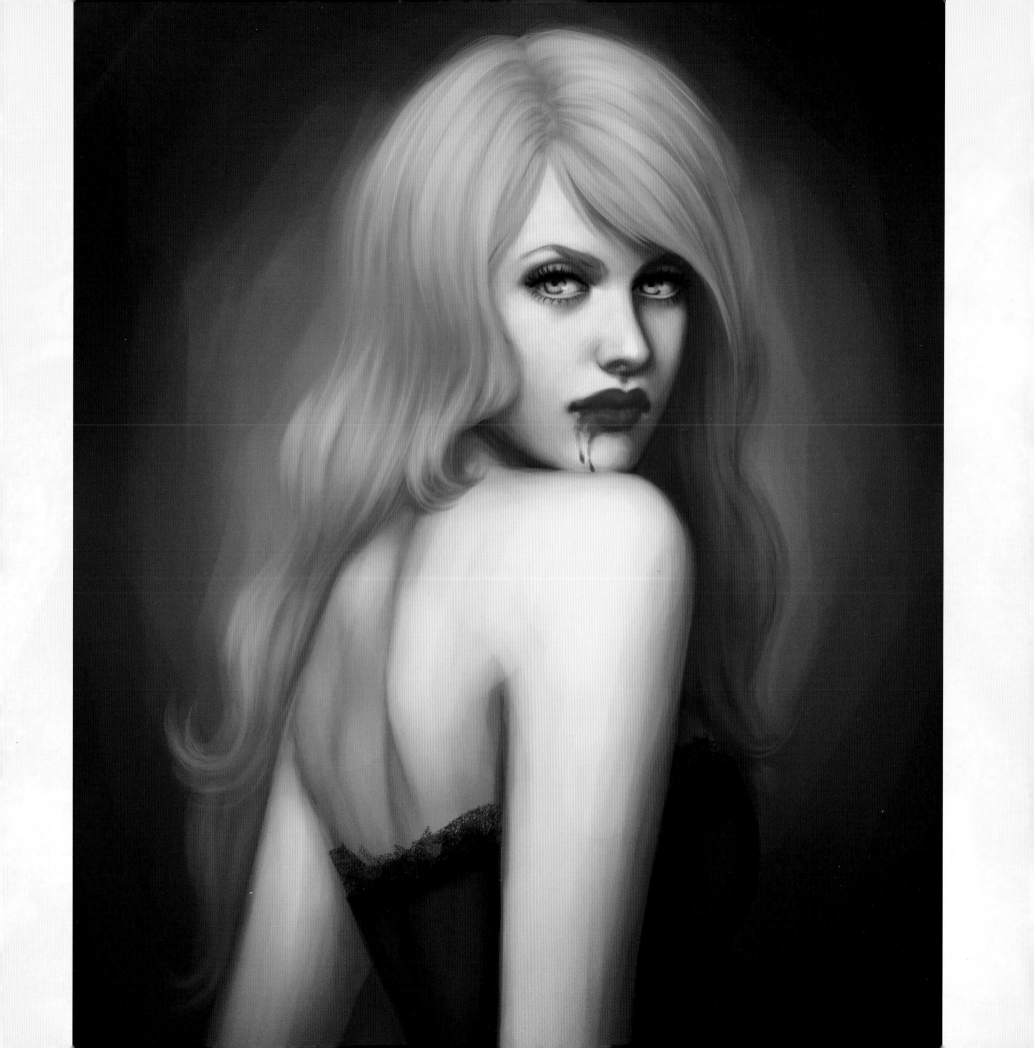

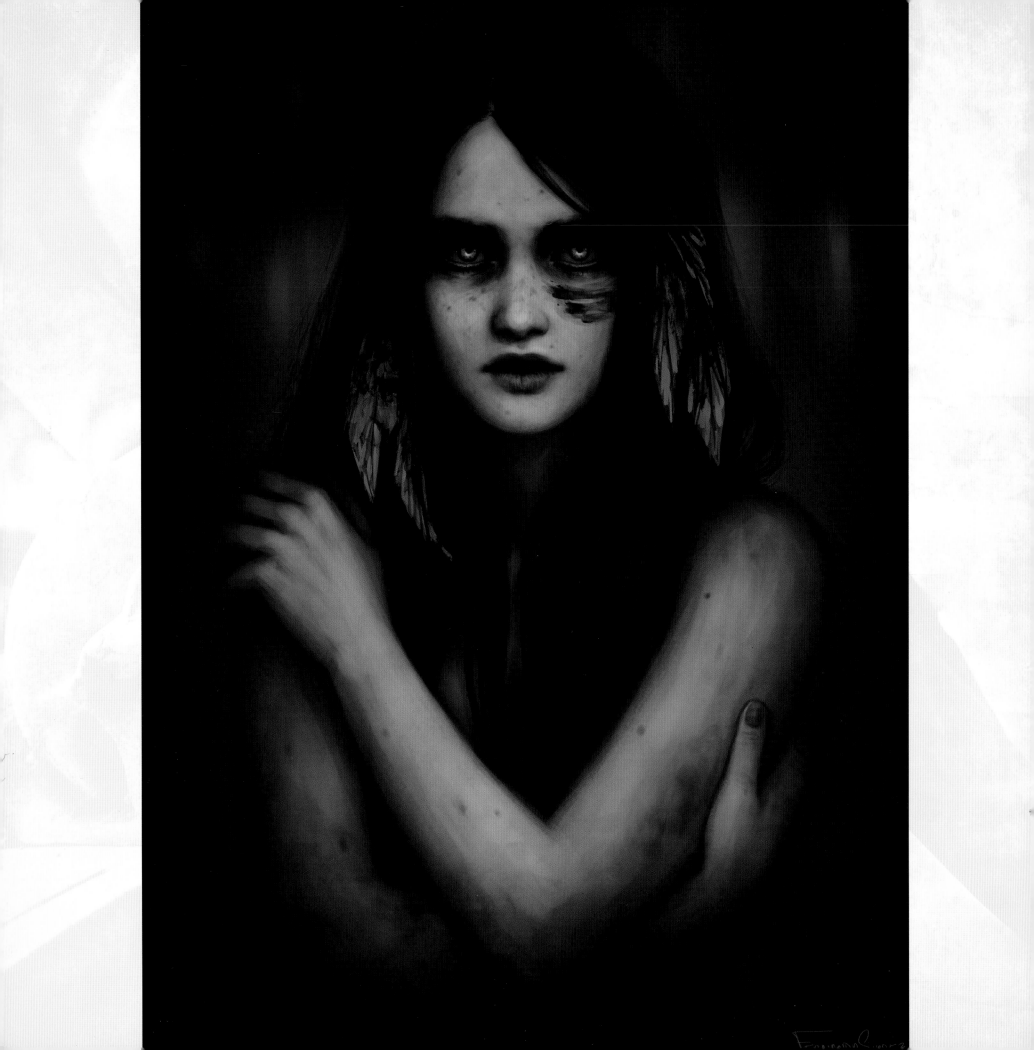

and immersive video games that cast us into this shadowy realm of blood and drama. The mainstream vampire has spawned a whole new subgenre that softens explicit and graphic concepts with a more sensitive and accessible approach.

Popular novel series like *The Vampire Chronicles* by Anne Rice and the *Twilight* saga by Stephenie Meyer have propelled the vampire into popular culture, along with TV shows like Joss Whedon's 'Buffy the Vampire Slayer' and the gloriously graphic HBO drama 'True Blood', based on the popular Sookie Stackhouse novels by Charlaine Harris.

Experimenting With Convention

When it comes down to it, an artist can make a vampire whatever they want it to be. There may be history, but there are no rules of what can and cannot work. Experimenting with staple features such as costume, general appearance and environments can lead to really innovative and original vampire art.

Take fangs, for instance. They come in all shapes and sizes, and can be as subtle or as fearsome as you like. Their style can have a massive impact on the overall tone of a piece: smaller fangs, for example, can help characterize a more demure vampire than a pair of prominent, glistening spikes.

Similarly, captivating eyes can help tell the character's story, which can be amplified further by how the lips balance the gaze. While the general rule of thumb is to emphasize either one or the other, vampire art often presents a rare opportunity to use both the eyes and the lips to their fullest effects, as both play an important part in the signature vampire aesthetic.

The Nature of the Beast

Even the very nature of the vampire can be experimented with in an abstract way. When you take away the glamorous aspects of vampirism, it can be seen as a plague that mutates the very essence of human nature, stripping everything back to the primordial fact that blood keeps us all alive. In Guillermo del Toro's *Cronos* (1993), for instance, the vampire is presented as an inanimate clockwork contraption that can

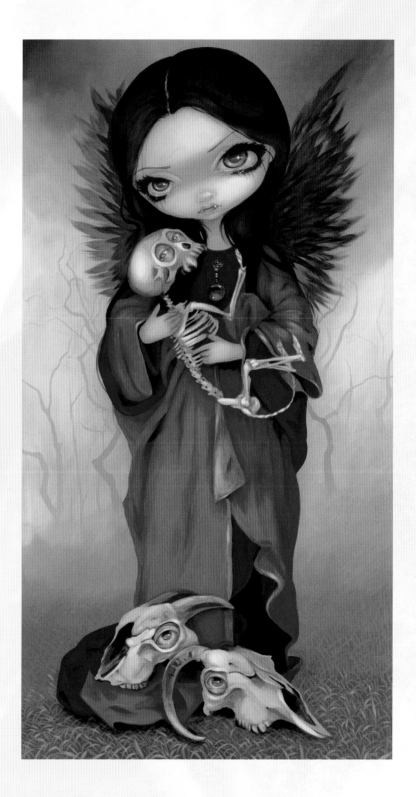

No Room for Innocence by Fernanda Suarez
© 2013 Fernanda Suarez
Digital media: Photoshop CS5 and Wacom Bamboo tablet
fdasuarez.deviantart.com

I Vampiri: Angelo della Morte by Jasmine Becket-Griffith © Jasmine Becket-Griffith
Traditional media: acrylic on wood, 40.5 × 8 cm (16 × 3 in)
The seventh in my series of paintings called 'I Vampiri' (which is Italian for 'The Vampires') – a new line of paintings that feature vampire beauties inspired by Italian Baroque and Renaissance themes and aesthetics (many of which I have been hired to create for my upcoming Vampire Tarot/Oracle Deck).
strangeling.com

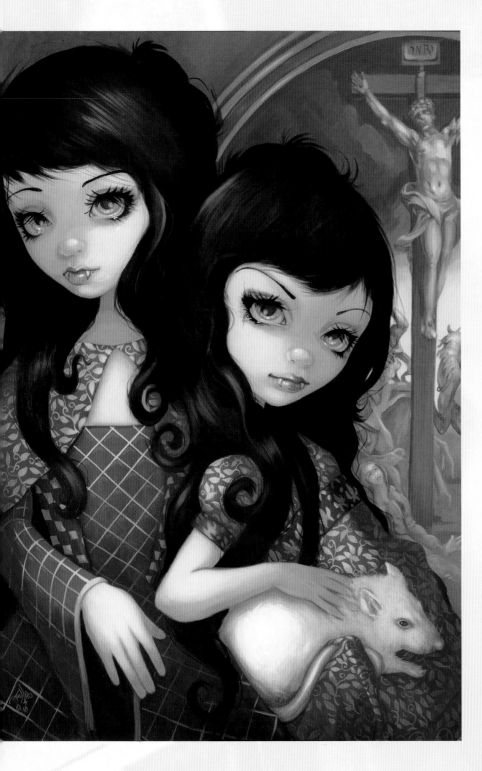

grant its owner the power of immortality by draining and preserving blood. The stripping back of the vampire condition can inspire some truly terrifying and unique Gothic creations, as we have seen with the ambiguous and haunting works of the American artist Jeremy Caniglia.

The Well~Dressed Vamp

While the more primitive vampires of medieval folklore were often depicted in their ragged burial clothes, the more sophisticated and noble vampires of Gothic literature preferred the finer things in life. Well, once upon a time anyway. Whether creating ancient vampires in Gothic settings or modern ones roaming the streets, mixing up styles and historical sources of inspiration can create wild and striking costumes.

Luxurious and elaborate designs that incorporate historical trends, such as corsets and evening gloves, can help evoke culture and antiquity, with flourishes of tailoring, fine detailing and sumptuous fabrics. The aesthetic can be applied to the modern vampire too, with splashes of leather, lace and silk adding extra touches of drama.

The Japanese artist Ayami Kojima is a master of using complex costumes to enhance vampiric character design. Best known for her evocative artwork for Konami's beloved videogame series *Castlevania*, Kojima's mesmerizing style is a balancing act of otherworldly beauty and exquisitely poetic clothing, using lavish and expressive detailing to express the subtlest of nuances.

Vampire Archetypes

Romantic idealist, aristocratic deviant or tempestuous siren, the rich history of the vampire has provided artists with an unruly but enviable ensemble of character archetypes to explore and reinvent.

First, we have those that are truly children of the night. Their wild nature is usually expressed through their actions and defined expressions. Costumes can play a major part, making full use of outlandish and provocative features. These are vampires with no restrictions – they do

I Vampiri: La Sorelle by Jasmine Becket-Griffith © Jasmine Becket-Griffith
Traditional media: Acrylic on wood, (18 x 24 in)
The fifth in my series of paintings called 'I Vampiri' (which is Italian for 'The Vampires') — a new line of paintings that feature vampire beauties inspired by Italian Baroque & Renaissance themes and aesthetics (many of which I have been hired to create for my upcoming Vampire Tarot/Oracle Deck).
strangeling.com

Black Lotus by Jason Engle © Savage Mojo 2011
Digital media: Photoshop
The character originally appeared in the roleplaying game expansion book Suzerain: Vampocalypse. It was done as a half page image, primarily just a light background and the figure. But I liked the character so much I later took her out of the original image, and painted a whole new background, creating a richer story in the background and a wider view of the world around her. jaestudio.com

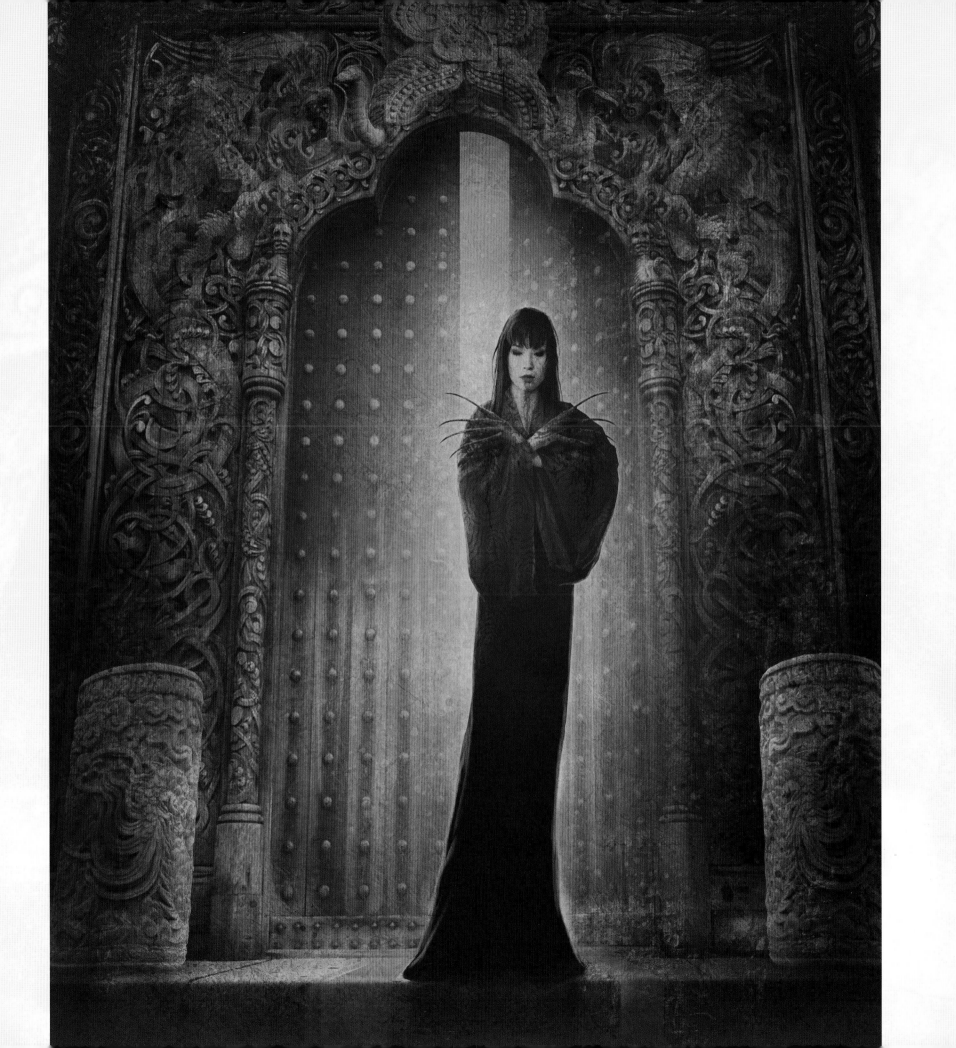

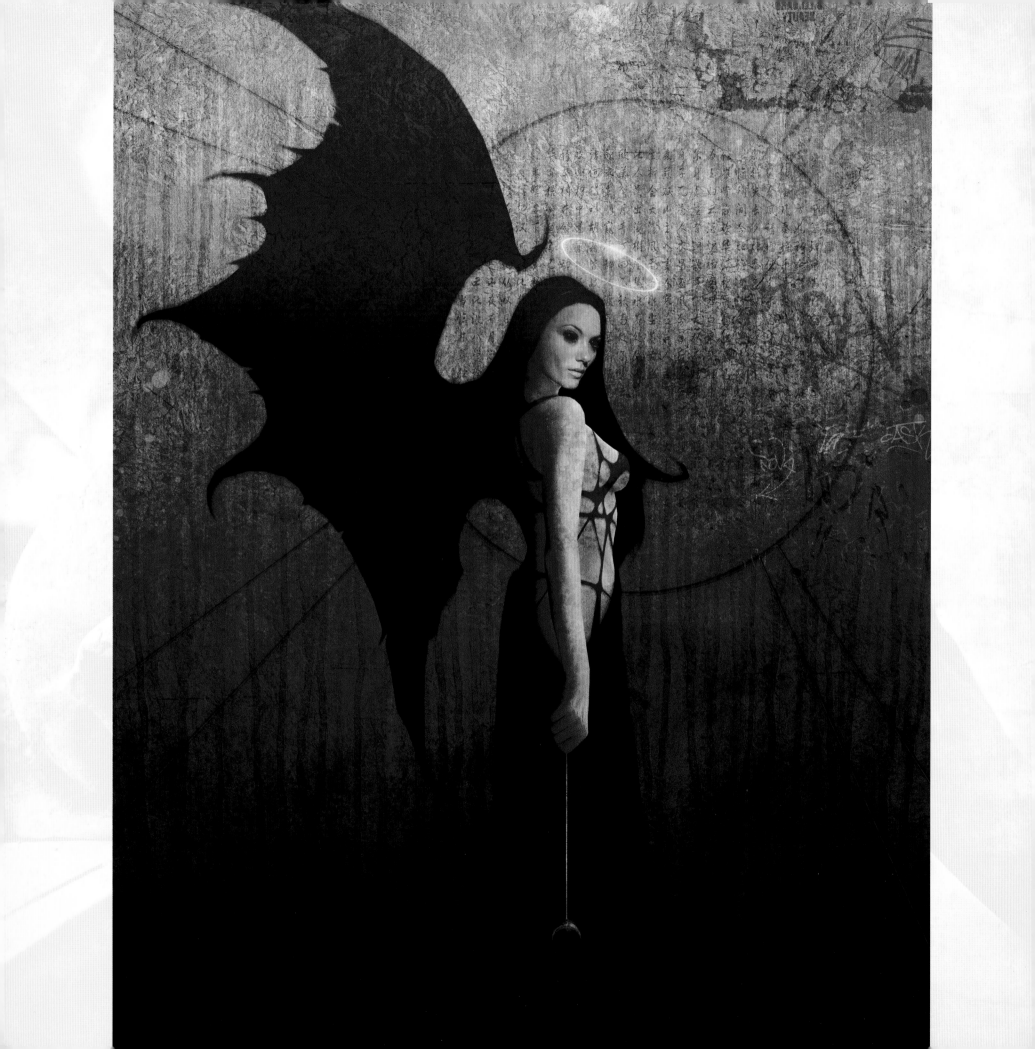

whatever they please, no matter the cost. A fine fanged example comes from the comic-book icon Vampirella as depicted by the likes of fantasy-art legends Alex Horley and Joe Jusko, along with the playful pin-up works of Serge Birault and Aly Fell.

Next up are the more sensitive kinds of vampire, often torn between instinctive blood lust and deep guilt. Artwork depicting these kinds of creatures often makes use of a softer tone, with emphasis on emotional resonance and romantic symbolism. The child vampire can be a particularly evocative way of creating an unsettling contrast between innocence and the loss of humanity.

The Unusual Vampires

It can be easy to forget that vampires don't have to be beautiful, and the more horrifying kinds can lead to spectacular artwork, as we see in the monstrous *Go for the Throat* (2011) by Dave Rapoza. The dreaded Count Orlok in Murnau's *Nosferatu* is a perfect example of how distinctive visual characteristics can be unsettling and otherworldly, directly inspiring Brom's unnerving *Dirt and Blood* (1999).

The implications that unusual vampires can bring can be truly disturbing, especially when juxtaposed with stereotypes and assumptions, as David Gaillet explores in his extraordinary take on vampiric relationships, *My Beloved* (2012). Enhancing the monstrous and creature-like qualities of the vampire can put an entirely new spin on the myth, especially when you consider the romanticism and sensuality that is simultaneously synonymous with the character.

The Gothic Witch

Much like the vampire, the witch has become an evocative symbol of Gothic sensibility and a popular role for female characters. Unlike the old, wizened hag from fairy tales and common superstition, the Gothic witch is a powerful, beautiful and confident character, who is a devoted student of sorcery and magic.

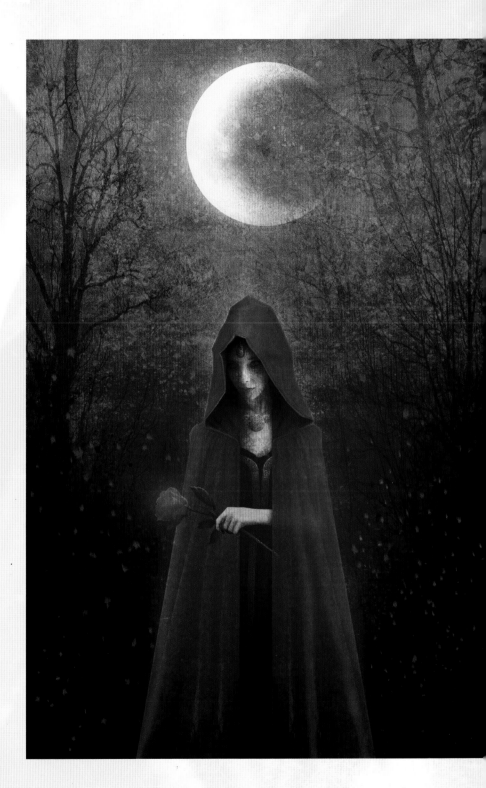

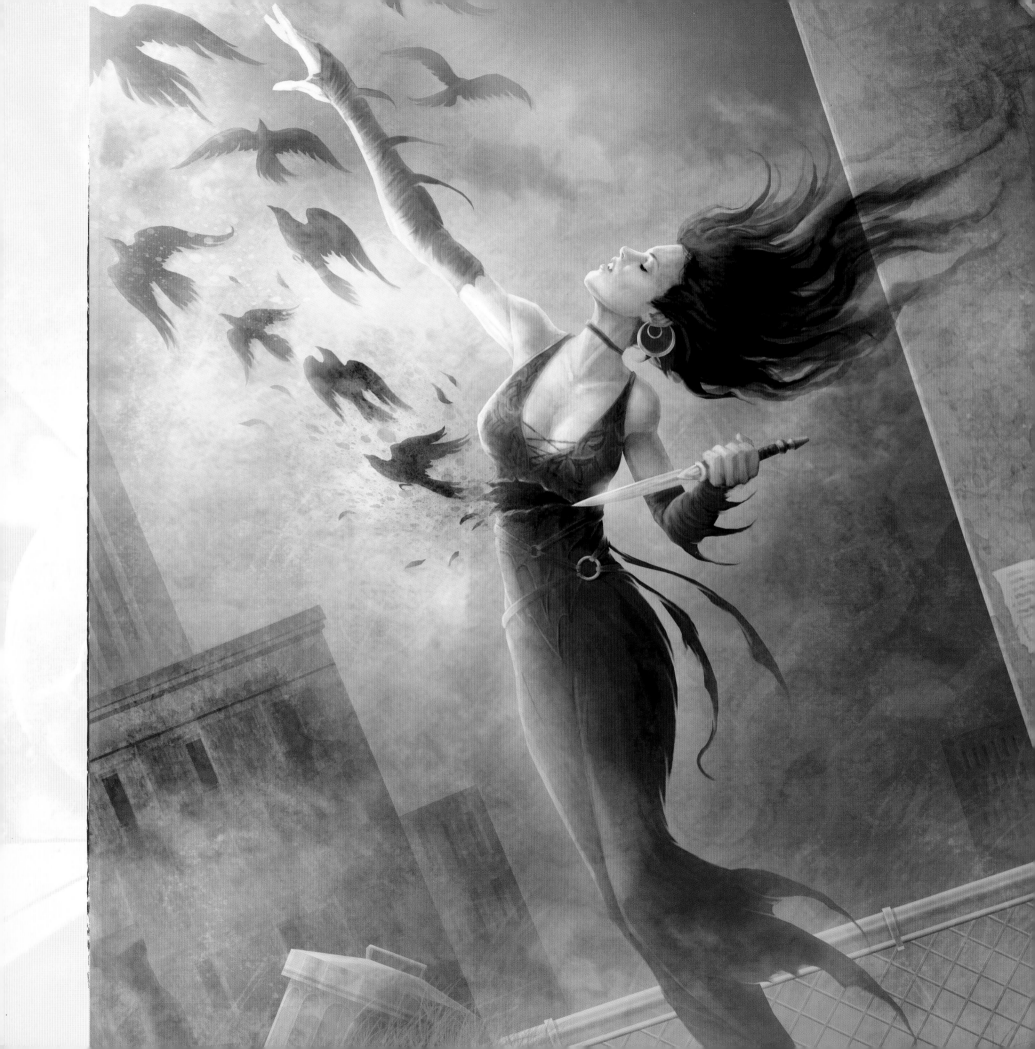

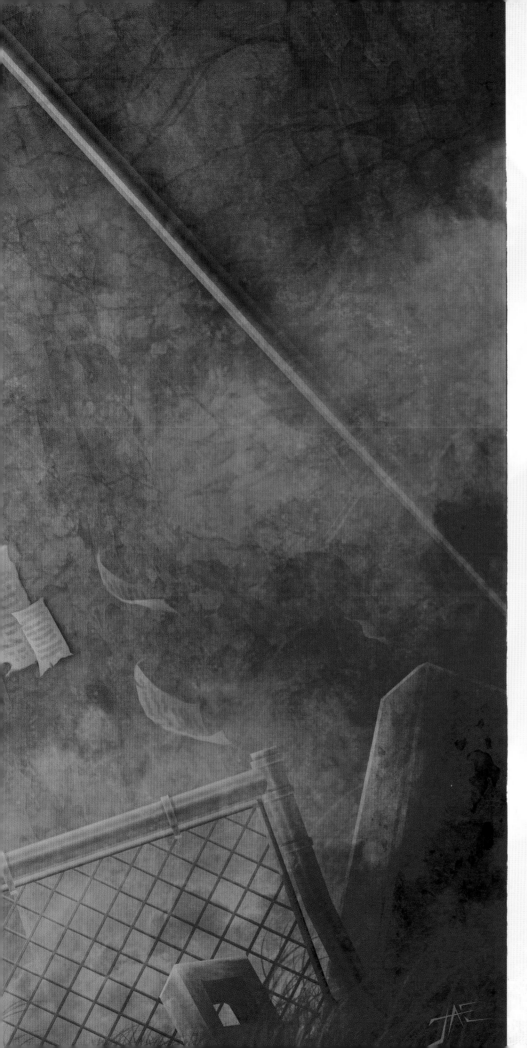

There is much more to the classic look of the witch than the average Halloween costume might convey, although pointed hats, broomsticks and flowing black gowns do still make frequent appearances, as we see in Aly Fell's *Vicky the Winter Witch* (2009) and *Elphaba – The Wicked Witch of the West* (2010).

Whatever the costume, fantasy art embodies the witch as a symbol of feminine power, a force to be reckoned with. Often decked out in attention-grabbing outfits that leave little to the imagination, the witch asserts her feminine power over her viewers, often enticing them into her world with an expressive gaze or theatrical pose. The visualization of the fantasy witch often goes hand in hand with allegiances to light or dark forces, with those belonging to the dark side often displaying a little less modesty than their better-behaved sisters.

What About Wizards?

Of course, there are plenty of incredible pieces of fantasy art that explore the role of male characters and magic, although it seems that the emotional associations of the Gothic aesthetic resonate more when applied to female characters.

Where the witch is concerned, the emphasis on the female practitioner may have something to do with the roots of paganism, in which the feminine power is worshipped in the form of the Goddess. From the Wiccan beliefs of the Triple Goddess to the ancient Egyptian cult of Isis, there are many magical attributes that seem unique to a female entity, which ultimately makes them more suited to the supernatural elements of the Gothic style.

White and Black Magic

The study and application of magic was a topic of contention even before the spread of Christianity branded followers of pagan religions as heathens or evildoers. Magic traditionally falls into two categories: white magic, cast for the benefit of others, and black magic, used for destructive or malicious purposes. In ancient Rome, for instance, laws

Witching Hour by Jason Engle © White Wolf Publishing
Digital media: Photoshop
Created as a chapter cover image for the Vampire: The Masquerade book *Ordo Dracul*.
Originally done in black and white, I went back later and added colour.
jaestudio.com

Dark Lena by Robert Kehl

© Robert Kehl; **Digital media:** Photoshop; bobkehl.blogspot.com

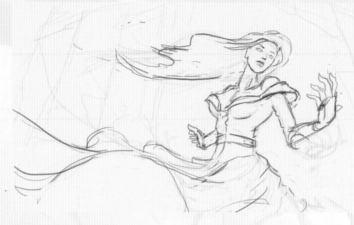

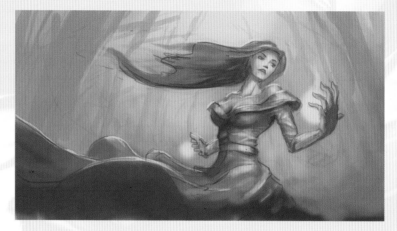

Step 1: First I figure out what kind of pose and feel I want the character to be portraying. For this particular image (Dark Lena) I was portraying a dark feminine caster. At the beginning I do a very rough sketch. Technical details don't really matter at this point since the sketch won't be part of the final image. It is there for a reference as I paint.

Step 2: The next step is adding in the values of the character and background. This is where I start to figure out if I will like the image or not. If the image does not read well with the values set in, then it is time to rethink the composition of the image. I usually start in black and white first before going on to colour.

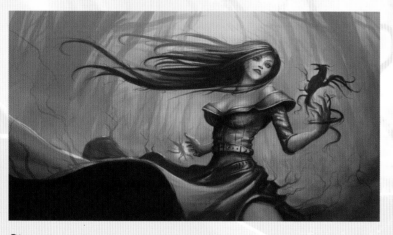

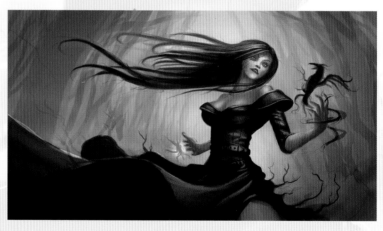

Step 3: Next, I continue to refine the black and white image to optimize readability. In this stage I try to focus on proper lighting and details. For this particular image, I didn't finalize the details completely because I knew that I would be adding in effects with colour.

Step 4: Once I finish the values I start adding in colour through different layer types. Sometimes colour layers or even overlay layers is usually how I get the base colours down.

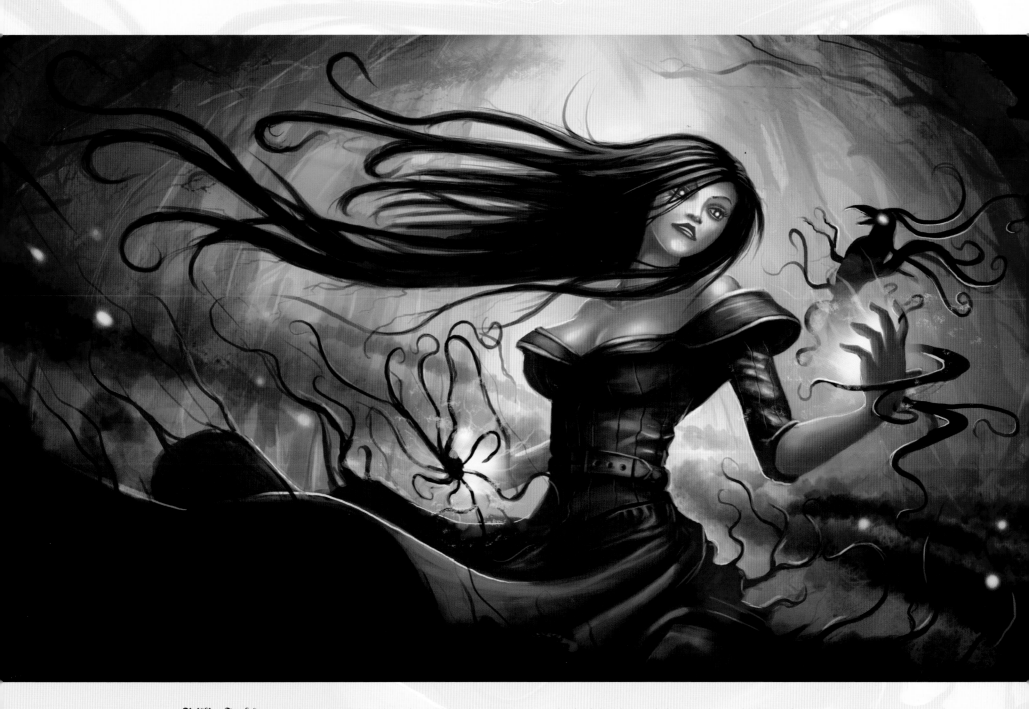

Finishing Touches: Once I have decided on the colours I like, the next process is the final detailing and cleanup of rogue lines, smudges, etc.

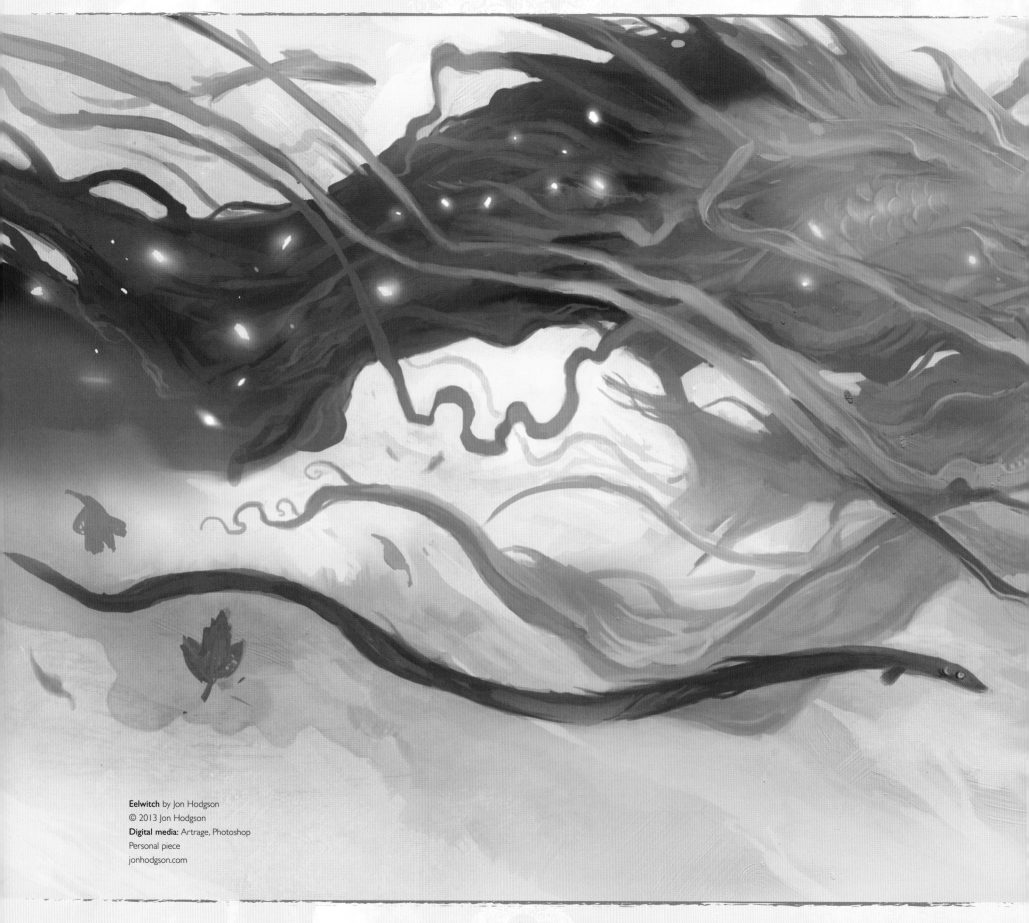

Eelwitch by Jon Hodgson
© 2013 Jon Hodgson
Digital media: Artrage, Photoshop
Personal piece
jonhodgson.com

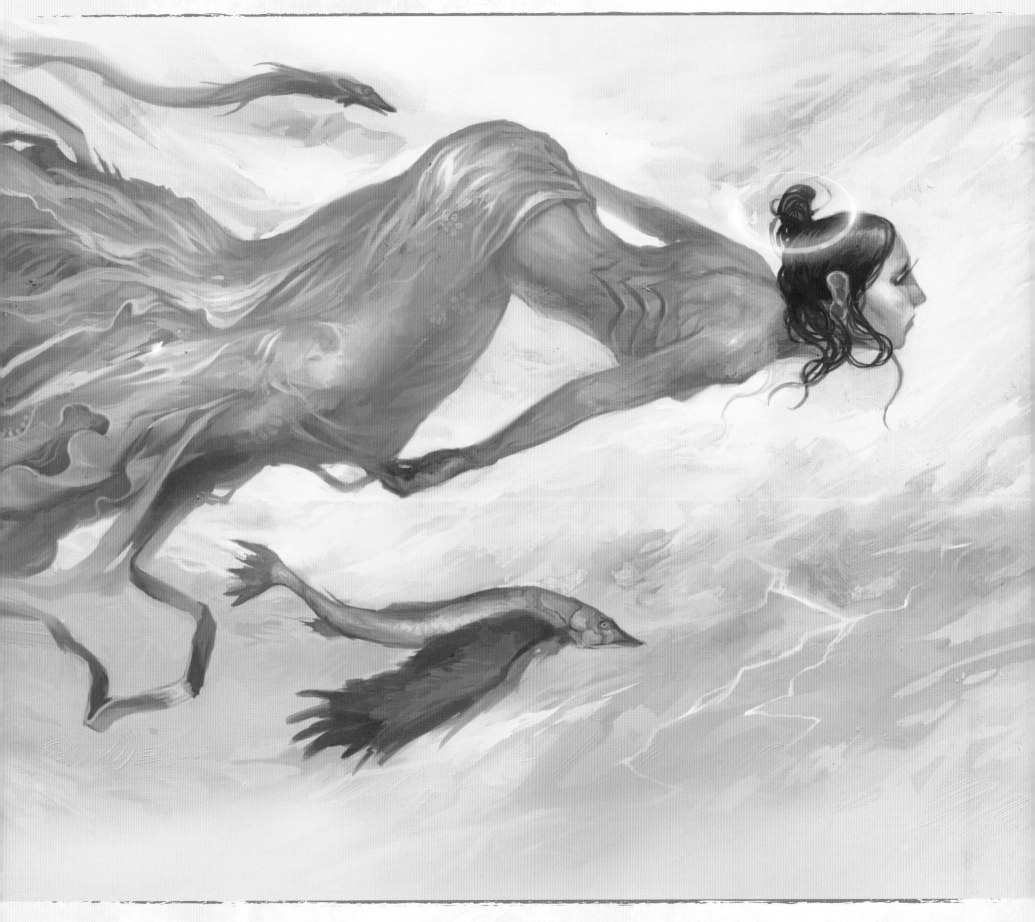

were passed outlawing the use of black magic, as such practices generally implied further brutalities or questionable activities, such as ritualistic sacrifice.

By the time Christianity had asserted itself across Europe, all practitioners of witchcraft were branded as evil followers of Satan, regardless of their actual intentions. Yet, the vilification of the witch didn't stop the silent fascination that many felt for those believed capable of commanding the forces of nature.

In Gothic art, whether the subject is aligned with white or black magic has a drastic impact on the kind of scene depicted. Black magic will often incorporate harsher and more graphic content with an emphasis on violence and sexualization that filters into character design, whereas their lighter counterpart will be depicted in a way that focuses on and amplifies their charm, confidence and magical prowess. It's more likely to find pieces that incorporate occult symbolism with darker pieces, as it gives the art an additional edge.

Favourable Views

While certain aspects of traditional witchcraft do filter through into modern fantasy art, such as the idea of ritual and associations with the natural elements, iconography connected to pagan religion does not necessarily have to become a staple part of witch-themed artwork.

In many ways, the visualization of witches in modern media owes much to the Pre-Raphaelite artist John William Waterhouse, who undertook a sensitive artistic exploration of magic and witchcraft throughout his body of work. Revered paintings including *The Magic Circle* (1886), *The Crystal Ball* (1902) and *The Sorceress* (1911) depicted mysterious females in the midst of ritual and study, delving into the symbolic virtues of the witch rather than an examination of religious practice.

Anima Vorax by Joana Shino Dias
© 2010–2013 Joana Shino
Digital media: Photomanipulation, Photoshop CS4
Anima Vorax means 'Soul Eater' in ancient Latin. I wanted to create a fantastic horror creature that wouldn't be a typical vampire, but instead an entity that would feed on humans flesh and soul.
joanashino.com

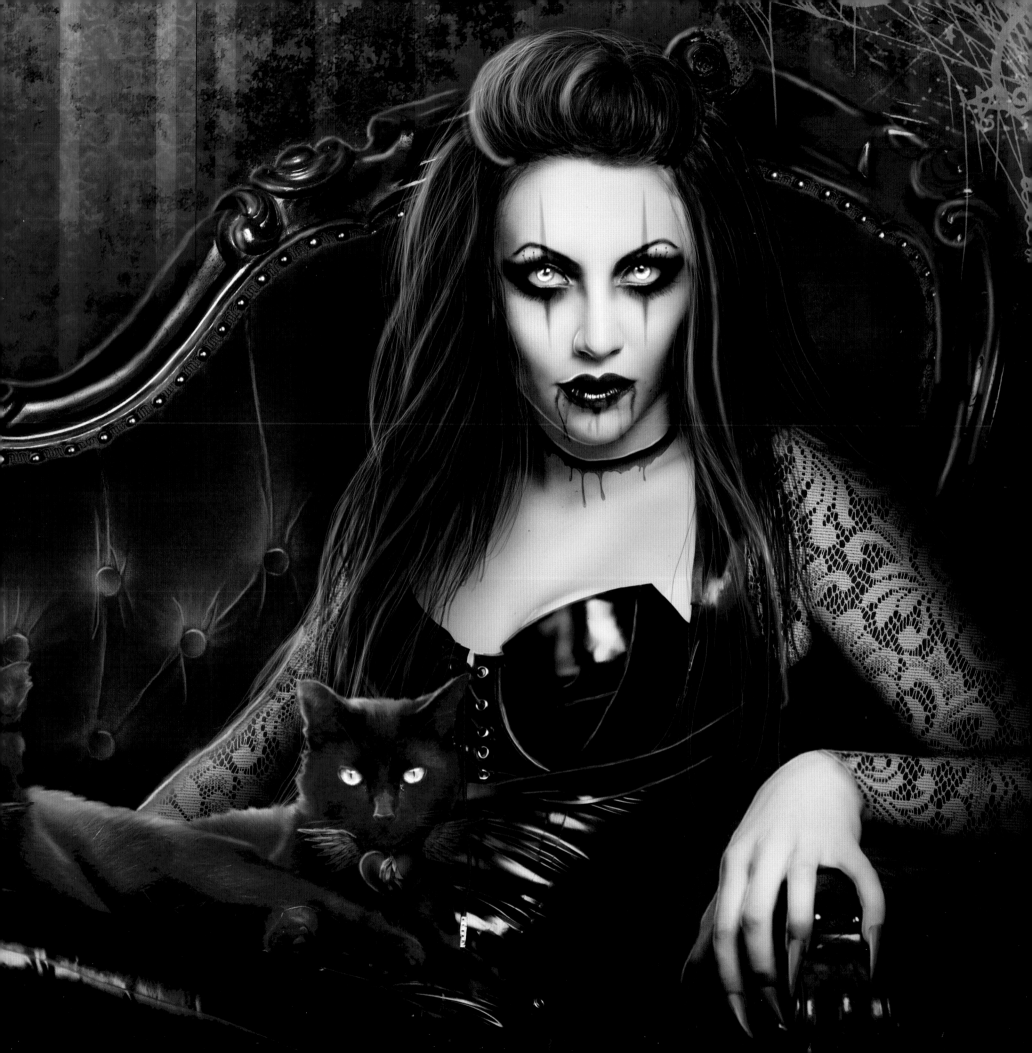

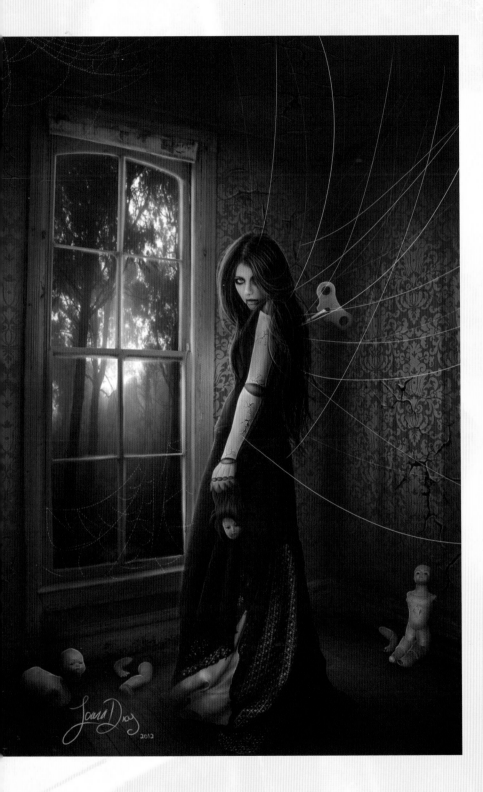

Literary Witches

Up until relatively recently, the literary witch often meant trouble. Witches were prominent figures of misfortune in Classical mythology, with the likes of the enchantress Circe in Homer's *Odyssey* and the malevolent Morgan le Fay from Arthurian legend causing trouble for all that crossed their paths. The tradition carried on well into the age of Shakespeare and beyond, with the three witches from *Macbeth* continuing to curse theatre stages to this very day.

Eventually, good witches filtered through into books and media, with L. Frank Baum's classic novel *The Wonderful Wizard of Oz* presenting a vibrant ensemble filled with good and bad magical characters, making way for witch-friendly titles like Terry Pratchett's *Discworld* series and J.K. Rowling's *Harry Potter* books.

The Elemental Witch

One of the staple kinds of witches you will find in fantasy art are those attuned with the natural elements of earth, air, fire and water. These witches hark back to the traditional roots of paganism, with magical power derived from the forces of nature. Natural occurrences, such as ice or lightning, will become the overriding visual theme of these kinds of pieces, often filtering into costume design and relevant symbolism. Colour may also play an important part of elemental themed pieces, with unified colour palettes further adding to elemental attributes and connotations.

The witches who grace the cards of table-top role-playing games like *Magic: The Gathering* and *Dungeons & Dragons* are often associated with particular elements for the purposes of the games, which results in some truly incredible pieces of themed artwork from some of the best artists in the fantasy-art circuit, such as Wayne Reynolds, Dan Scott and William O'Connor.

The characteristics of the force will often match the disposition of the witch: ice denotes a cold-hearted character, while fire represents passion and rage. Also, the associated element may determine the kind of powers the character is likely to possess: fire, for instance, suggests a

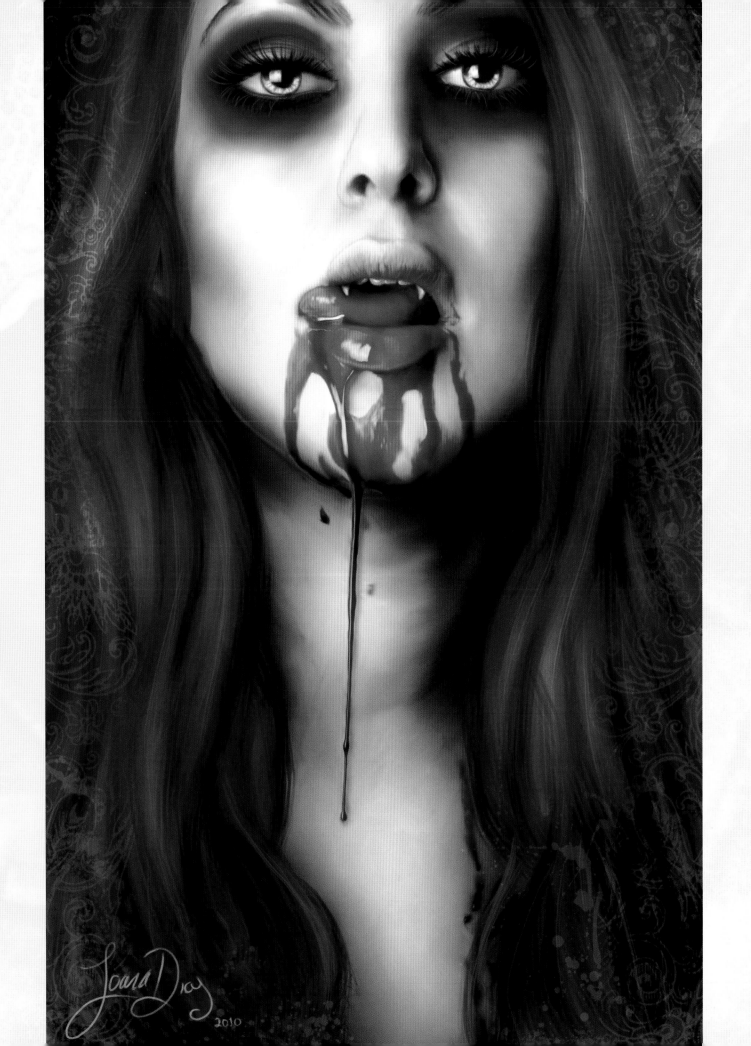

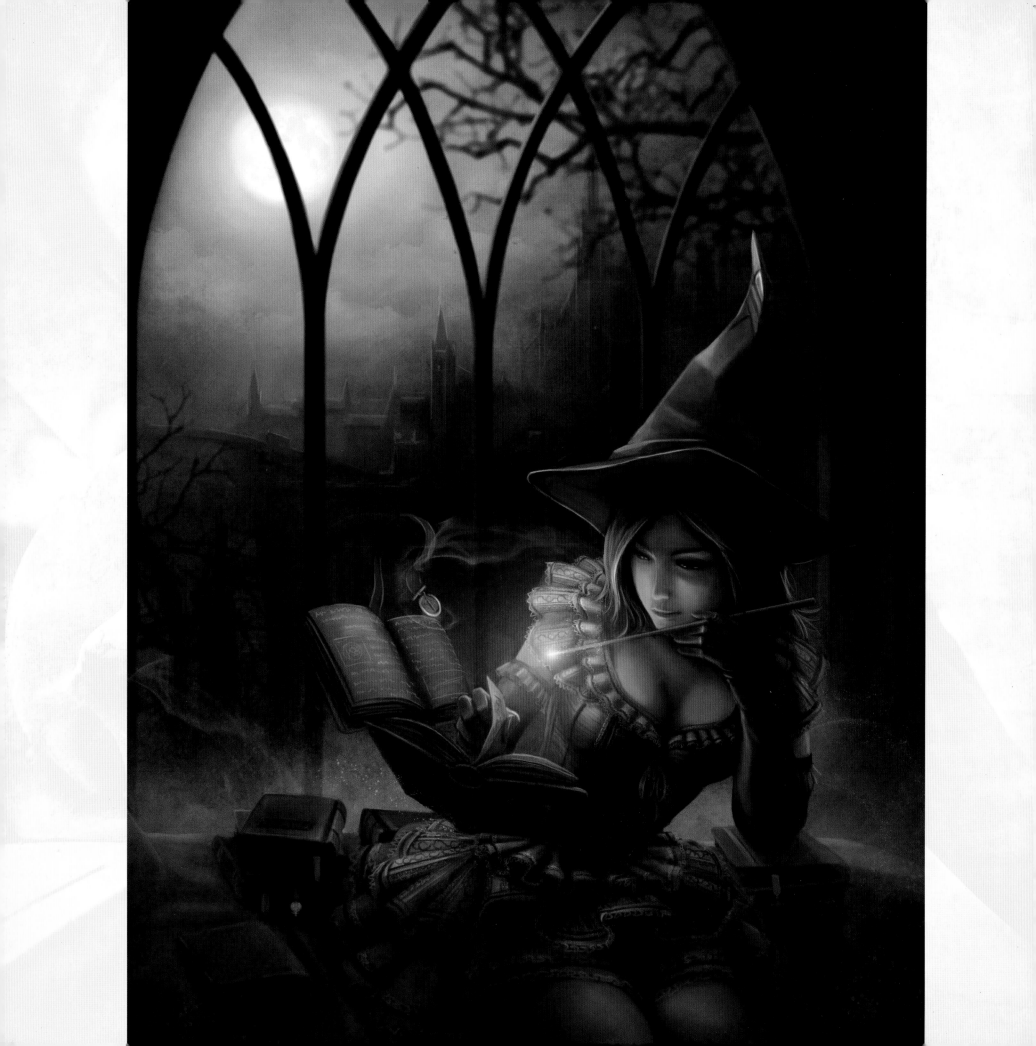

more unpredictable and dangerous force, as opposed to the healing qualities that might be expected of a witch of the earth.

Spell Casting and Ritual

Scenes in Gothic art depicting ritual and spellcasting are particularly fascinating, as they can be as outlandish or as historically viable as the artist can conjure. Following in the footsteps of historical tradition, many witches are depicted using cauldrons to cast spells, as we see in *Hecate's Cauldron* by Michael Whelan (1982), or poring over spell books like the plucky witches of Leos Ng Okita's works. Many pieces of this kind will feature historical artefacts and symbolism relating to alchemy and the occult, along with arcane paraphernalia such as spell-casting ingredients and enchanted objects.

For the more sinister witch, the art of ritual can create darker and more horrifying pieces. The dark master Brom draws upon the themes of dark magic in many of his works, such as the haunting *Blood Ritual* (1996) and the ceremonial *Ghoul Queen* (1998). These darker, more visceral visualizations can also be seen in *Sacrifice* (2002) by contemporary horror favourite Kyri Koniotis.

The High Priestess

Scenes of ritual and ceremony often focus on the figure of a high priestess, who is often depicted as a stately and powerful figure with a strong visual presence. Again, Brom features powerful and domineering women in many of his works that fall into this category, such as the elaborate *Shade of Blue* (2000) and *Guardian* (2000). This character archetype often carries a nobler air than her fellow spellcasters, and she is often depicted with ceremonial staffs, daggers, ornate jewellery or symbolic artefacts.

The Necromancer

Of all the popular witch archetypes, the necromancer is perhaps the most dreaded, as he or she will use the darkest kinds of magic to raise

A Touch of Magic by Leos Ng Okita
© Leos Ng Okita
Digital medium: Photoshop
luches.deviantart.com

Dark Star by Marcus Jones
© Marcus Jones
Digital medium: Photoshop
facebook.com/TheGothabillyShop

Haunting Aconite by Mina M

© Mina M, 2013; **Digital media:** Photoshop; yamina.wix.com/mina-m-illustration

 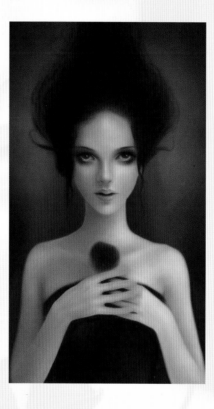 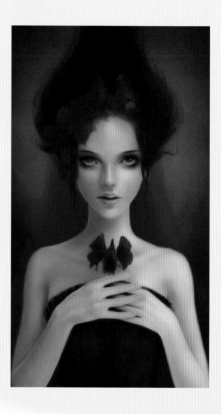

Step 1: At first, I decided which size, colours and composition I wanted to establish. Then I applied the background colour before drawing my character. I drew gradually, mixing the touches of colour. I paid special attention to the eyes and facial expression of my character from the beginning of this work, because Aconite is supposed to captivate and spellbind the spectator.

Step 2: Next, I focused on the areas of light and shadow. Here, the light comes slightly from the right, but the shadows are not very pronounced because I wanted her skin to seem rather pale. I wanted Aconite to be evanescent and mysteriously unreal.

Step 3: Then I continued to detail the face and skin of the young woman, without creating too many shadows, always with the aim of obtaining a porcelain doll complexion. For this, I used very soft brushes that I created (soft brushes but evenly textured). The shades I used for skin tone are themselves rather desaturated, not too bright or too dark.

Step 4: At this stage, I wanted to incorporate aconite flowers (*Aconitum napellus*). As for skin tones and hair, I started to apply the dominant colours without worrying about the details. I painted some details on the garment, avoiding too high contrast for a more gentle and realistic effect.

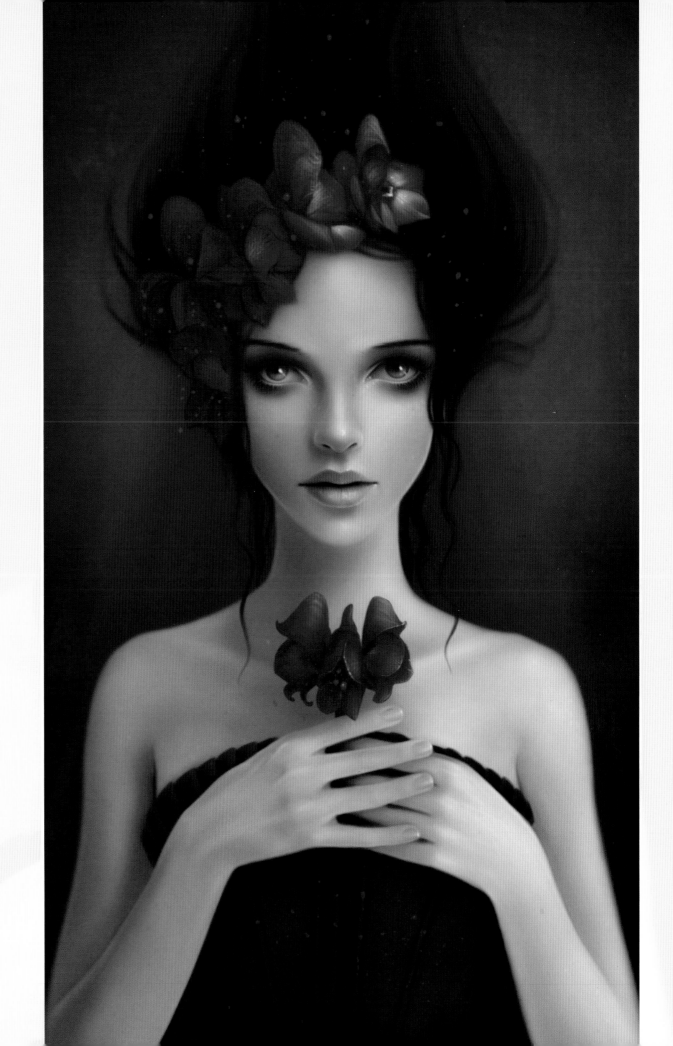

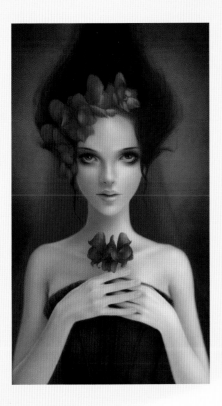

Step 5: Finally, I focused on the details until I was satisfied with the result. I tried to detail the centre more than the edges of the painting, to draw in the viewer's eye and give more depth to the whole.

Finishing Touches: In the final image, some light spots add a sprig of mystery, a touch of magic...

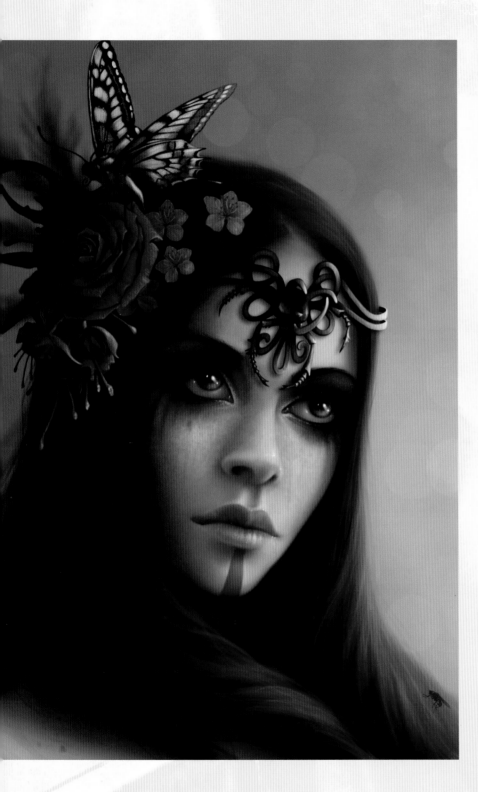

the dead from their graves and control them from afar. Necromancer artwork will often pull out all the stops, representing terrifying feats performed with unnatural power, making prominent use of the occult, satanic symbolism and ritualistic imagery.

Strong character poses often lead the viewer's gaze around the composition, with the evidence of their unearthly powers flowing around the rest of the piece. Playing with expectations and choosing surprising characters to perform such a dark role can create really striking pieces, such as Aly Fell's classroom hell-raiser in *The Necromancer* (2010).

Witches' Familiars

Where would a witch be without her familiar? Animal companions play an important role in witch art, in reference to the popular superstition that supernatural animals were needed to help the witch in her magical deeds. A witch's actions could be performed through her familiar, who could carry out magical deeds without detection or suspicion. Cats were long held to be the default magical pet of choice, although lizards, snakes, dogs and goats have also been depicted serving the witch's needs throughout history. Familiars are often illustrated alongside their mistresses, serving as an additional character-building tool to further explain what kind of person the viewer is looking at.

The Urban Witch

Magical powers don't have to be a thing of the past. Taking traditional concepts and applying them to the modern world can create captivating and intriguing artwork, as we see in the creations of the acclaimed Dan Dos Santos. Who knew that capes and jeans could look so good together? Much like the urban witches we meet in Andrew Fleming's cult film *The Craft* (1996), modern mages often incorporate visual elements of the modern Goth into their appearance, as we see in the gritty work of illustrative photo manipulator Chris McGrath. The appeal of urban fantasy is to juxtapose the mysticism of the past with the familiar world around us, presenting surprising and intriguing concepts that blur the lines between reality and imagination.

Scarabaeidae by Mina M
© Mina M, 2013
Digital media: Photoshop
yamina.wix.com/mina-m-illustration

Melancholy by Mina M
© Mina M, 2012
Digital media: Photoshop
yamina.wix.com/mina-m-illustration

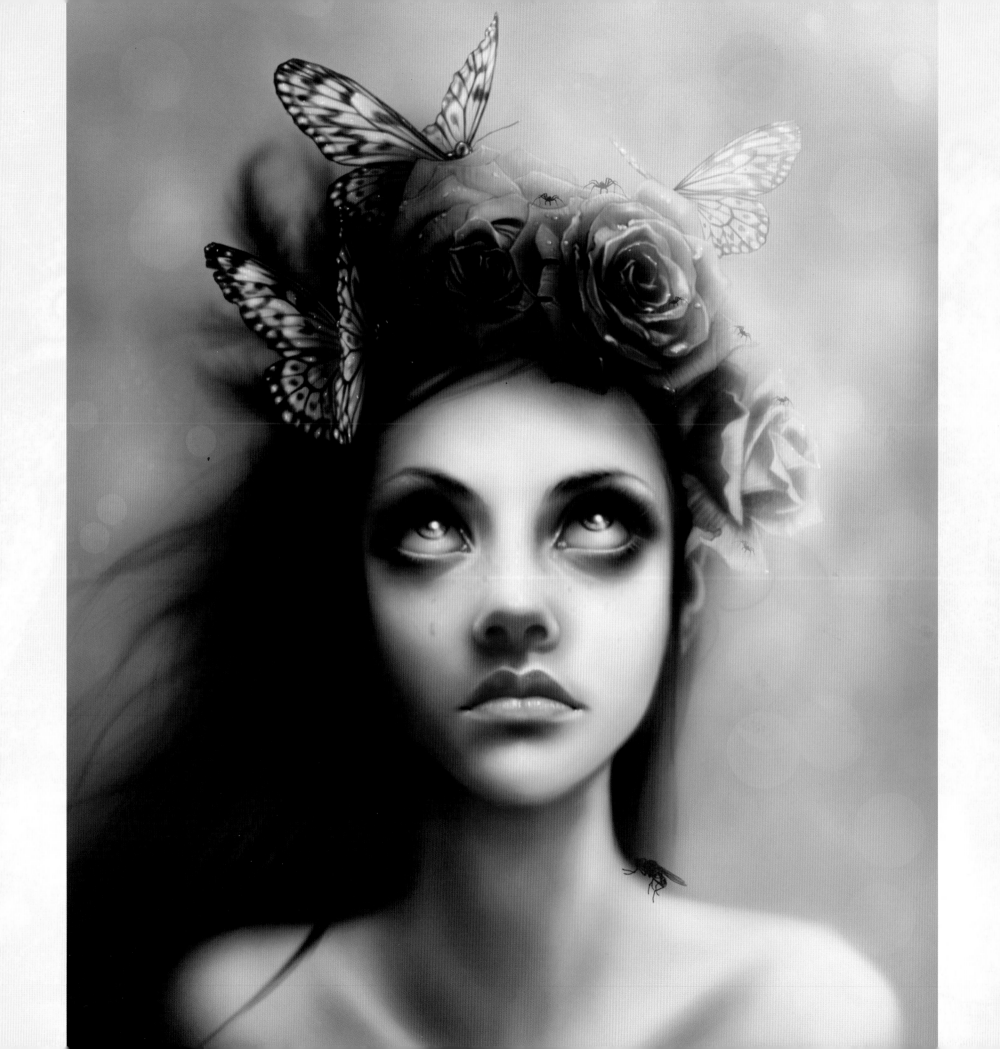

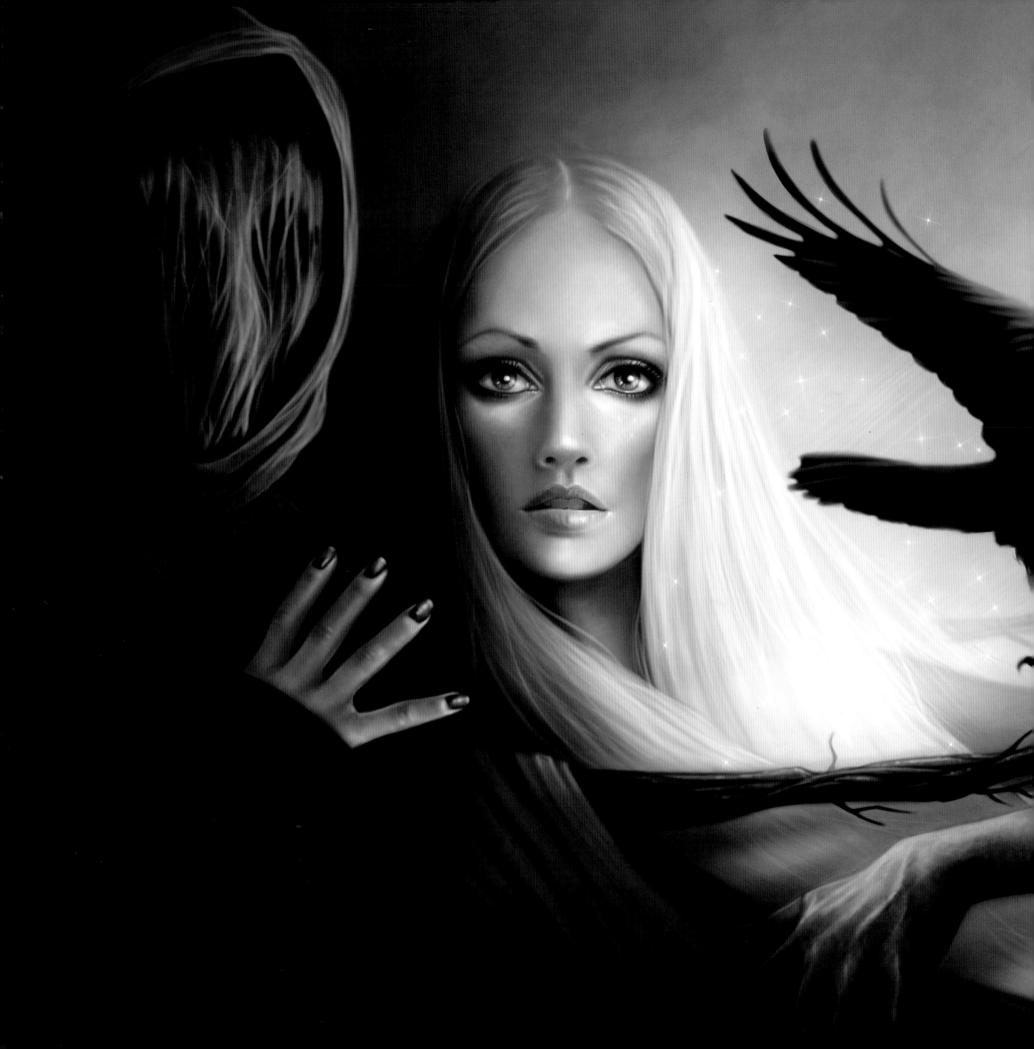

Death & Demons

While hardly the cheeriest of subjects, death plays a significant role in Gothic art and culture, often featuring as a thematic core or underlying subtext. Whether depicted explicitly or implied through symbolism, the metaphysical implications of death and the inhabitants of the worlds beyond the mortal realm are explored in many surprising ways.

Though it may seem that these kinds of works are morbid in nature, the acceptance of death is one of the most enduring themes of the Gothic sensibility. By embracing such themes, naturally unsettling concepts can be explored and understood in a theatrical and allegorical way. It all comes back to the idea of contrast, with the stark and inescapable certainty of death heightening the beauty, drama and romanticism of the world around us.

Death in Symbolism

Man's quest for the meaning of life first prompted us to try to make sense of the world around us by means of symbolism, which is the act of imbuing images with representative meaning. Unsurprisingly, some of the oldest symbols in recorded human history are those connected to the eternal cycle of life and death.

The sun, for instance, can be seen as both a symbol of life and death, as it is capable of sustaining life and destroying it. Images that depict the passage of time, such as clocks, hourglasses, sundials and candles also represent the countdown to the inevitable, as do more obvious symbols such as coffins, holes in the ground and tombstones. Nature too can possess melancholic qualities, especially lilies, ivy, barren trees and withering flowers. Many animals also hold darker meanings, such as cats, crows and owls, along with insects like the moth or spider.

There are many symbols originating in ancient cultures and civilizations, and exploring and working with these can help an artist add further and historical meaning to their work. Many Gothic artists

September by Mina M
© Mina M, 2013
Digital media: Photoshop
yamina.wix.com/mina-m-illustration

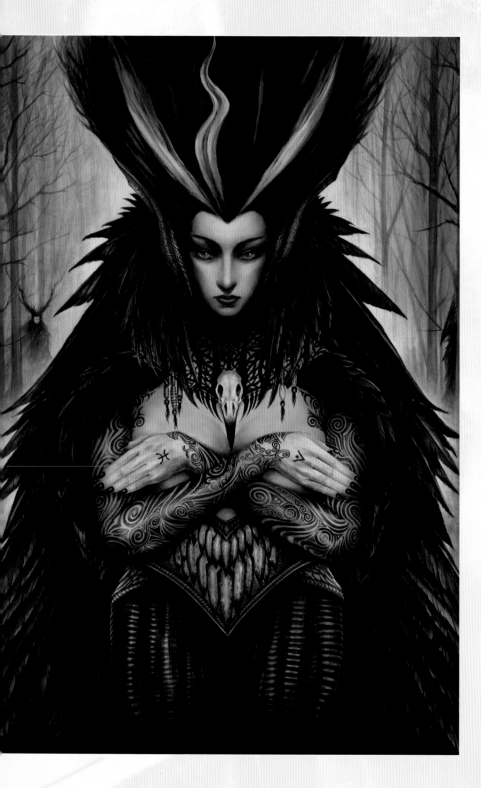

favour the symbolism of the great ancient civilizations, such as the exotic mysticism of the Babylonians and the Egyptians.

The Symbolism of the Skull

Above all symbols, skeleton imagery has long been associated with themes of death and mortality, with skulls being particularly prominent in ancient allegory. The skull is the easiest part of the skeleton to recognize, which is why it holds more symbolic power than any other part of the human skeleton. Its traditional symbolic purpose was to reflect the transient nature of life, with everything natural eventually succumbing to decay; a reminder of what's inside all of us, and of what we will all become.

The symbolic nature of the skull has also taken on several interesting additional meanings: if paired with wings, it can represent enduring spiritual life after death; when paired with crossbones, it suggests peril, as in the infamous Jolly Roger sign used by pirates in the seventeenth century. The skull can also be used to denote change, as the Death card in a tarot pack can signify, or be an ironic good luck charm for those with risky lifestyles.

The Mexican festival *Día de Muertos*, or Day of the Dead, has fully embraced the skull in its central imagery, with brightly coloured and boldly patterned skeletons featuring heavily in festive art and costume. The festival celebrates the memories of those who have passed, whilst at the same time embracing mortality.

Memento Mori

One of the most enduring aspects of skull symbolism that regularly finds itself incorporated into Gothic art is that of the triviality of vanity. Also known as the memento mori, its purpose was to remind people that everything is eventually lost to time, especially in regard to frivolous superficialities. The *danse macabre*, or dance of death, was a popular medieval allegory that used the theme of a dance to symbolize the inevitability of death. All walks of society are depicted dancing alongside a grave or beside skeletons, from the young and beautiful to the old and wealthy.

Morven by Marc Potts
© Marc Potts
Traditional medium: acrylics
marcpotts.co.uk

Look At Me by Omar Díaz
© Omar Díaz
Digital medium: Photoshop, Painter
omarportfolio.blogspot.com.es

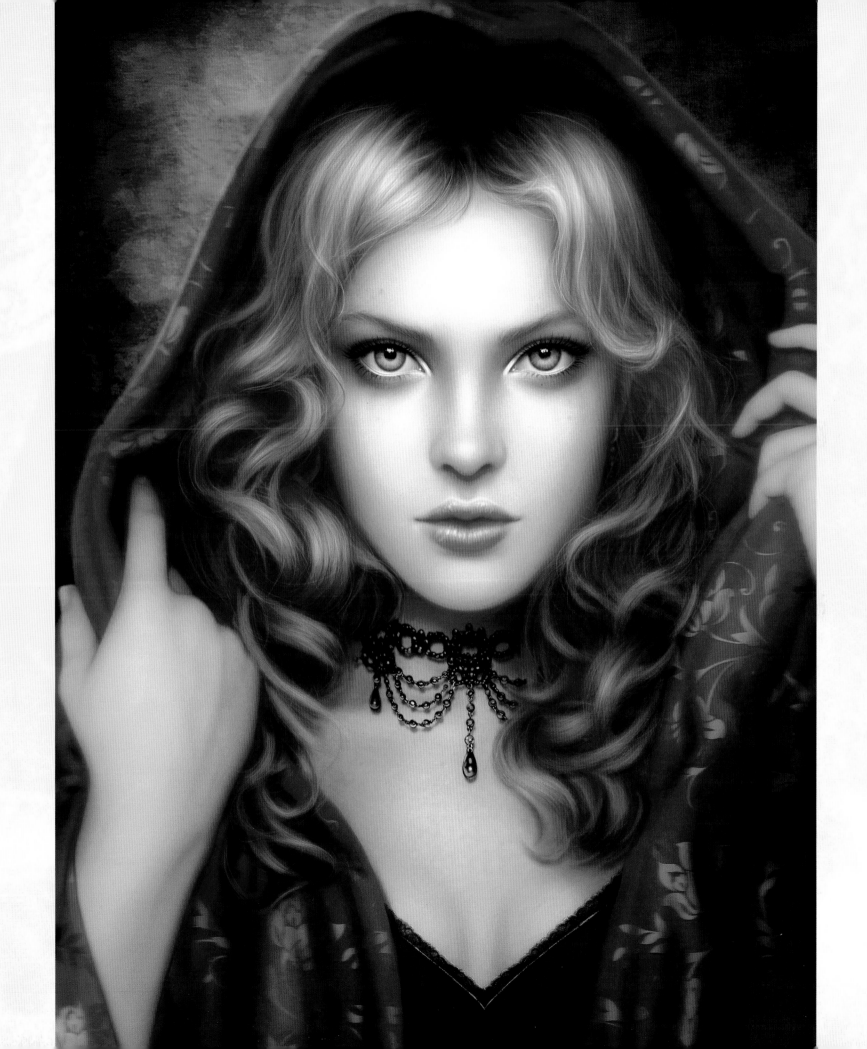

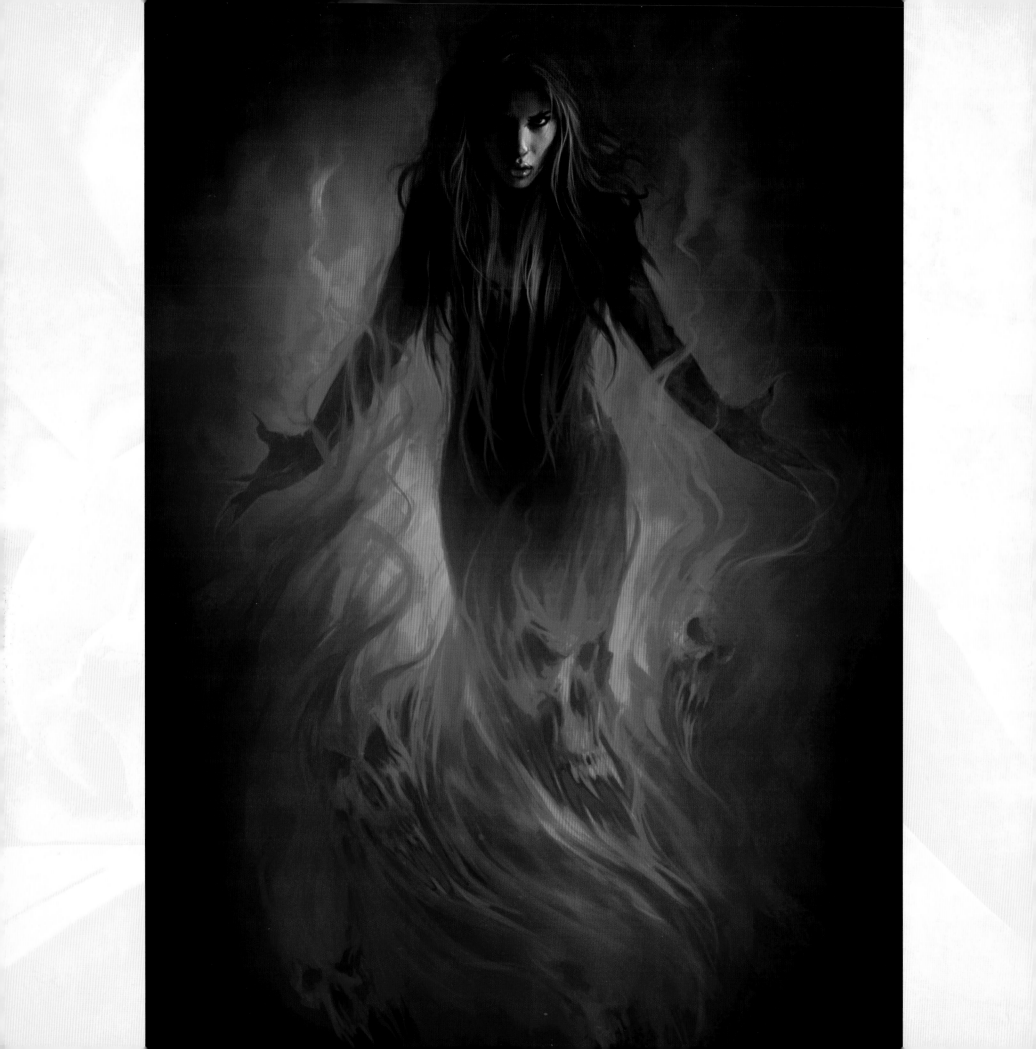

Vanity images often played on the motif of tainted beauty, which contrasts symbols of youth and vitality with darker concepts of decay and loss. The iconic Victorian illustration *All Is Vanity* (1892) by Charles Allan Gilbert is one of the most influential images of this kind, as it incorporates the ghostly visage of a human skull into the image of a young woman admiring her reflection in the mirror. The illustration has had a lasting impact on Gothic art, especially with the added appeal of being an authentic token of Victorian Gothic romanticism.

Death Personified

Death has taken many forms throughout history, but the most recognizable is that of the Grim Reaper. This is the archetypal image of death, whose appearance hasn't changed much since emerging as an allegorical figure of medieval art: a skeletal figure in a billowing black, hooded robe, always seen holding a large scythe.

The image is filled with symbolism: the skeletal frame represents decay and transient form, while the colour black symbolizes oblivion, loss and mystery; the scythe is a symbol connected to traditional farming methods, in which the instrument was used to harvest crops. Along with the symbolic act of cutting down growth, the tool is also related to autumn, a season that represents the end of one life cycle and the beginning of another. Grim Reaper imagery often incorporates other well-known symbols (see page 73) in order to further define meaning and tone. Many artists continue to use the same imagery in their own Grim Reaper works, such as *Summon the Reaper* (2010) by Anne Stokes and *Reaper* (2010) by Ken Kelly.

Angels of Death

Along with the Grim Reaper, another popular representation of death is that of the Dark Angel, a heavenly creature tasked with delivering souls to Heaven. Angels can be found in many strands of mythology and religion, but their powerful imagery and majestic presence can be appreciated outside the realms of faith.

The Dark Angel appears in many forms in fantasy art. The angel we are most familiar with is the kind that can be found in graveyards and

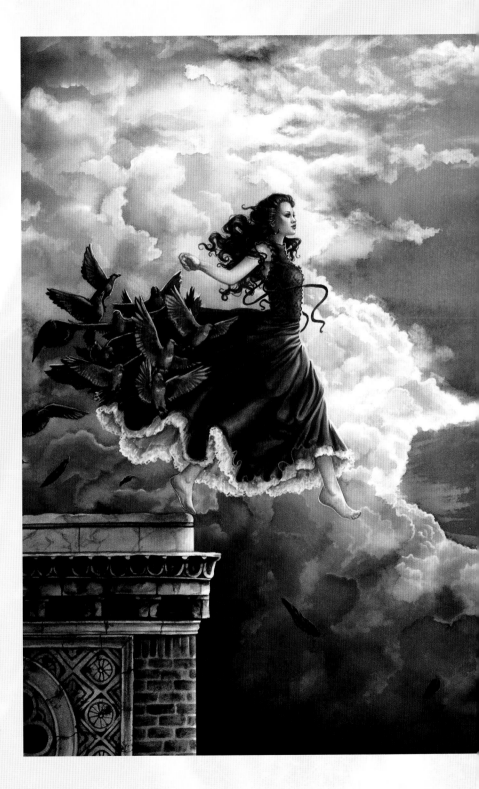

Dark Priestess by Pete Thompson
© Atomhawk Design
Digital media: Photoshop
atomhawk.com

Catch Me by Selina Fenech
© 2008 Selina Fenech
Traditional media: watercolour and acrylic paint on hotpress watercolour paper.
selinafenech.com

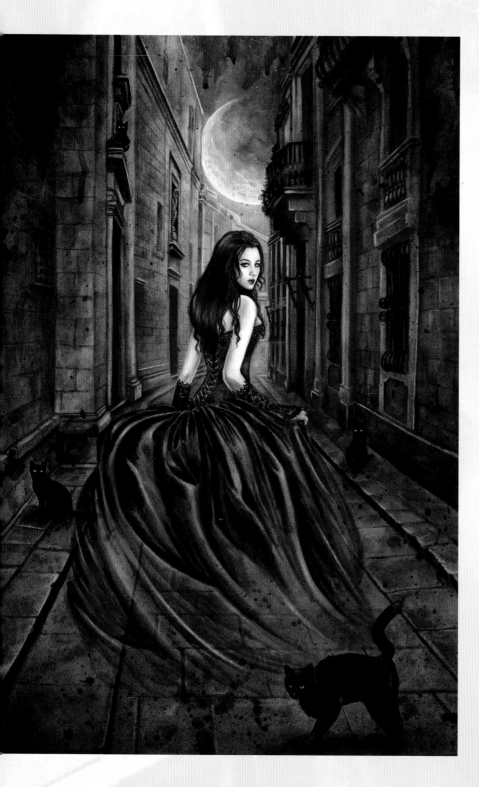

cemeteries: statuesque figures of grace and sorrow, caught in a perpetual state of mourning and melancholy. In Gothic art, these angels are often depicted as female, with elaborate costumes and jewellery. It's become a popular motif for Gothic photography as well as illustration, with prominent wings of fine plumage often leading the composition. *I of the Mourning* (2012) by photo-manipulation artist Alexandra V. Bach is a beautiful example of the sorrowful angel, with the romantic symbolism of the roses, thorns and candles adding to the emotional drama.

Menacing Angels

Not all angels are sympathetic beings, however. The Angel of Death is also commonly depicted as a proud creature with little remorse for the souls it must deliver, creating a more aggressive and confrontational kind of character. As an extra note of discomfort, many angels of this kind will appear to be as monstrous as the Grim Reaper, with skeletal features that remove any connotations of humanity.

Again, the legendary Brom frequently explores the nature of the Dark Angel, with the paintings *Death* (1995) and *Black Wing* (2000) providing two very different concepts of the Gothic angel. In *Death*, Brom cleverly uses the power of the unseen to conjure images of terror with his foreboding angel, whose only visible features are its faded black wings and grotesque clawed hands. In *Black Wing*, an armoured angel surveys the wake of her destruction whilst her ornate halberd remains poised for attack. Along with her bold wings, she also wears a raven headdress that merges into her swirling black hair. The image is sumptuous but inescapably cold, despite its vibrant colouring and strong contrasts.

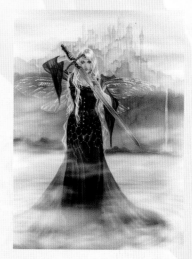

Deathly Riders

The menacing ensemble of the Four Horsemen of the Apocalypse is one of the most powerful images of the

Lost Soul by Selina Fenech
© 2010 Selina Fenech
Traditional media: acrylic and pastel on hotpress watercolour paper.
selinafenech.com

Lady of Avalon by Selina Fenech
© 2009 Selina Fenech
Mixed media: watercolour, acrylic paint and pastel on hotpress watercolour paper. Some digital elements added in Photoshop.
selinafenech.com

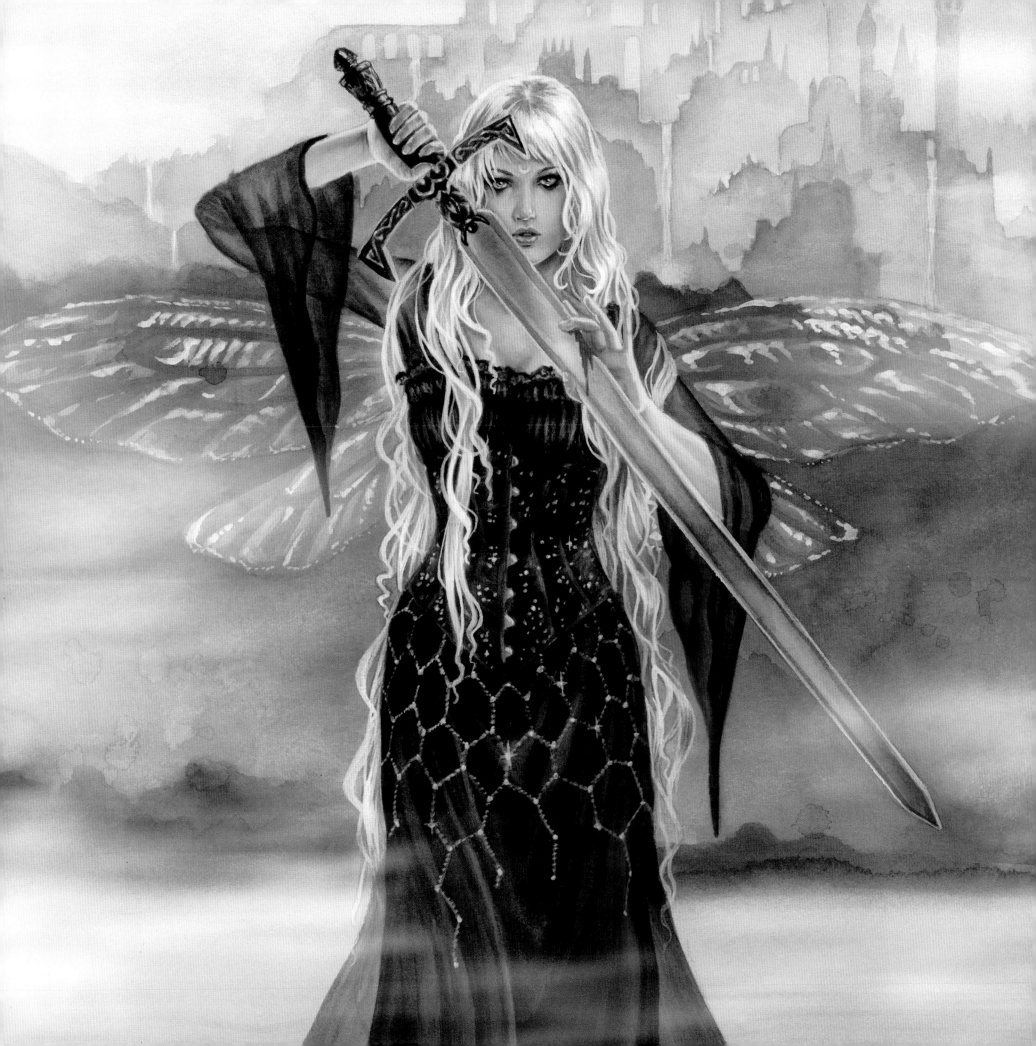

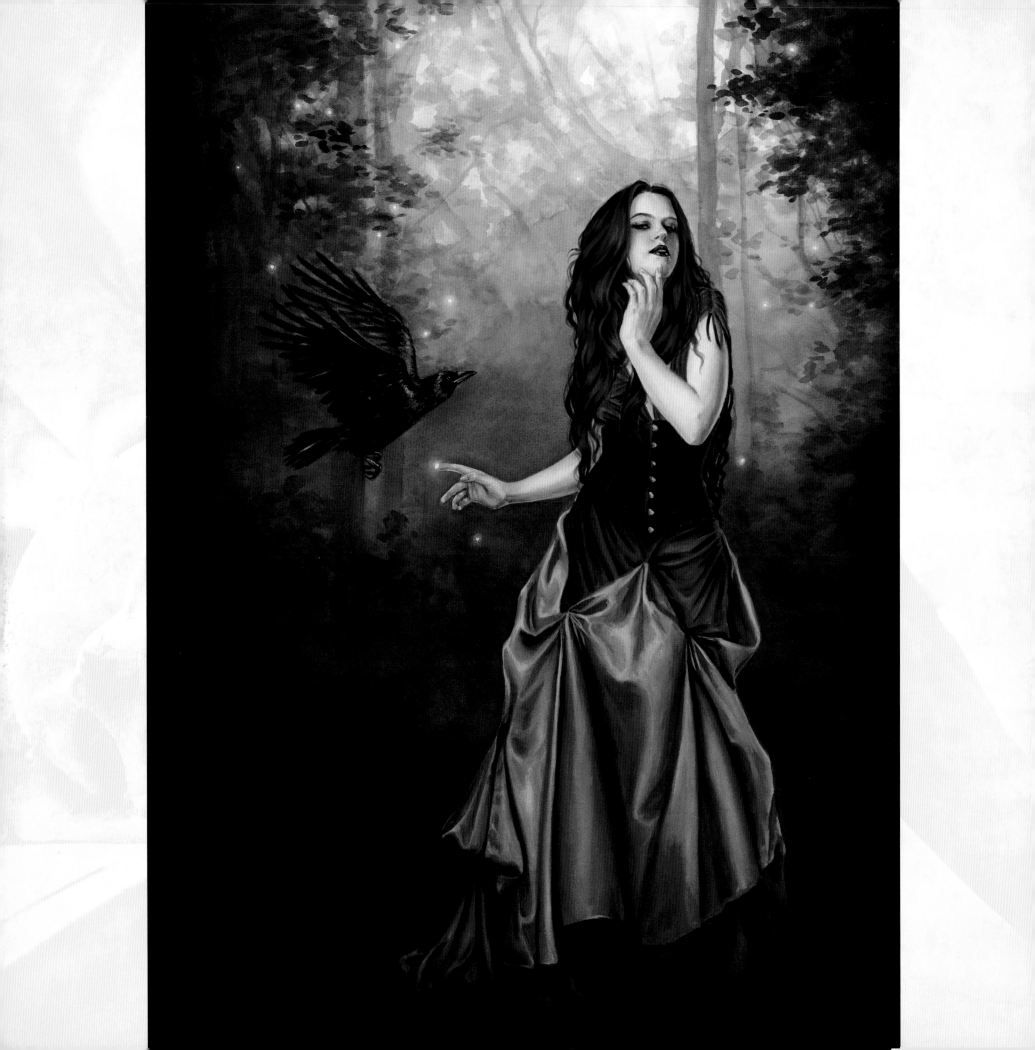

Christian faith; the nightmarish figures of Conquest, War, Famine and Death ride across the world, bringing forth the Apocalypse before the final earthly Judgment Day. Each horse also reflects the nature of their rider's designated calamity: Conquest on white, War on red, Famine on black and Death on pale.

Beyond Christianity, the Four Horsemen of the Apocalypse have made the imposing symbol of a deathly rider an archetype of destruction and carnage an irresistible prospect for fantasy artists, from Boris Vallejo and Julie Bell to comic-book favourite Joe Madureira in the video game *Darksiders* (2010). Although not necessarily one of the four horsemen, *The Death Dealer* (1973) by the revered Frank Frazetta is widely cited as one of the most influential paintings of fantasy art ever created. The deathly rider doesn't necessarily have to ride a horse these days either, with titles such as Marvel Comics' series *Ghost Rider* popularizing the idea of outlandish motorcycles as being a stylish alternative.

The Graceful Valkyrie

There are many strands of mythology that describe heavenly deities tasked with helping the dead find their way to the afterlife. One of the most inspiring to artists past and present is the noble Valkyrie from Norse legend. The Valkyrie was said to be a female entity who would scan the battlefield for soldiers on the brink of death and, if worthy, bring them to Valhalla, the realm of the afterlife reserved for the most powerful warriors who fell in combat.

In depictions of the Valkyrie, many artists have explored the nature of the battle-brazen entity both as the guide of departed souls and as an agent of death, as the Valkyrie has the power to decide whether a soldier lives or dies. Some artists show her as a melancholic war maiden, such as Alexandra V. Bach's *The Valkyrie* (2012), while others depict the character as a strong and proud warrior, as we find in Magic: The Gathering card artwork by Greg Staples and Jeremy Jarvis.

Death in Popular Culture

Despite its scary nature, the figure of Death has made many appearances in modern media and literature, and not always in the most expected

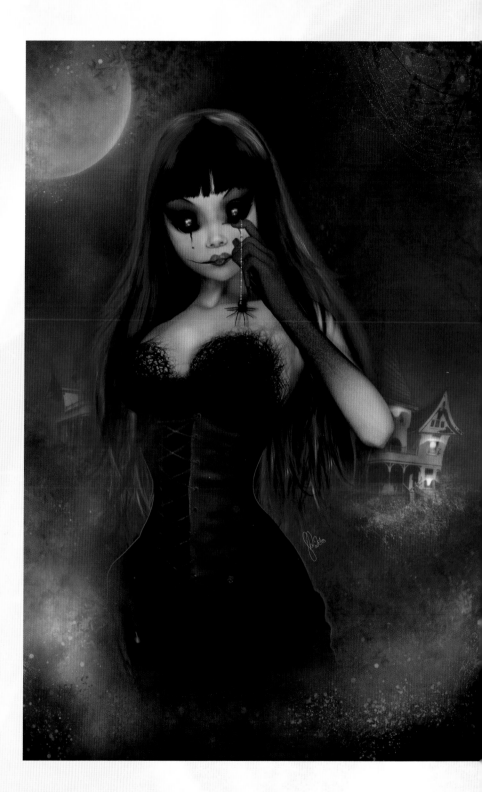

Shades by Selina Fenech
© 2010 Selina Fenech
Traditional media: acrylic paint on hotpress watercolour paper.
selinafenech.com

Black Widow by Susanne Radermacher
© Surama
Digital media: Poser, Photoshop
surama.net

Gothic Voo Doo by Sutat Palama

© Sutat Palama; **Digital media:** Photoshop; Sutat Palama is a freelance artist and instructor in the Faculty of Digital Art at Rangsit University, Thailand; ninejear.deviantart.com/gallery

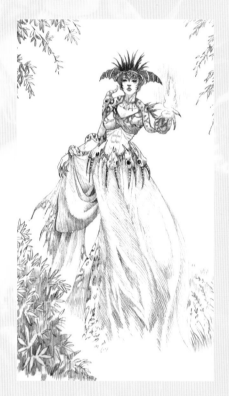

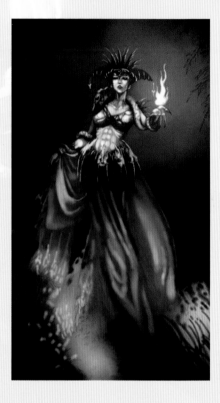

Step 1: Research: Before I began brain-storming, I researched styles that I liked. I am especially interested in West African voodoo for its sacrificial ceremony, the ritualistic dance and the intriguing 'mix-and-match' local clothing style. Gothic is another style I really appreciate for its architectural traits and larger-than-life figurative proportions that often show figures in beautiful clothes. I then chose to combine Gothic and West African voodoo together to create a unique look.

Step 2: Thumbnail Sketch: Once I locked down the direction, I started to scribble down a few ideas. Silhouette sketches were used to find my preferred design, then I further developed and polished out the idea in Photoshop.

Step 3: Painting ~ Value Refinement and Detail: At this step, I painted this sketch in monochrome. This way helps me concentrate easily on the lighting and refinement without worrying about the colour scheme. I used a hard round brush to define the shapes and forms.

Step 4: Change Monochrome to Colour: Upon completing the monochrome version, I added an additional layer in order to paint colour on top. It is important to use colours with higher brightness and saturation than the monochrome underneath. I enhanced the overall look by blending selected colours with new shades; I deepened the shadows by adding some darker blue and gave more life to the cheeks by adding more green and brown to them. As for the brushes, I always apply colours with the hard round brush with opacity set to pressure (and with a low flow).

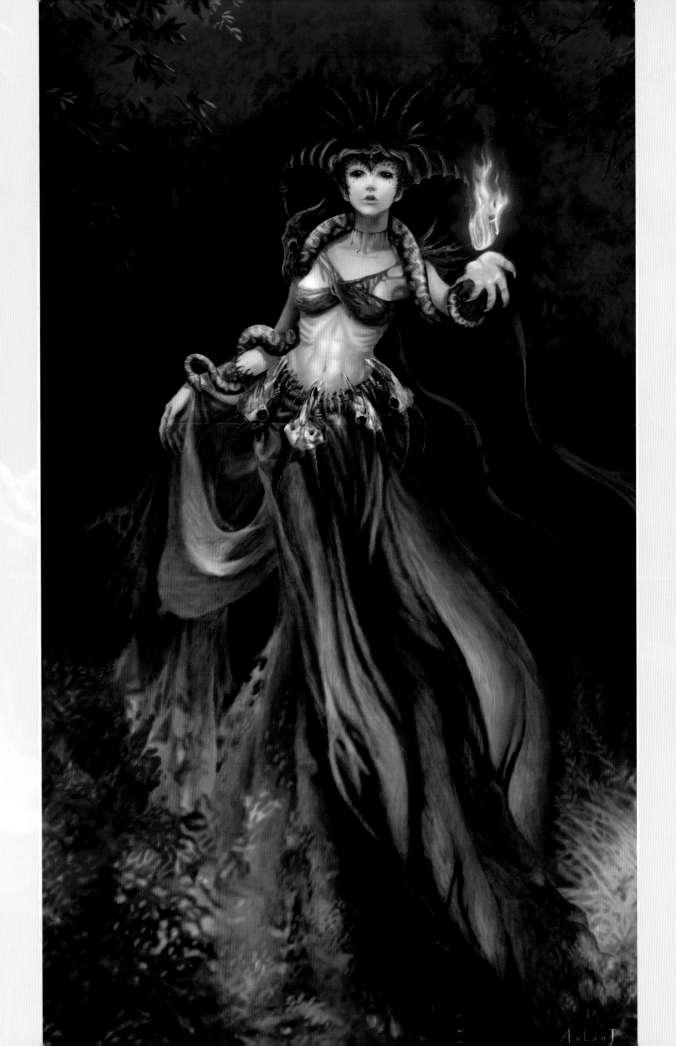

Step 5: It's All Detail: In this picture she's slitting her throat as a bloody sacrificial ritual for her lord, Python, in a mystical forest. I made her eyes jet black to add more powerful character. In addition, her body's extremely lean, revealing her ribs through her pale skin.

Finishing Touches: I used an overall dark tone to control the ambience of the picture and utilized lighter colours to lead the viewer's attention towards the main subject. In this image I have tried extremely hard to improve my technique, especially when it comes to painting skin (colour- and texture-wise), hair and experimenting with light sources. Many, many hours were spent on this one.

of forms. The Grim Reaper, in an ironic twist, has been known to be portrayed in a comedic light, as we see in Terry Pratchett's beloved *Discworld* series with the character of Death. In a similar spirit to Pratchett's books are the cult films *Monty Python's The Meaning of Life* (1983) and *Bill & Ted's Bogus Journey* (1991), which both feature the Reaper in a more light-hearted fashion.

In further deviation from the usual track, Martin Brest's romantic thriller *Meet Joe Black* (1998) presents the figure of Death as a handsome and sharply dressed man who is empathetic, chivalrous and noble. The popular Japanese manga and anime series *Soul Eater* distils the iconic visual features of the Grim Reaper and turns them into something much cuter with supernatural schoolmaster Shinigami.

Enter Sandman

Staying with comics, one of the most engaging characters of recent years can be found in the incredible *Sandman* graphic novels by Neil Gaiman, whose anthropomorphic entity Death is the polar opposite of the traditional archetype. Gaiman's take on Death presents the character as a charming and spirited young woman, who is one of the immortal universal beings known as the Endless. Taking a direct influence from classic Goth style, Death has a pale complexion and midnight-black hair, usually depicted as casually dressed in black jeans and simple shirts, chunky boots and her trademark Egyptian ankh necklace. Many of the finest artists in the comic-book industry have illustrated Death during the novels' seven-year run, including Chris Bachalo, Jill Thompson, Shawn McManus and long-term Gaiman collaborator Dave McKean.

Ghostly Apparitions

Another deathly figure closely tied to Gothic art is that of the ghost, which is often depicted as a troubled spirit bound by unresolved wishes, malice or denial. The ghost story is a staple part of almost every culture, which is why it is no surprise that tales of supernatural activity continue to thrill us to this day.

The Path of Fear by Susanne Radermacher
© Surama
Digital media: Poser, Photoshop
surama.net

Angels of Death by Anne Stokes
© Anne Stokes
Digital media: Photoshop
annestokes.com

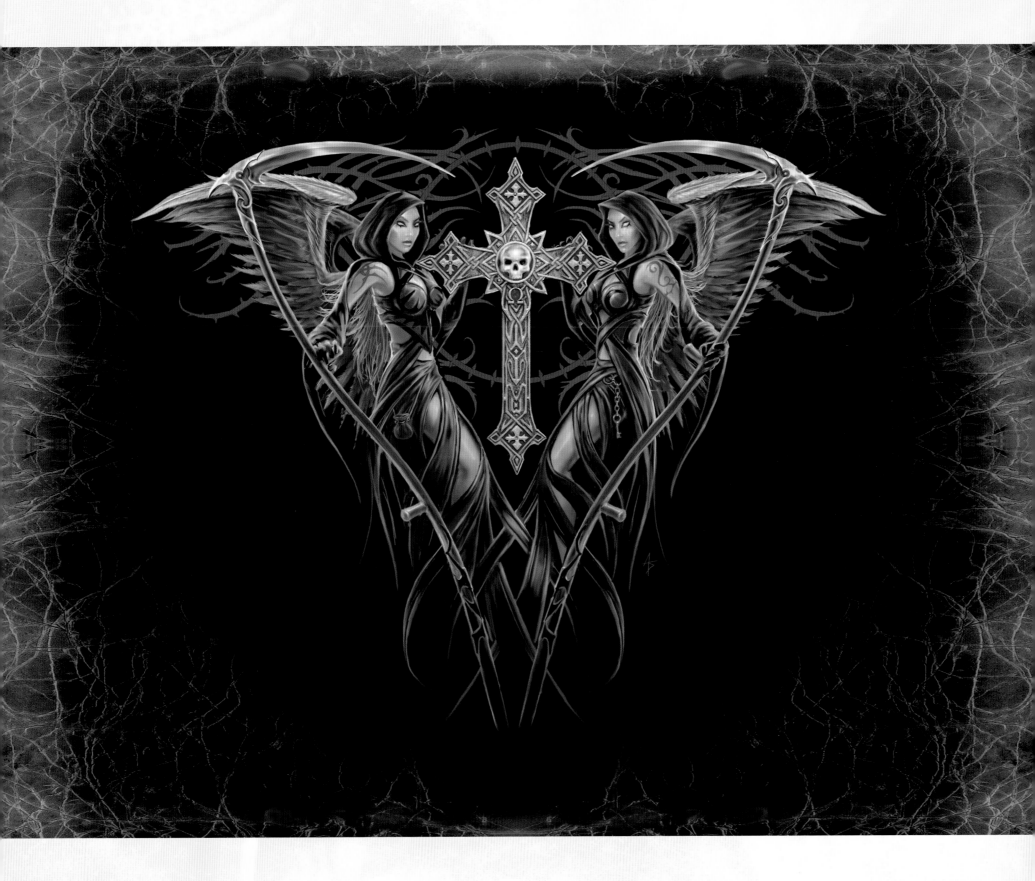

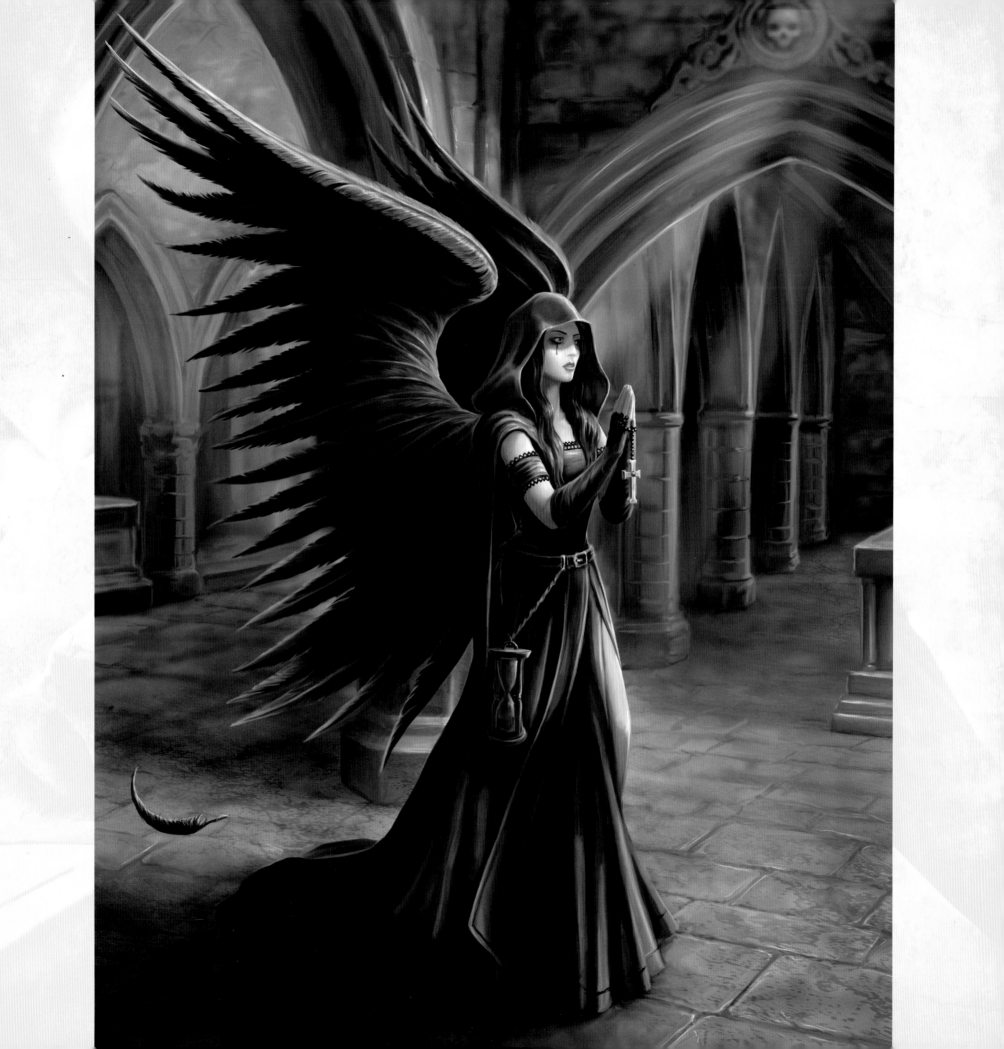

Even without the boom of Gothic fiction, ghost stories have always attracted the attention of enthusiasts and cynics alike, and have never really gone out of fashion. Classic tales such as Washington Irving's *The Legend of Sleepy Hollow* (1820), Charles Dickens' *A Christmas Carol* (1843) and *The Turn of the Screw* (1898) by Henry James continue to fascinate, with the ghost appearing in almost every genre conceivable, from horror to romance and even science fiction.

Melancholic Ghosts

According to folklore, if a person dies in a state of extreme emotion, they may return to haunt the people or places connected to their demise. With this in mind, many Gothic artists depict ghosts as tragic and lovelorn spirits trapped in a perpetual state of emotional melodrama, as we see in the delicate works of French artists Rozenn Illiano and Mina Meslin. Portraits of ghosts will often feature clues to give the viewer an idea of what may have caused the spirit to feel such pain, and will be rendered in a soft, ethereal style using colours at the cooler end of the spectrum.

Vengeful Spirits

Of course, not every ghost is content to wait silently in the shadows. There are many malicious kinds of spirits, such as poltergeists and banshees, which prefer to lash out and cause physical harm or extreme terror to those around them. Vengeful ghosts are particularly popular in Japanese horror, especially after the international success of films like Hideo Nakata's *Ringu* (1998) and *Ju-on* (2000) by Takashi Shimizu. Known natively as the *onryō*, these spirits are typified by long, dishevelled black hair that obscures the face and white funerary gowns, sometimes depicted with contorted limbs and heavy bruising. In keeping with kabuki theatre tradition, exposed faces often bear exaggerated expressions, although many Western artists often keep expressions on the subtle side, as we see in Rudy Faber's *Portrait of Ikuko's Ghost* (2009).

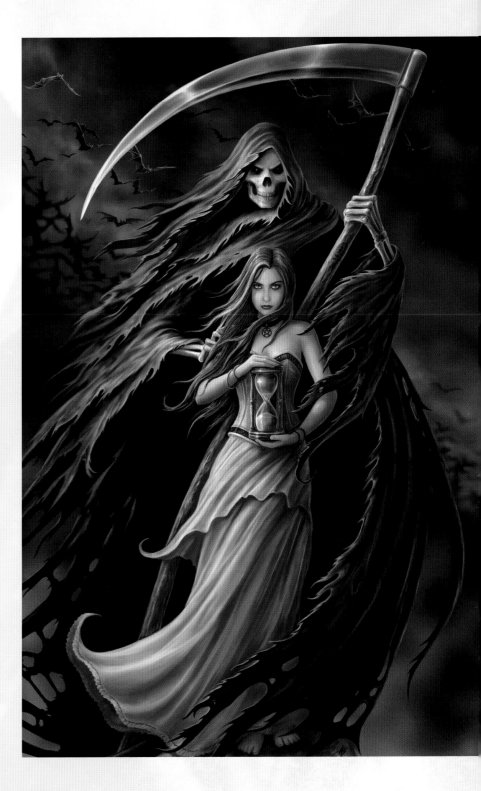

Harbinger by Anne Stokes
© Anne Stokes
Digital media: Photoshop
annestokes.com

Summon the Reaper by Anne Stokes
© Anne Stokes
Digital media: Photoshop
annestokes.com

Down to the Devil

Satan, Lucifer, Mephistopheles, the Antichrist ... there are many names for the Devil, the very personification of evil and sin. All major religions cast the Devil as the complete opposite to God, as a force that tempts mortals into sin in order to claim their souls. Many religions share the story of the Devil originally being an angel who fell from Heaven after committing the sin of pride. The Devil is typically depicted as a horned being with large hooves and a forked tail, although he can appear in any guise he wishes when trying to lure people towards corruption. The signature look of the Devil is what Tim Curry's iconic

role as the Prince of Darkness in Ridley Scott's *Legend* (1985) is heavily based on, with fearsome black horns and an intimidating physique.

Outside religious contexts, iconic depictions of the Devil appear throughout many of the most revered works of Western fiction, such as John Milton's charismatic Satan in *Paradise Lost* (1667), the enigmatic trickster Mephisto in the legend of Faust (most notably in Christopher Marlowe's *Dr Faustus* of 1604 and Johann Wolfgang von Goethe's *Faust* in 1808) and as the sneering severed pig's head in William Golding's *Lord of the Flies* (1954).

Fires of Hell

Once cast out of Heaven, the Devil and his demonic followers resided in the fiery depths of Hell, where all corrupted or evil souls would find themselves when their time came. Hell was originally described as a fiery realm of endless torture and suffering.

Dante Alighieri's Renaissance masterpiece *The Divine Comedy* explored the concept of Hell and in *Inferno*, the first part of his epic trilogy, he showed it divided into nine circles that represented all mortal sins. In many ways, the imagery expressed in Dante's graphic depiction of Hell has been more influential to artists than the Bible itself, with each circle and its inhabitants explored at length and in immensely vivid detail, as we find in the beautiful illustrations that William Blake created just prior to his death in 1827.

Devil Worshippers

When delving into the historical implications of the Devil, it's important to point out that there are many misconceptions that paganism is outright demonic worship, which it is not. The confusion often arises with the misinterpretation that the horned deities of paganism, such as Pan, are incarnations of Satan. This assumption was popularized by the medieval Christian church, and still holds sway even to this day.

However, there are several groups that do worship the Devil as both a physical deity and as a moral code. There are many diverse strands of Satanism, many of which were founded amidst the spread of New Age

occultism in the early twentieth century. There are two main offshoots of Satanism, although both hold different principals; followers of Theistic Satanism worship the Devil a physical entity, while LaVeyan Satanists (founders of the notorious Church of Satan) use Satan as a metaphor for serving the self. Although some groups do practise ceremonial ritual, the popular notions connected to Satanism of demonic invocation and virgin sacrifice may be more than a little far-fetched.

The Devil in Gothic Art

Although it may seem at first glance that there are many pieces of fantasy art that glorify the Devil or evil forces, the truth is that the vast majority of artists use the character purely as an allegorical figure; fantasy art is not evil! With Gothic art focusing on the darker themes of fantasy, it's no surprise that the figure of the Devil often finds itself integrated into artwork in one way or another. His presence immediately creates an immensely dramatic and dark narrative tone, which can be heightened even further if combined with other characters.

Satanic Symbolism

Pigs, goats, rams and snakes are widely associated with the Devil, with the snake appearing as one of the oldest symbols in recorded history to represent evil forces. This may account for why the dragon is also often viewed as an evil creature connected to the forces of darkness. The marking of three sixes is said to be the Number of the Beast, as discovered on the Devil's son Damien in *The Omen* (1976).

The trouble with satanic symbolism is that there's a lot of contention between followers of Satanism, the Christian Church and the general public on which signs do and do not represent the Devil. Nevertheless, common symbols such as the inverted pentagram and the reversed cross of the Christian martyr St Peter continue to appear in artwork invoking satanic themes. The popular horned-hand symbol, or *mano cornuto*, was believed to both signify a horned deity and protect against the Evil Eye. The sign is especially attached to heavy metal, and often appears in Gothic art that uses rebellious musicians as the main focus, as we find in several pieces by Anne Stokes.

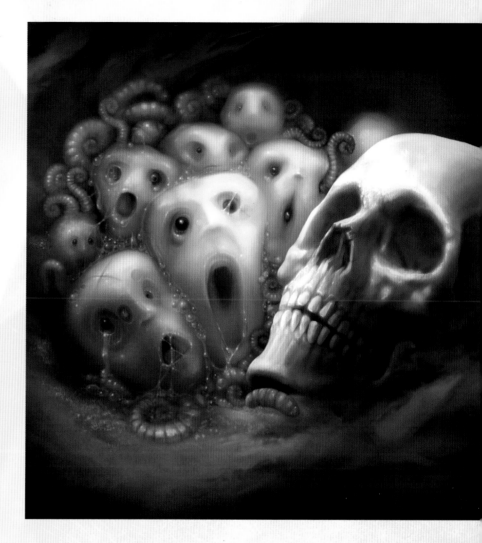

The Inverted Pentagram

The inverted pentagram, for instance, is often assumed to be the symbol of Devil worship and ritualistic sacrifice. In truth, the symbol is another facet of the traditional Wiccan pentagram: when pointing upright, the star represents positive energies associated with the elements of earth, air, fire, water and spirit; when facing downwards, it represents the more chaotic and aggressive sides, but not evil. However, Satanic worship has misappropriated the inverted pentagram, often incorporating a goat's head or snake into the design, leading to its more common associations.

Caernûn by Dave Oliver
© Dave Oliver
'Neither is he a lord of the dark nor the light, neither benevolent
nor malign. / Ancient as the land, older than the mound he raised.'
Digital media: Photoshop
dloliver.deviantart.com

Mycoids by Dave Oliver
© Dave Oliver
Digital media: Photoshop
dloliver.deviantart.com

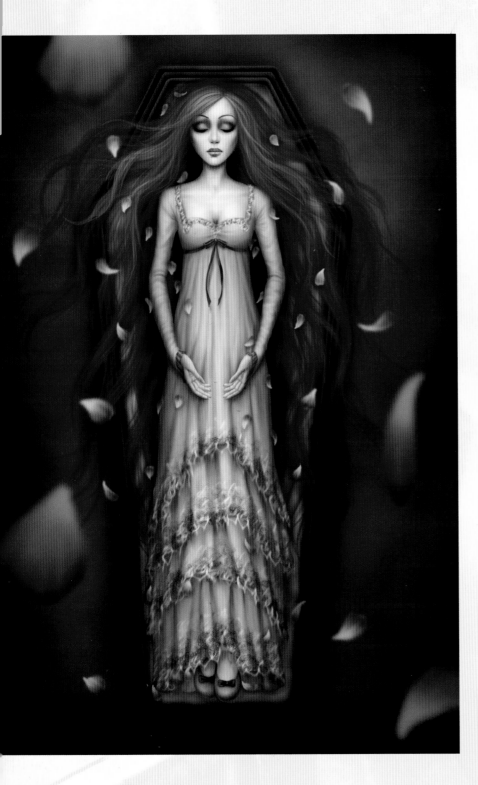

Beware the Demon

As with the figure of the Devil, demons of one form or another can be found in virtually every ancient and modern culture. While some forms of demon were considered to be helpful and protective, others were believed to be malevolent and unquestionably evil. Good demons have more or less faded into obscurity, with the word now coming to signify evil spirits that seek to cause harm to others. While several faiths promote the idea of enlisting the help of angels through prayer, certain occult doctrines readily believe in the ability to physically summon a demon to carry out their wishes, usually through some kind of ritual or alchemical compound.

Demons appear in Gothic art as powerful entities that represent dark forces, often personifying particular themes and concepts associated with sin and misfortune. They can take on many appearances, with some looking completely human while others appear as grotesque monsters.

Popularizing the Demon

While there are many conflicting ideas of how demons should look, some of the most influential images were created in an edition of *Dictionnaire Infernal* by the French occultist Jacques Albin Simon Collin de Plancy. Forty-five years after its original publication in 1818, Louis Le Breton painted 69 illustrations for the book, inspired by earlier works and typifying the monstrous image of the demon that we continue to see today. What makes Le Breton's detailed illustrations so compelling is that each expresses a sense of intent and motive behind each ghastly figure; every grotesque visual element has been deliberately considered in order to reflect the demon's nature and purpose in addition to striking fear into the viewer's mind. Le Breton's illustrations can often be spotted in horror films that require a character to investigate demonology with a view to summoning a particular spirit.

Popular Demons

There is certainly no shortage of demons to draw artistic inspiration from, thanks to the many historical collections of demonology that survive. In fantasy art, we see many demonic archetypes depicted in the most

At Peace by Enamorte
© Enamorte
Digital media: Paint Tool SAI and Photoshop
enamorte.deviantart.com

Beauty and the Beast by Enamorte
© Enamorte
Digital media: Photoshop
enamorte.deviantart.com

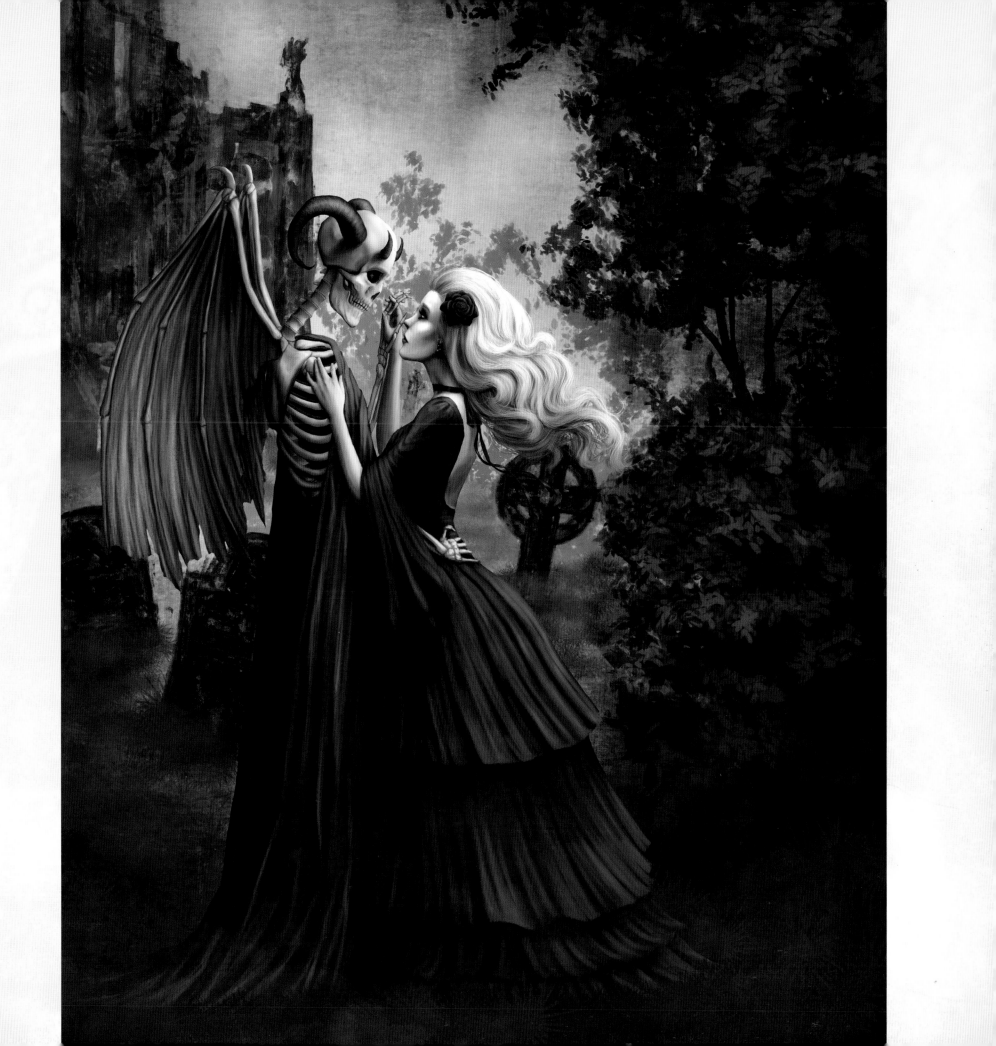

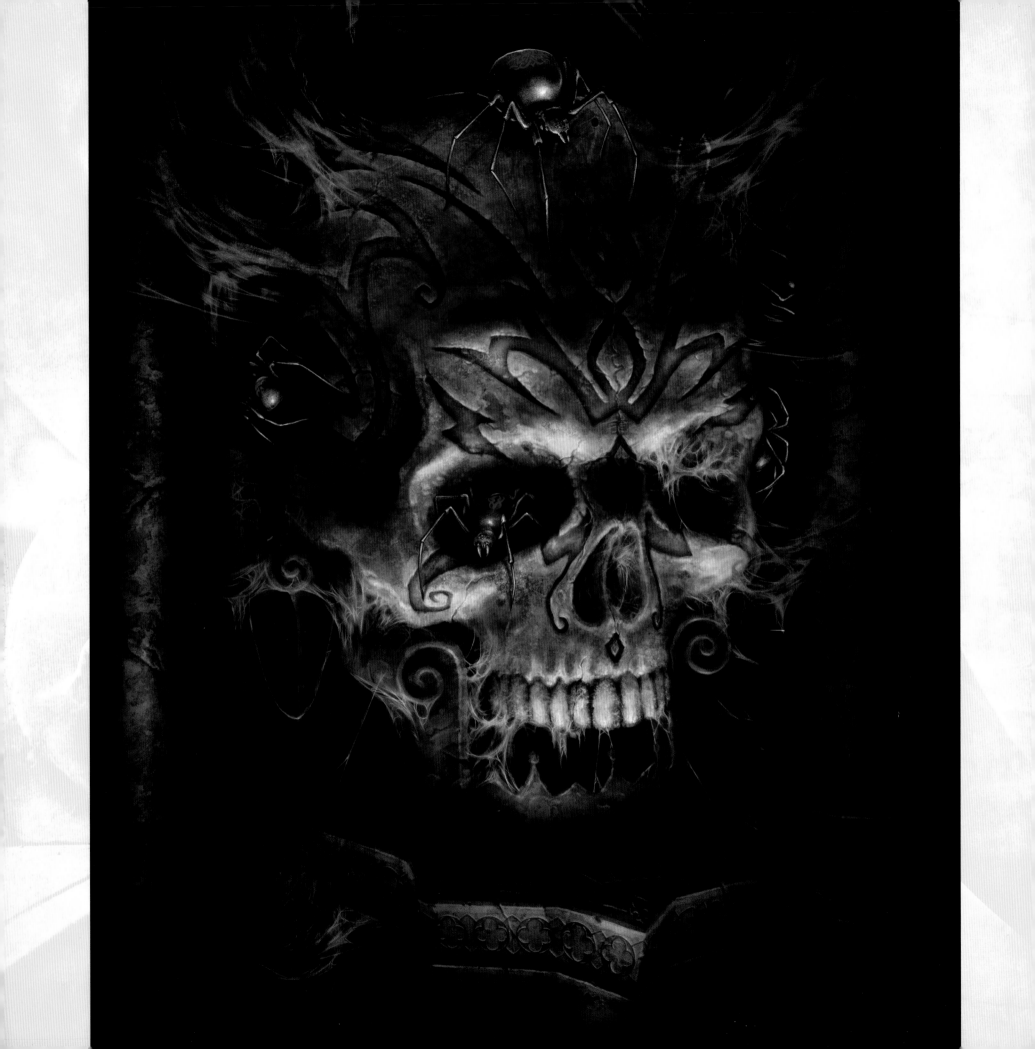

spectacular of ways, especially in regard to video games and traditional table-top role-playing games. An especially popular deviation from the demon myth is that of the half-demon, as we see with the silver-haired Dante in Capcom's Devil May Cry series and the half-dog demon InuYasha from Rumiko Takahashi's popular manga series of the same name.

Demons of Dark Beauty

It's no surprise that demons whose agenda is to seduce are enticing subjects for artists to explore. The term 'nightmare' was originally the name given to evil spirits that plagued sleeping victims with bad dreams, often straddling their victims like a horse, as the Swiss supernatural painter Henry Fuseli captures in *The Nightmare* (1781).

The succubus and incubus are the most notorious demons, as they carry out sexual acts on their unsuspecting victims. Aside from a few physical aberrations, such as heavy dark hair covering the legs, both entities were generally believed to be exceptionally beautiful. The theatrical sensuality of the succubus is especially popular in fantasy art, and she is noticeably more present than her male counterpart, the incubus. Many of the greatest fantasy artists, such as Boris Vallejo and Todd Lockwood, have taken on the lurid and alluring subject of the succubus.

Similar kinds of demon include the Japanese Hone-onna, who will drain the life out of men by holding hands, and the Scandinavian Huldra, an entity of the forest who will kill her sexual partners if not satisfied with them.

Elemental Demons

There are many demons that correspond to the natural elements of earth, air, fire and water, with many nightmarish creations found in popular table-top role-playing games like *Dungeons & Dragons*. The majestic Leviathan was said to be a primordial entity of the ocean, and is often depicted in grand fashion to emphasize its enormous stature, as demonstrated in the works of Anthony Francisco and Karl Kopinski for *Magic: The Gathering*. Fire demons such as Ifrit remain popular choices for artists to study, as we see with the spectacular *Ifrit the Ruiner* (2013) pieces by Svetlin Velinov for Applibot's *Legend of the Cryptids*.

It's common for artists to incorporate traits of elemental design into their demons, so that the viewer can get a good idea of where they came from and what kind of powers they possess. In J. Edwin Stevens' *Mother of Grendel Grief-Wracked and Ravenous* (2010) for example, Grendel's water-dwelling mother is depicted as a demonic mermaid.

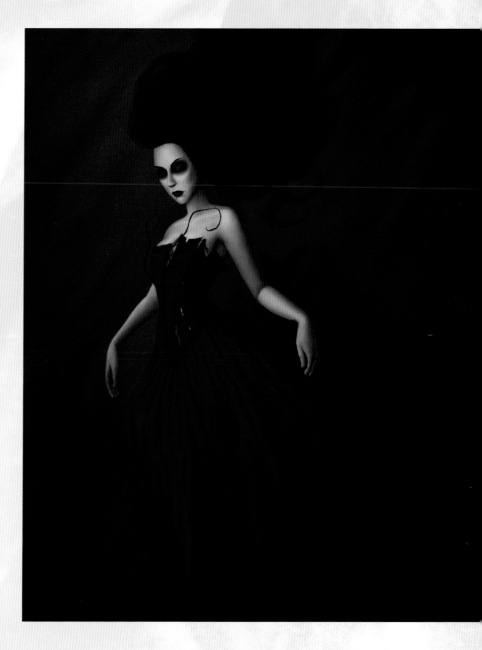

Webbed Skull by Jason Juta
© Spiral Direct
Digital media: Photoshop
jasonjuta.com

She Drowned by Enamorte
© Enamorte
Digital media: Photoshop
enamorte.deviantart.com

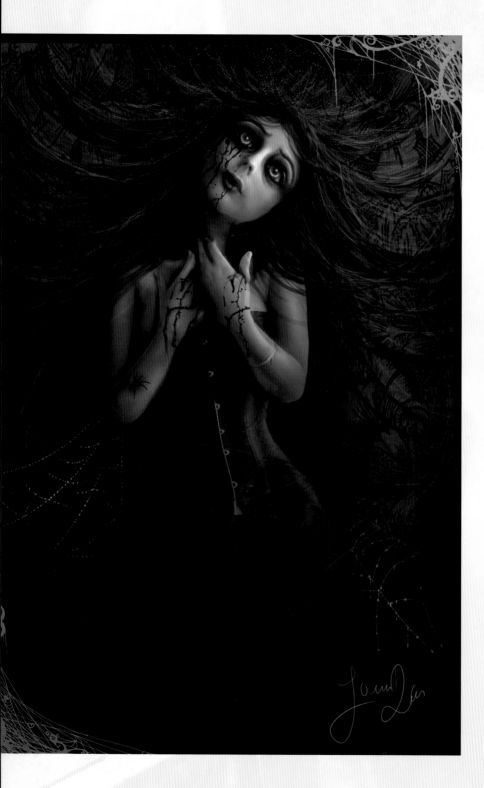

Demons of the Mind

Demon art doesn't have to be based on historical creatures. Some of the more terrifying entities are those created from the artist's mind's eye. Many artists will pick a theme to base a demon on and work from there, which often results in some truly ghastly creations. The end results often bear resemblance to the illustrations of Louis Le Breton, with demons constructed from bizarre combinations of animal and human appendages and features. They tap into well-known figures or archetypes, but develop a unique sense of character and purpose. The grotesque sketches of Jim Pavelec and the eerie demonic creature designs by Samuel Araya and Mike Corriero are particularly fascinating examples of the limitless scope for visual experimentation.

Demonic Possession

The act of demonic possession is just as fascinating to depict as the demons themselves. In Gothic art, victims of possession are often female, often in submissive poses that suggest a total loss of control. Whether in illustration or photography, many possession-themed pieces use the eyes of the victim as the most prominent visual sign of paranormal activity, often exposing only the whites of the eyes and omitting iris detail.

Variants of this motif extend to replacing the white of the eye with deep black or other distinctive colours and adding an otherworldly glow.

Supernatural forces may be expressed by suggestive shadowing and abstraction, as we see in concept artist Simon Goinard's intriguing piece *Possession* (2009). Here, the subtle act of possession is conveyed by intermixing shades and highlights that trick the eye into looking for shapes amidst the chaos.

The Black Widow by Joana Shino Dias © 2009-2013 Joana Shino
Digital media: Photoshop
In this piece I tried to combine a mix of emotions between the creepiness of the black widow (the spider) and the grief of actually losing a loved one. Her despair is making her almost metamorphose, turning her blood into poison and her hair into spider webs.
joanashino.com

Bella Muerte by Joana Shino Dias © 2012–2013 Joana Shino
Digital media: Photoshop, Trust Tablet
Commissioned work for a tattoo shop's flyer. They ended up choosing another artwork of mine, but this was my favourite one. The make-up was a pleasure to draw. The Day of the Dead is always a super colourful but 'dark' theme to work with.
joanashino.com

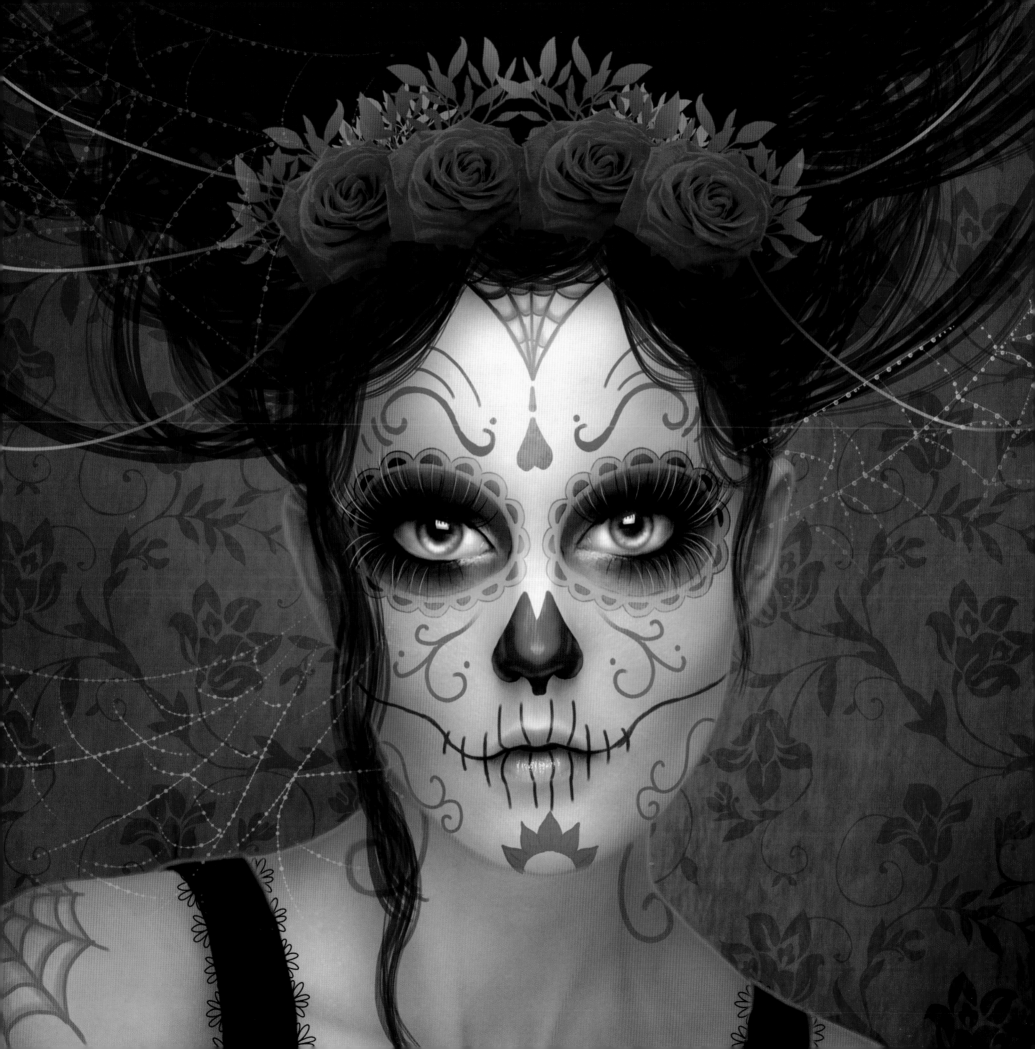

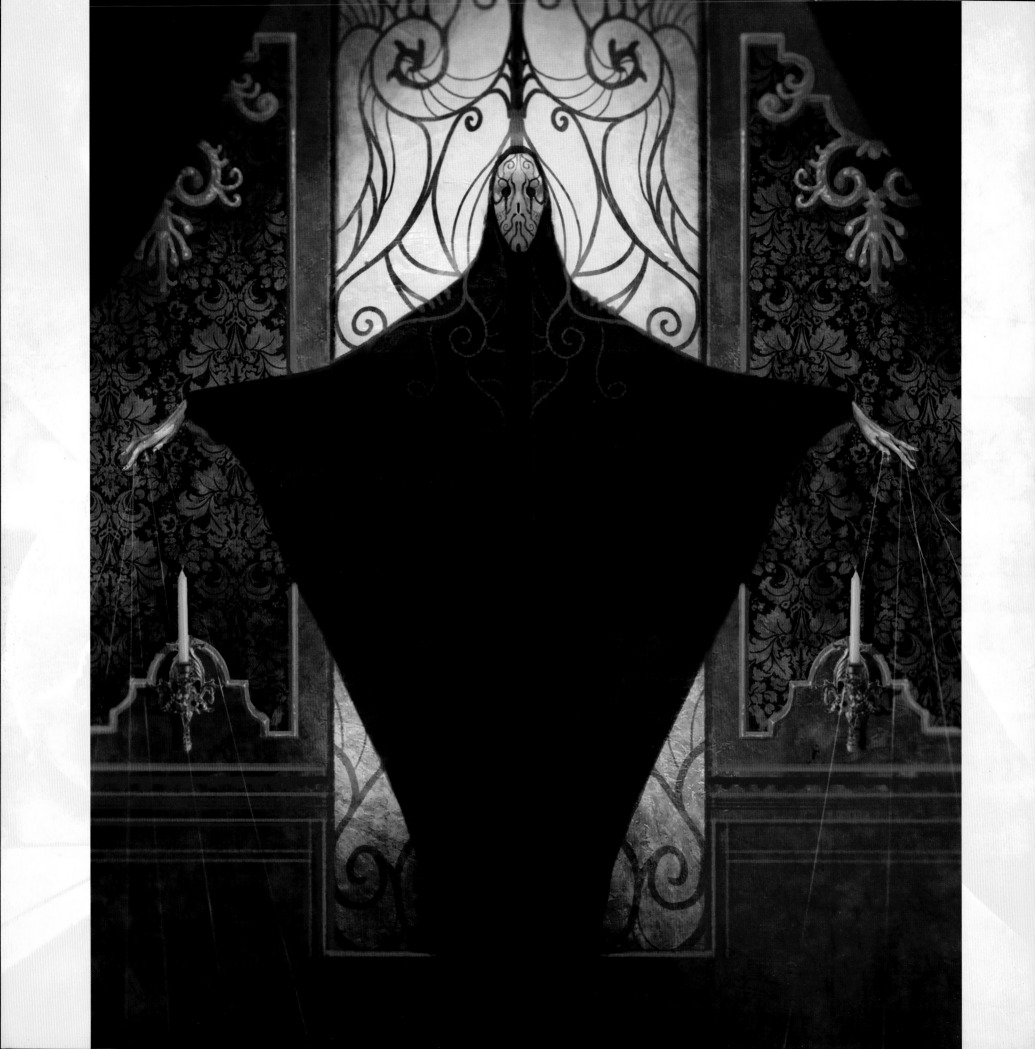

Gothic Monsters

Whatever form they take, monsters personify the strangest and most surreal aspects of nature, and have played important roles in mythology all around the globe. While some monsters may be easily identified by distinctive physical features, others blend in seamlessly with the rest of us, and only show their true colours when it's too late. Monsters can be fearsome beasts of immense power, agents of elemental forces, mysterious rumours from distant shores, or even the man living next door. Whatever the case, there's a monster to suit every theatrical need and dark purpose, as you'll soon see.

The Majestic Dragon

Scales, wings, claws, fire. The imposing shadow of the dragon still holds tremendous power after centuries of intrigue and myth-making. Despite being something of a fearsome creature, the dragon stands for knowledge, intelligence, freedom and power. In its most iconic form, it is depicted as a reptilian creature of enormous physical size, with a body covered in protective scales. It stands proudly on four clawed limbs, balanced by an outstretched tail and two colossal wings similar to those belonging to a bat. Its head is defined by a majestic horned crest, piercing eyes of bold colour and a prominent snarling jaw. And teeth. Lots and lots of very sharp teeth.

Despite such an intimidating appearance, the dragon is a remarkably graceful creature of great poise. Even when caught in the most ferocious of moments, the dragon is irrefutably elegant and majestic, serving as a duel token of order and destruction.

While the archetypal dragon is known for scorching its enemies with fire, it's not too uncommon to find dragons that correspond with other elements such as water or air, commanding these immense forces as they please.

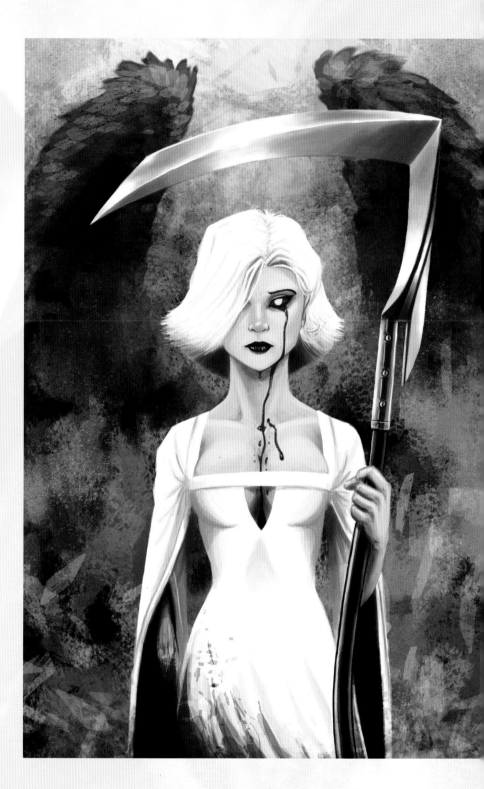

Darker Kinds of Dragon

So how does an imaginary creature differ from genre to genre? Although dragons can appear any way an artist chooses, there are certain formulae that seem to get the right kind of message across. Gothic dragons are generally more visually aggressive than their fantasy counterparts; an added sense of ferocity can be seen in every element of design, such as an elongated tail, enhanced sharpness of the teeth, claws and scales, with wings and crest taking on a sharper, spikier form.

Experimentation with texture can also be a way to add more drama and fearsomeness to a dragon; bodies composed of bones or ethereal smoke can be extremely atmospheric and surprising, for instance. The fierce dragons of Todd Lockwood and Kekai Kotaki are well worth looking into to see what can be done with an age-old monster.

Epic Scenes

The dragons we see in fantasy art often take a leaf out of the books that first popularized them, especially tales of early medieval origin such as *Beowulf* and the victory of Saint George as told in *The Golden Legend*. The dragon traditionally finds itself used as a narrative device designed to highlight a hero's strength and capability: the more fearsome the dragon, the more magnificent the defeat. Scenes of intense battles between stern warriors and tempestuous beasts are still exceptionally popular in fantasy art, especially in the works of the masters of classical fantasy such as Boris Vallejo, Chris Achilléos, Dan Scott and Michael Whelan, and the artists they in turn inspired.

Although scenes of battle are prevalent in Gothic art, the darker side of fantasy tends to focus on the imposing presence of the dragon rather than its defeat. Overall atmosphere and tone may be somewhat heavier and more foreboding than the more whimsical flights of fancy seen in fantasy art. The three-headed dragon *Calastryx* (2011) by Eric Deschamps is a brilliant example of adding a darker flair to dragon battle scenes.

Humanoid Dragons

Human incarnations of the dragon are also extremely popular in fantasy and Gothic art, which finds characters taking on visual traits from their larger and scalier counterparts. With the new-found popularity of franchises like George R.R. Martin's *A Song of Ice and Fire*, there's a strong chance that captivating characters like Daenerys Targaryen may encourage a surge in artwork exploring the cross-species balance of

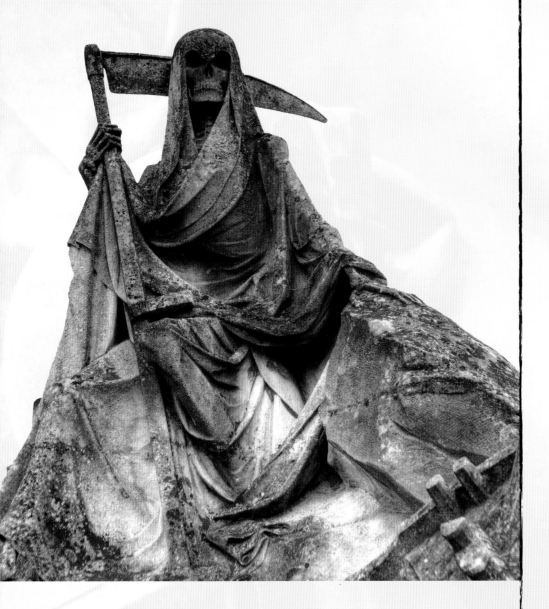

A weathered **Grim Reaper** on a tombstone from a French cemetery.
Medium: stone

The Death by Laura Csajagi
© Laura Csajagi
Digital media: Photoshop
His name is l'Ankou, he helps The Death.
laurart.book.fr

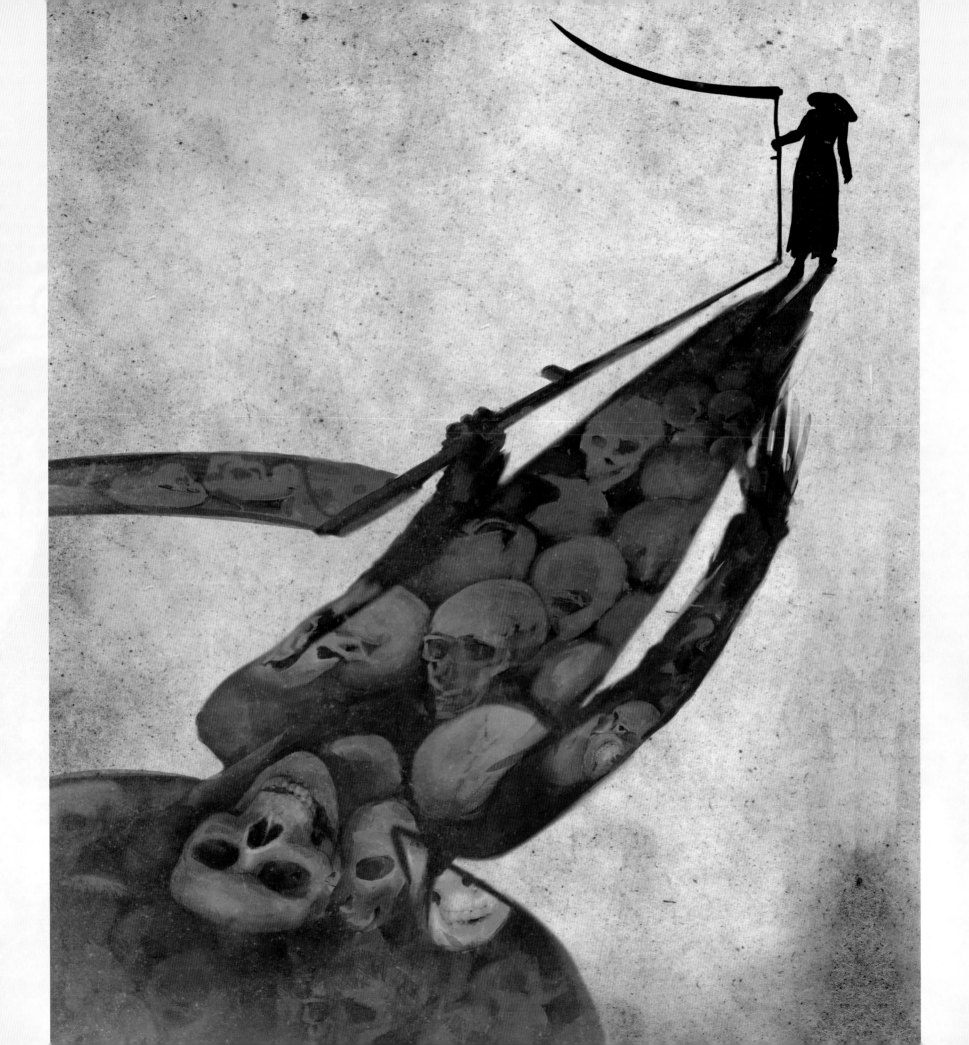

human and beast. Not that this is anything new, of course – there are many incredible pieces of art exploring how both species can become a single form, such as the brilliant *Form of the Dragon* (2010) by Daarken. Similarly, the concept of taming the beast can be a powerful way to juxtapose imagery, as we see in *The Young Dragon Trainer* (1993) by Chris Achilléos, as can the even more surreal concept of otherworldly lovers, as Boris Vallejo suggests in *Dragon Prince* (1984).

Curse of the Werewolf

Along with the dragon, one of the most readily recognizable legendary creatures is the ferocious werewolf. Often bearing some kind of physical semblance to their stolen humanity, the werewolf is a cursed human who finds themself transformed into a wolf-like creature on the night of a full moon.

It's interesting to see that, in Gothic art, no matter how drastic the transformation from human to wolf, the creature rarely loses its human features completely. The werewolf is usually depicted with an unmistakably wolf-like head and tail, and skin laden with thick, dark fur, although many contemporary artists have experimented with merging only the head of a wolf on to a regular human body for a modern twist, such as the sultry *Wolf Girl* (2007) by the photographer Shannon Hourigan.

One of the main features of the curse is the gift of unearthly strength, which means that the upper body is adapted to bear much of the creature's weight; the shoulders broaden and the back arches, limbs elongate and stretch, while enlarged hands and feet claw at whatever falls into its path. The brilliant *Pack Leader* (2011) by *Wizards of the Coast* artist Svetlin Velinov is a great example of how the archetypal elements of the werewolf can be explored in an arresting and dynamic way.

Howl at the Moon

With the moon so closely linked to its mythology, it's no surprise that the werewolf is most commonly illustrated roaming through moonlit wilds. As a result, many artists choose to explore the atmospheric enhancements of midnight colour palettes and deeper shades,

Kiss of Death by Michelle Monique
© Michelle Monique
Digital media: photo manipulation in Photoshop
michellemoniquephoto.com

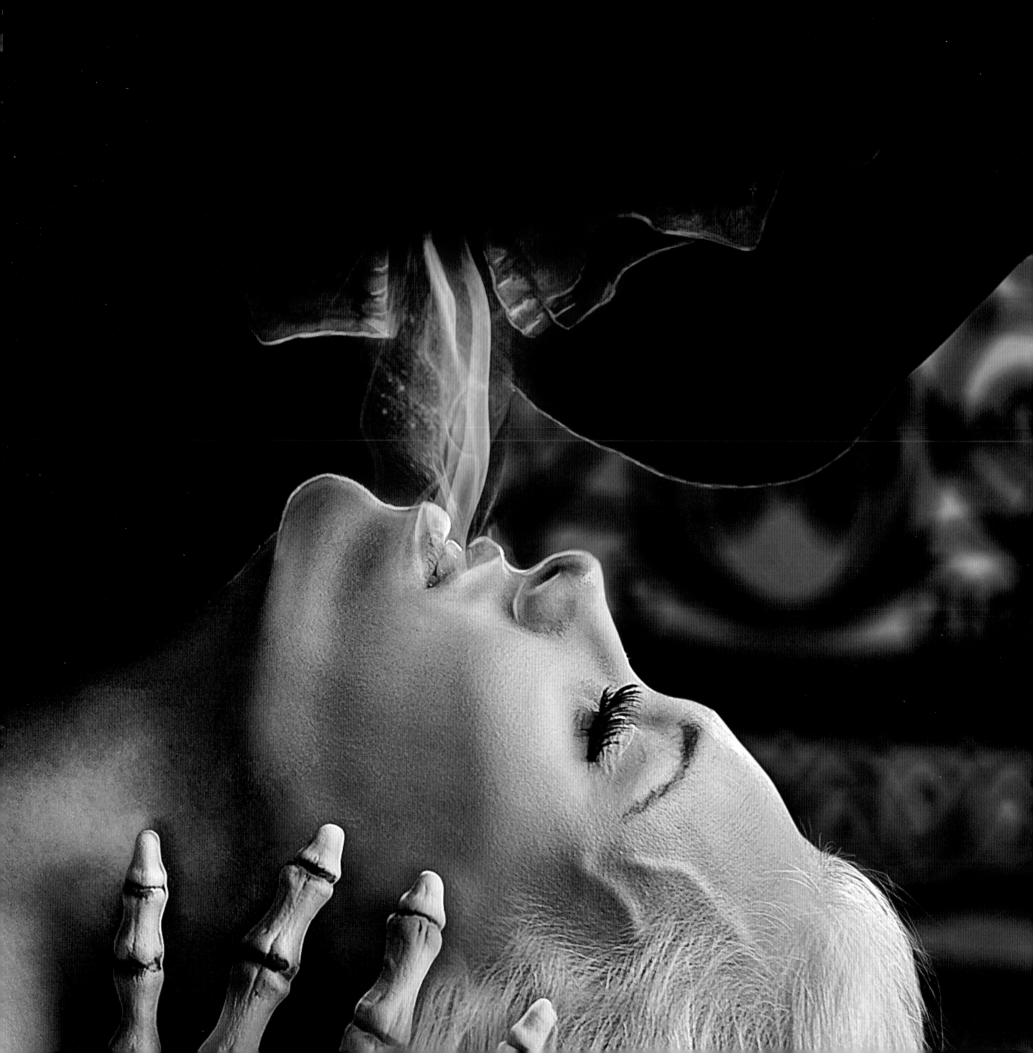

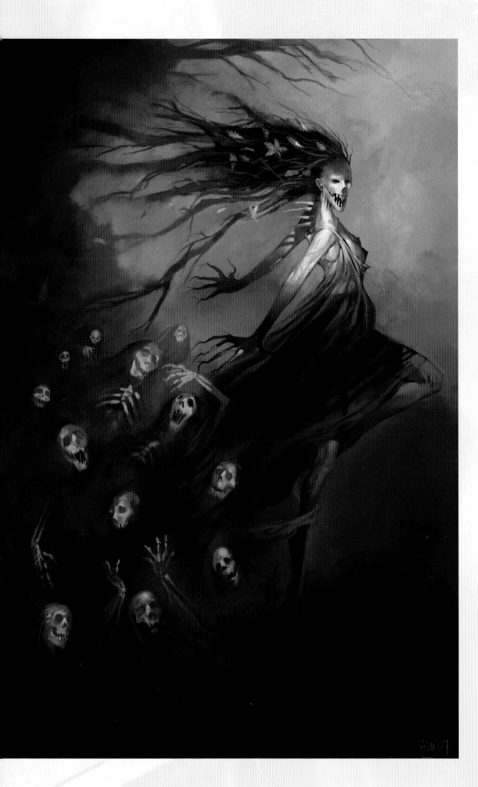

sometimes adding unusual accents to bring out an extra sense of definition or mood. Likewise, the moon often becomes a character in its own right, serving as a silent observer and graceful companion to its beastly acquaintance. Admittedly in Gothic art, the moon often occupies a much larger share of the horizon than it does in reality, but such casual consideration of science can be overlooked when the final result is so visually enticing.

Traumatic Transformation

Another appealing scenario the werewolf can present is the gruelling act of transformation. According to legend, those afflicted with the werewolf curse will involuntarily – and often very violently – transform from a normal human being into a trembling and ravenous beast. When captured in art, scenes often include unnatural physical contortions and displays of extreme discomfort, as we find in David Gaillet's striking and savage *Instinct* (2012). Those looking to try to curb their transformation or the blood lust of their transformed selves may resort to tying themselves up with heavy ropes and chains. For any artist looking to explore an edgier side of the werewolf, the visual implications of bondage of this sort could be quite an interesting place to start.

Werewolves and Fiction

Although tales of werewolves have been popular since ancient Greece, their prominence in the horror genre has been a relatively recent uprising, despite numerous appearances in Victorian Gothic literature and later pulp fiction. It has only really been in the last eighty years or so that the creature has earned the recognition it now commands.

One of the first novels to capture the potential of the legend was the American author Guy Endor's *The Werewolf in Paris* (1933), which heavily inspired Universal's *The Wolf Man* (1941) in terms of both plot and werewolf aesthetics. In turn, *The Wolf Man* has proven to be as important as Endor's influential novel, with Lon Chaney Jr's performance in the title role, his distinctive costume and the cautionary poem recited by nervous villagers all providing additional sources of inspiration for artists of all kinds down the line.

The Soul Catcher by Aly Fell
© Aly Fell
Digital media: Photoshop
A character designed for an online challenge.
darkrising.co.uk

Deathwing by Alex Horley
© 2013 Blizzard Entertainment. All Rights Reserved.
Traditional media: acrylic on canvas, 46 × 61 cm (18 × 24 in)
alexhorleyart.com

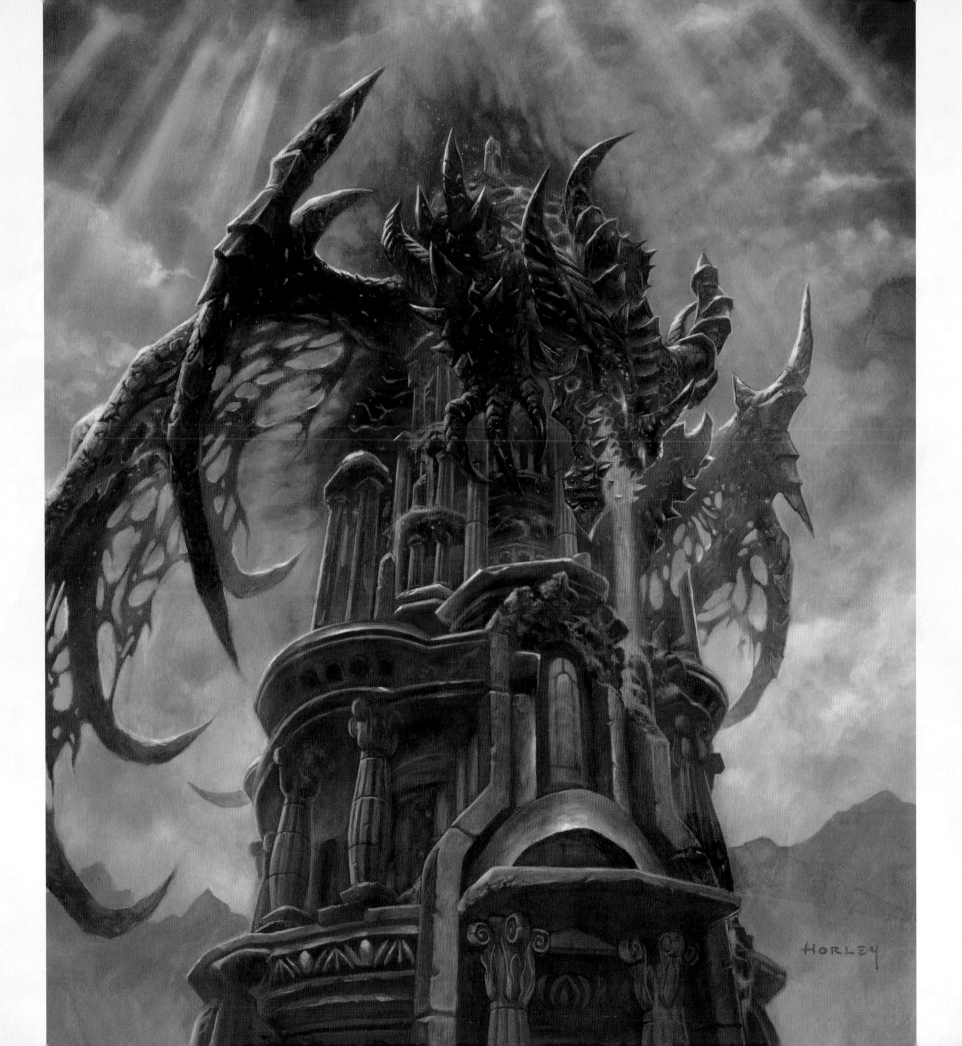

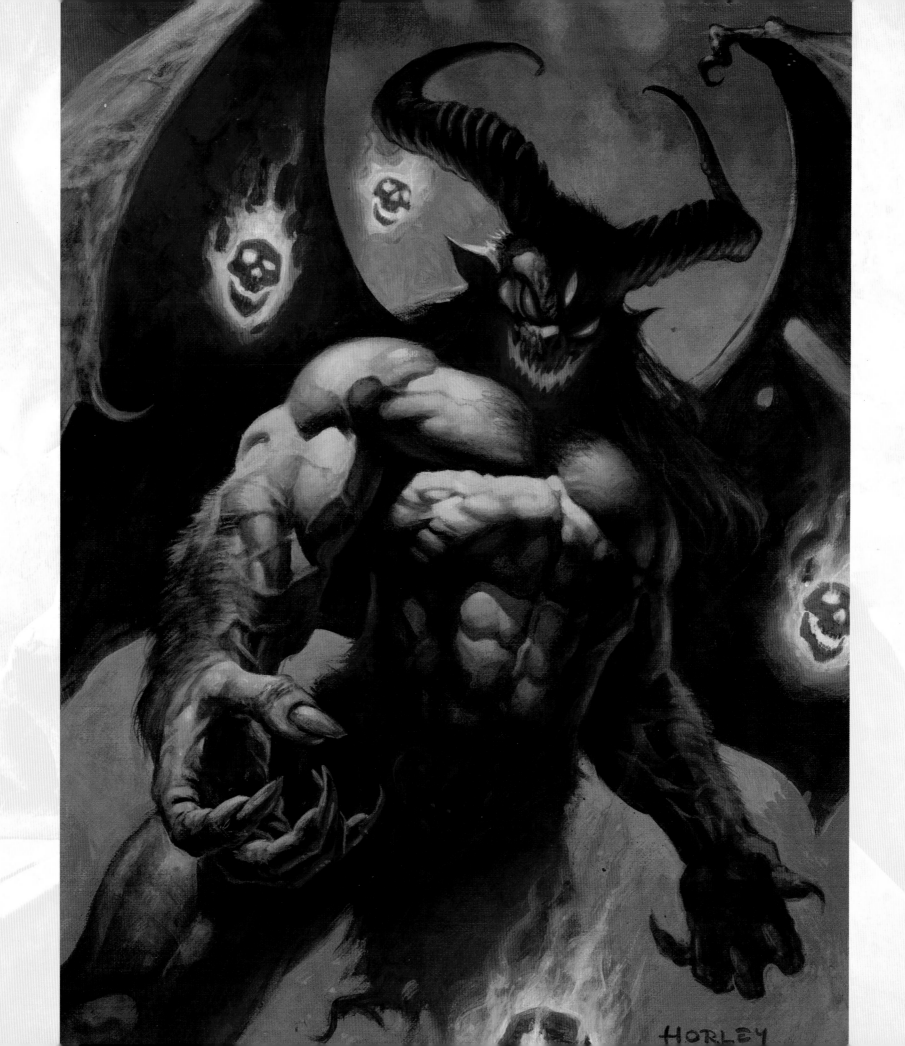

Other notable explorations include Angela Carter's haunting extraction of the Red Riding Hood tale in the beautiful short story *The Company of Wolves* (1979), later adapted into a film of the same name in 1984. The movies *An American Werewolf in London* (1981) and *Ginger Snaps* (2000) also provide compelling accounts of modern werewolves, while Vertigo's beloved *Fables* comic series casts the reformed werewolf Bigby Wolf into a law-abiding sheriff.

Animal Hybrids

Werewolves aren't the only kinds of animal hybrids that make Gothic art so interesting. There are many kinds of mythological entities that were believed to carry both human and animal characteristics, or even possess the ability to shape-shift into any form desired. The appeal of such characters is immeasurable for artists looking to create unique characters with extraordinary visual presence. An image of the human form with various animalistic qualities imaginatively introduced can provide endless fascination, and the freedom to experiment with the relationship of the familiar human form and the sudden contrast of features such as horns, claws and skin texture can lead to some truly haunting pieces of art.

Fauns and Satyrs

Another fascinating creature is the goat-legged faun, also known as a satyr. While the upper half of the figure is broadly human in form, the waist, legs and feet are those of a goat, although horns and animalistic ears are often seen in depictions of these creatures.

The faun possesses many interesting layers of symbolism that are wonderfully suited to the darker side of fantasy. Led by the god Pan, the creature is a powerful symbol of sexuality and trickery, with many Classical myths using it as a cautionary figure in tales about lust and manipulation. The faun is closely tied to the forces of nature, and is often depicted skulking around forests and woods.

The creature has remained in popular imagination from antiquity right up to the present day, with one of the most haunting explorations of its

duel nature in recent years found in Guillermo del Toro's beautiful *Pan's Labyrinth* (2006), which subtly hints at the faun's darker intentions for the hapless heroine Ofelia. Also dabbling with demonic satyrs is Malaysian artist Zeen Chin Jinghui as seen in *The Airish* (2011).

The Demon by Alex Horley
Traditional media: acrylic on paper, 21.5 × 28 cm (8.5 × 11 in)
alexhorleyart.com

Frankenstein by Alex Horley
Traditional media: acrylic on canvas board, 23 × 30.5 cm (9 × 12 in)
alexhorleyart.com

Werewolf Attack by Laura Bevon

© Laura Bevon, 2011; **Digital medium:** Photoshop; Inspired by the 'Are you a werewolf' card game from Thiercelieux; www.black-baccara.fr

Step 1: I always start my illustrations with a loose and quick sketch (whether it's done in traditional or digital), then I take the time to replace all the elements in order to find the best composition possible. Here, I needed to focus on the main werewolf, so I paid special attention to his general shape which needed to be immediately readable and not overwhelmed by the background.

Step 2: When I'm satisfied with the sketch, I start the painting and place my colours loosely, area by area. Here, I added more details to the main character to be sure of my composition choices. I also started to work on the lighting by placing the werewolf between two different light sources in order to make him stand out.

Step 3: Then I did the same with the rest of the illustration, detailing the foreground and the other beasts a bit more. They had to be present but not steal the show from the main character. For that, I mainly focused on the contrasts: light and shadows are smoother than they are on the main werewolf.

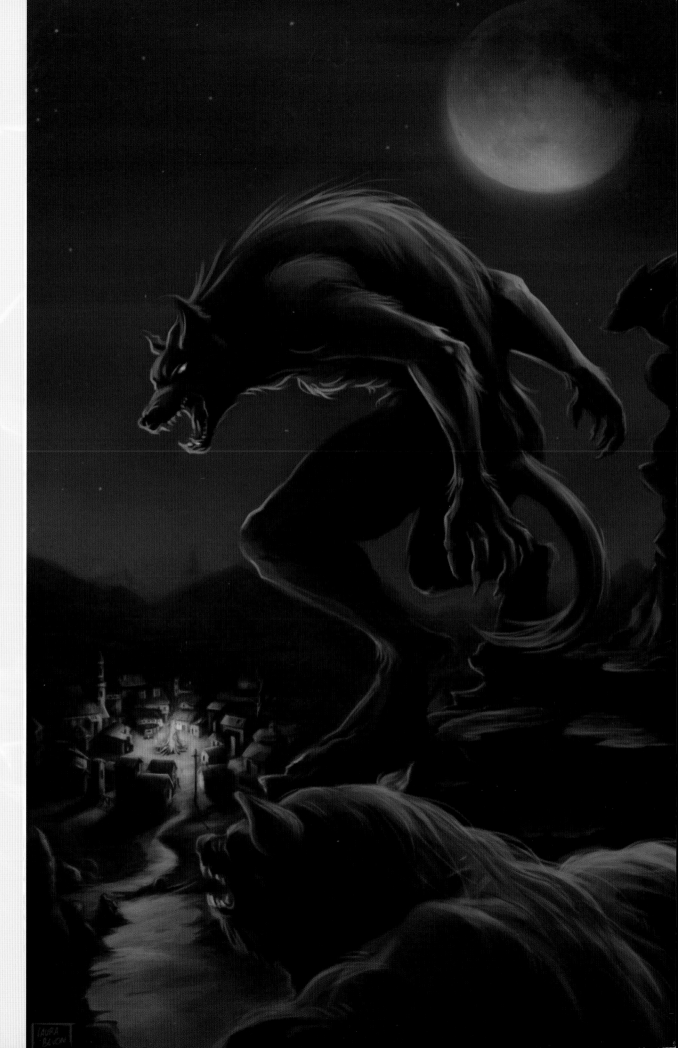

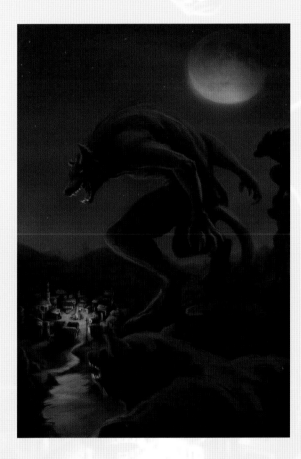

Step 4: When the distribution of light and shadows looks good enough, it's time to work on the details. Most of the time, I start with the most distant scenery and work back to the foreground. Here, the sky and moon were done first, followed by the mountains and the village. I also used some textured brushes in the sky and over the mountains to give them a blurry aspect which, again, allowed the werewolf to stand out.

Finishing Touches: Last but not least, I strengthened all the lighting and worked on the last details in order to finalize the illustration, giving more importance to the foreground (in contrast with the blurry background). The lighting also allows the central werewolf to have a neat and distinguishable shape. He is now ready to rush in to the village.

Bird Hybrids

Some would argue that, despite their grace and beauty, there is something a little bit creepy about birds. Humans have long held a desire to take flight, which may be why there are many mythical creatures that combine elements of humans and birds in order to be able to take to the skies. From the fearsome harpy of Greek mythology to the elegance and poetry of a swan in motion, bird imagery has been used to powerful effect in fantasy artwork, with human characters sprouting wings, feathers, crests and clawed feet. The Gothic bird hybrid is often depicted in a melancholic and brooding state, with feathers and wings worn in a way that enhances and conveys emotion and atmosphere.

Spider Queen Arachne

The ancient Greek myth of how the jealous goddess Athena punished the talented seamstress Arachne by turning her into a spider is a fascinating tale for artists looking to inject a little added Gothic imagery.

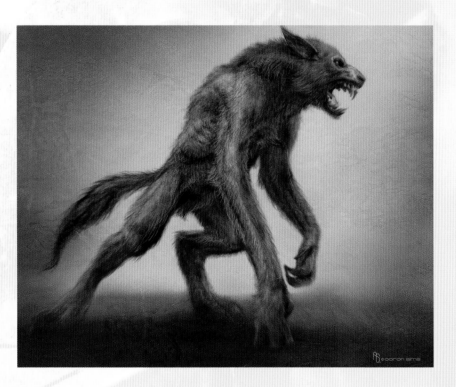

Although the traditional myth suggests that Arachne became a spider, Gothic artists often depict her as a beautiful young woman with a human torso blending into spidery appendages. With cobwebs and spiders already serving as long-standing motifs in Gothic imagery, it's no wonder that Arachne is a popular character to explore, with artists including Justin Sweet and Genzoman putting their own spins on the myth.

The Gorgon

Another immensely popular Greek monster is that of the gorgon, or better yet, the three gorgons – sisters Stheno, Euryale and the infamous Medusa. Centuries after their creation in ancient mythology, the enduring image of tangled hair made from writhing snakes has left an imprint on Western culture, with Medusa especially becoming one of the most recognizable characters in history. Coupled with a stare that turns enemies to stone, the gorgon has fascinated artists from antiquity to the Renaissance and far, far beyond.

One of the most influential visualizations of Medusa can be found in the 1981 film *Clash of the Titans*, with the legendary stop-motion animation models created by Ray Harryhausen. Artists of all disciplines and styles, such as H.R. Giger, Chris Achilléos and John Howe, have succumbed to the lure of the gorgon, conjuring unique ideas of how the creature might look and experimenting with the many different ways she can be reinterpreted.

Nightmare Creatures

Whether drawing from nature or mythology, Gothic art can elevate even the most familiar animals to the realm of nightmares. Animals with nocturnal associations, such as insects, rodents, bats and owls, have long been regarded as symbols of supernatural activity, which means that their visual presence can help add an extra element of mystery to dark imagery. Along with nocturnal creatures, animals with revered majesty and loyalty can also be subverted to appear ominous and otherworldly, especially horses, dogs and cats. When you consider mythical creatures such as Cerberus, guard dog of the Underworld, or the very real and equally terrifying wild wolf, it's easy to understand why certain animals evoke feelings of unease and suspicion.

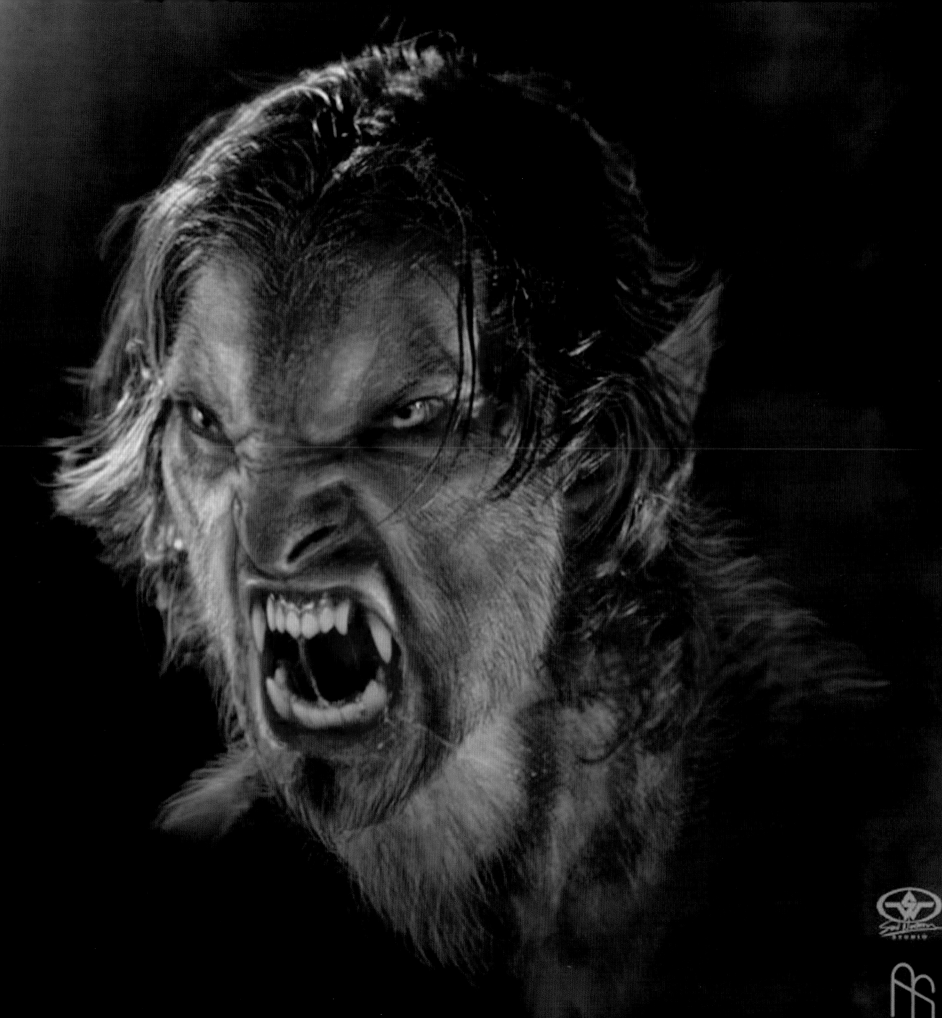

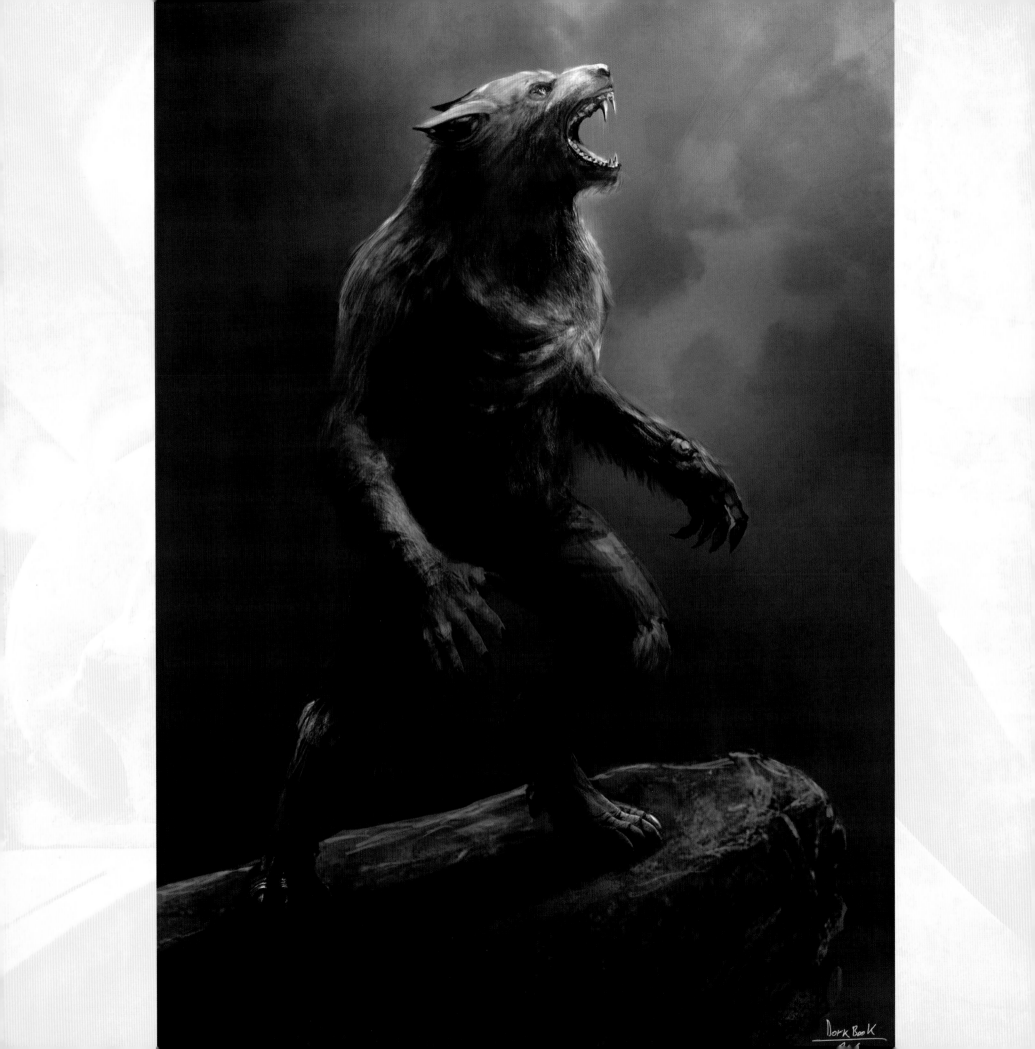

Equally, creatures born from the imagination alone can be the epitome of fearsomeness. These terrifying creations will often make a focal point of heavily distorted facial features, especially through rage-driven eyes and protruding teeth. Skin texture may also become a channel for grotesque imagery, with graphic depictions of unsightly scarring, sinew and tissue, clotted blood and strange growths serving to fascinate and repel the viewer in equal measure.

Strange Folklore

If you've ever wondered why dark twists on fairy tales and folklore are popular in Gothic art, it's because the original tales were often much grimmer than the versions that became popular in the mid-nineteenth century. These more troubled versions have fortunately survived in one form or another, and turning to the original sources for creative inspiration can quickly become an eye-opening experience.

In many ways, darker renditions of beings such as fairies and goblins with magic and mystery featuring heavily in character designs and overall tone are actually truer to their more peculiar natures. Scenes depicting captivity and spiriting away are particularly suited to Gothic art, as we find in Selina Fenech's sinister goblin piece *Stolen in her Sleep* (2006). The duality of supernatural creatures is always a welcome subject for exploration, with the works of the renowned folklore artist Brian Froud being particularly rich in darker undertones and characterization, especially in regard to the contrasting good and bad fairies that regularly appear in his work.

Monsters in Stone

Of the many wonders of medieval Gothic architecture, the sculpted forms of snarling gargoyles are perhaps the features most popularly associated with it. These protective and sometimes playful grotesques, designed specifically for the purpose of scaring away misfortune and ill will, offer endless variety in characterization. A gargoyle could be based on any kind of mythical creature, with demons, griffins and serpents being popular choices throughout medieval Europe.

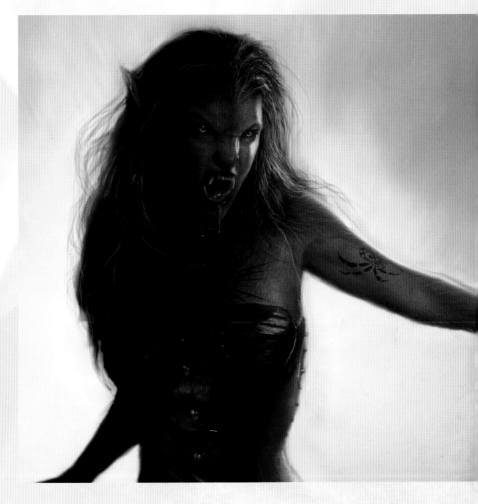

In art and literature, gargoyles are often depicted as sentient beings that have somehow been brought to life, and are characterized by their fierce nature and horrific appearance. The legendary Frank Frazetta typified the terrifying wrath of the creature in his 1970 painting *Gargoyle*, with its heavy contrasts and emphasis on fear paving the way for later Gothic masters such as Brom to carve out their own nightmarish creatures.

Freaks of Nature

The great outdoors can be home to a horde of strange entities and creatures ripe with sinister imagery, with Mother Nature herself often becoming a malevolent force with an appetite for destruction and chaos.

Werewolf by Sergey Zagladko
© Sergey Zagladko
Digital media: Photoshop
lewa-art.blogspot.com

Werewolf 4 by Aaron Sims
© Aaron Sims 2007
Digital media: Photoshop
asc-vfx.com

When representing the power of nature, pagan imagery can be an excellent place to start. If the fruitful and nurturing imagery of figures like the leaf-covered Green Man or the serene Mother Nature is subverted into a more aggressive and barren form, the connotations of such characters can be quite different and unsettling. For example, replacing lush greenery with wilting or dead plant life can emphasize the more unforgiving aspects of the cycle of nature, focusing on death and decay rather than birth and growth.

Similarly, plant life and shrubbery have a long-standing tradition in legend and art of being transformed into carnivorous creatures, with exotic plants like the Venus flytrap becoming beasts of insatiable hunger. It became a particularly popular pulp-fiction motif during the early twentieth century, with enormous grotesque plants sporting incredibly sharp teeth and antennae strong enough to squeeze the life out of their prey. Fantasy artists have applied these qualities to human figures, such as the sultry villainess Poison Ivy in DC Comics' *Batman* series, or the deceptive *Queen Triffidia* (2006) by John Kearney.

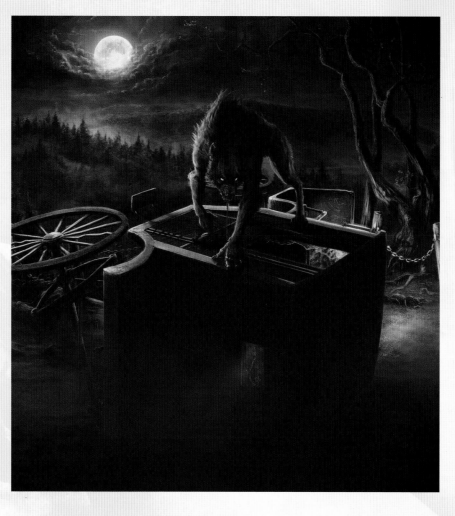

suddenly transform into something unwelcome and frightening. Turning primitive creatures such as worms or single-cell organisms into horror shows of monstrous power is a timeless trick, with artists homing in on unsettling features and textures, multiplying size and recognizable features to create something alien and unknown. Pieces like *Howler* (1996) by Brom, or the bizarre creatures we find in *Magic: The Gathering*, like Steven Belledin's fearsome *Sinew Sliver* (2011) and Raymond Swanland's *Caldera Hellion* (2011), play on the viewer's associations with familiar back-garden critters, elevating the creatures into monstrous titans of untold power.

Creatures of the Sea

Ever since we summoned the courage to set sail across the seas, the mysteries of the ocean have plagued thinkers and artists with wild ideas of the kinds of nightmares that could be lurking in the murky depths. Fascinating creatures such as the demonic Leviathan and the many-headed Hydra serve as grotesque personifications of the unrelenting power of the sea, with more than an undercurrent of domination and destruction.

Sea monsters remain fascinating even to this day, with people being driven by a curiosity and thirst for knowledge about the inhabitants of these last corners of the planet to be explored. What makes the underwater realm so compelling is that, when we find traces of the actual creatures that inspired so many outlandish tales, the link to creatures born from mythology begins to merge with scientific fact.

Creatures Great and Small

When applying Gothic sensibilities to familiar creatures or concepts, one of the more effective ways of achieving a sense of foreboding is to pay close attention to how an otherwise ordinary element could

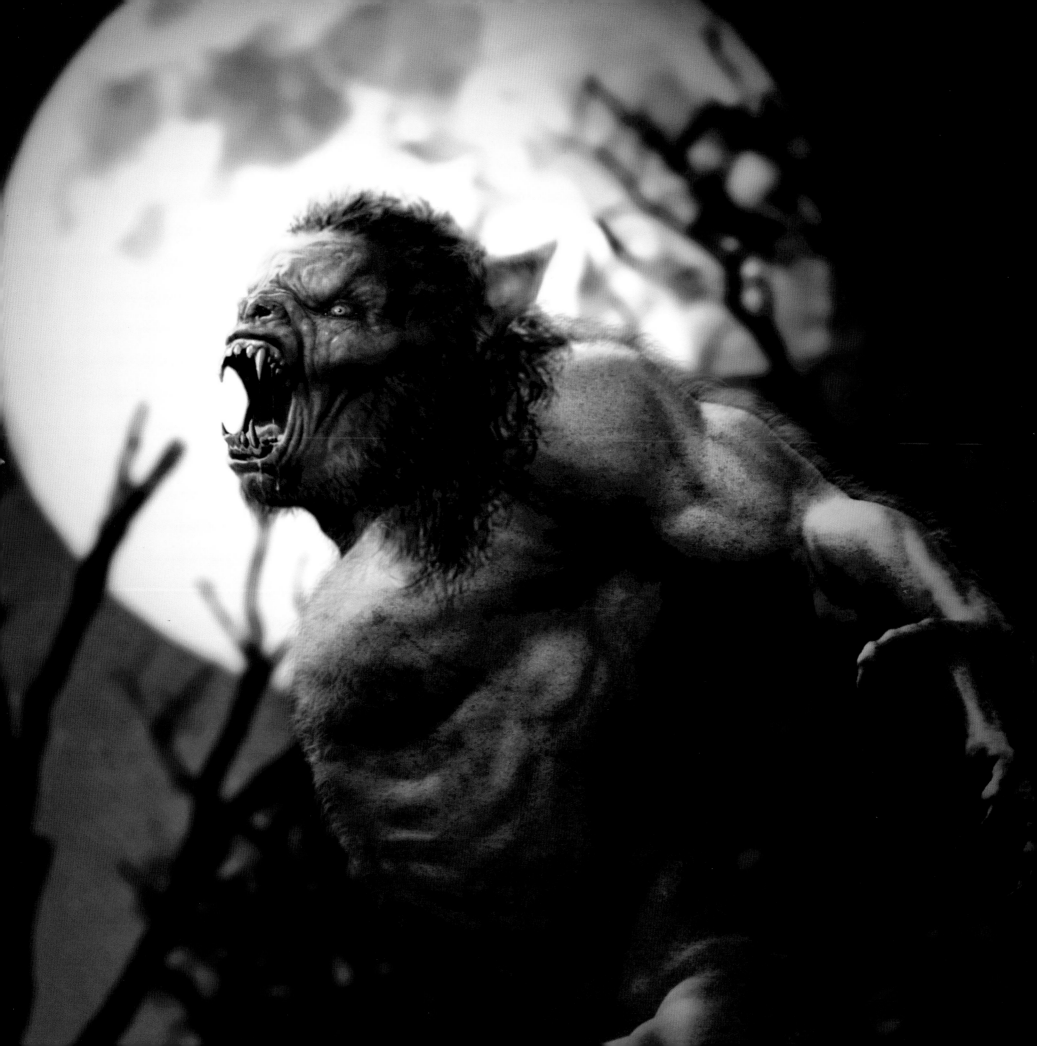

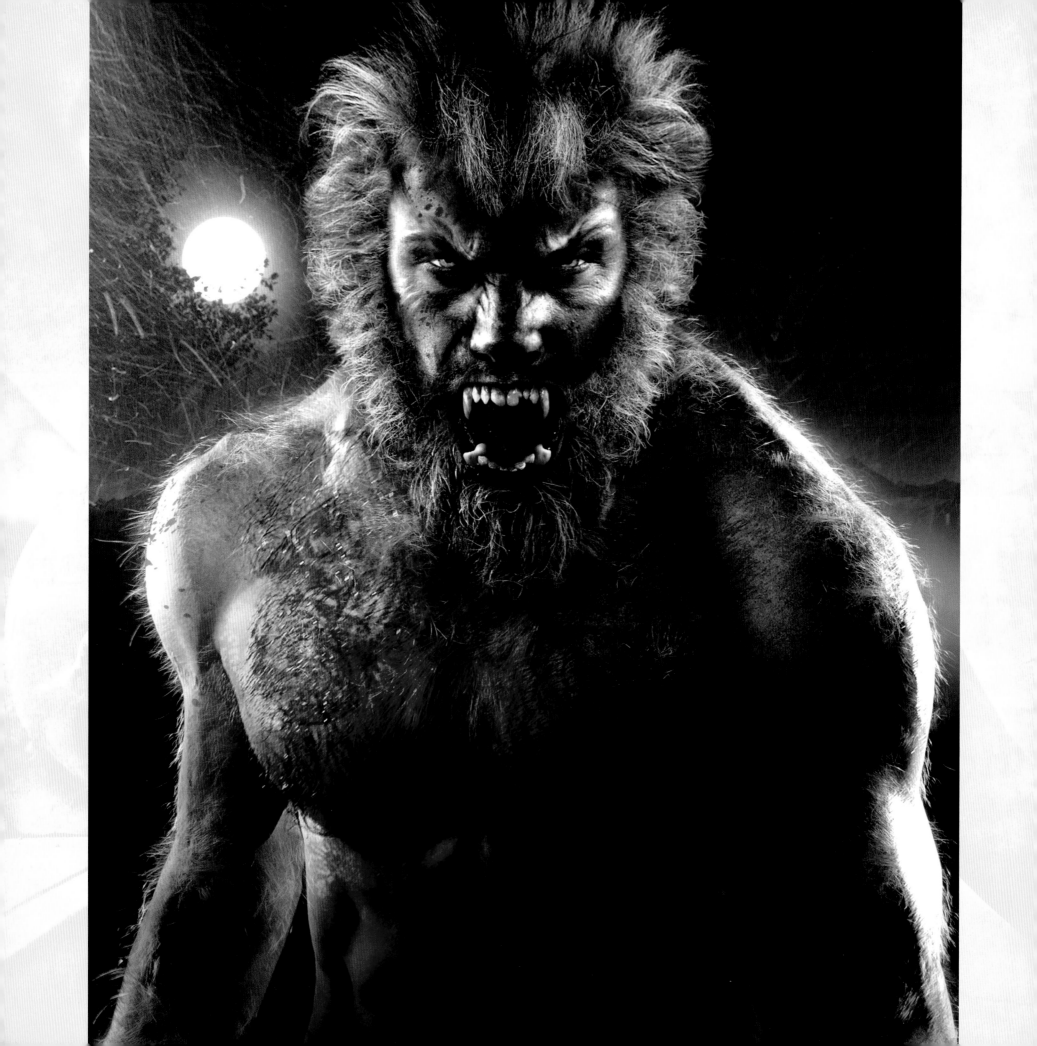

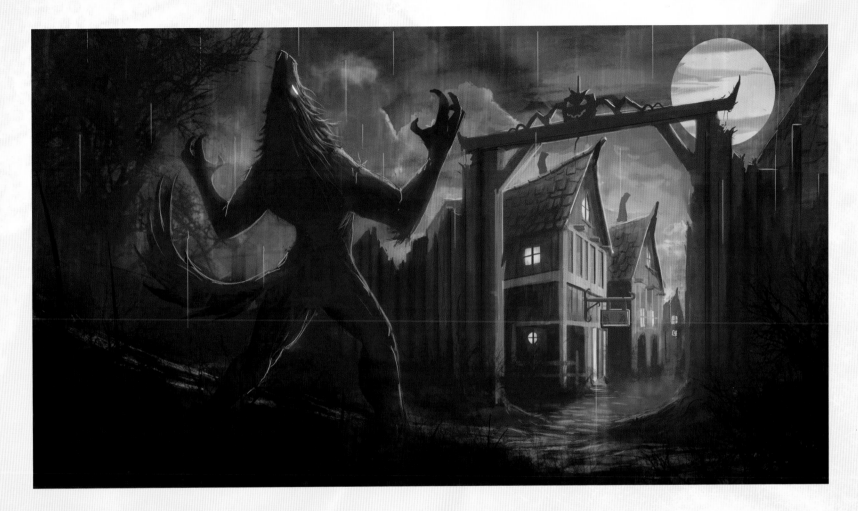

The Kraßen

One such creature is the giant squid, perhaps more commonly recognized as the Kraken. This monstrous beast was believed to be deadly enough to sink even the sturdiest of ships; a scene which Gothic art repeats over and over without ever losing its dramatic appeal. The Kraken has made frequent appearances in literature and film, and was more recently popularized by the ingenious creature designer Ray Harryhausen in *Clash of the Titans* (1981). Peering eyes and gigantic tentacles tend to lead the scene, with the features of a squid sometimes replaced with a more fish-like appearance, as seen in the incredible *Talon of Umberlee* (2011) by Tyler Jacobson.

Lovecraft's Torments of the Sea

The stirring writings of H.P. Lovecraft are widely regarded as some of the most influential additions to the dark fantasy genre, with the Cthulhu mythos providing artists with haunting images of unknowable, eternal beings, many of whom live at the bottom of the ocean. The works of Lovecraft introduce a cast of monstrous beings, from the titular tentacle-faced beast in *The Call of Cthulhu* (1928) to the Deep Ones in *The Shadow Over Innsmouth* (1931), who would regularly mate with humans and demand sacrifice in order to appease their unrelenting gods. The sensibilities explored in Lovecraft's works have spawned the genre of Lovecraftian horror, a style that presents destructive entities as an unstoppable race of immortal beings that hold immeasurable power over mankind.

Wolfman by Joe Roberts © Joe Roberts
Digital media: mixed
Commissioned for a Wolf-Men anthology, using human and animal (such as ape and lion) references to create the humanoid effect.
JoeRoberts.co.uk

Werewolf by Robert Kehl
© Robert Kehl
Digital media: Photoshop
bobkehl.blogspot.com

Toile by Mélanie Delon

© Mélanie Delon, 2010; **Digital media:** Photoshop & Painter; melaniedelon.com

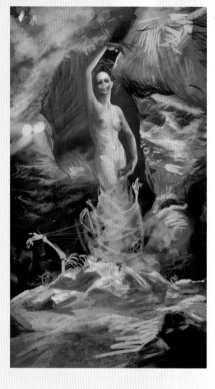
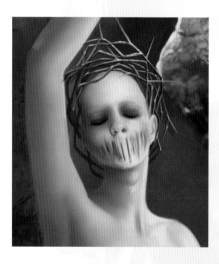
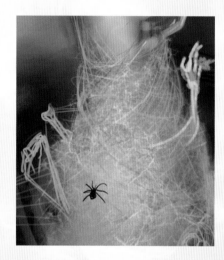

Step 1: First I start with a quick concept, just to find and lay down my basic colour scheme and to find a good composition. I always keep everything simple at first; going into detail too soon is the best way to get lost in a painting. The subject is quite dark and morbid, I want her to be in a sort of chrysalis with a lot of skeletons around her, but I will use a very light and pale colour scheme to create a contrast between the story and the character.

Step 2: Now that I've found my composition, I can start to add some details, like the spider web, the skulls and more stones. I also refine some parts, like the main subject and the cave in the background. I work on the lighting as well, I want it to light up the character mostly; this way the viewer's attention will be attracted here.

Step 3: I will now detail the face. I want her to have a big hole instead of a mouth with some flesh threads, very 'gorey' but without blood, as I still want my character very bright and desaturated. She will also have some scars on her neck and forehead. For this I simply use a basic round brush and slowly add those flesh threads on the jawline; I add some dots of light here and there to increase the skull presence underneath her skin.

Step 4: The textures are really important in this illustration, especially the web chrysalis all around her legs. This is a complex element, so to achieve this effect of several layers of webs I create a custom brush that will speed up the painting process. I use different tones to render the transparency and depth of the element. And to make it more realistic I add extra light on a different layer set on screen mode.

Step 5: To do the stone texture I also create several custom brushes, with which I slowly add texture, layer upon layer. I play with the layer mode in order to add more colour variation and a nice effect to the stones. Then I slightly blur some parts to blend the texture with the element.

Finishing Touches: Now I just have to refine the whole composition, making sure all the elements work well together, and adding the last touches to the general lighting.

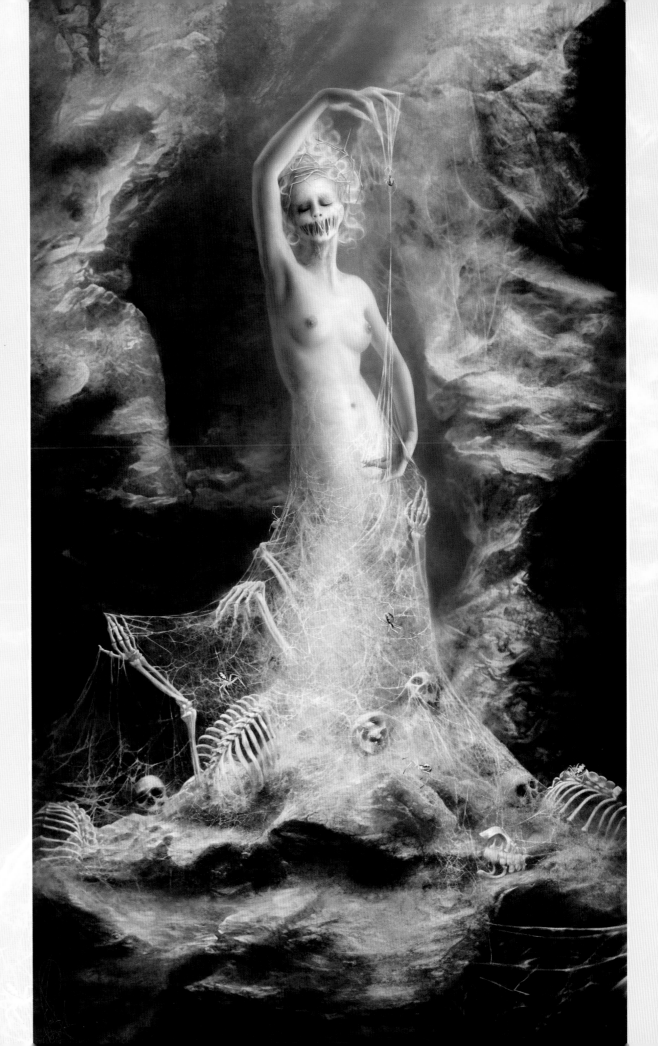

Bas relief of a skull in **Kutna Hora**,
Czech Republic.
Medium: stone

The Lure of the Mermaid

Perhaps in the aftermath of Disney's *The Little Mermaid* (1989), the darker connotations of the mermaid have been somewhat lost. In the original legend, the mermaid was said to be a beautiful maiden who would lure sailors to their deaths by tempting their ships over to rocks, or by dragging them into the sea in one everlasting embrace. The archetypal mermaid is believed to take the shape of a young woman who appears human down to the waist, where legs are replaced by a tail similar to that of a fish or a dolphin. Departing from the vibrant mermaid works of traditional fantasy, sinister mermaids often make striking use of muted colour schemes and starker contrasts, giving an almost ghostly quality to the character.

Subtle Danger

In terms of style, many pieces take an influence from the 1900 painting *Mermaid* by John William Waterhouse, with the soft curvature of the mermaid's body and fish tail serving as a seductive contrast to the hard, rock-strewn world around her – an interesting way of tricking the viewer into finding her world more appealing than ours, therefore falling into her trap.

Much like the vampire, the mermaid can be deployed as a powerful character to evoke the conflicting concepts of beauty and danger. In Gothic artwork, the artist frequently places the emphasis on the creature's attractive qualities in order to divert attention from a lurking and sinister subtext. A mermaid may be posed with objects that reveal her true nature, such as skulls, shipwrecks or even the bodies of her drowned victims. Symbolic elements, such as reflective pearls and mirrors, often hint at the creature's deceptive qualities, with tempestuous fog-laden environments further suggesting a sense of impending doom.

The Siren

Those poor sailors really do have their share of peril. As if the lure of the mermaid wasn't enough, there are still more creatures of the sea that rely on the powers of their sexuality to tempt sailors to their deaths. The

Medusa by Rob Shields
© Rob Shields Illustration
Digital media: Photoshop
robshields.net

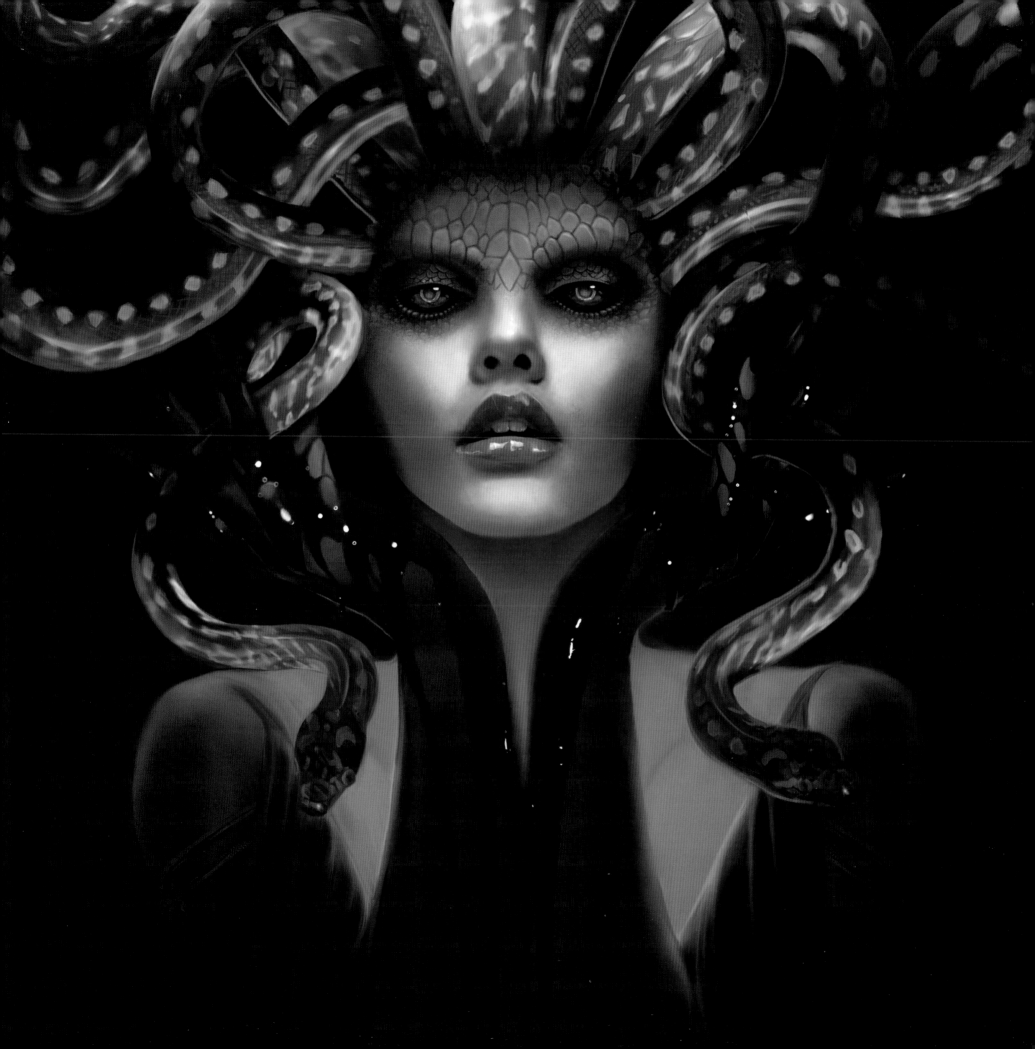

siren is another such creature, who lures unfortunate sailors closer to the rocks with the power of music and song. In Classical art, the siren often appears as a beautiful young woman sitting amongst rocks and caverns, often playing a harp or singing to the sea. Greek mythology traditionally described the siren as also possessing feathers or scales along with bird-like wings and legs, although many modern artists choose to emphasize her alluring human qualities and the pulling power of music. *Lost Note* (1998) by Brom is a beautiful example of how the creature translates into Gothic art, with a myriad of subtle signs indicating that this graceful musician is not entirely as she seems.

The Timid Selkie

A further variant is the selkie, a creature associated with Britannic folklore that could transform from a seal into a beautiful woman (or , in some tales, man). Unlike the mermaid or siren, the selkie is a more timid and melancholic figure, who tends not to harm the humans she comes into contact with. She has a strong potential for romanticism, often taking on a softer and more ethereal appearance than the more fearsome temptresses of the sea, as depicted in Selina Fenech's *Selkie* (2012), sharing similarities in fur and skin markings with her seal friends.

Man-made Monsters

Then of course come the monsters made by man's own hand; creations summoned from the sinister reaches of the human imagination when an all-conquering fiend of unimaginably destructive power and vengeful intent is called for. The most iconic of all man-made abominations is the tragic monster created by Victor Frankenstein in Mary Shelley's seminal Gothic novel *Frankenstein* (1818). Built from the body parts of the recently deceased, Victor's monster refers to himself as Adam, in reference to the Christian creation story of Adam and Eve. Shelley describes him as a towering figure with an immediate and unsettling appearance, a look that became epitomized by Boris Karloff in Universal's classic film adaptation of the novel in 1931. While Karloff's iconic features solidified the look of the monster, many artists have added their own embellishments to the tale, such as Boris Vallejo's dishevelled and decidedly human-like *Frankenstein* (1993).

Swamp King by Candra
© Candra
Digital media: Photoshop
candra.deviantart.com

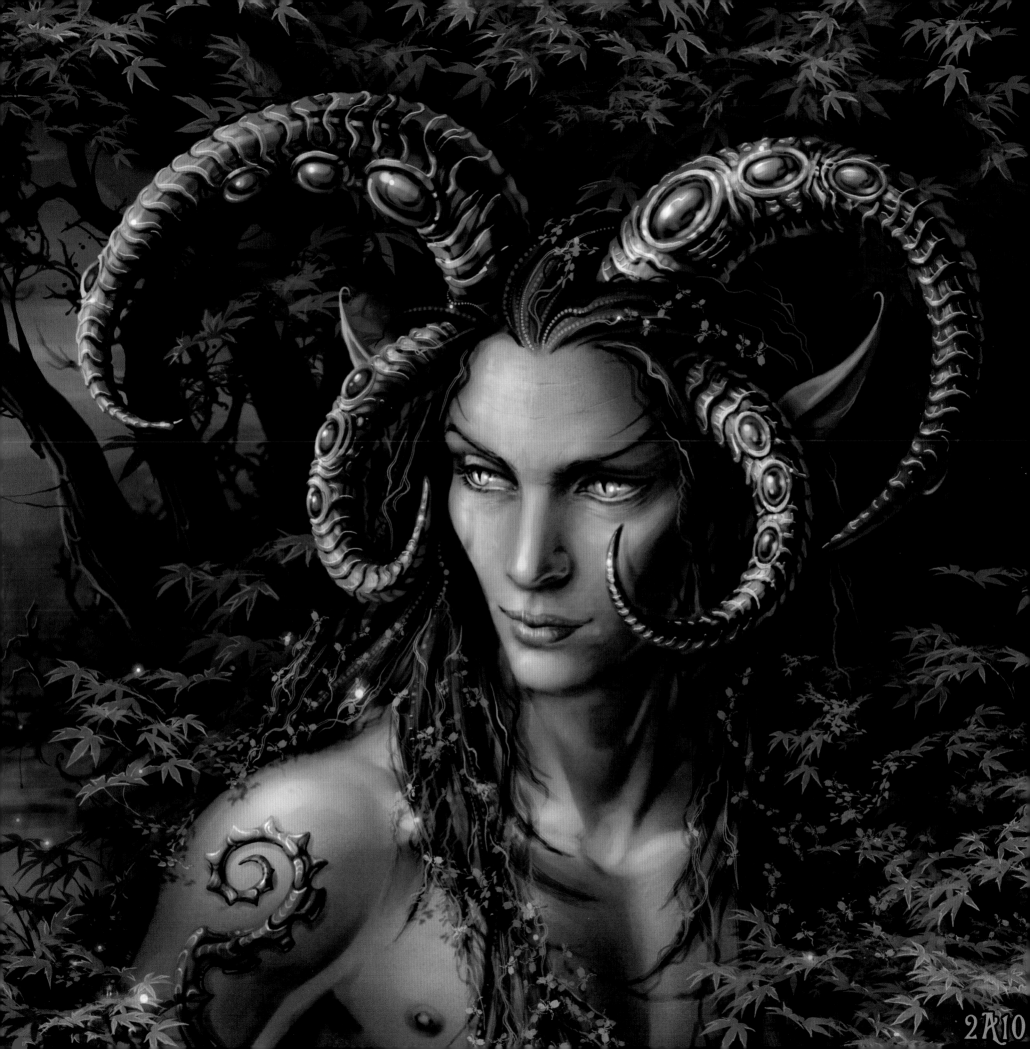

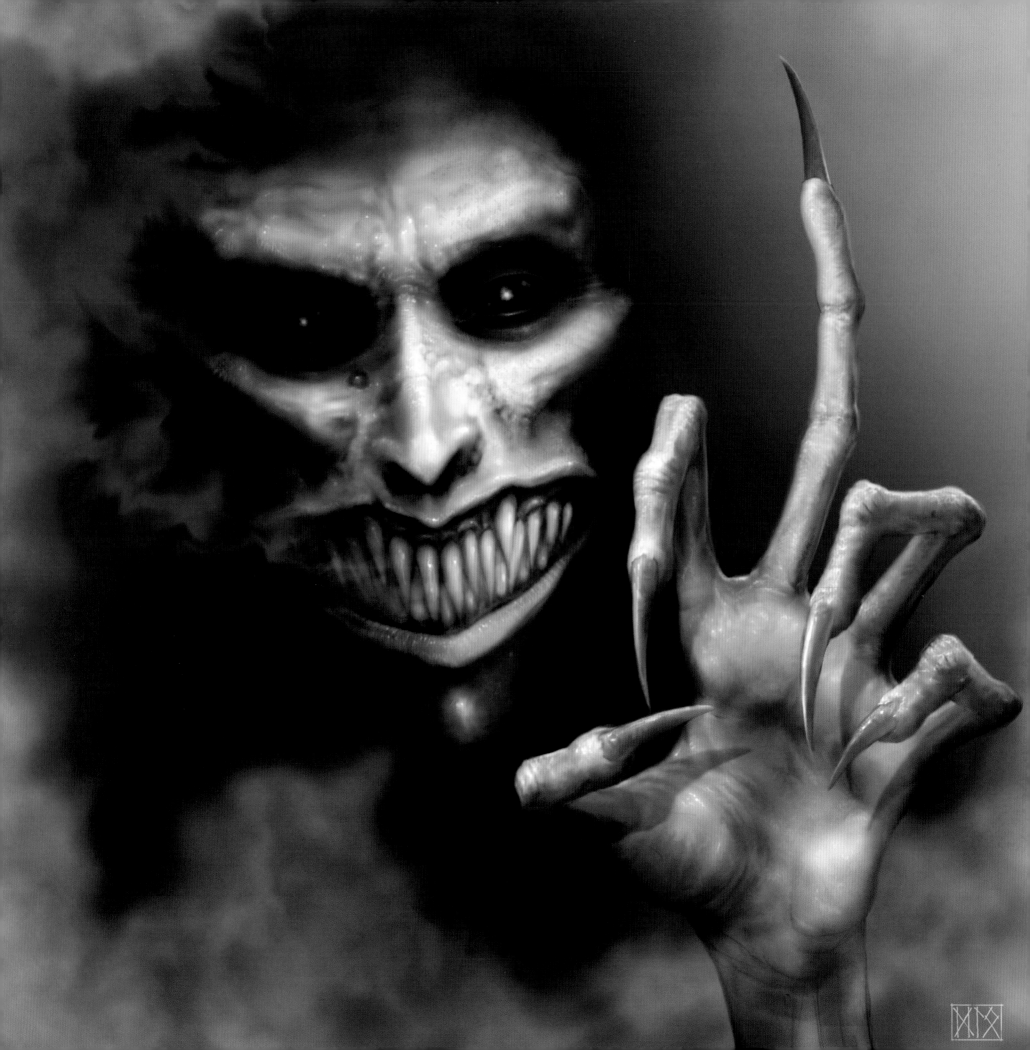

The Lasting Impressions of Frankenstein

What makes Shelley's creation so enduring is that he is the result of man's vain desire to play with powers beyond his control. After attaining his goal of creating sentient life, Victor becomes appalled by his achievement and tries to destroy what he gave life to, prompting his monster to rebel against his master as he fights to survive. The novel ponders the true nature of monstrosity, posing the question of where the real responsibility lies for the ensuing chaos.

Along with Shelley's original creation, the concept of a mate with whom the creature can share his troubled existence has been as inspirational as the original tale itself. Four years after its original Frankenstein venture, Universal Pictures released *The Bride of Frankenstein* (1935), a film that explored the possibilities of this dark romance while delving deeper into the monster's humanity.

Originally played by Elsa Lanchester, the bride's distinctive style combines the worlds of Gothic horror and science, with the bride bearing unnaturally pale skin, dark lips and lightning-infused hair. Artists remain fascinated with the concept of the deathly bride, with many creating their own takes on Lanchester's distinctive costume or creating entirely new visions, as is the case with the supremely beautiful work of the illustrator Anne Yvonne Gilbert.

Organic Robots

Although not strictly monsters per se, figures created with the sole intention of carrying out men's wishes could easily be recast as bizarre and unsettling beings if a little Gothic sensibility is applied. One such myth that really seems to cry out for a Gothic makeover is the legend of Pygmalion and Galatea. After dismissing the virtues of mortal women, Pygmalion creates a statue that captures his own ideas of beauty. The gods eventually take pity on his devotion to his ivory idol, and transform his statue from an inanimate object into a living, breathing woman. When you consider the ways that the myth could be re-examined to highlight themes of submission, domination and fulfilment of desire, the tale could take a very dark turn indeed – especially if the tables are turned, as they are in Angela Carter's Gothic

short story *The Loves of Lady Purple* (1974). Similarly, the alchemical pursuit of creating a homunculus, a miniature human being that grows inside a test tube, could also be twisted in a strange way to highlight the eternal desire to create and control life.

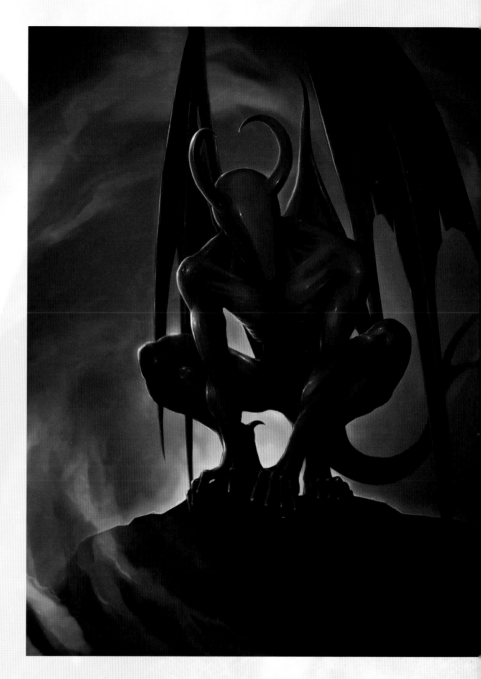

Cold Ned by Dave Oliver
© Dave Oliver
'Eyes like faint cold stars / His face, a blade / A smile of needles from ear to ear / Hands like great pale spiders…'
Digital media: Photoshop
dloliver.deviantart.com

Nightgaunt by Dave Oliver
© Dave Oliver
Based on one of the dark imaginings of H.P. Lovecraft.
Digital media: Photoshop
dloliver.deviantart.com

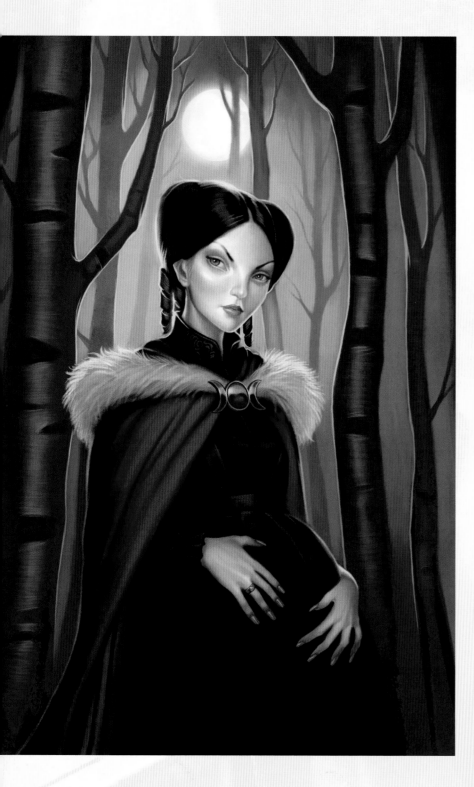

Quirky Gothic

It may come as a surprise to many that for something to be classed as Gothic, it doesn't necessarily have to follow a set aesthetic. It all comes back to the importance of contrast. Gothic art can be bold and colourful, and yet retain an air of melancholy and mystery, of foreboding and sadness. Many of the best contemporary artists choose to focus on these core principles of the Gothic tradition, veering away from its historical and literature-laden roots and towards a more stylized direction. The results are often playful, experimental and unique. It's like playing dress-up along a theme while simultaneously becoming its very essence.

In many ways, the interplay between mainstream and counter-culture movements is due to a large degree to the diversity that is found in dark fantasy. The genre has expanded far beyond its founding visual identity, finding its way to many new and exciting artists who reinterpret its meanings, history and boundaries in a limitless number of ways.

Tim Burton: King of Quirk

As soon as the wonderfully deranged dark comedy *Beetlejuice* graced cinema screens in 1988, the world became aware that rising director Tim Burton had an uncanny ability to disrupt the harmony of suburban America with a little Gothic mischief, uniting the clashing worlds of serene reality and supernatural mayhem.

Not only did *Beetlejuice* feature a ghostly couple struggling to cope with spectral life, a mischievous demon for hire and a young Goth girl trying to find her place in the world, it also demonstrated Burton's fascination with adding dark twists to everyday life, albeit in a more comical than grisly fashion. The movie also introduced the key visual themes that would eventually become synonymous with Burton's work: candy stripes, bold shapes, vivid colours, elaborate costumes, mad hair, strange creatures and eccentric characters.

Red by Aly Fell
© Aly Fell
Digital media: Photoshop
A stylized twist on Red Riding Hood.
darkrising.co.uk

Boogeyman by Yefim Kligerman
© Yefim Kligerman
Digital media: Photoshop
yefimconcept.com

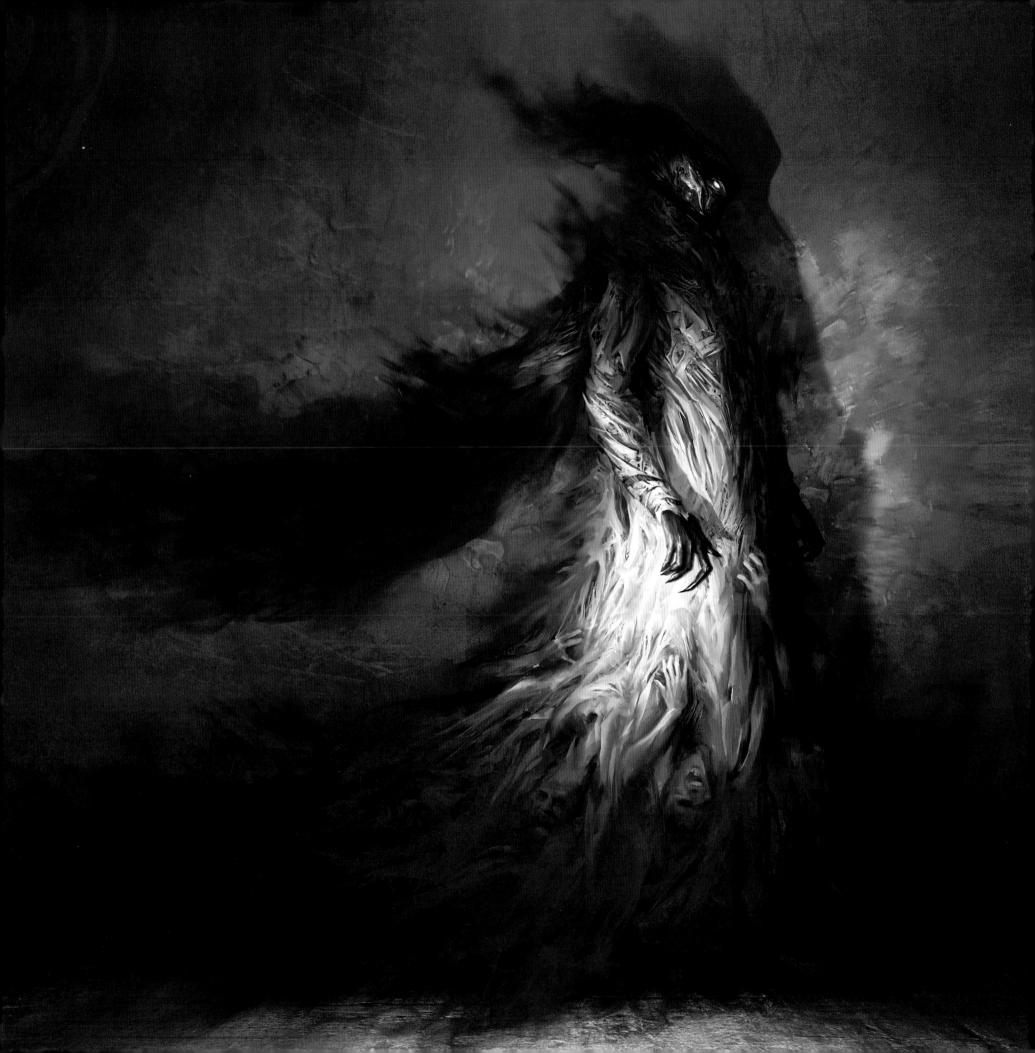

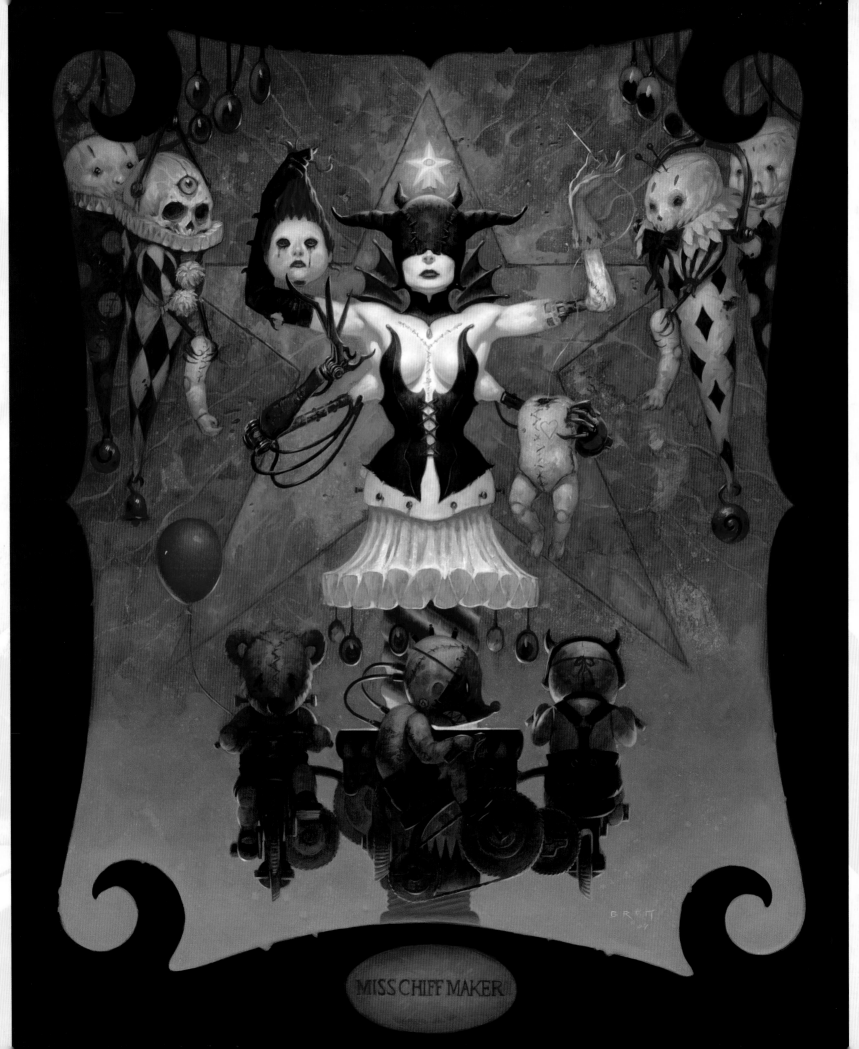

MISS CHIFF MAKER

Burton's Defining Moments

Since the days of *Beetlejuice*, the creative works of Burton have had much to do with the Gothic tradition filtering into mainstream culture, especially during the 1990s. That decade saw the sublime urban fairy tale *Edward Scissorhands* (1990), the inventive and charming stop-motion animation *The Nightmare Before Christmas* (1993) and the gruesome adaptation of Washington Irving's *Sleepy Hollow* (1999). What all three of these have in common is that the visual design plays as important a role as the leading actors themselves.

Like all pioneers, the imaginative creations of Tim Burton have inspired many artists and fellow film-makers to tread on similar ground, stylistically and thematically. When you consider the fact that the grimacing face of Jack Skellington is now as widely recognizable as more commercial characters such as Mario or Felix the Cat, you have to admit that's a pretty impressive feat for the skeletal king of Halloweentown. In the aftermath of *The Nightmare Before Christmas*, a company of oddball characters were inspired and given the confidence to take something grim and turn it into something cute.

Tara McPherson: Queen of Pop Goth

If Tim Burton is the king of the quirky Gothic style, then Tara McPherson is most definitely its illustrious and all-powerful queen. McPherson's distinctive illustrative style often focuses the viewer's attention on the captivating storytelling abilities of the eyes, with relationships frequently an overriding theme. What makes McPherson's artwork so hypnotic is the effortless merging of genres: behind the vibrant colours and clean style, there's a real dark heart of angst and torment, with dramas of the heart just waiting to be told. Much of her work plays on the conflicting signals of surface meaning and hidden subtext, sometimes even taking a more literal form, as we see in the *Fractal Lake* series (2009).

Another aspect of McPherson's work that really stands out is the examination of the modern Gothic female, who often appears as an odd yet familiar figure. Many of her paintings feature female characters depicted in some recognizably emotional state, with hearts and the

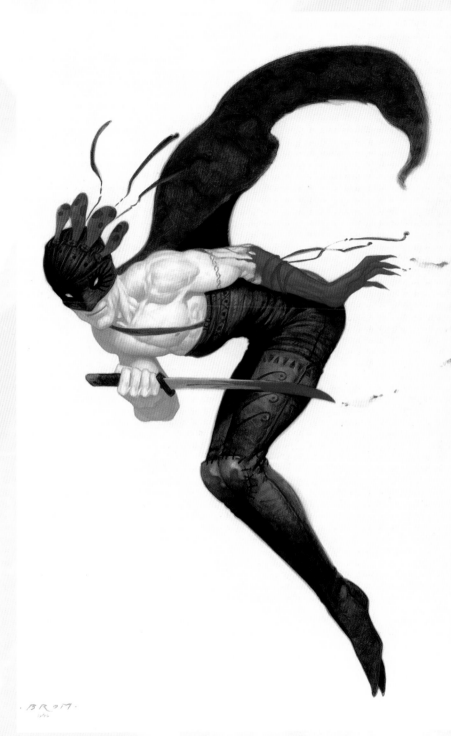

Miss Chiff Maker by Brom
© Brom
Traditional medium: oils
bromart.com

Blood Ritual by Brom
© Brom
Traditional medium: oils
bromart.com

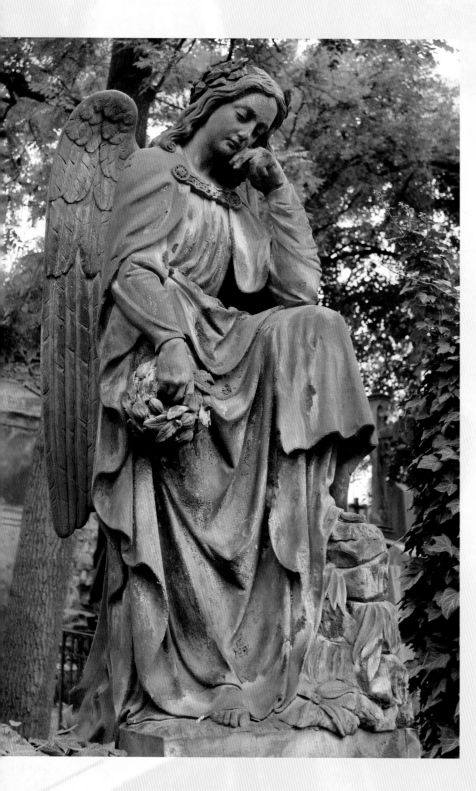

female form itself often playing a vital role in the story being told. There's a distinctive feminist quality to her work, with many of her nude figures expressing themes of honesty and self-reflection rather than sex appeal.

A Bold New Form

What unites the creative approach and style of the likes of Tim Burton and Tara McPherson is an evolution of Gothic aesthetics, which is the result of a very careful and calculated selection process. Along with the elaborate style of artwork that is synonymous with the genre, modern innovators have encouraged a new generation of artists to create highly stylized works that encompass the narrative and dramatic nature of the Gothic tradition and distil it further to capture its essential features: tone, mood, meaning and power. Once these areas have been addressed, an artist can apply these themes to any kind of visual style, whether abstract, cartoony or realistic. It may be a world away from the archetypes depicted by artists such as Brom, but the fundamental identity remains the same.

Sweet and Scary

By keeping tight hold of the core Gothic principles of contrast and atmosphere, artists can create highly stylized characters that can combine the cute and the whimsical with darker subtexts and connotations. Often dressed up in a fashion that could easily be suited to children's books, artists following this approach often depict characters who express a certain air of melancholy, even though they may be rendered in a clean style or with bold and bright colouring. Artists such as Andrzej Kuziola and Lola make powerful use of disguised darkness, with haunting pieces such as Kuziola's *Having a Meal: A Conversation with God* (2010) and Lola's *Luminous Edge of Beginnings* (2008) illustrating provocative concepts under the brightly coloured guise of sweetness and charm.

Artwork created in such a stylistic way may often veer into the illustrative forms popularized in animation, favouring a more cartoon-like appearance with exaggerated anatomical features and precise facial expressions. In order to convey deeper senses of emotion, artists will often create characters who channel their appeal through their eyes, hair and costume.

An angel in a **Prague cemetery**, Czech Republic.
Medium: stone

Redd Wing by Brom
© Brom
Traditional medium: oils
bromart.com

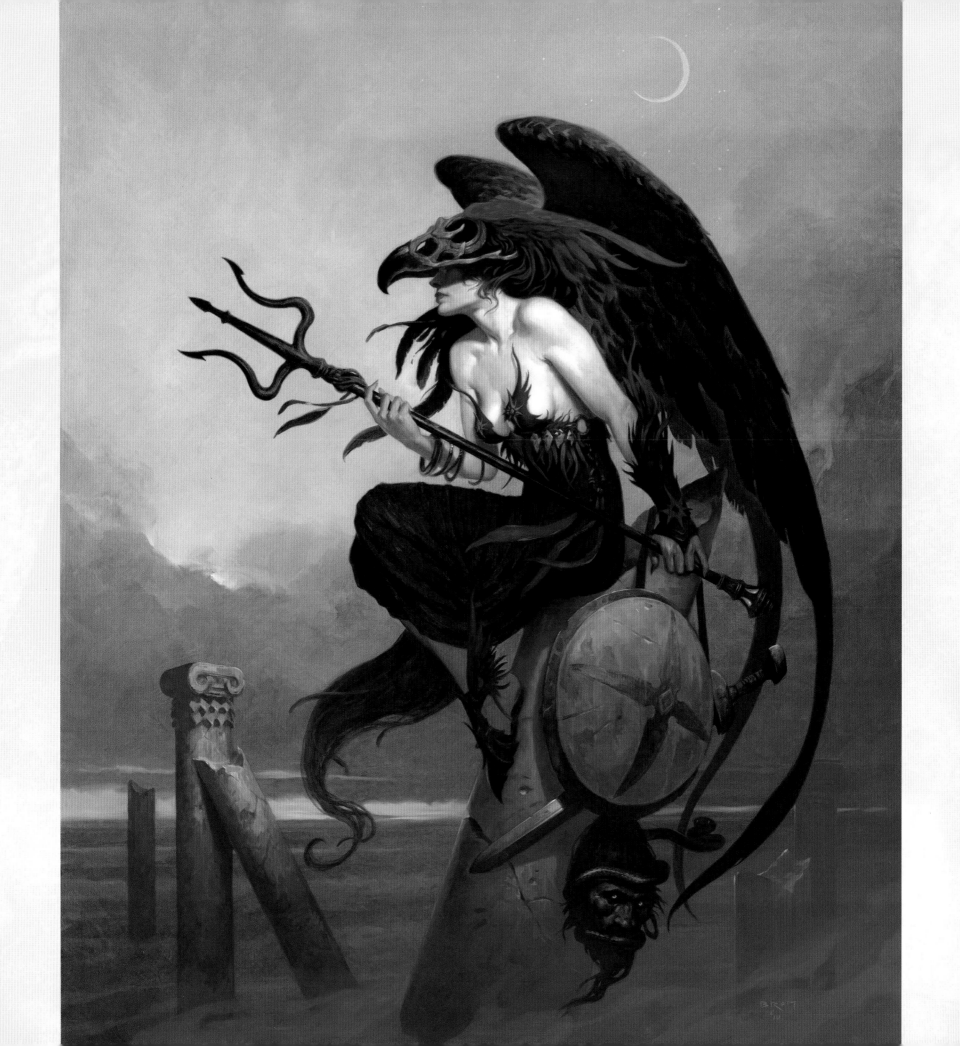

Sweet Death Like Poison by Ana Cruz

© Ana Cruz Arts; **Digital media:** Photoshop, using photographic collage, 3D and rendered elements, and full digital painting; anacruzarts.com

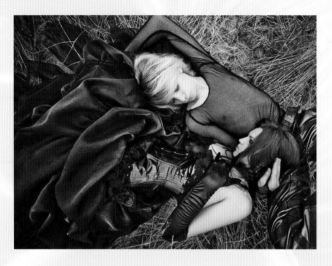

Step 1: I studied the original image for some minutes: thinking about the angle, light sources, if my ideas would work on that original image… (Sometimes I get some last-minute ideas for changes, right before starting the artwork itself.)

Step 2: Then, I changed the original tones into blue tones.

Step 3: For the next step, with a soft brush, I painted some light blue highlights in all the hotspots, focusing on the original light sources, and I also painted tears and some make-up on both models.

Step 4: Next, I applied a green filter all over the grass area and I added some vines and roses, as well as the bottom shadows and highlights.

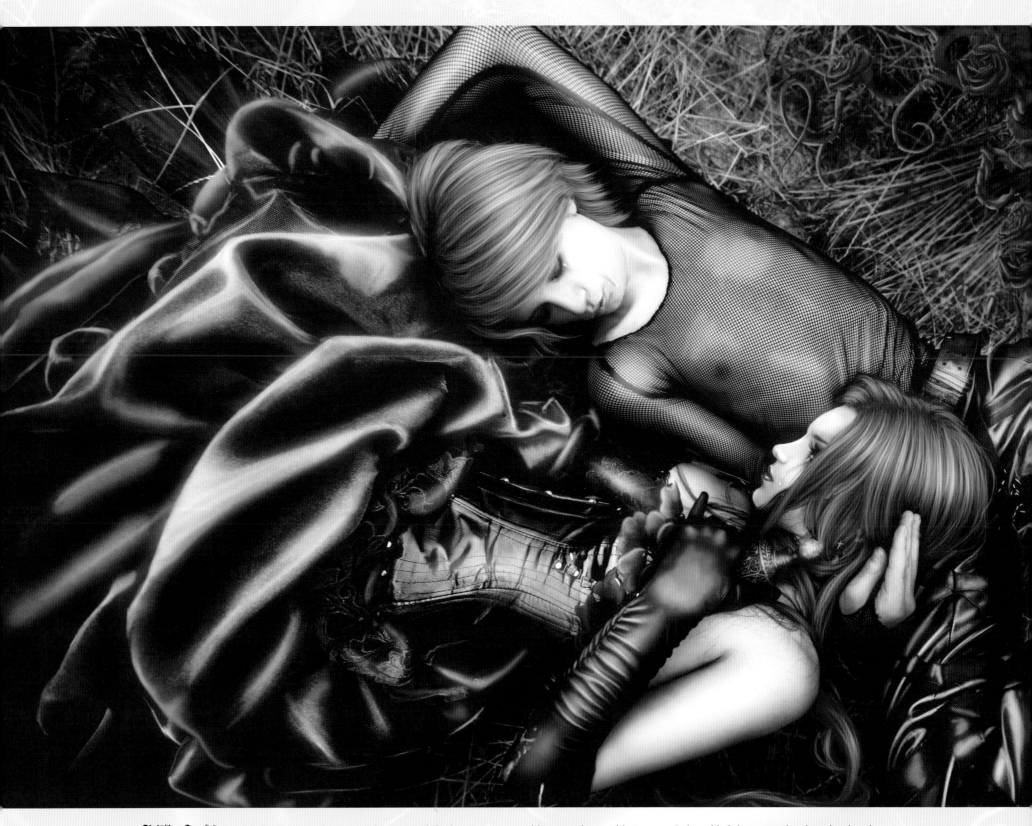

Finishing Touches: For the final stages of my artwork, I painted the hair, using several layers and several hair tones; I also added the poison bottle in her hand. For the final step, I just added a soft texture to harmonize the whole scene and I adjusted the overall tones.

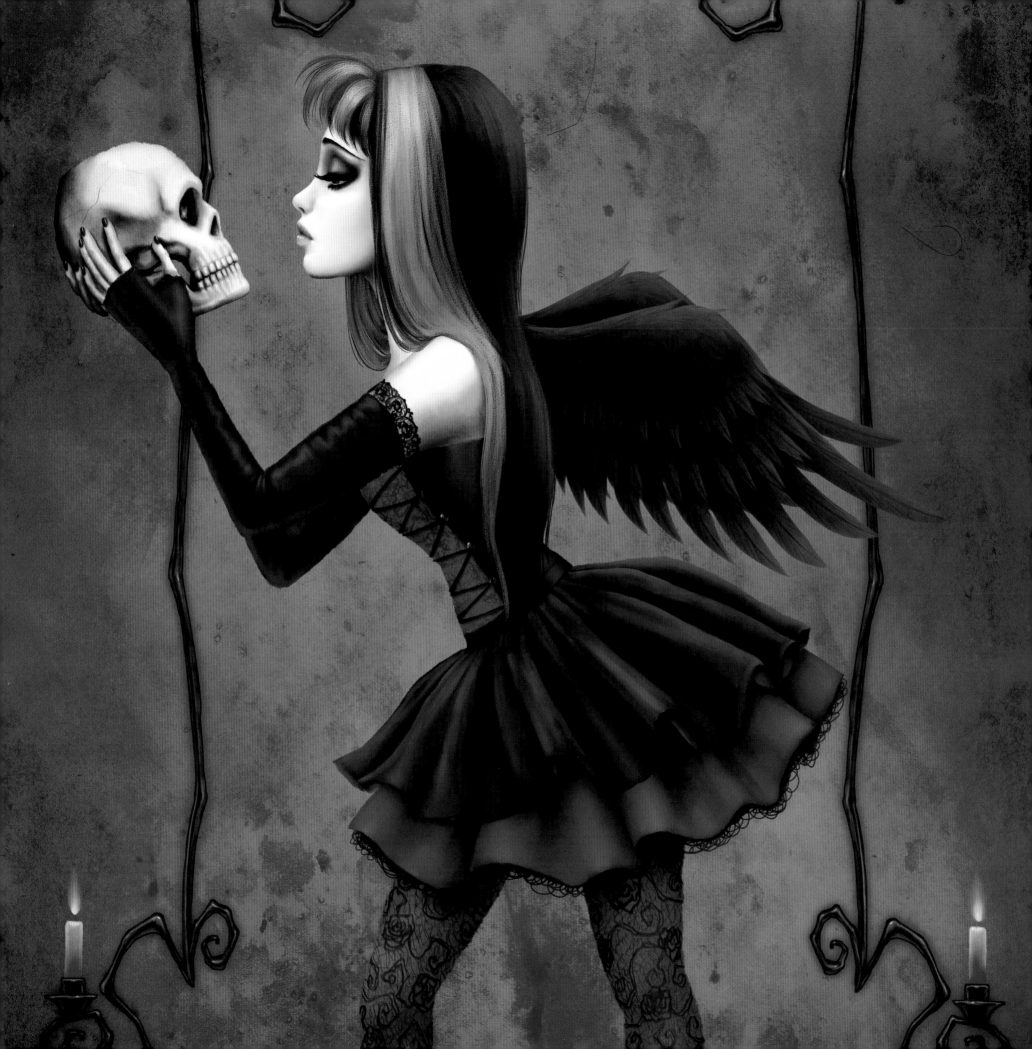

Creepy Children

Let's face it, children can occasionally be creepy, whether they mean to be or not. Dark fantasy has a strange history of depicting children as demonic forces capable of full-blown acts of terror. As such, childhood innocence – or loss thereof – is a powerful theme that finds itself explored over and over in Gothic artwork. One of the most intriguing artists to explore the darker side of childhood is the aptly named PeeMonster, whose haunting works have been displayed in galleries all around the globe. Many of PeeMonster's works focus on innocence in the face of darkness, with several pieces bringing out a darker side of scenarios that would otherwise be considered harmless.

Playing With Colour

Traditionally, the key colours of Gothic art are from the darker end of the spectrum, with black reigning supreme. Darker shades of earthly hues of midnight blues, hazy purples and deep greys are also popular choices, with powerfully emotive colours like scarlet and white often appearing as contrasting accents. While there is absolutely nothing wrong with such palettes, many contemporary Gothic artists choose to experiment with the visual effects that can be achieved by playing with surprising and conflicting colour choices.

For instance, injecting bright flashes of colour into monochromatic artwork can create compelling results, especially when used to bring out emotive qualities. The Spanish multimedia artist Nekro uses flourishes of a signature shade of scarlet in his Gothic works as a striking means of directing his viewers around his artwork.

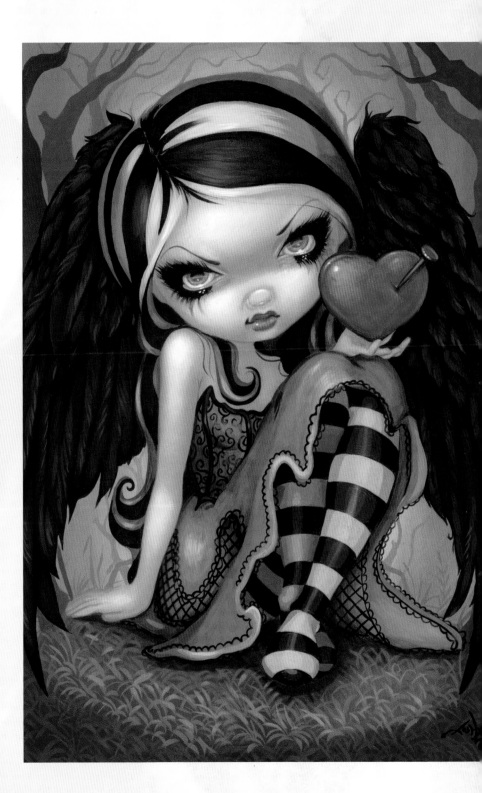

Enamored by Enamorte
© Enamorte
Digital media: Paint Tool SAI and Photoshop
enamorte.deviantart.com

Heart of Nails by Jasmine Becket-Griffith
© Jasmine Becket-Griffith
Traditional media: Acrylic on wood, 40.5 x 51 cm (16 x 20 in)
Some years I like to portray a darker, more cynical Valentine's Day in my paintings....
strangeling.com

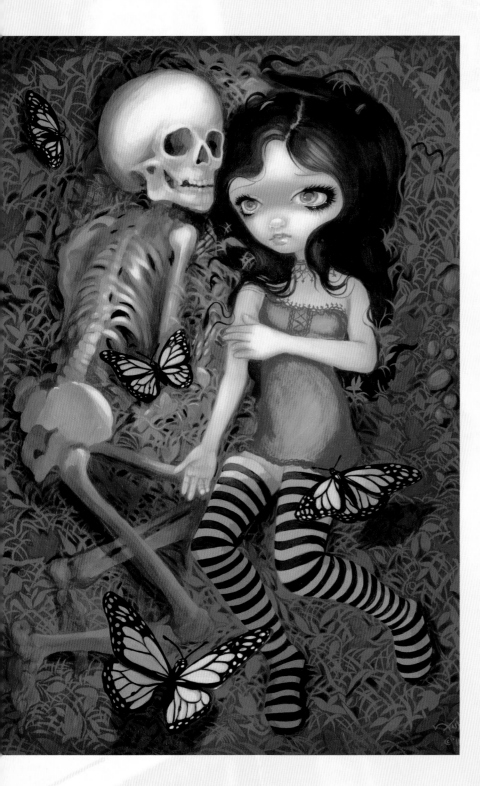

Another interesting offbeat technique is to depict horrifying scenes in bright and lurid colours, leaving little room to hide all the grisly details. This kind of approach is particularly prevalent in graphic styles popular in comic-book artwork, using fine details and crisp outlines to draw attention to whatever kinds of horrors the artist wants to inflict on their viewer.

Reflections of the Modern Goth

It's only natural to find the themes woven into subcultural identity reflected in the art it inspires, which is why there are many pieces of Gothic art that depict characters clad in authentic outfits that would look as good in real life as they do on the canvas. Clothing is an effective way of adding personality and relevance to a character, which is why it's not uncommon to find modern Gothic princesses decked out in corsets and bustle skirts with fishnet tights and heavy boots.

Gothic fashion can be used as a means of enhancing narrative, as we find in the intriguing *Love Potion* (2011) by Pierluigi Abbondanza, where the protagonist's striking style seems to enhance the rather grim nature of what she's eating. Certain styles seem to work particularly well when applied to characters of an unexpected and traditionally far-removed type, such as the punk-rock fairy or the suited-and-booted demon.

Lolita Fashion

There are many wonderful crazes that have come out of Japan and had a direct impact on international subculture, and the lace-clad style of Lolita fashion has left a permanent and provocative mark on the modern Gothic aesthetic. The core aim of Lolita fashion is to create a coherent outfit that encapsulates a character archetype, preferably in as lavish and cute a fashion as humanly possible. Much to the suspicions of many, there is no association with the sexualization of young girls as the name has been taken to suggest.

I'm Almost With You by Jasmine Becket-Griffith
© Jasmine Becket-Griffith
This one might beg a lot of questions – who is the skeleton? Why isn't it buried? Was it somebody important to her? How did they die? Is it just a Halloween decoration? Only she knows for sure.
Traditional media: acrylic on wood, 40.5 x 51 cm (16 x 20 in)
strangeling.com

Nocturne by Jason Juta
© Jason Juta
Mixed media: photo manipulation in Photoshop
jasonjuta.com

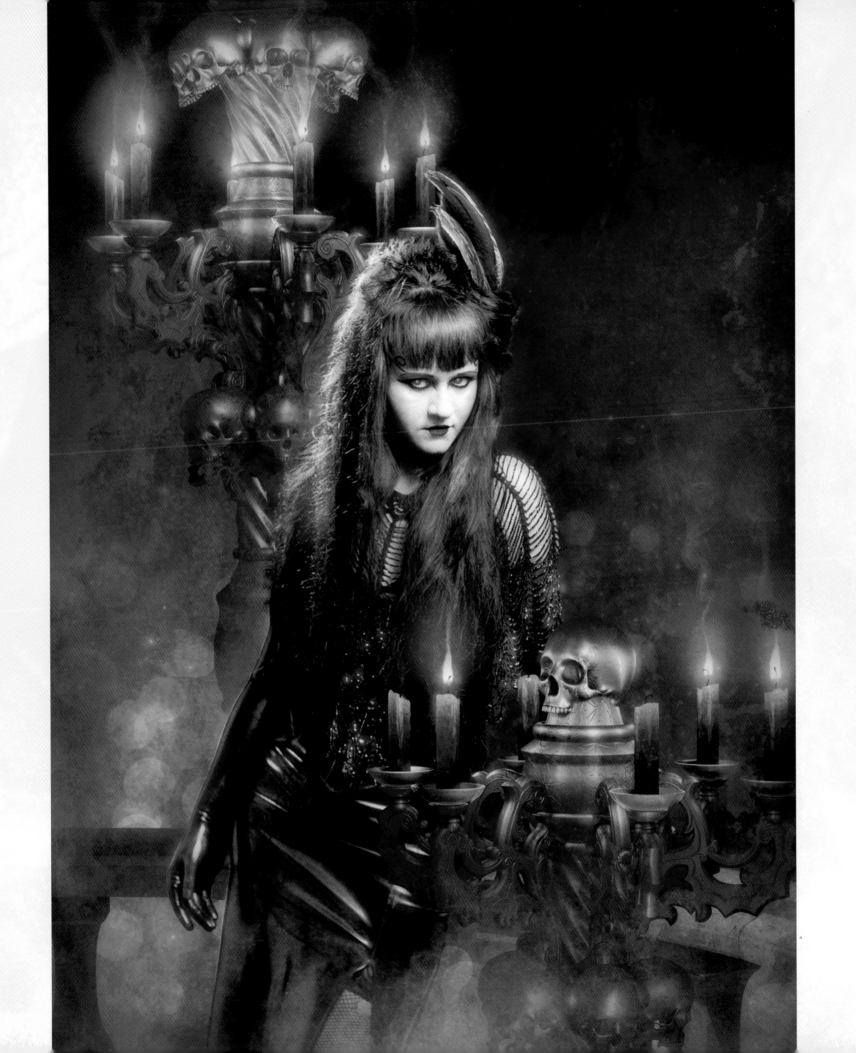

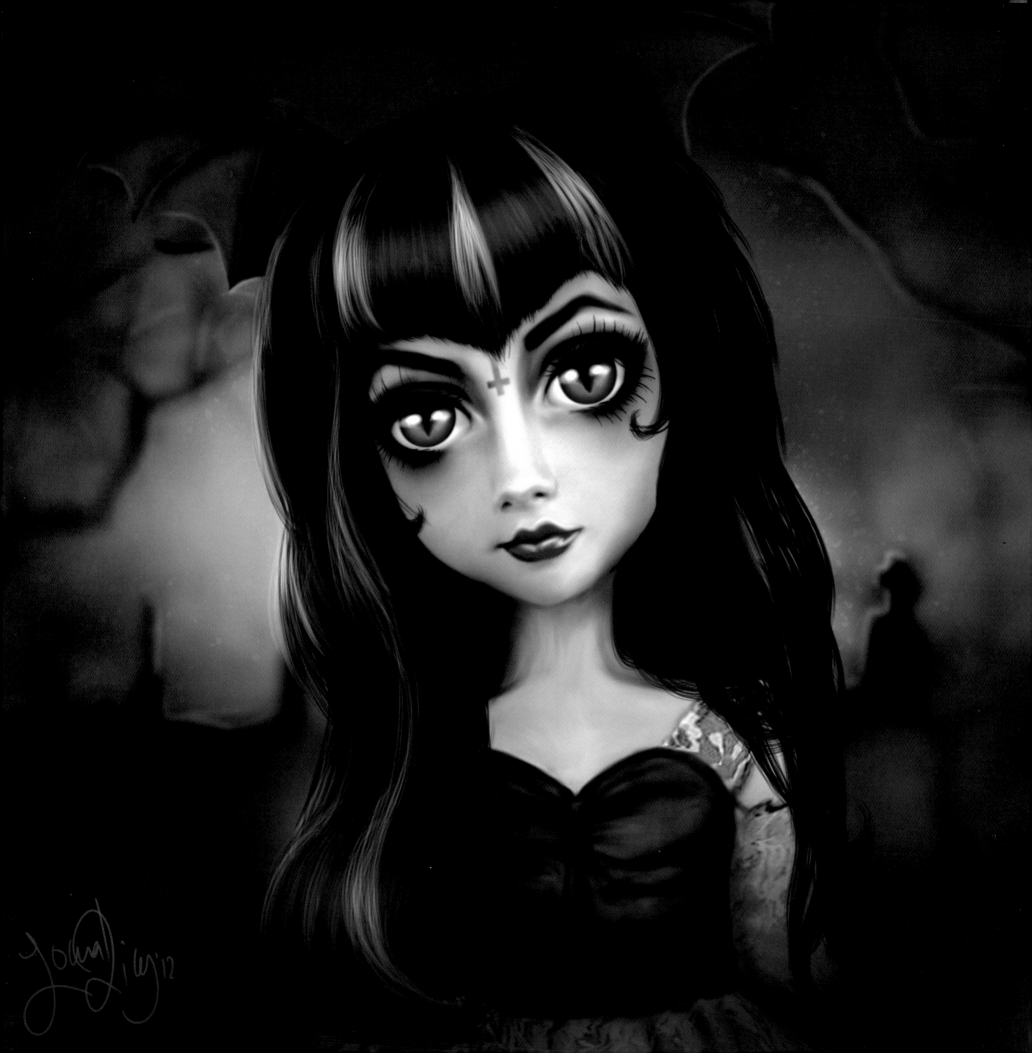

The Lolita style of dress mixes influence from iconic historical periods and the elaborate costumes found in anime and manga. We're talking big puffy dresses and petticoats, ribbons and lavish textiles that create dramatic shapes and bold silhouettes, accompanied by complicated hairstyles and theatrical props. There are many rules that apply to make-up choices, which often remain deliberately subtle in comparison to clothing and hairstyle. Lolita fashion is a fascinating style to incorporate into art, as it prides itself on making the most outlandish concepts in fashion a reality.

Gothic Lolita

While Lolita fashion spans many genres, Gothic Lolita has in many ways become the definitive style to follow. As with the Western Goth subculture, black asserts itself as the dominant colour, with various accent colours and cute accessories adding embellishments and flourishes. Gothic Lolita places a particularly strong emphasis on Victorian heritage dress: expect to find veils, gloves and ornate headpieces in addition to corsets and bustles. Gothic maids' outfits are also especially popular, taking the traditional Victorian housemaid and giving her a truly spectacular makeover.

Gothic Lolita is also closely connected to Visual Kei, a music movement that combines theatrical costume and dramatized stage antics in order to enhance the link between music and the visual arts. Lolita fashion has become extremely popular in terms of character design for manga and anime series such as *Tsukuyomi: Moon Phase* (2004–05) and *Gosick* (2011), along with international projects such as the video game *Alice: Madness Returns* (2010), with the last using Lolita fashion as a means of expressing the fragile mental state of the game's protagonist, Alice Liddell.

Glamour and Gore

There are many literary theorists out there who claim that everything created by the human mind comes back to two things: sex and death. The combination is certainly a compelling one when it comes to Gothic art, with the two themes often appearing side by side in one form or another.

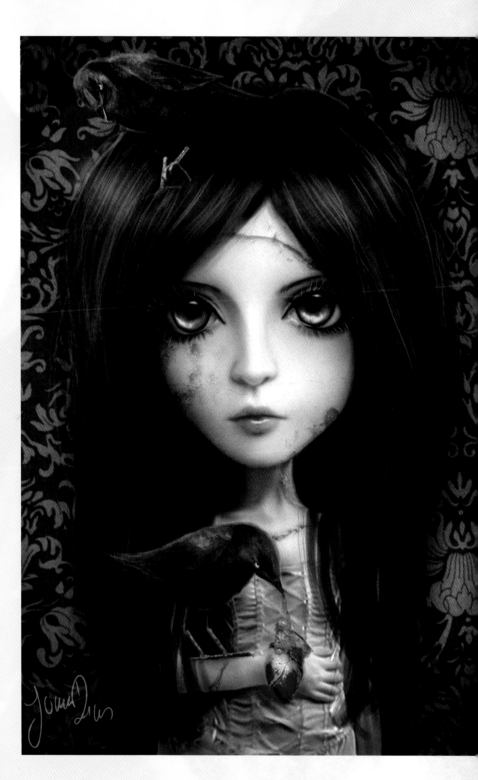

Little Lilith by Joana Shino Dias
© 2012–2013 Joana Shino
Digital media: Photoshop, Trust Tablet
This is the first of a series of 'Little Ghouls' I'm planning to make. Lilith was the first one, but lots of little demons and monsters are yet to be created. Creepiness and cuteness always look great together.
joanashino.com

So Long Scarecrow by Joana Shino Dias
© 2008–2013 Joana Shino
Digital media: photo manipulation, Photoshop, Trust Tablet
A pretty old work of mine, one of the first times using a digital tablet. Got inspired while listening to the song 'So Long Scarecrow' by Scarling. Used a photo of an actual doll head to create this artwork.
joanashino.com

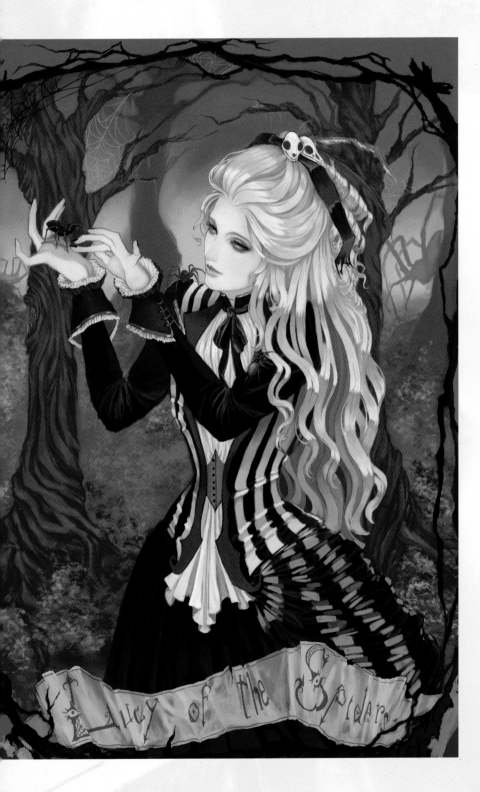

One of the more playful expressions of this juxtaposition is the eclectic realm of pin-up art, which has enjoyed something of a resurgence over the past few years. Creepy and cute can easily work in harmony, with artwork casting an opulent vintage glamour over popular character archetypes, especially vampires and witches. With such an overt emphasis on sexuality in these kinds of images, it's not surprising that pin-up art is still something of an acquired taste.

The most interesting examples of pin-up art thrive on adrenaline. This is achieved by combining elements of horror and sensuality into one bizarre character, often appearing as threatening and seductive at the same time; a balancing act of fear and submission. Along with the obvious and titillating potential of suggestive clothing, fabric often plays an important role in drawing the viewer's attention, with the qualities of PVC and latex particularly prominent.

Pin-Up Parody

Blushes aside, Gothic pin-up art can be highly comical and light-hearted despite its emphasis on sexuality. The Gothic tradition has a long-standing association with self-parody, stemming from Jane Austen's cynical dissection of supernatural melodrama in *Northanger Abbey* (1818). Many pin-up artists use the tool of parody as a means of grounding their outlandish concepts and characters, such as Aly Fell's glam and gory *Tiffany May: Killer Prom Queen* (2009) and Serge Birault's wonderfully mad *Tomato From Hell* (2011).

In a similar vein, many Gothic pin-up pieces also feature characters who are almost deliberately overexaggerated in order to bring a sense of postmodern humour to their design.

Dark Chemistry

One of the most fascinating offshoots of the Gothic tradition is the exploration of science, as Mary Shelley used to devastating effect in her seminal novel *Frankenstein* (1818). Since the days of Victor Frankenstein and his tragic monster, the darker side of science has spawned a visual language of its own, with the opposing forces of organic life and synthetic mechanics merging together, often in the most disturbing of ways. By harnessing the fear of science gone bad into their works, artists can evoke the same sense of terror that Shelley created within the murky corners of Frankenstein's lab. In one's imagination, there are no areas that science can't reach and explore, which is why it has found such a welcome home in dark fantasy. Many artists widely associated with science fiction, such as Jim Burns and Syd Mead, have been known to incorporate dark subtexts into their work, delving into subjects connected with occultism, dystopian decay and social paranoia.

Strict Machines

Along with *Frankenstein*, one of the most enduring examples of how dark science fiction can inspire Gothic imagery is Fritz Lang's masterpiece *Metropolis* (1927), a dystopian tale of social disarray and desirable machines. Not only is the film rich in symbolism, the pervasive Art Deco design creates an air of faded glamour in an uncertain future. Its influence can be seen in many diverse forms today, including the immersive *Bioshock* video game series by Irrational Games and in haute couture fashion.

Perhaps towering above the many attractions of *Metropolis* is the enigmatic Maria, a character with a dual nature that sees her fighting for exploited workers as a human before igniting the desires of the

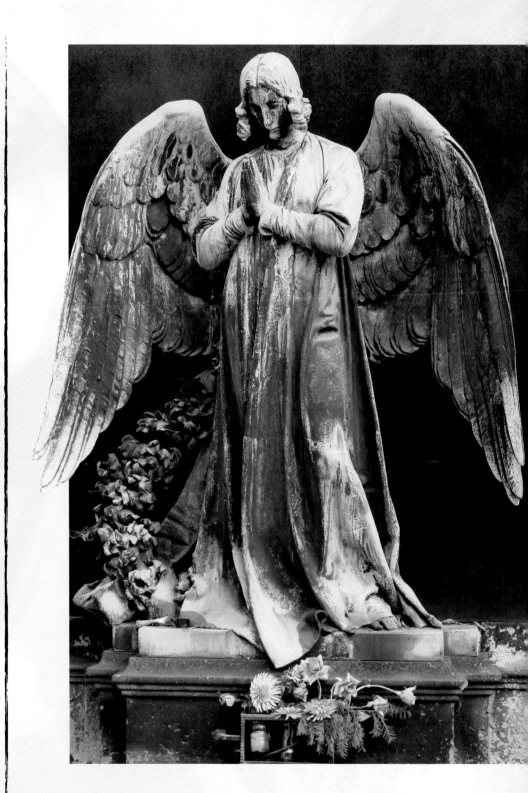

Castle Forest by Senyphine
© Sandrine 'Senyphine' Replat, 2010
Traditonal and digital media: pencil, black ink, acrylic, Photoshop
senyphine.com

An angel in the **old Prague Cemetery,**
Czech Republic.
Medium: bronze

Dust & Echoes by Senyphine

© Sandrine 'Senyphine' Replat, 2012; **Traditonal and digital media:** pencil, acrylic, Photoshop; senyphine.com

Step 1: It may be important to mention that I am both a traditional and a digital artist. I always start by drawing and painting (pen, ink, charcoal pen, watercolours, acrylic) and finish all the details in Photoshop. It is a way for me to explore all the possibilities of each medium and to get the effect that will better fit the mood. I try to give more originality and accurate details to my paintings using digital media, but I still need to keep an authenticity with the traditional media. This character was first designed for a custom tattoo, which is why there is no background in the sketch.

Step 2: I then scanned in the sketch, along with some textures created separately (acrylic painting on paper), and began to colour it with the textures in Photoshop. At this point, I tried to define the atmosphere of the picture, choosing the colours and light effects, playing with the layers. I began to rework some details (hair, outline) with the tool brush by means of my graphics tablet (Wacom Cintiq A4). The blue colours are appropriate for the night-time setting and give an eerie mood to the picture, as I made it for Halloween.

Step 3: I added a background using two other sketches (castle, moon and tree). I kept on working on the picture with some textures to give more detail to the dress. Then I painted the cloudy sky using the tool brush (smooth), playing with the opacity and size.

Step 4: I reframed the painting to add some details on the bottom of the picture. I created the smoke/skull effect in the same way as the clouds. I worked on the shape of the wings and made them translucent with a light white, using a smooth brush. I enlivened some elements (dust in her hair, violin and lamp) with orange/brown colours to increase the contrast with the complementary colour of blue.

Step 5: I focused on the details of the dress, painting some branches, flowers and plants within it. Furthermore, I reworked the girl's face and the lamp design.

Finishing Touches: I continued to paint with the tool brush and play with its opacity and size.

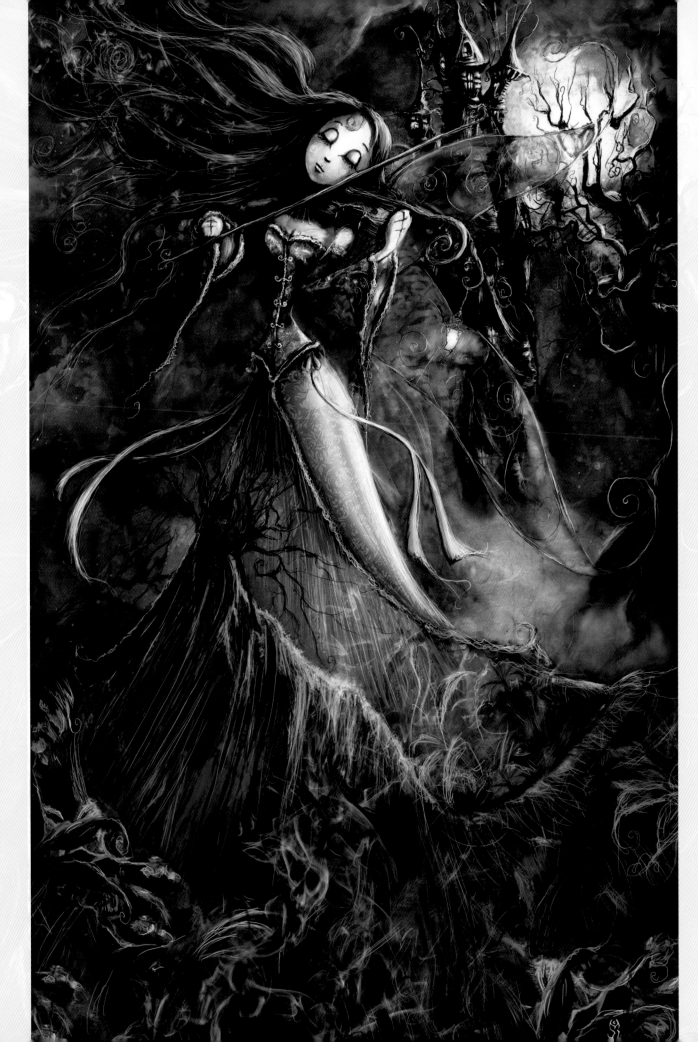

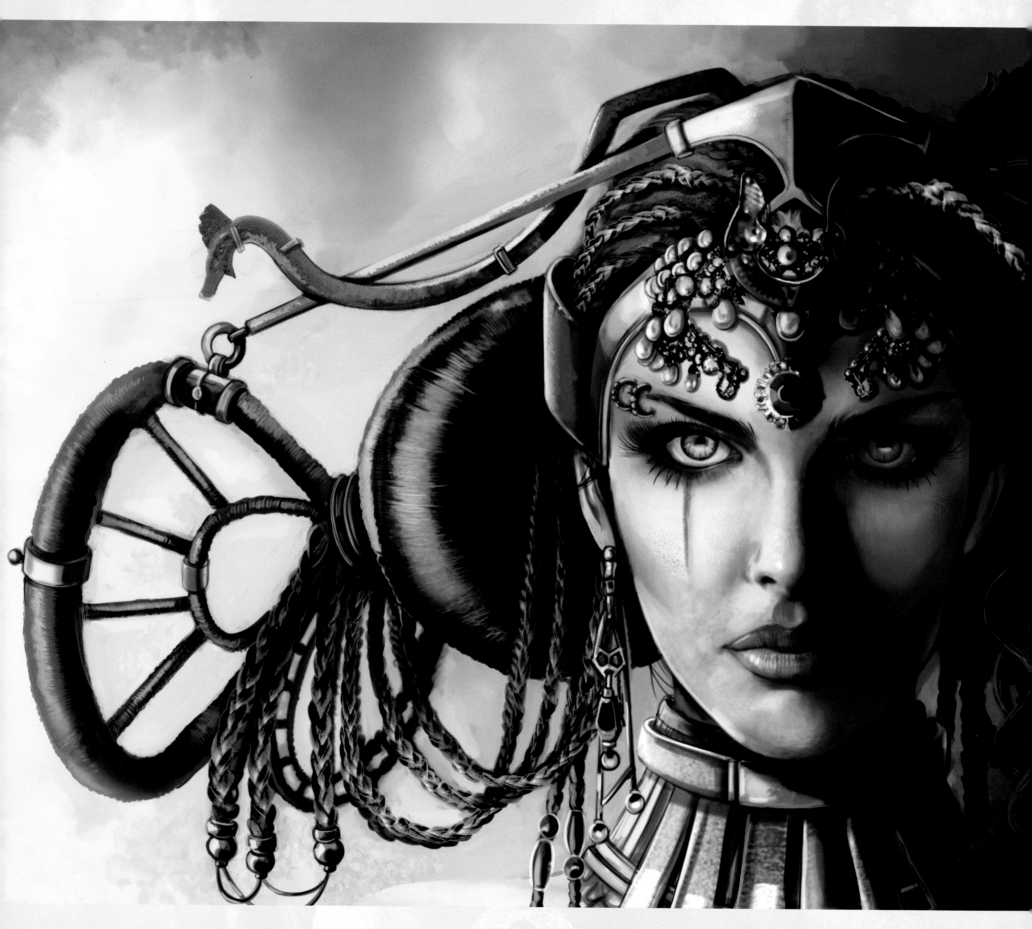

corrupt as a robot. The symbolism of her transformation could be discussed at length, but what remains so fascinating about her is the way that, both as a human and as a machine, she embodies a very Gothic kind of appeal, which is to be both innocent and seductive, albeit at the command of others. She is a pitiful but powerful character, who commands such power but never asked for it. Many artists have further explored the divide between organic and synthetic ideals, but Lang's mechanical creation remains one of the most intriguing and mystifying figures to embody such a philosophical concept.

The Works of H.R. Giger

Of all the artists to dabble in dark technology, the Swiss artist H.R. Giger is undeniably the subject's primary pioneer and most influential innovator. Taking inspiration from the surrealist painters Salvador Dali and Ernst Fuchs, Giger's work examines the fragile relationship between humanity and technology, often depicting haunting scenes of automated terror, anger and biological processes in ways that virtually destroy the notion of organic life being any different from calculated mechanical impulse.

Although most widely known for his incredible visual design in Ridley Scott's groundbreaking *Alien* (1979), the works of Giger have had an immeasurable impact on almost all aspects of the Gothic aesthetic, especially in relation to the dark exploration of fetish and sexuality. The intricate assemblage of skeletal components integrated into mechanical constructs is a prominent and recurring theme in his work, with technological brutalism exaggerated in stark monochromatic colour schemes. The body of work from the late 1960s to the early 1980s known as the *Biomechanoid* series obsesses over this notion, and contains some of the most influential pieces of modern surrealist art of our times.

Dark Dystopia

The fascination with strange science and uncertain futures led to something of an explosion during the 1980s with the emergence of the cyberpunk genre, a gritty form of science fiction driven by social

Tribute to Amidala by Laura Csajagi
© Laura Csajagi
Digital media: Photoshop
The blue woman with an original hairstyle and jewels is inspired
by the beauty of Amidala from Star Wars. laurart.book.fr

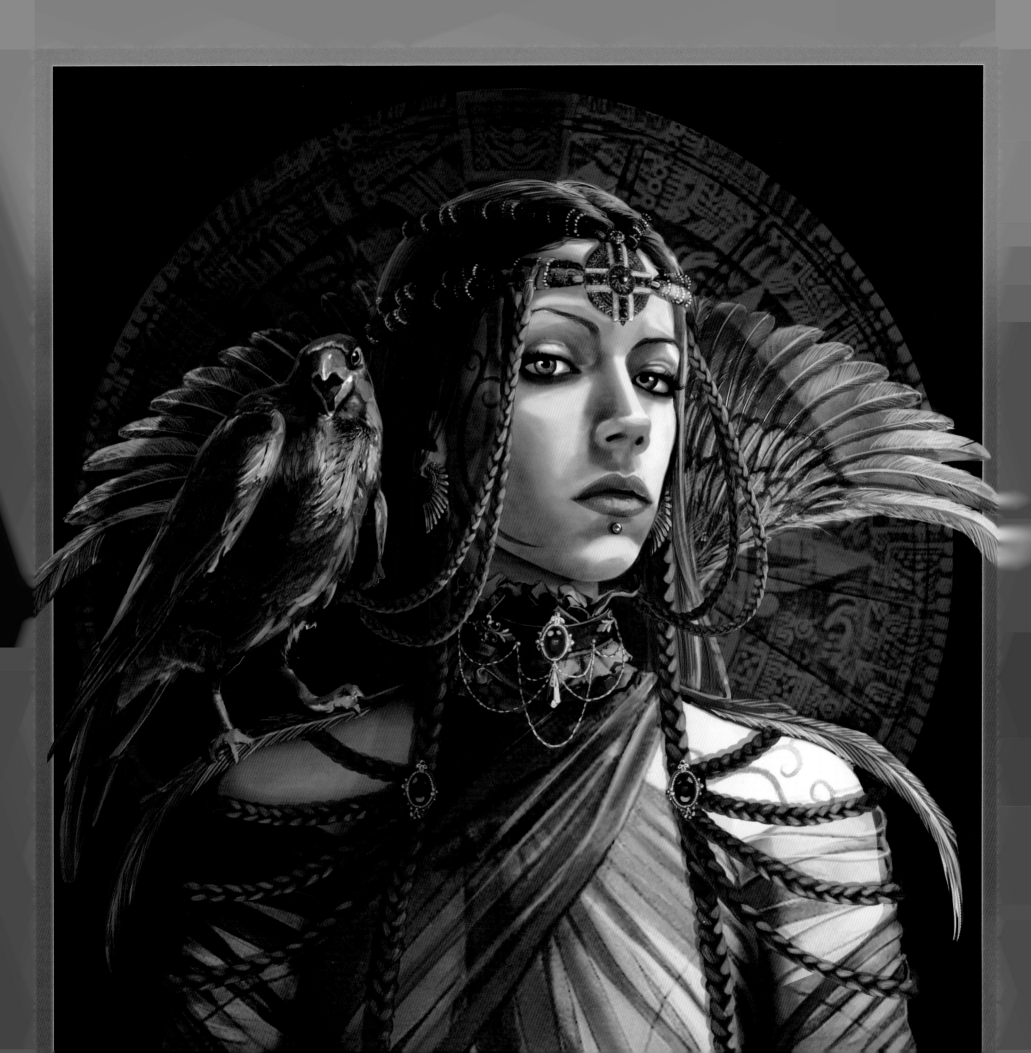

fears and our dependence on advanced forms of technology that need to be mastered or run the risk of cyber sedition. The movement became exceptionally popular on the back of such ventures as Ridley Scott's visionary *Blade Runner* (1982) and the international success of Japanese manga and anime serials, including Katsuhiro Otomo's seminal manga series *Akira* (1982–90) and Masamune Shirow's *Ghost in the Shell* (1989–90). In cyberpunk fiction, heroes are more often vigilantes or outlaws than the traditional romantic sort, often seeking to break away from government restraints, exposing the corruption lurking behind enforced laws.

Rise of the Cybergoth

A deviation from cyberpunk is the emergence of the 'cybergoth'. As a strand of dark science fiction, it further explores the dystopian effects of technology, describing a future that is plagued by some kind of manmade threat, such as a biohazard or nuclear contamination. Society is often depicted as lawless and degenerative, with loose attitudes towards sex and violence. One example is the *Sprawl* trilogy by William Gibson.

The term is perhaps best known to describe a style of alternative fashion that became popular during the 1990s, which added elements of rave culture into the Gothic aesthetic. The style revolves around the theme of high artifice and dystopia, with neon colours featuring heavily in clothing and hair. In reflection of the significance of social threat, items such as gasmasks or protective goggles are popular, as are synthetic fabrics such as PVC. The cybergoth approach to gender is often very playful, with androgynous tailoring and incredibly tall platform boots popular with males and females alike.

Sublime Steampunk

When you consider that the Gothic tradition attaches itself to science as much as to fantasy, the merging of the two was an inevitability. The combination of romanticized history and speculative science makes the genre of steampunk a hard one to resist.

Essentially, steampunk is retro-futurism; a genre where the technological capabilities of our modern world are applied to the historical materials and methods of the Victorian Industrial Revolution and taken into an alternative reality. Steampunk often explores the awe and fear associated with progressive technology, with experimental devices powered by steam and intricate mechanisms opening the door to new possibilities.

Common Visual Motifs

Visually, steampunk can be defined as the integration of technology into various aspects of character design, such as costume, vehicle, set dressing and environment. Engineering paraphernalia, such as gears, dials, tubes and vials, are fashioned in a more design-conscious way, rather than created for the sole purpose of functionality. Against the backdrop of exquisite Victorian style, integration of old fashioned machinery operated by cogs, steam power and wind-up gears creates a fascinating and romantic portrait, tapping into the spirit of discovery and adventure popularized in early science fiction novels by the likes of Jules Verne and H.G. Wells. With the emphasis on feats of engineering and mechanical expertise, industrial garments such as goggles and

Ravenn With Her Raven by Laura Csajagi
© Laura Csajagi
Digital media: Photoshop
Ravenn is the name of the heroine of my illustrated book project called *Blue-Beard*.
laurart.book.fr

Ravens by Laura Csajagi
© Laura Csajagi
Digital media: Photoshop
Originally I drew these ravens, thinking of Hugin and Mugin, Odin's crows, but I decided to finally use them in my illustrated book project called *Blue-Beard*.
laurart.book.fr

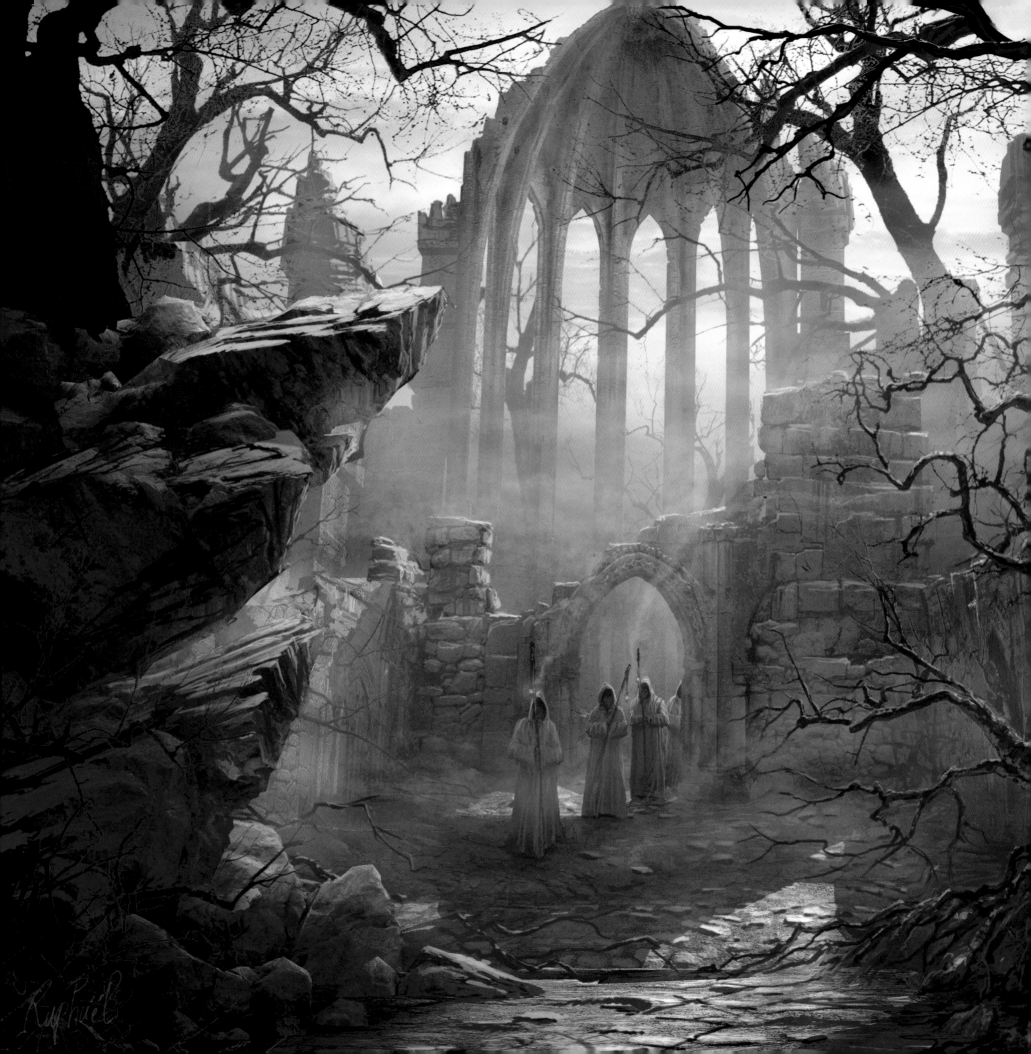

protective clothing feature heavily in character design, along with strong metals and reinforced materials.

Much in the same vein as Verne's classic *Twenty Thousand Leagues Under the Sea* (1870), steampunk tends to focus on humanity's desire to master our environment and reach new heights (or depths, in Captain Nemo's case) as a measure of mankind's worth. So explorers, wanderers, vigilantes and adventurers are common character archetypes, with many promoting the role of strong female leaders.

Functionality versus Style

Authentic steampunk needs to be well researched. It's not just a case of adding the odd vintage-looking accessory or random gear. The best steampunk artists tend to create subtle scientific objects that are grounded in some kind of historical reality, even though the actual design may be theoretically impossible.

With adventure playing such an important role in the genre, vehicles fit for long-haul travel are a recurring theme in steampunk art, with airships and submarines becoming the vessels of choice for the intrepid explorer, as seen in Peter Pohle's *The Departure* (2010) and *Discoverers* (2010). Similarly, the elegant works of the artist Edward Howard are particularly stunning in this regard, especially in the robot and clothing design of *The Search Begins* (2011) and the Iron-Giant inspired *The Sentinel* (2012).

Wind-Up Consciousness

In terms of character artwork, the steampunk genre is rich with portraits of captivating personalities possessed of dark desires. Costume often plays an important role in conveying character and motive, with technology sometimes even woven into the outfit itself. Steampunk armour for instance, will often include dials and gauges to indicate that the costume is serving another purpose, like powering up an integrated life support system. Such experimentation has inspired fan-art communities to give popular characters from video games, comic books and film quirky retro makeovers.

Coeur Gothique by Raphael Lacoste
© Raphael Lacoste
Digital media: Photoshop
raphael-lacoste.com

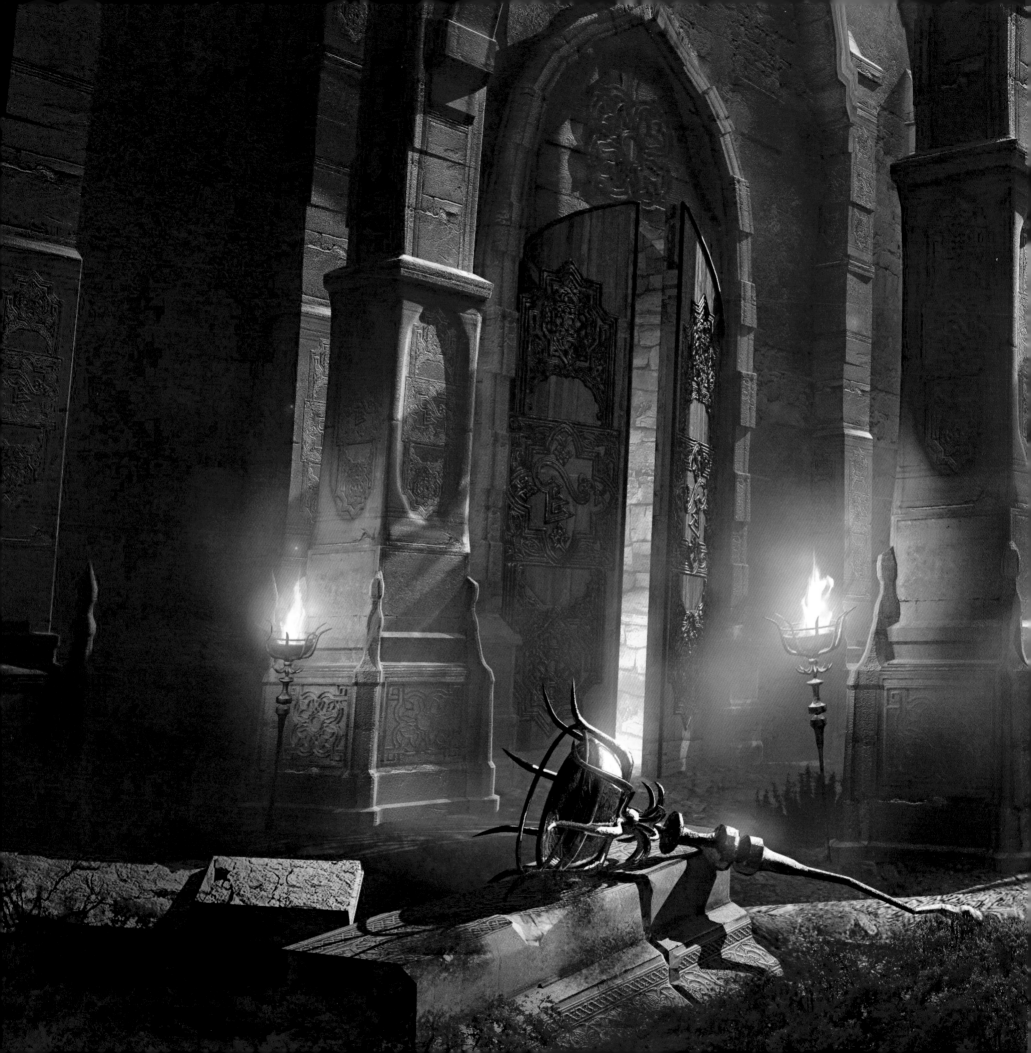

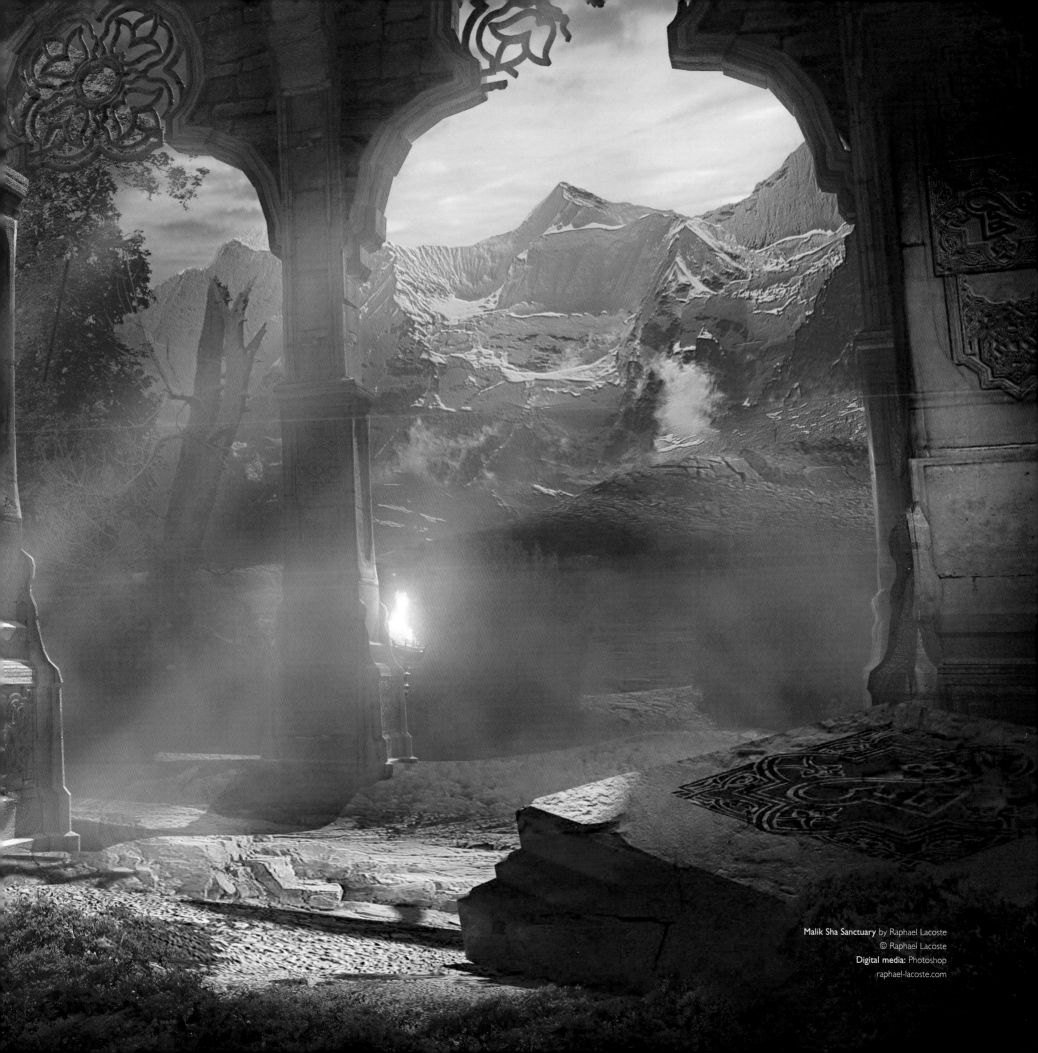

Malik Sha Sanctuary by Raphael Lacoste
© Raphael Lacoste
Digital media: Photoshop
raphael-lacoste.com

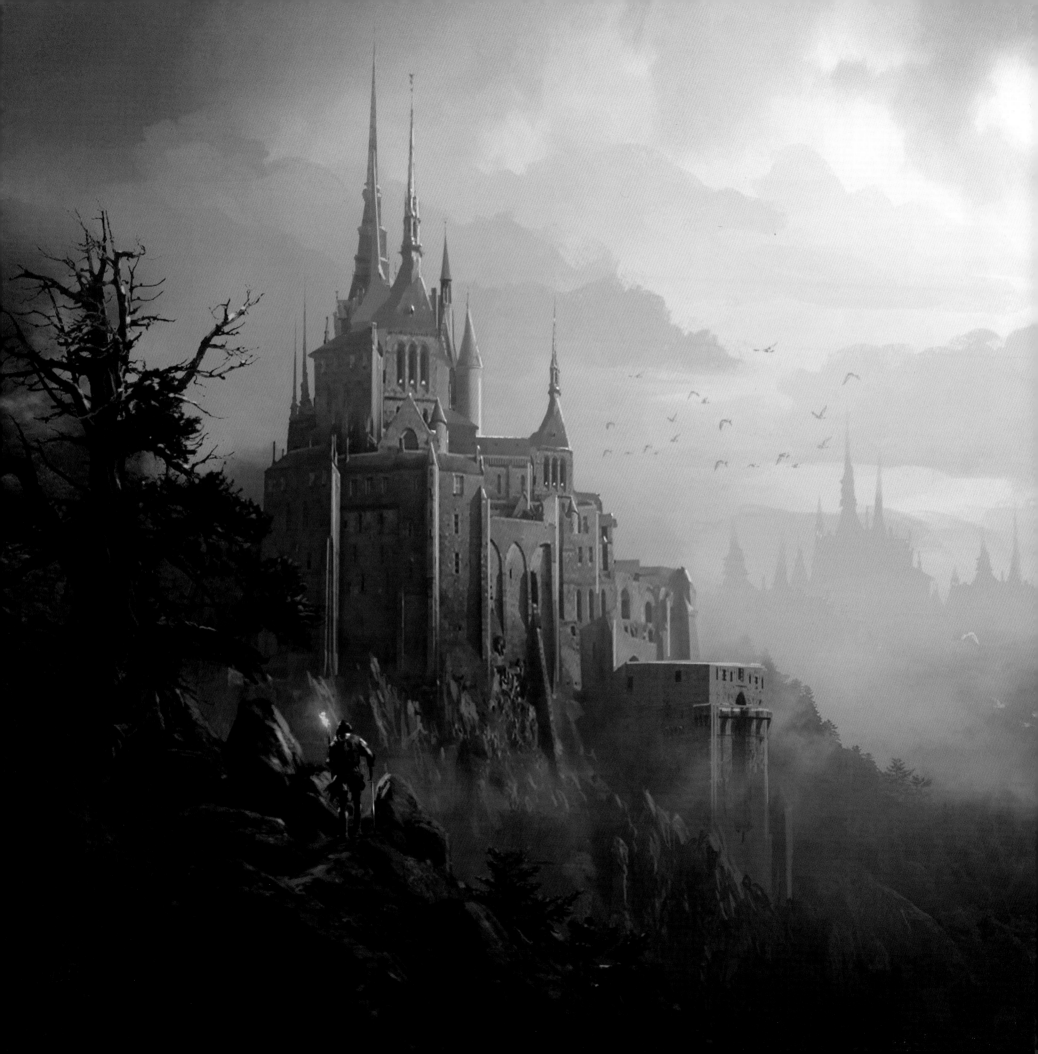

Mechanical biology is also a popular motif in Gothic steampunk art, its homage to the concept of creating artificial life. The trend is especially popular in jewellery design in both the real world and the imagined, with many artists using the motif 'wind-up consciousness' as a means of setting the tone for their characters and mechanical companions, as we see in pieces like *Homuncularium* (2010) by Jim Burns and *Insect* (2011) by David Lecossu. As illustrated in both works, mechanical creatures are often constructed from many small and strange parts, with synthetic materials mimicking what would have been formed from natural life.

Every Kind of Punk

If there's one thing that alternative culture proves, it's that you can make a punk out of anything. Hot on the heels of movements like steampunk and cyberpunk, Gothic culture has a knack for finding innovative and quirky ways to bring out the darker side of just about anything. Seapunk, for instance, is the art of making everyday objects and style appear as though they originated from Atlantis. Think mermen and mermaids roaming the streets in disguise, with aqua-coloured hair and ocean-related iconography incorporated into dress style and jewellery.

Likewise, stitchpunk is a grungier version of the home-made arts and craft style, taking inspiration from the stitched-up ragdoll Sally in Tim Burton's *The Nightmare Before Christmas* (1993). Here, buttons, needles, mismatched fabrics and heavy thread seams interact with each other to create strange visions with a distinctly man-made feel.

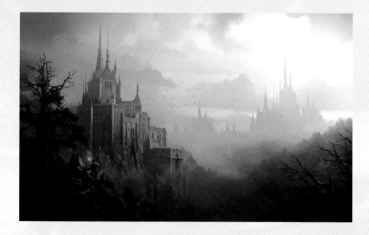

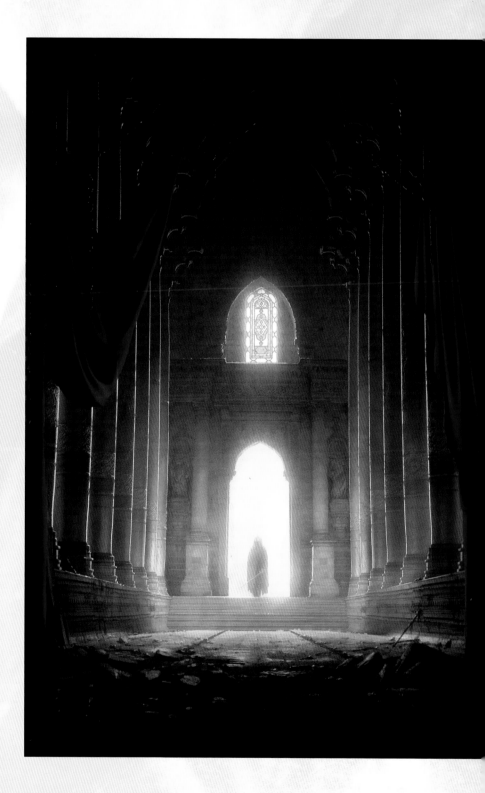

Return of the Knight by Raphael Lacoste
© Raphael Lacoste
Digital media: Photoshop
raphael-lacoste.com

Return of the Emperor by Raphael Lacoste
© Raphael Lacoste
Digital media: Photoshop
raphael-lacoste.com

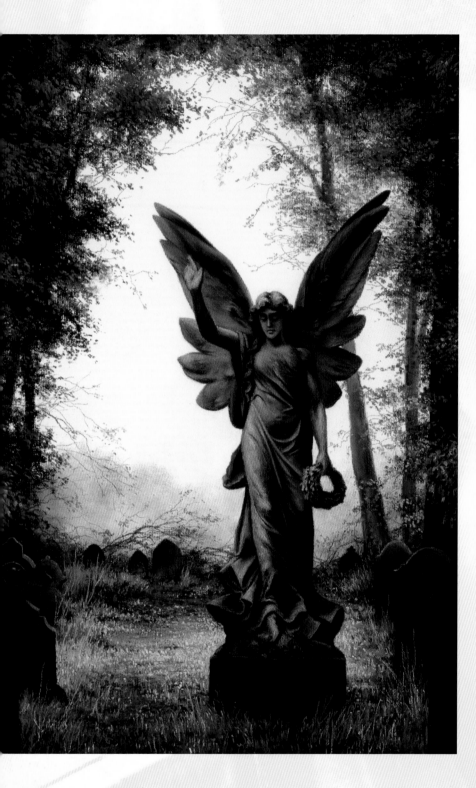

Eerie Visions

Once you really get under the skin of the Gothic philosophy, it becomes apparent that, by having such a rich stylistic identity, Gothic themes and concepts can be applied to an infinite number of possibilities. It's a style that has so much meaning ingrained in it that even the most subtle references in it can add a whole new level of context, both visually and thematically.

The style is much more versatile than many might assume, which is why even those who do not specifically centre their work on darker concepts are able to tap into its many facets and represent its themes whatever their creative goal.

Gothic Environments

In many cases with Gothic artwork, the setting and location can be just as important as the strange characters framed within its spaces. By tapping into the historical traditions or emotional contexts associated with Gothic style, locations can become anthropomorphic channels for mood, tone and atmosphere, driving a piece closer towards its intended effect on the viewer.

Evocative landscapes and interiors often make striking use of the premise of pathetic fallacy, in which elements such as the weather, terrain, furnishings and texture are presented in a way that provokes emotional reactions and responses connected to the deepest reaches of the human mind. Gothic environments are those that carry mysterious and supernatural connotations, often also integrating powerful emotions connected to the more unfathomable aspects of human nature, such as fear, melancholy and anger. If handled correctly, a landscape can speak as clearly as any character can.

Angel by Anne Sudworth
© Anne Sudworth
Traditional media: pastel, 58 x 41 cm (23 x 16 in)
AnneSudworth.co.uk

Ethidwyre by Anne Sudworth
© Anne Sudworth
Traditional media: pastel, 69 x 54 cm (27 x 21¼ in)
AnneSudworth.co.uk

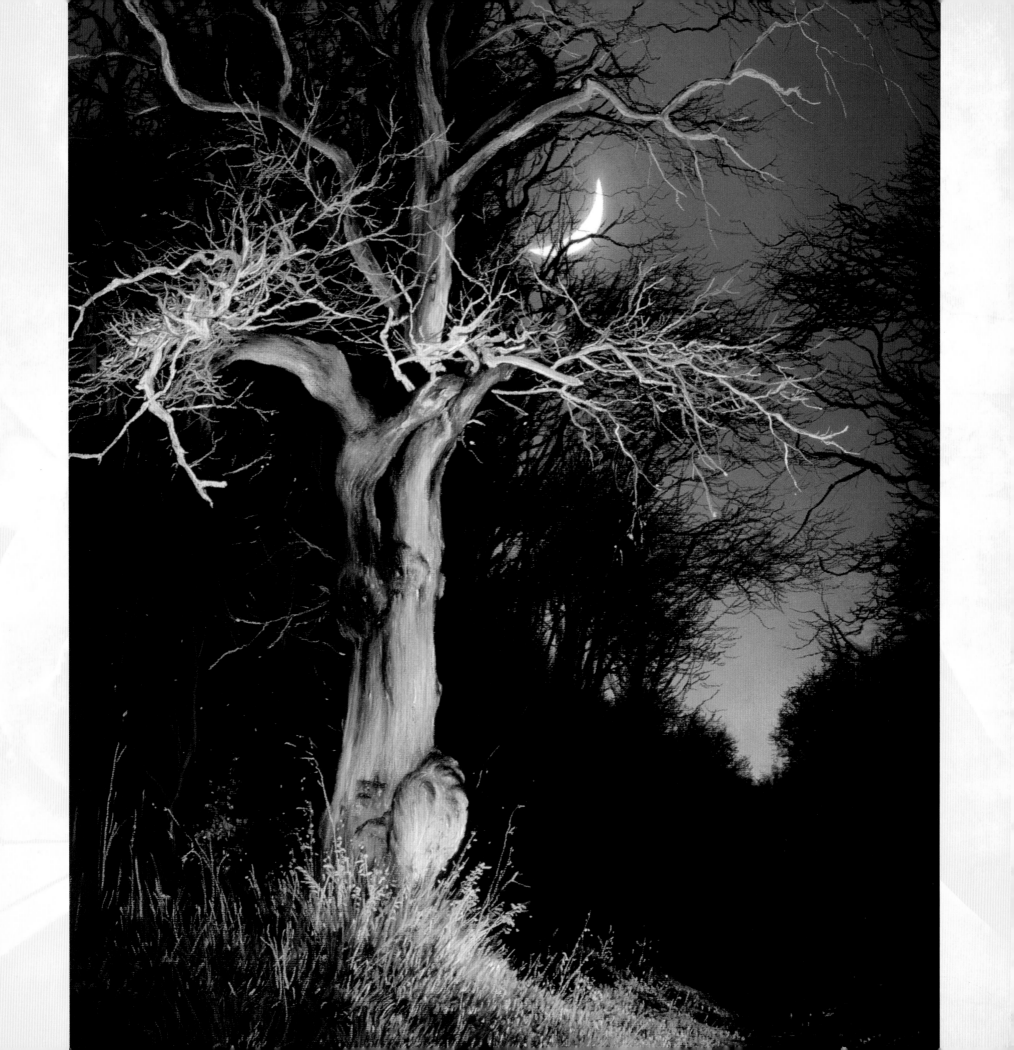

Emotive Scenery

Along with representing the natural world around us, the elements can also carry additional narrative connotations that can be used to heighten the mood of a piece; fire possesses strengthening qualities, but also suggests destruction and chaos; air can be simultaneously liberating and wayward; earth and nature can also represent decay, while water can be overwhelming and destructive. Finding the balance between using positive and negative qualities can make a real difference to a finished piece, especially when elements are juxtaposed in surprising ways.

Many artists tap into the narrative qualities of the elements to add extra meaning to their work, including one of the most influential paintings on the modern Gothic aesthetic, *Ophelia* (1852) by the Pre-Raphaelite artist John Everett Millais. What makes the painting so powerful is that Ophelia's descent into madness is heightened by the landscape around her; you can imagine her singing to herself as she slowly sinks into the murky lake she's thrown herself into, surrounded by lush forestry that thrives while she crumbles into decay. The painting is a haunting play on contrasting qualities, using beauty to highlight inherent darkness and despair.

Blame the Weather

Similarly, elemental qualities can also be achieved by certain kinds of weather, with traditional Gothic art favouring harsher conditions such as rain, snow and heavy mist. Implementing these kinds of conditions

further implies a sense of drama and struggle, although many modern Gothic artists challenge these suggestions further by applying the same kinds of sensibilities to conditions that are not normally associated with melodrama or supernature. Time of day is one such thing; with so many supernatural entities preferring to make their appearances after dark, the Gothic tradition is very much tied to the mysterious qualities of the night. These effects become all the more surprising when applied to scenes that take place in the bright light of day.

The Goblin Tree by Anne Sudworth
© Anne Sudworth
Traditional media: pastel, 109 x 53 cm (43 x 21 in)
AnneSudworth.co.uk

A **dark angel** from a cemetery in **Florence**, Italy.
Medium: bronze

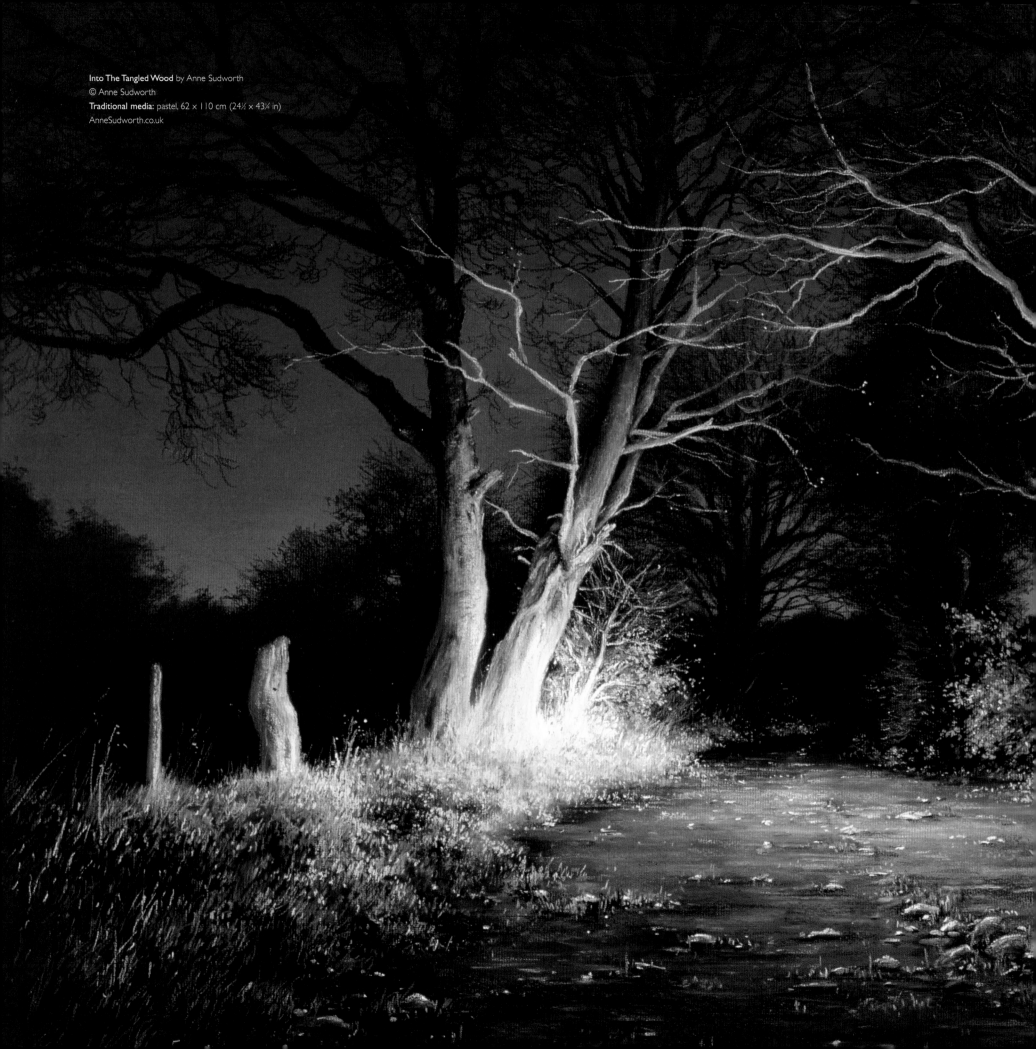

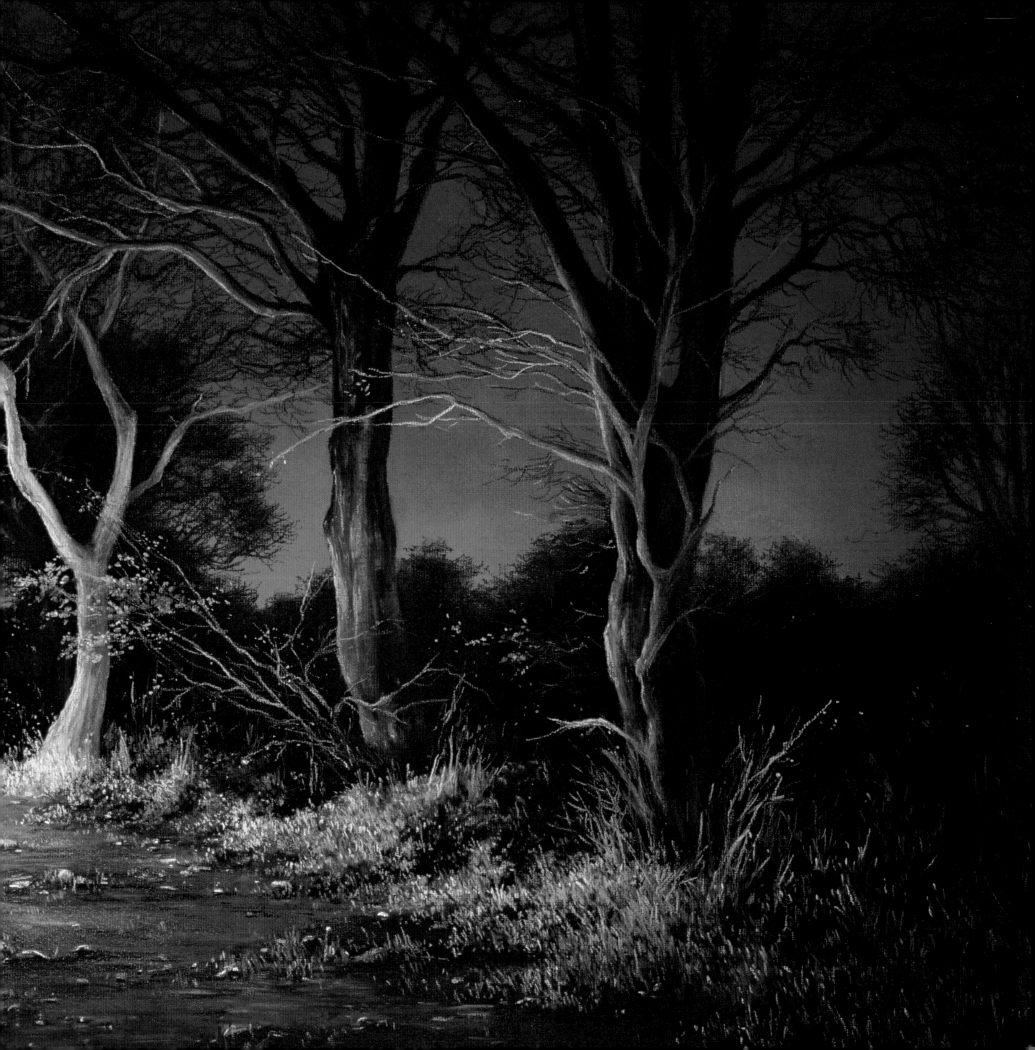

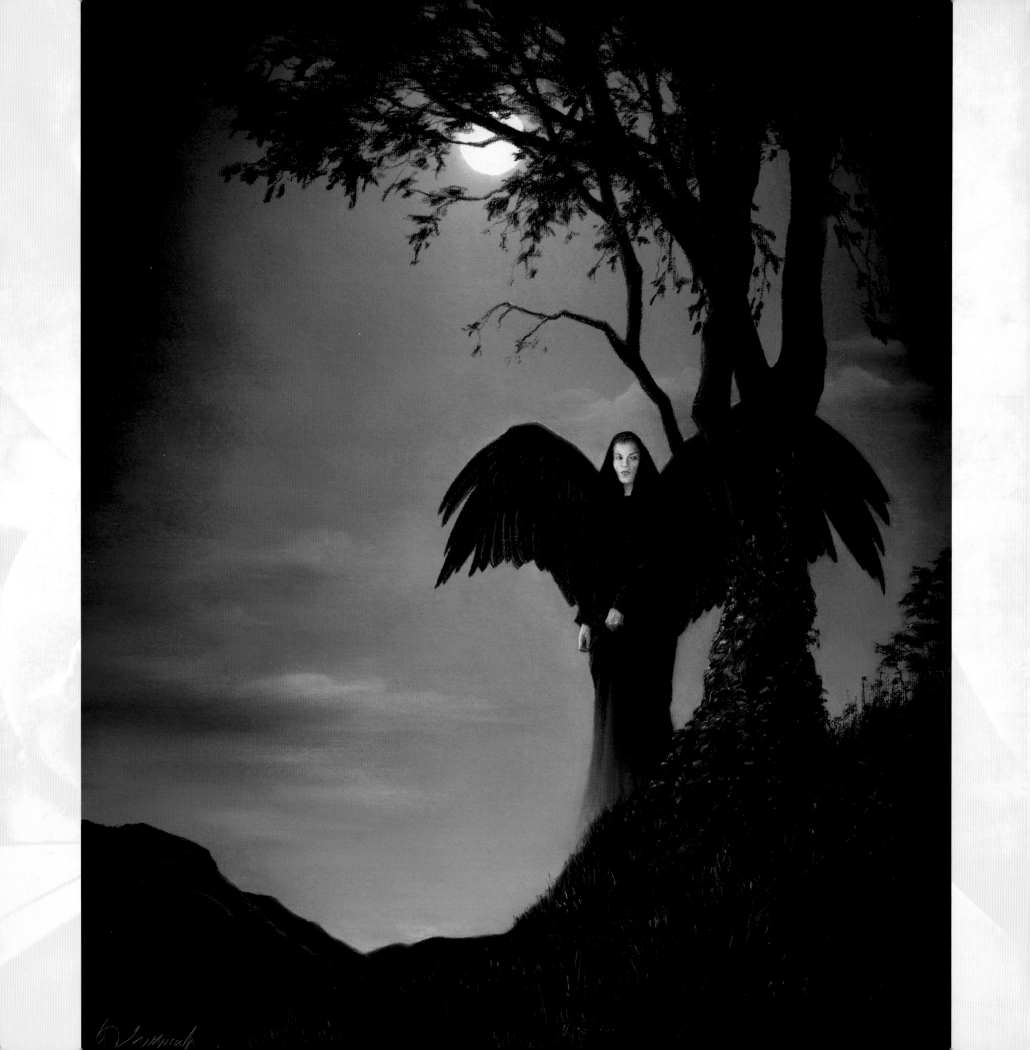

Relevance of Gothic Architecture

To draw attention to the impact that Gothic. architecture has had on modern Gothic art may seem a little obvious, but the intricate and allegorical styles of medieval design have played a monumental role in setting up the framework for Gothic artists to follow and explore.

The architectural splendour of cathedrals like Notre Dame in Paris or Westminster Abbey in London defines everything that the Gothic tradition encompasses, built for the purpose of uniting the world around us with the realms beyond our earthly reach. Every visual element of Gothic architecture serves the double purpose of not only making such grand structures actually stay together, but also to reflect the majestic beauty of the religion that inspired it. For every moment of awe the church could inspire, it also had to remind people of the powers it was built in servitude to – and for the medieval mind, there was nothing that could instil more fear than the threat of divine wrath, which would be the consequence of misgivings and sin.

Fear in Beauty

This fear of heavenly punishment is perhaps what encouraged the likes of Horace Walpole to set their supernatural melodramas within the walls of sacred spaces, with the grandeur of Gothic architecture further magnifying the depth of despair and fear experienced by those paying the price for crimes and misdemeanours. Furthering this, the notion that whatever caused reverence should also be feared was championed by the poets of the Romantic movement during the eighteenth century, which may also indicate why Gothic art became synonymous with sinister and otherworldly imagery in later years. In modern Gothic art, magnificent backdrops of ornate castles, churches, cathedrals and abbeys are synonymous with dark intent and defiance, often with an emphasis on corrupting holy places of worship. *Gothic Siren* (2008) by Anne Stokes is one such example, which sees a vampiric figure desecrating a church by spilling blood on its floors. The effect is amplified further when in the company of statuesque figures that adorn sculpted walls or tapestries that can only watch in horror whatever unfolds before them.

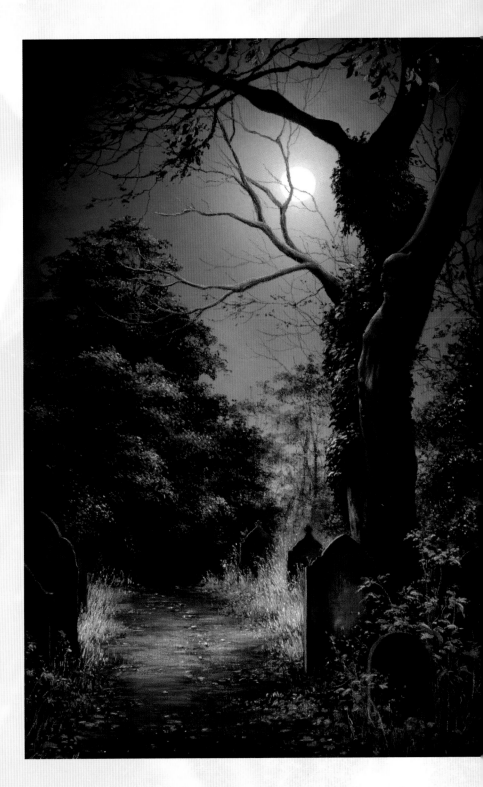

Shadow by Anne Sudworth
© Anne Sudworth
Traditional media: pastel, 65 × 53 cm (25½ × 21 in)
AnneSudworth.co.uk

Night by Anne Sudworth
© Anne Sudworth
Traditional media: pastel, 69 × 51 cm (27 × 20 in)
AnneSudworth.co.uk

Skeletal Churches

Further experimentation with the typical features of Gothic architecture can also create mesmerizing results, both in real life and in art. Some of the most striking churches, that really leave a lasting impression, are those that integrate human remains into their designs; the Sedlec Ossuary in Kutná Hora, Czech Republic, uses the remains of over 40,000 human skeletons to decorate its interiors, as does the Kaplica Czaszek, or chapel of skulls, in Kudowa-Zdrój, Poland. Similarly, the walls of the Catacombs of Paris are adorned with skeletal remains that really do send a shiver down your spine.

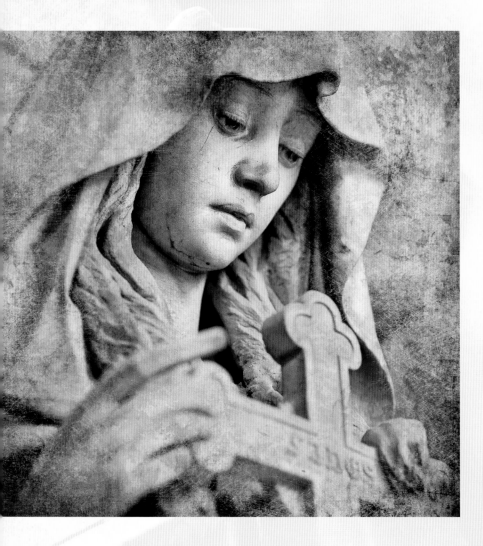

Dwellings of the Dead

Like churches and cathedrals, graveyards, mausoleums and tombs remain popular settings in Gothic art because of the overt connection they have to the morbid subjects of death, grief and loss. Graveyards possess a unique visual language that deliberately conjures up emotions of sadness and fear, which is why many artists choose to set their characters mourning the dead, or even rising from their graves. As with churches, robed statues of tormented figures and mournful angels personify the atmosphere even further, with many artists incorporating statuesque poses into their characters as a means of creating the same effect.

While the sombre atmosphere of graveyard imagery is an incredibly powerful tool, it's not uncommon to come across artists who challenge the accepted idea that resting places have to be gloomy and depressing. Ever the innovator, Tim Burton presented the idea of the underworld being vibrant and lively in comparison to the drab and dreary land of the living in his stop-motion animation *Corpse Bride* (2005), with a Victorian reality paling in comparison to the neon-lit excitement of ghosts and spirits.

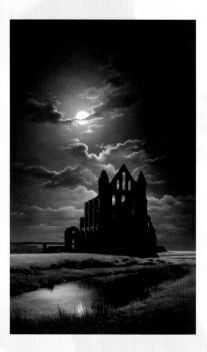

Eerie Forests and Woodlands

Beyond the walls of forlorn castles and churches, many Gothic artists explore the mysterious qualities that can be found in woodlands and forests. Perhaps in the aftermath of pagan beliefs in nature spirits, woodlands have a long history of being thought of as playgrounds for supernatural beings, along with the additional fears of becoming lost or falling into the path of something dangerous. The paintings of Anne Sudworth are particularly renowned for bringing out the magical appeal

Sculpture relief at **Staglieno cemetery**, Genoa, Italy.
Medium: stone

Whitby Abbey by Anne Sudworth
© Anne Sudworth
Traditional media: pastel, 84 × 51 cm (33 × 20 in)
AnneSudworth.co.uk

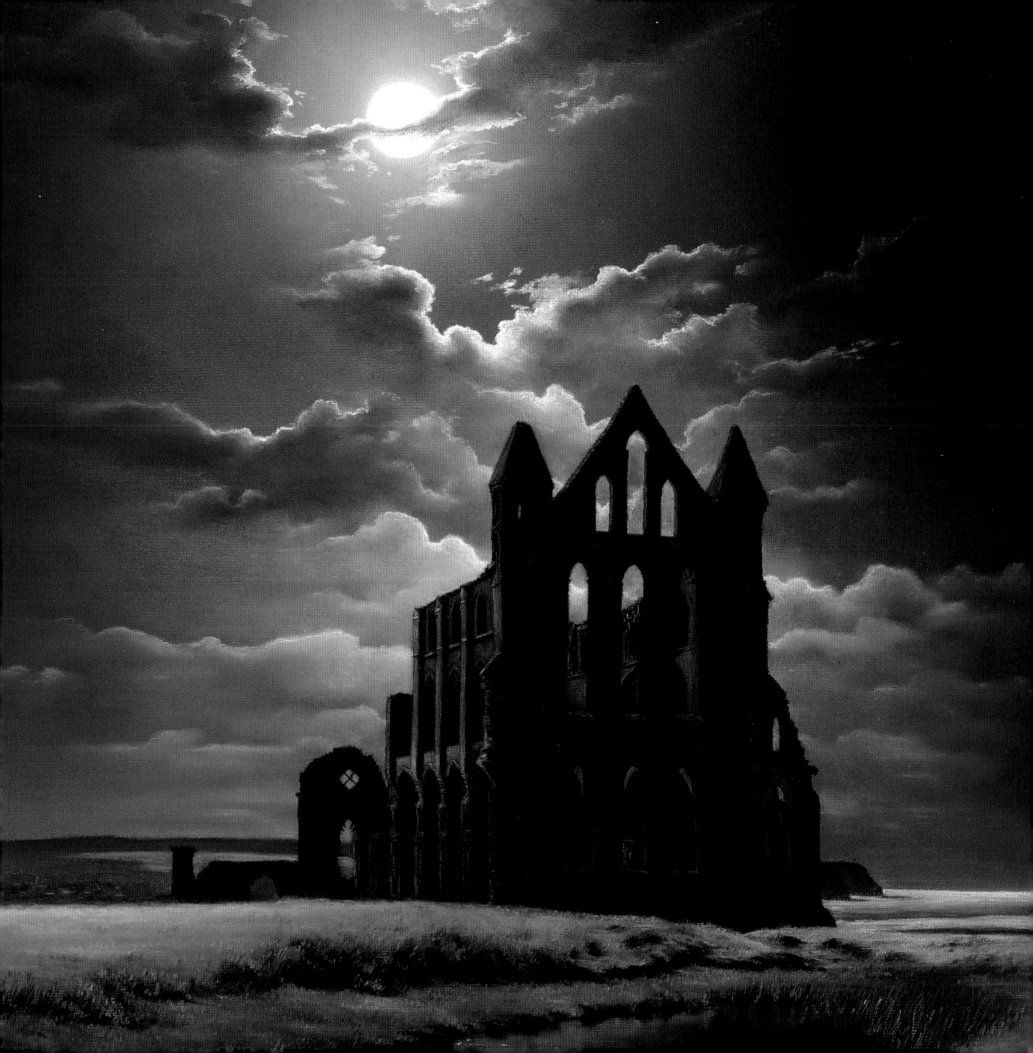

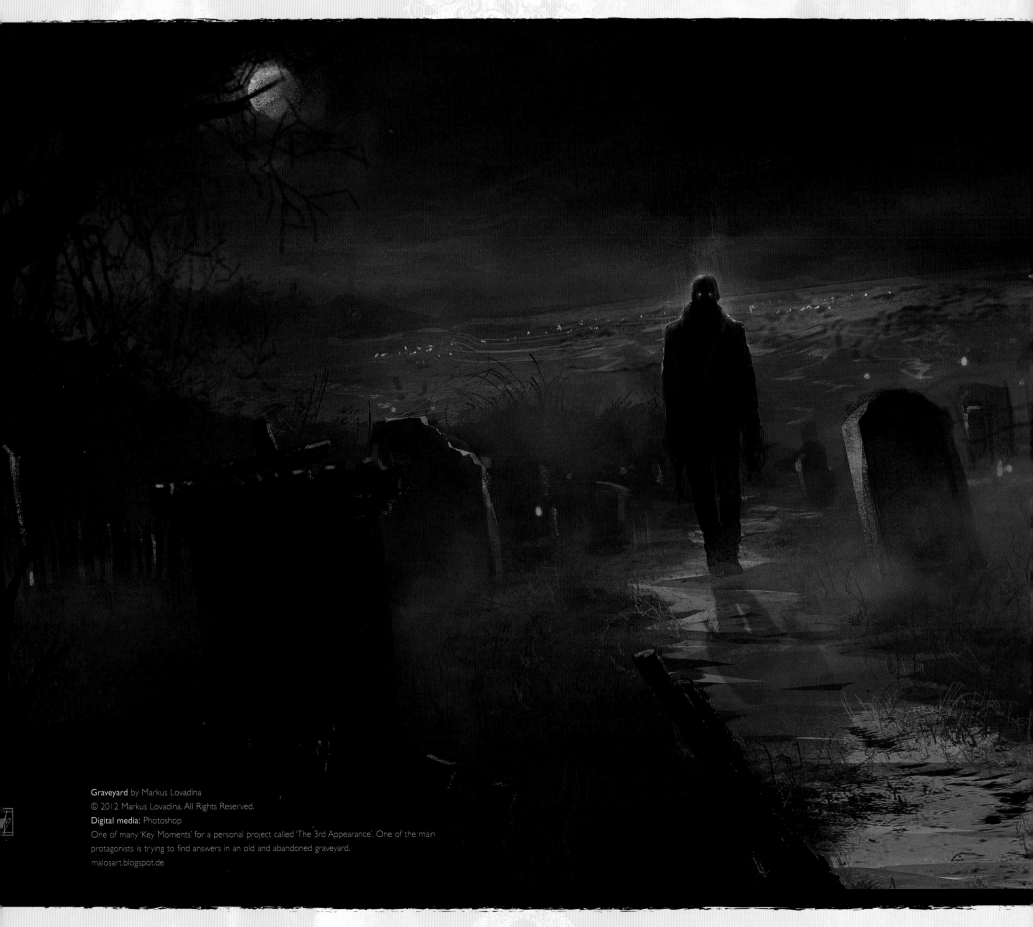

Graveyard by Markus Lovadina

Digital media: Photoshop

One of many 'Key Moments' for a personal project called 'The 3rd Appearance'. One of the main protagonists is trying to find answers in an old and abandoned graveyard.

malosart.blogspot.de

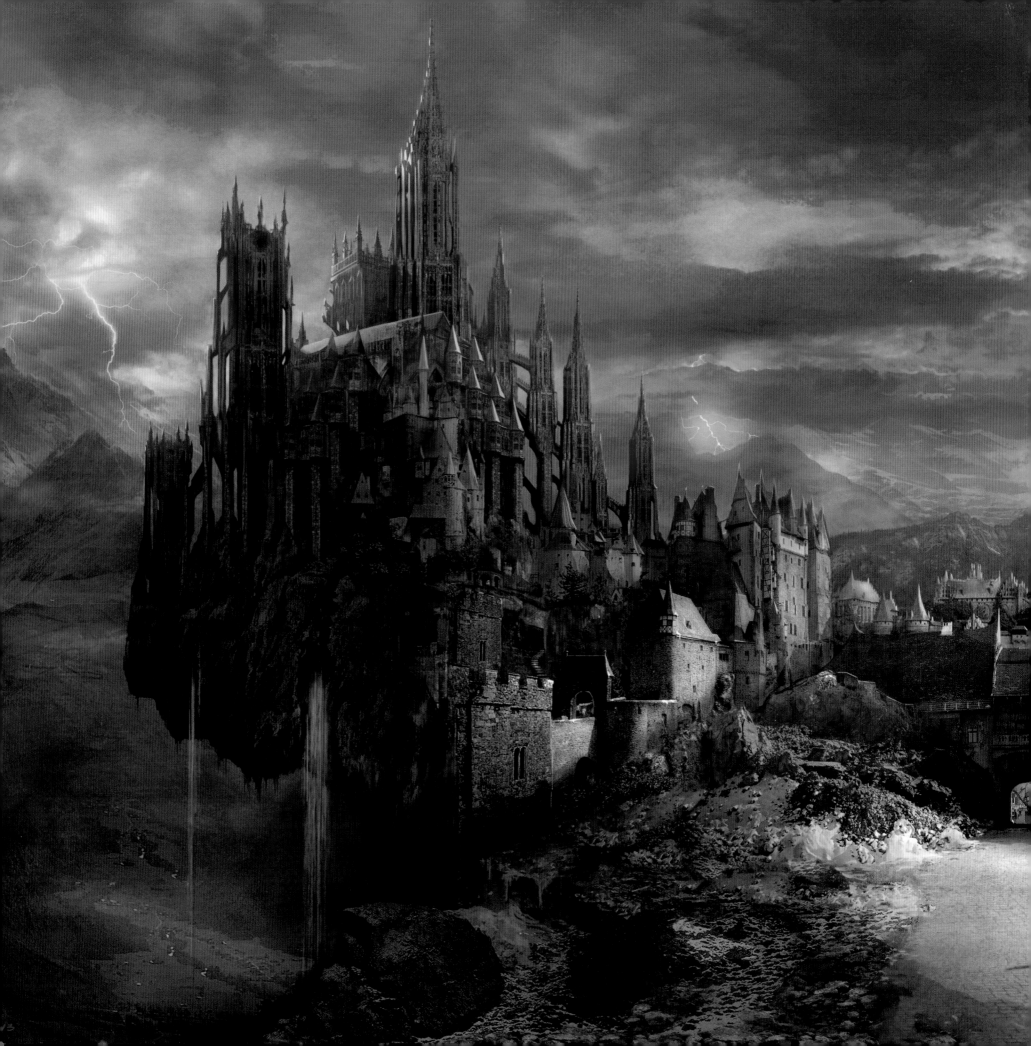

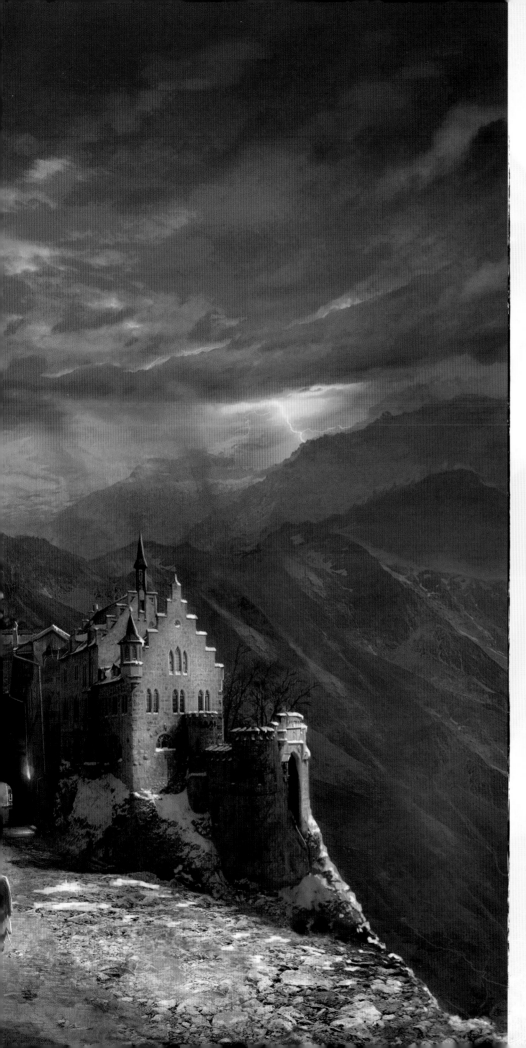

of the forest, which resonates from the trees and plant life in her works. Lighting plays an important role in creating an enchanting atmosphere, with moonlight and ephemeral glowing effects used to impressive effect throughout her creations.

The Great Abyss

Just as the land has inspired majestic visions, so too has the sea. The caverns of the coast and tempestuous oceans have served as metaphysical embodiments of raw power, as typified in Coleridge's epic poem *The Rime of the Ancient Mariner* (1798). Much like Coleridge's masterpiece, the presence of the ocean in art often reflects the state of the characters who stand before it, with darker moods echoed in turbulent seas and aggressive coastlines.

The great unknowable depths of the sea remain completely out of reach, which is why the oceans continue to hold a mysterious quality that transcends the notion of mere supernature. Even in our age of technology, we still can't completely overpower the unrelenting force of the waves, which heightens the sense that one is so easily lost at sea.

In turn, the motif of a solitary figure standing before the vast coastal horizon often appears as a metaphorical image of someone on the brink of giving up; standing on the edge of a cliff, one step away from complete destruction – or salvation, depending on how you look at it.

Windswept and Troubled

Along with the dramatic suggestions of succumbing to the sea, other features of the coast also serve as additional signifiers of inner and outer turmoil. Windswept hair and clothing, for instance, are extremely powerful tools for visualizing unsettled emotional states that could elevate at any moment. The dishevelled and sultry witch in Lauren K. Cannon's *Black Bride* (2012) is a stirring example of how mess can be a very good thing, with flowing fabrics and unkempt hair adding to the character's mystique and strange intent. Likewise, stormy skies filled with brooding rain clouds are also effective means of bringing out fragile and pensive character traits.

Castle Beyond the Forest by Mike Sebalj
© Mike Sebalj
Digital media: Photoshop
mikesebaljart.com

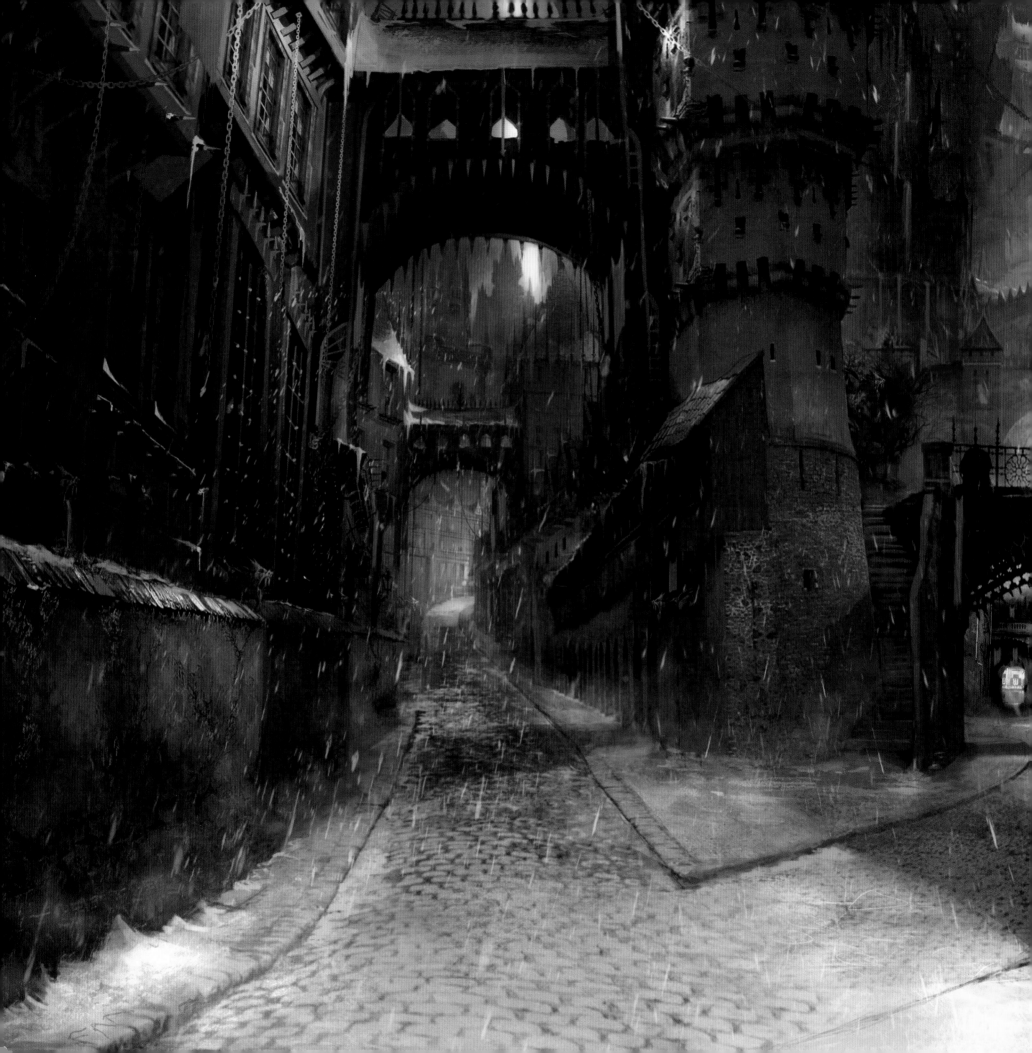

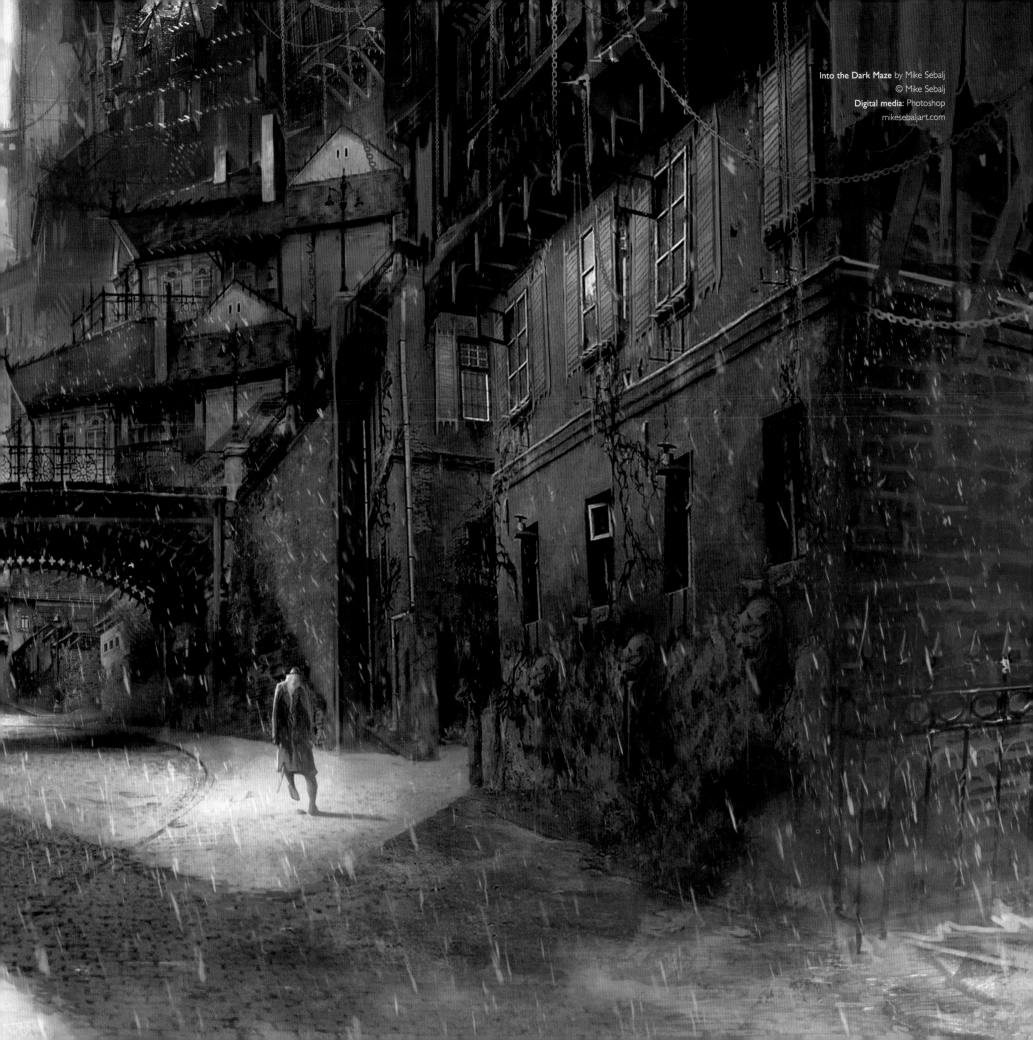

Pure Gothic

As you have seen so far, there are many intriguing kinds of characters and themes that make the genre of gothic art so addictive, which is why it is such a pleasure to find all of the different elements united into exquisite set pieces dripping with evocative drama. Many artists seek to capture the very essence of Gothic style and appeal, whether focusing on the darker side of beauty or the stark reality of supernatural horror. An artist who seeks to layer everything with a darker subtext can create truly haunting sights to behold.

Gothic Elegance

Many of the most stirring pieces of Gothic art seem to weave an element of poetry into their designs, with every visible detail serving a point and purpose. One such illustrator was Harry Clarke, a prominent figure of the Irish decorative arts movement at the turn of the twentieth century. Although an accomplished stained-glass artist, one of the most important parts of his legacy was a set of illustrations that were created to accompany a 1923 edition of Edgar Allan Poe's *Tales of Mystery and Imagination*, as we mentioned in an earlier chapter. Clarke's illustrations have left a lasting imprint on modern Gothic aesthetics, especially those rendered in a monochromatic fashion in stark black and white.

What makes Clarke's illustrations so intriguing is the integration of elongated forms that featured heavily in medieval Gothic art. Also, several pieces, such as the rendition of *The Pit and the Pendulum*, include distinctive strap markings and bindings that, intentionally or not, bring something of a fetishistic air to the final results. Clarke's influence can be seen in artists such as Patrick Arrasmith and Abigail Rorer, whose monochromatic pieces bear a similar sense of style, tone and compositional rhythm.

The Visual Poetry of Amano

Along with Clarke, one of the most influential pioneers of Gothic elegance is the legendary Yoshitaka Amano. In the West, Amano is most widely cited for his beautiful illustrations that

Angel by Bryan Syme
© Bryan Syme
Digital media: Korell Painter9
Done for a role-playing game book called *Power Chords* by Phil Brucato.
bryansyme.com

accompanied Hideyuki Kikuchi's *Vampire Hunter D* (1983–97) novel series, along with artwork created for the immensely popular Square Enix video-game franchise *Final Fantasy* (1987–present) and a collaboration with Neil Gaiman for the novella *The Sandman: Dream Hunters* (1999).

Amano's distinctive style bears a resemblance to traditional Japanese calligraphy, with line work and brushstrokes carrying expressive meanings in a wonderfully subtle way. When applied to dark subject matter, as we see in the case of *Vampire Hunter D*, Amano's works suddenly take on a uniquely poetic style unlike anything ever seen before, as evident in *D*-related set pieces *Hunter* (1985), *Wind* (1985) and *Sword* (1996). The characters we find in Amano's work are exquisite and elegant creatures that appear as weightless, delicate beings; facial details are hauntingly elongated and lyrical, with stark contrasts between skin and costume. It's no wonder that many of the greatest Western, Gothic artists, including Gerald Brom, cite Amano as a defining influence on how to harness Gothic sensibilities in visual form.

Elaborate Darkness

Despite such murky connotations, the traditional Gothic aesthetic can become an incredibly elegant and refined style, heavy with fine detail and elaborately defined characters and environments. Gothic elegance is often achieved by taking influence from the ornate medieval manuscripts and tapestries that became popularized during the Gothic art movement, with ornate detailing and symbolic patterns playing a dominant role in composition.

One of the most influential artists to really master the ability to create lavish dark artwork is Ayami Kojima, as mentioned earlier on. Her works build upon the relationships between stark colour contrasts and the narrative qualities of clothing and narrative props, all beautifully framed in delicately balanced compositions. In other disciplines, the photo manipulator Marcela Bolivar is famed for a similar kind of stylistic approach, as demonstrated in the stunning *Sulfur* series (2011). Bolivar's work often plays with the contrasting effects of heavy textures and soft colours, creating mesmerizing set pieces fuelled by fantasy.

Skyggen: The Dark Companion by The Alchemist
© 2008 Alchemy Carta Ltd
Traditional media: acrylic on watercolour board
alchemygothic.com

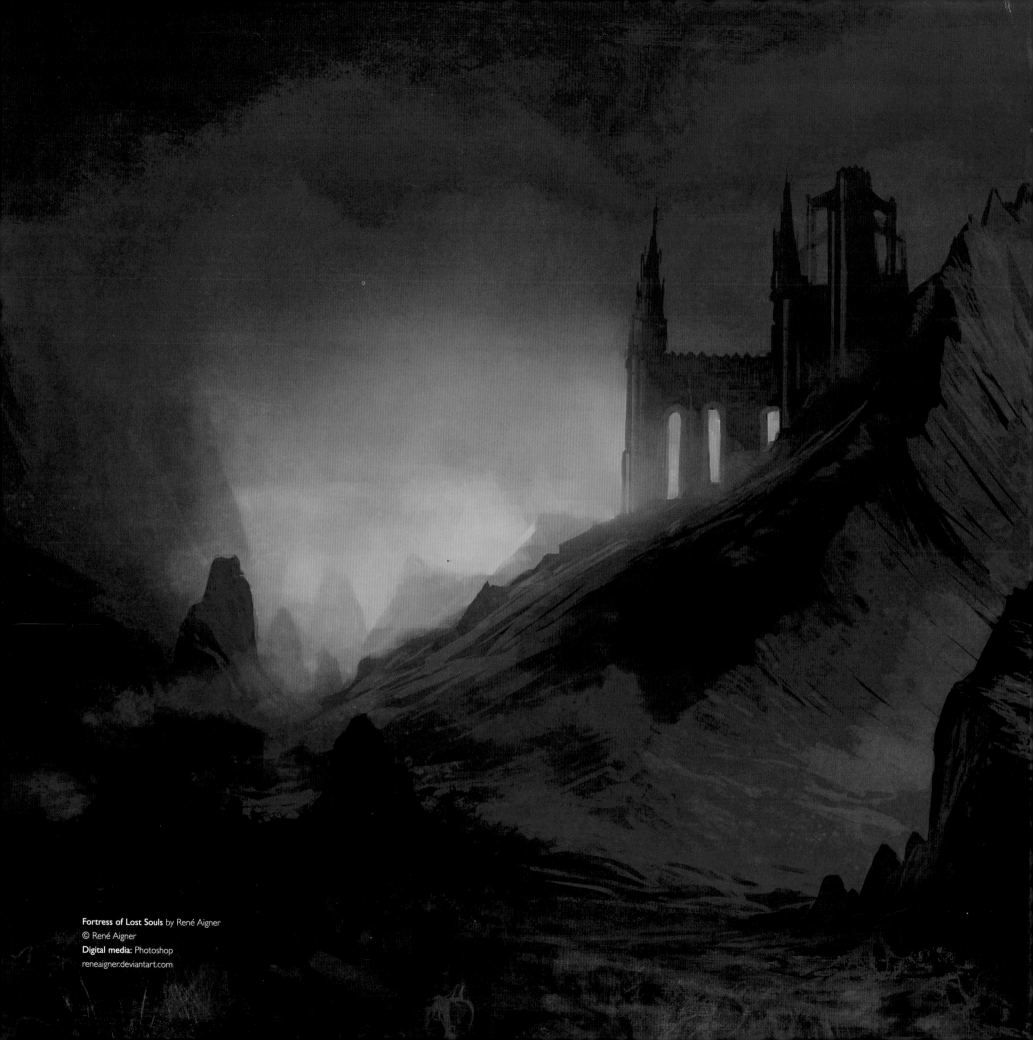

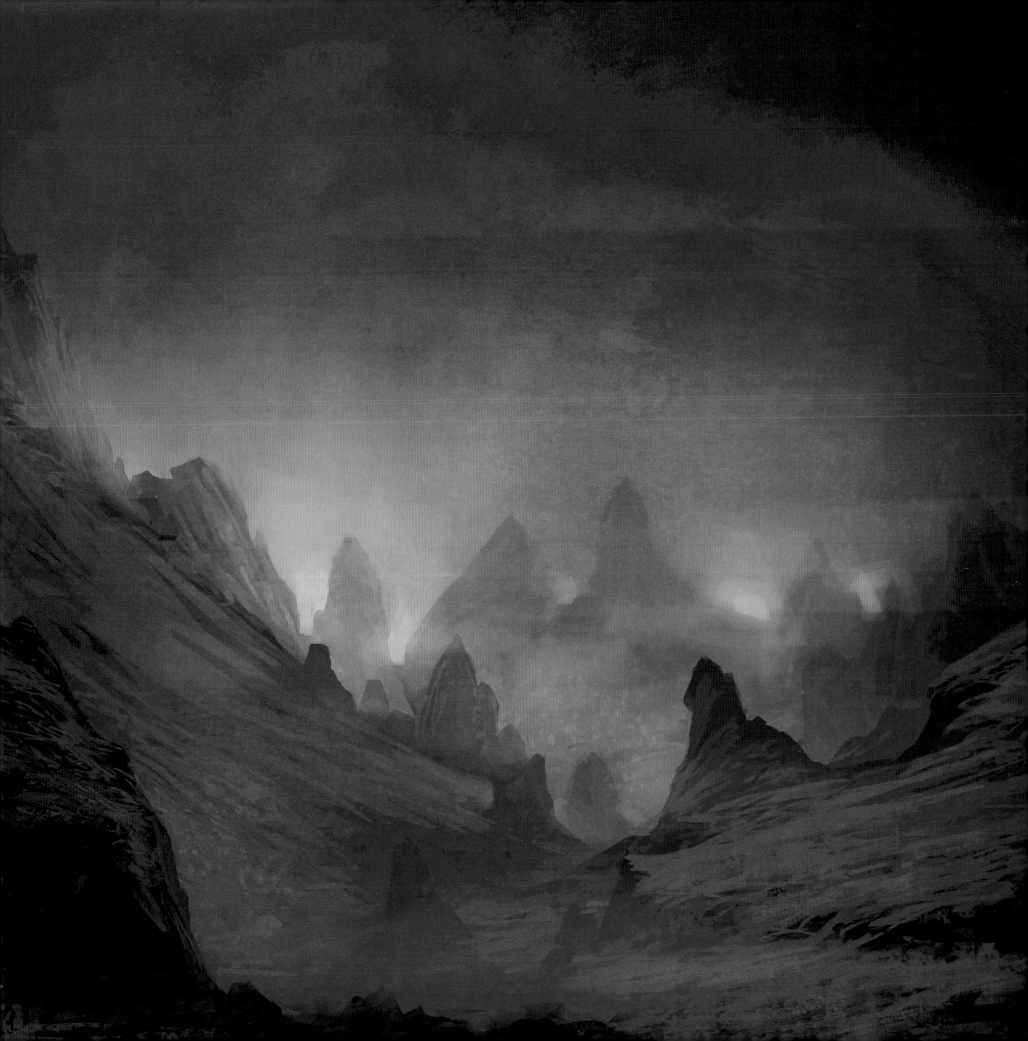

Gothica: City of Zeus by Brooke Gillette

© Brooke Gillette; **Digital media:** Photoshop; brookegillette.deviantart.com

Step 1: Basic Construction: Using 1-point perspective as a guide, I created simple building blocks of the architecture I had in mind, using Lasso and Pen Tool. The sculptures are drawn in. Using my 'clouds' brush I quickly added some clouds in the sky, to establish a mood and give some depth to the composition.

Step 2: Adding Architectural Detail, Adjusting Size & Placement: Keeping the perspective guide on a separate layer, I added architectural details to the basic blocks, giving the city more character. I wanted to combine Greek and Gothic architecture, as the story was about the return of Zeus (and other gods) after an apocalyptic war that destroyed humanity and their dominant existing faith. I also experimented with the size and placement of each building, making sure that the Zeus statue remained the dominant feature of the city. For example, the Greek columns (at the back) from the previous step has been moved and reduced in size because they were competing with the main focus, almost matching the Zeus statue in size.

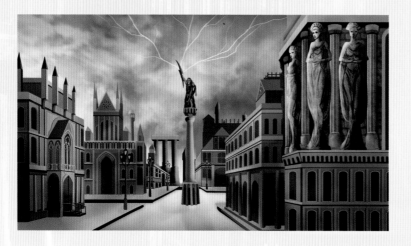

Step 3: Detail & Texture: I added more and smaller details to the buildings. When I was happy with the architecture overall, I started to add texture and adjust the lighting of the artwork.

Step 4: Colour & Lighting: After adding more architectural details, lightning from the Zeus statue and some streetlights, I added a 'blue wash' over the artwork to establish a dominant colour using Layer Mode as 'Color'.

Step 5: Texture Detail & People: I kept painting and texturing, adding more details to the buildings and the background. This was the most laborious stage, when there was less design and much more painting/rendering involved. I had to make sure that each element was well done and not just 'roughed out' like the concept stage. I evaluated the lighting of the overall piece and added more lights to the buildings to reflect the pattern of the streetlights, and also to add more lit areas to the dark buildings. Since some parts of the city were of 'Ancient Times' that were incorporated into 'Gothica', I added moss to them to signify that they were old and had witnessed much of human history. People were now painted into the composition, to add more focus and provide a sense of scale. And since there was lightning, I added some rain as well.

Finishing Touches: I adjusted the people's poses and added more detail to their clothing; I wanted to show that they belong, or fit into, the environment that I created. I also added a large crow in the foreground, to increase the depth and drama of the composition. He is angled to lead the viewer's eyes into the city. I used rim lighting to emphasize the silhouette for the crow as well. I also added more birds in the background, creating more depth by contrasting their small size with the large crow in front. Since this artwork had almost a monochromatic colour scheme, I focused on establishing clear form and contrast. Adjusting the final lighting, I saved the most contrast for the Zeus statue; around him are the brightest values of the painting to intensify contrast. Finally I added more atmospheric lighting by reducing the contrast and sharpness of the buildings in the back.

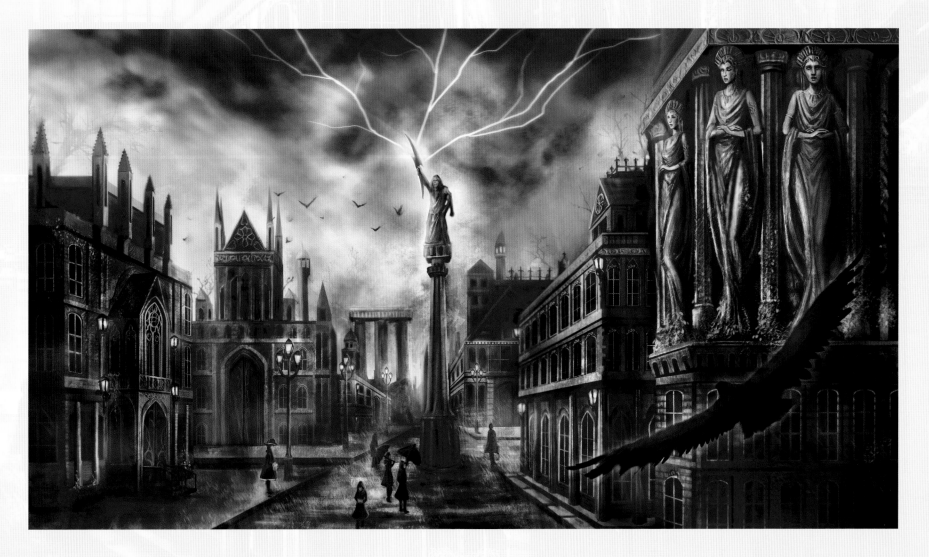

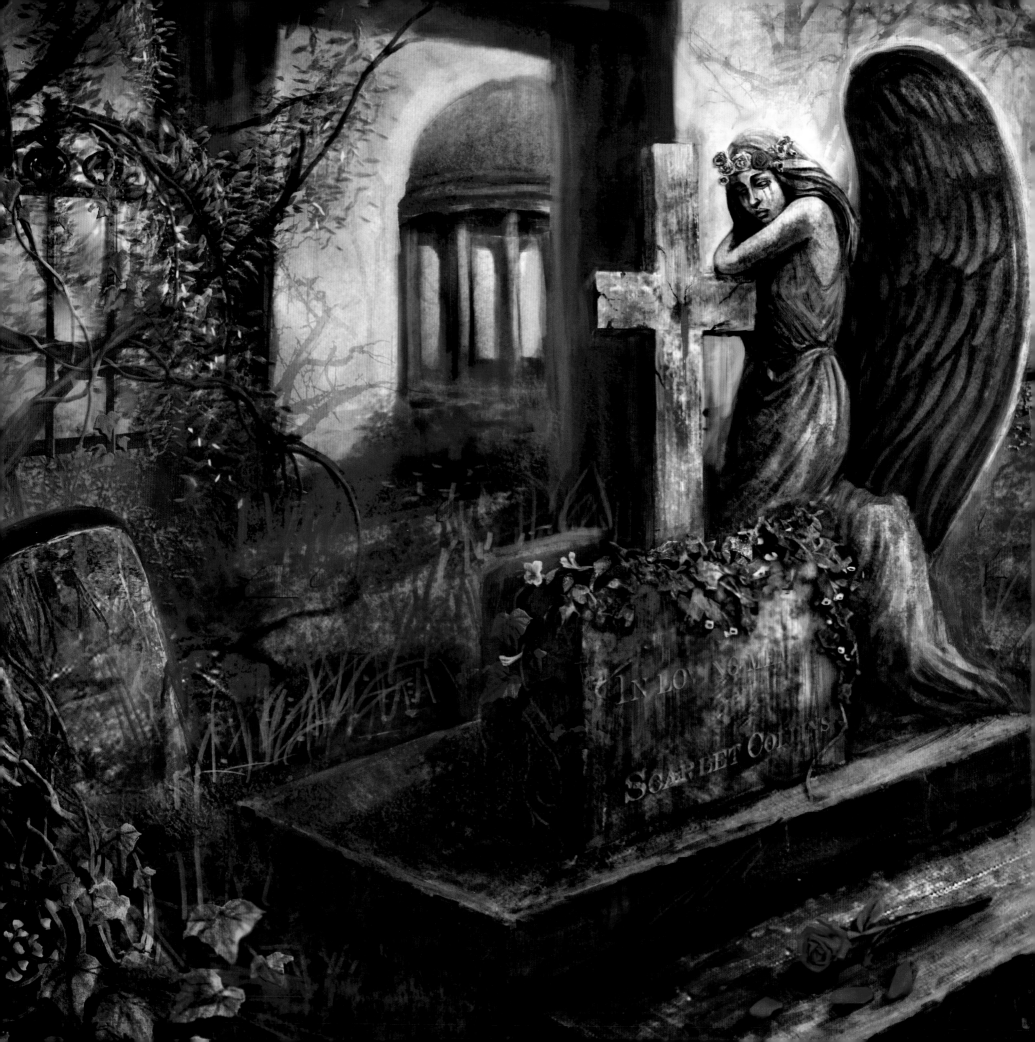

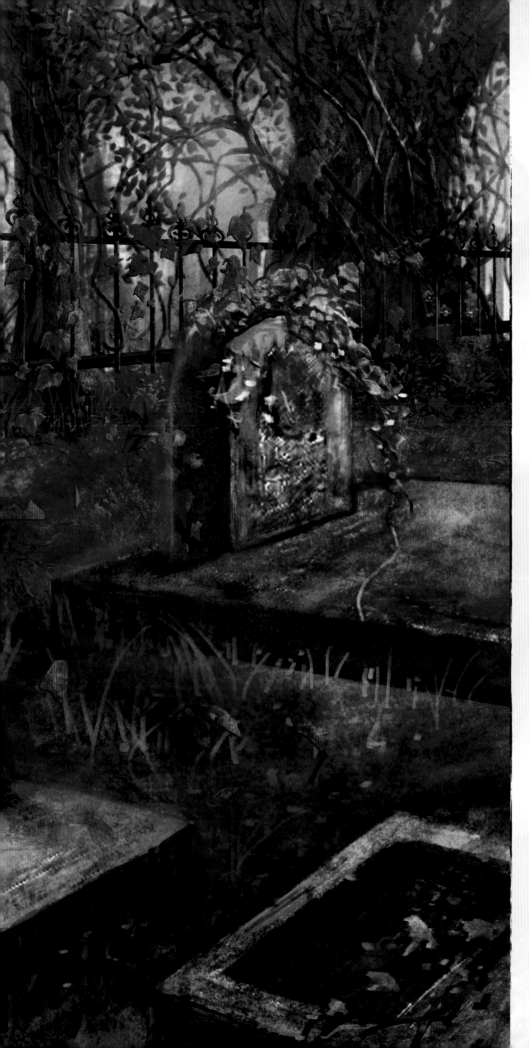

She Was a Vision

With contrast lying at the heart of the Gothic ideal, the realm of beauty is a fascinating area to examine and admire. Images that delve into Gothic glamour tend to focus on feminine beauty rather than masculine attraction, as is the case within the wider realm of fashion. Photography is particularly rich with artists looking to capture haunting scenes of beauty, with many photographers incorporating fairy-tale motifs into their works. Gothic beauty often balances muted colour palettes with vibrant accents, adding surrealist elements into the mix in order to emphasize subtext, such as the ornate *Rose Bleed* (2011) by photographer Natalie Shau.

Staying with Shau, darker portraits of beauty are often epitomized by conflicting visual aspects of light and dark, both thematically and stylistically. *Nemesis* (2013), for example, pits vibrant shades of scarlet and gold against cooler shades of muted peach and white, while strange symbolic imagery conjures up an image of beauty that is ghostlike and transient; it's mesmerizing but incredibly unnerving, which is the very essence of dark beauty.

Abstract Gothic

One of the most intriguing sub-branches of modern Gothic art is the abstraction and experimentation of form and thematic traits. Taking influence from the Surrealist movement, led by figures including Salvador Dalí and Max Ernst, artists are free to explore the core themes of dark fantasy in a more abstract and impressionistic way. Pieces of this kind are often created in a highly stylized fashion, often focusing on single key areas such as emotion, narrative or atmosphere. Colour may also play an important role in abstract visions, with carefully considered palettes carrying qualities to further express the artist's intent. One such example of abstract high Gothic can be found in the works of Vladimir Zimakov, whose book covers and illustrations often take on something of a homage to M.C. Escher, with geometry, heavy contrast and exaggerated form setting the tone and atmosphere for the oddities that follow.

Fallen Gates by Brooke Gillette
© Brooke Gillette
Digital media: Photoshop
brookegillette.deviantart.com

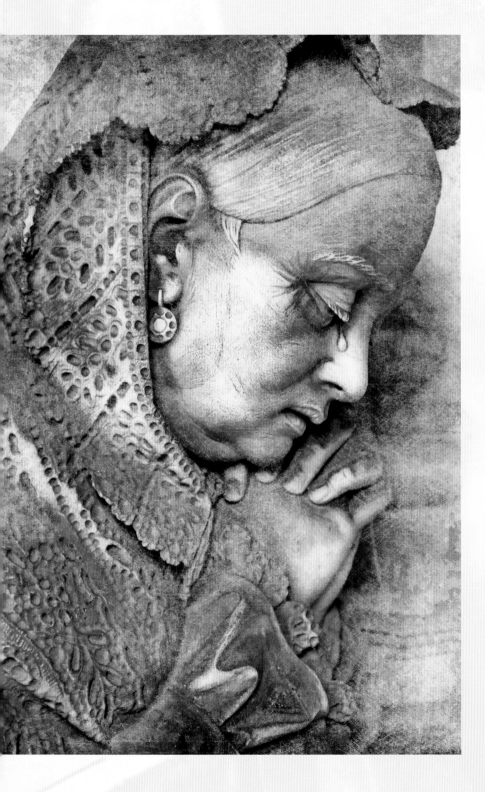

Sculpture relief at **Staglieno cemetery**, Genoa, Italy.
Medium: stone

Emotional Resonance

There are certain emotional themes that are central to Gothic ideals, with the vast majority being those more commonly associated with negative attachments, including melancholia, sorrow, fear, rage, guilt and lust. Pieces that are centred on specific emotions often strive to encapsulate visual elements that replicate the same feeling within the viewer, using shocking imagery and suggestive concepts to pinpoint the desired emotional trait. A more abstract form also allows creative freedom to experiment with colour palettes not commonly associated with the Gothic genre; one such example is the stirring *Heron* (2012) by Samuel Araya, in which the dusty yellow-tinted hues of twilight seem to amplify the connotations of loneliness and despair experienced by the painting's quivering female nude.

The Strange Compositions of Dave McKean

The works of the mixed-media artist Dave McKean are widely regarded as some of the most influential modern pieces of surrealist-inspired art, often uniting the realms of fantasy, science fiction and impressionism together in evocative designs with bold messages. McKean is known to many for his long-standing service history with the author Neil Gaiman, with McKean producing cover artwork for the *Sandman* graphic novel series, along with collaborations on the film *Mirrormask* (2005) and many of Gaiman's book covers. McKean's engaging style has made him one of the in-demand conceptual designers on the circuit, with an eclectic range of clients including Richard Dawkins, Heston Blumenthal and John Cale.

What makes his style so unique is his ability to use texture, form and colour to capture emotional concepts and identities in a raw and uncompromising manner. When turned to darker subjects, heavy textures and contrasts really come into play, with texture upon texture laced together to shout and scream out at the viewer. McKean tends to depict the human form in a more allegorical way, often using its abstracted shape as a conduit to wider meanings, such as *Unexpected Need* (2005) and *Flood* (2003) created for the Narcolepsy exhibition.

Save Us by George Patsouras
© 2008 George Patsouras
Digital media: Adobe Photoshop
cgaddict.blogspot.com

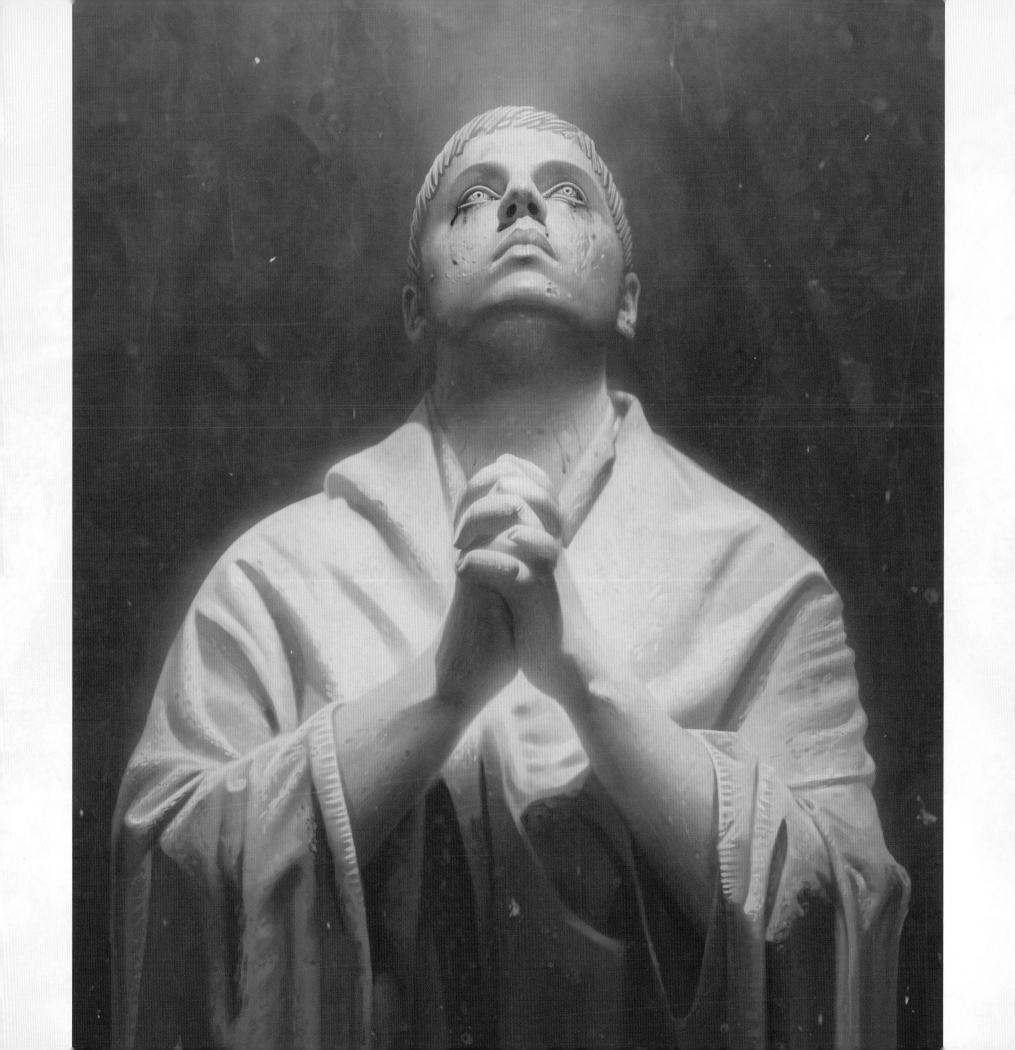

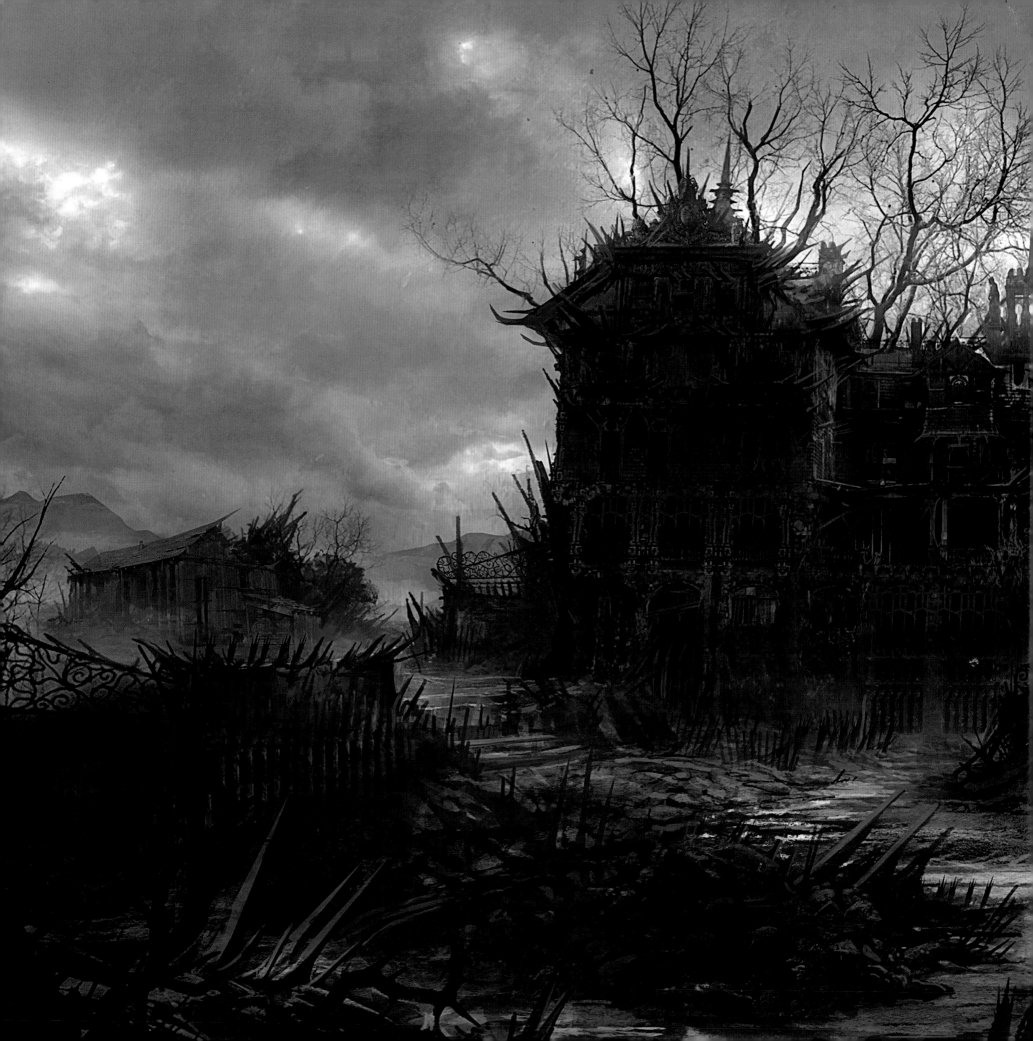

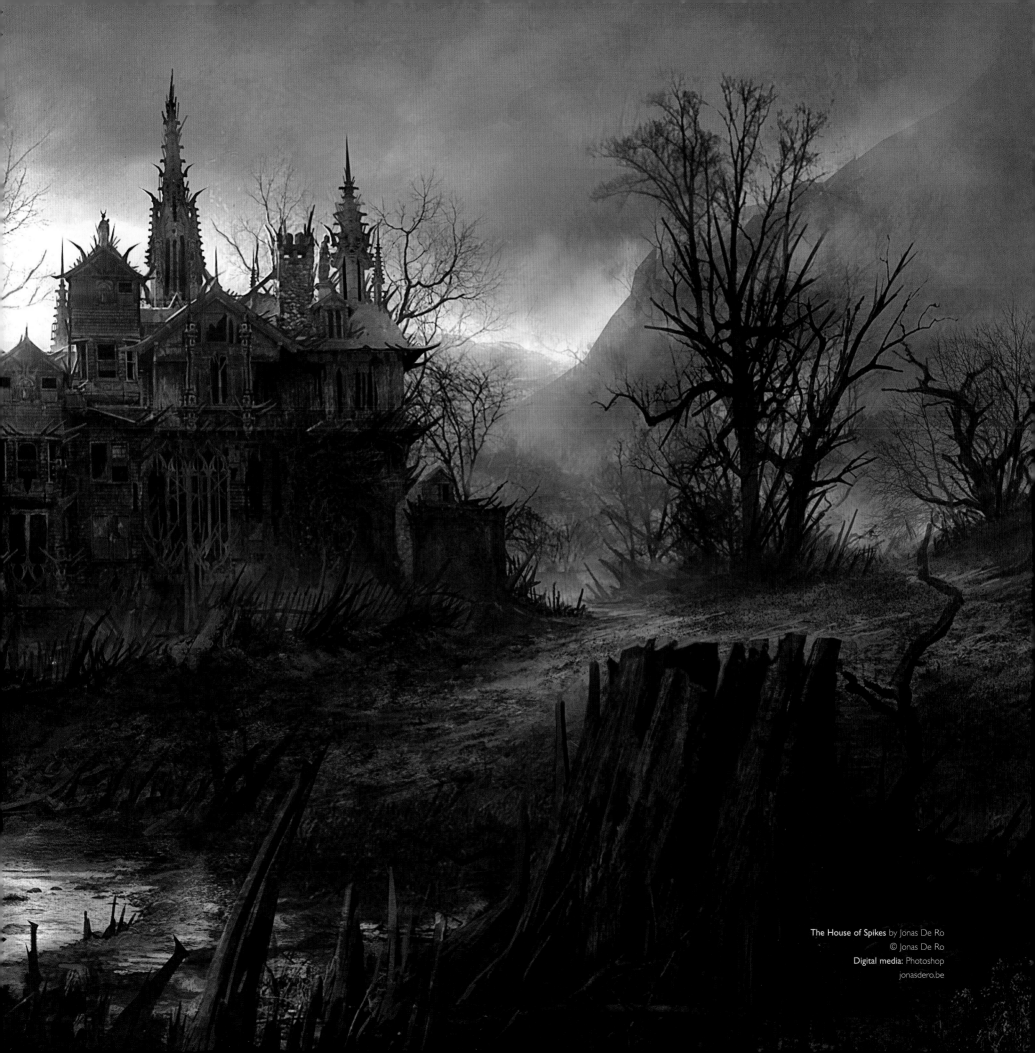

The House of Spikes by Jonas De Ro
© Jonas De Ro
Digital media: Photoshop
jonasdero.be

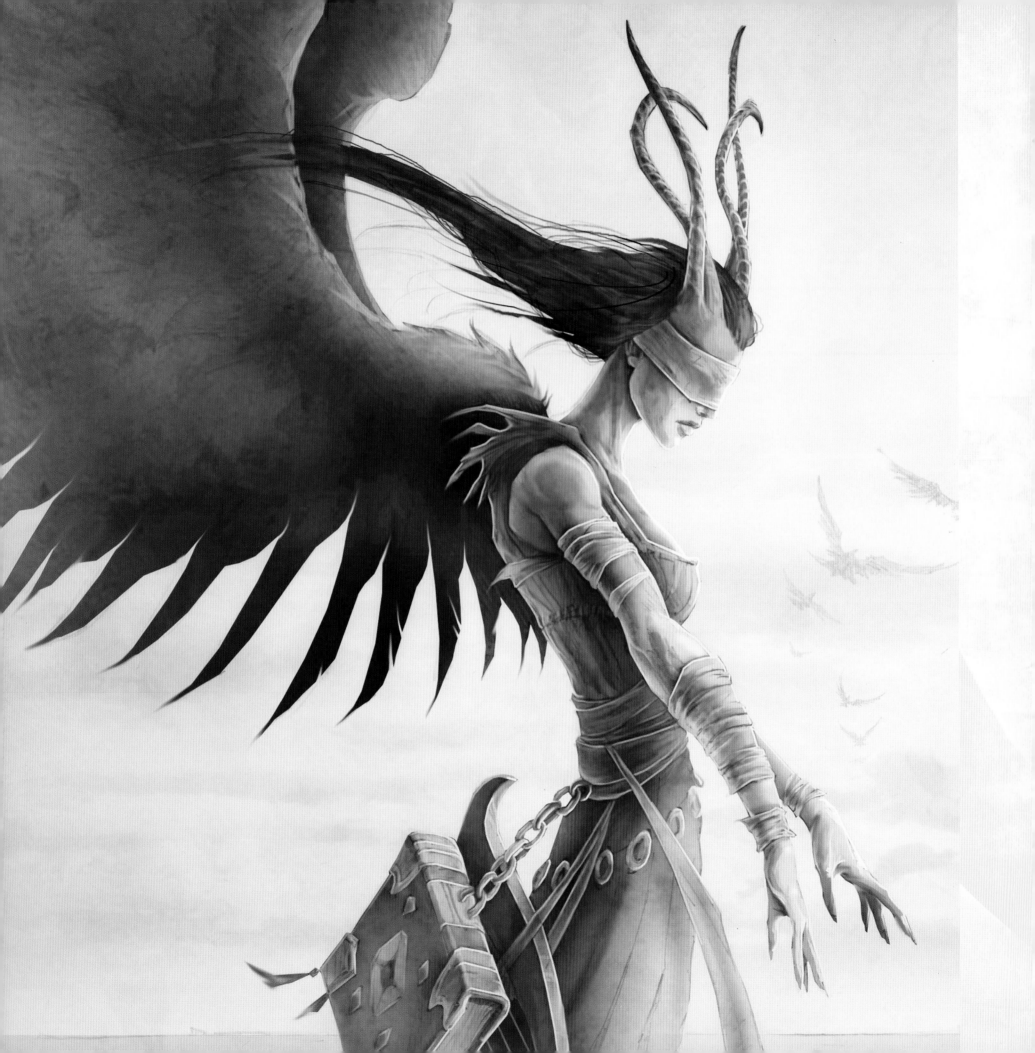

The Nature of Fear

For all of its grace and elegance, one of the most consistent appeals of dark fantasy is that artists can use it as a means of exploring horror and the nature of fear. As touched on earlier, the Romantic notion of the Sublime has much to do with the link between awe and fear, based on the premise that wonder stems from the same primal urge as terror; to gaze at something that overpowers thought and reason so much that one becomes lost in another's presence.

The sensations of horror and terror can be recalled by presenting viewers with imagery that both repels and fascinates in equal measure, creating a conflict of whether to keep watching or to turn away.

Lurking Horror

It takes a lot of skill to be able to tap into the subtle nuances of fear, and when a more lingering kind of terror is desired, it often comes down to the ability to use as few elements as possible to provoke an incredibly

potent reaction. It takes a tremendous amount of research and restraint for an artist to be able to create imagery that calls to the darker parts of the human psyche, skirting the border between the beautiful and the monstrous.

One such form is the integration of serenity and dysfunction; to unify the elements of order and chaos into a concoction of the familiar and the altogether unknown. The stunning paintings of Steven Kenny are centred on the premise of expressing a profound appreciation of nature while wholly consuming it in one form or another. The brazen stare of the model we find in *The Semaphore* (2007) entices the viewer, while her halo of a nest with birds impaled on it repels, as does the overtly submissive *The Shout* (2009). In a similar

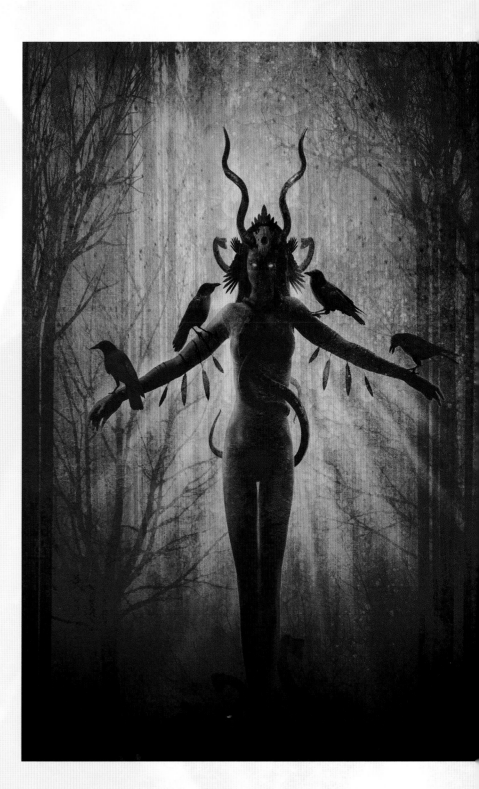

Penance by Jason Engle © Bastion Press
Digital media: Photoshop
Originally done as an interior for the Oathbound roleplaying game, it has since appeared in many art books and other products.
jaestudio.com

Vengeful by Jason Engle
© Jason Engle 2012
Digital media: Photoshop
Unpublished personal work.
jaestudio.com

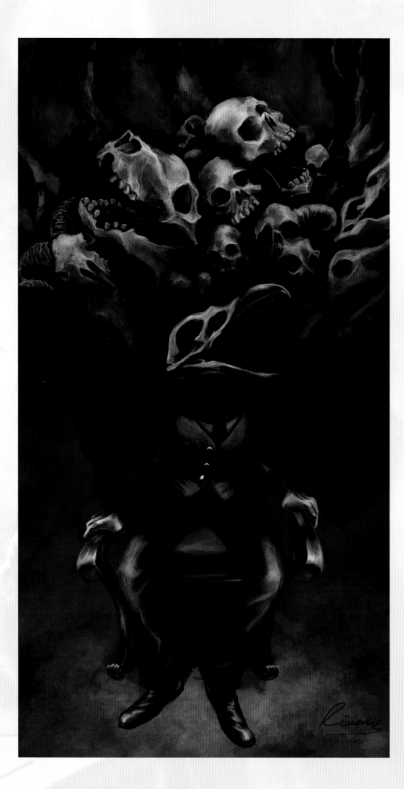

Shaw by Rivenis
© Andrew Blackman
Digital media: Photoshop
facebook.com/rivenisart

vein, the interplay between external and internal horrors that we find in *Fatal Stage* (2008) by Ryohei Hase raises the question of whether fear is stronger when moved from a hidden space to one for all to see.

Shock Tactics

If an artist desires to shock in a more instant and immediate fashion, the gradual impact of a more subtle approach may not be ideal. In this case, the most effective way of drawing from fear is to harness the ability to express complex concepts in as bold a way as possible, making clear and unsettling statements that leave nowhere to hide.

Imagery of this kind often employs strong visualizations of violence and brutality, and is certainly not for the faint-hearted. Building on the concept of voyeurism, such brash images often include an element of exposing the shadier sides of culture, with religion, society, gender roles and sexuality becoming regular targets of dark exploration. The chilling photographs of John Santerineross fully demonstrate the ability to shock and scare, with many of his pieces exposing the hidden darkness of humanity, touching on subjects including the sexual perversion of the female form and the corruption of innocence.

Although imagery of this nature can be hard to stomach, artists like Santerineross cleverly walk the line between obscenity and philosophy, with artwork seeking to actively expose the darker sides of society that many try to ignore.

Making a Scene

While the Gothic sensibility can be applied to almost any kind of subject matter, there are certain kinds of scene that seem to just fit perfectly the ideals behind the aesthetic. As we've covered, much of the archetypal Gothic visual language revolves around the premise of contrasting elements. Narrative-driven scenes are no different; those most naturally suited to the genre tend to be centred on opposing elements coming together in one guise or another. The possibilities are endless – contrast could be played out in some kind of conflict, a strange relationship or even a visually deceptive character.

Many Gothic artists choose universally recognizable sources as a starting point, especially those connected to culture and history; myths, legends, religion and fairy tales are extremely popular, as are historical figures, literature, film and music. From here, darker qualities shrouded in subtext are brought to the forefront and pinned to the core of the piece, allowing artists to simultaneously create renditions of established concepts while delivering something new. This can splinter off into many different directions, depending on the will of the artist, from transforming good characters into hellish fiends all the way to re-evaluating the world around us.

The Marvels of Kris Kuksi

Although many artists strive to create highly elaborate microcosmic scenes of allegory, few manage to achieve the overwhelming and profound effects that the sculptor Kris Kuksi so effortlessly creates in his incredible works. His stunning array of evocative sculptures depict metaphorical scenes of human nature, religion, life and death, all exquisitely crafted and composed in intricate forms. Whether the skeletal frames of *Lust and Self-Abuse* (2007), the machinations of war in *The Beast of Babylon* (2008) or the euphoric and classical *A Neo-Roman Landscape* (2010), gothic subtext and intent are abundant in Kuksi's designs, with their striking beauty also serving as a hallmark of a deeper destruction and impending chaos.

Strange Families

While we all joke from time to time about our own families being the stuff of nightmares, for many Gothic creations this seems to be a literal phenomenon. During the 1960s, the popular TV series *The Munsters* (1964–66) and *The Addams Family* (1964–66) ran side by side, embracing the concepts of strange gothic families and their madcap homely comforts. As such, the idea of exploring the scope of the Gothic tradition in a whole troop of unified characters offered a more light-hearted and comical application of the genre, which continues to serve as a popular theme for artists and photographers such as Gus Fink.

Bygone Days

With such an emphasis on the past, it's really interesting to note how many artists take motifs that were popular during the time of the original Gothic Revival and literature movements and create works that hark back to those days. Along with the reoccurring inclusion of Victorian fashion, many antiquated social practices find themselves becoming the subject of attention, especially those connected to devious activities.

A skull bas-relief in **Kutná Hora**, Czech Republic.
Medium: stone

One such relic is the cult of absinthe, the notorious alcoholic drink favoured by artists and poets of the nineteenth century that was believed to inspire creativity and madness in equal measure. The bright green hue of its undiluted form and its mellow, consumable counterpart became a symbolic colour of Bohemian freedom, as did its mascot, the Green Fairy. Absinthe bears a close connection to the stylistic movement of Art Nouveau, after many advertising posters replicated its hypnotic effects with swirling patterns and ornate elegance. The unification of these elements can be found in many pieces of absinthe-inspired works, including *The Absinthe Fairy* (2009) by Aly Fell.

Other popular motifs include fashioning artwork in styles similar to those found in forms of entertainment, such as antiquated theatre set dressing complete with wire hangings, layered and decidedly flat paper puppets and vintage advertising posters.

The Legacy of Gothic Art

As you have seen over the pages of this book, Gothic art is unique in the sense that it can take on so many different forms while still retaining its own distinctive identity. Whether followed strictly in keeping with its historical tradition or loosely bound into a more contemporary form, the style can become an experimental and truly liberating frame to work with. Once understood and embraced, Gothic sensibilities can be translated further into wider genres and fulfil an ever-increasing number of diverse purposes, no matter the creative discipline or chosen style.

When you think about how far back the Gothic narrative tradition dates, it's incredible to think that the themes that defined the genre have more or less stayed the same after centuries of stylistic evolution; Gothic aesthetics and ideologies remain true to the Romantic notions that inspired them in the first place, and, although these can be shaped to fit a wider set of needs, its core identity remains untouched; even now, hundreds of years after its inception, the style is still what it was meant to be, which is why it's fair to assume that it's going to stay that way for many more centuries to come.

Symphony Insomnium by Rivenis
© Andrew Blackman
Digital media: Photoshop
facebook.com/rivenisart

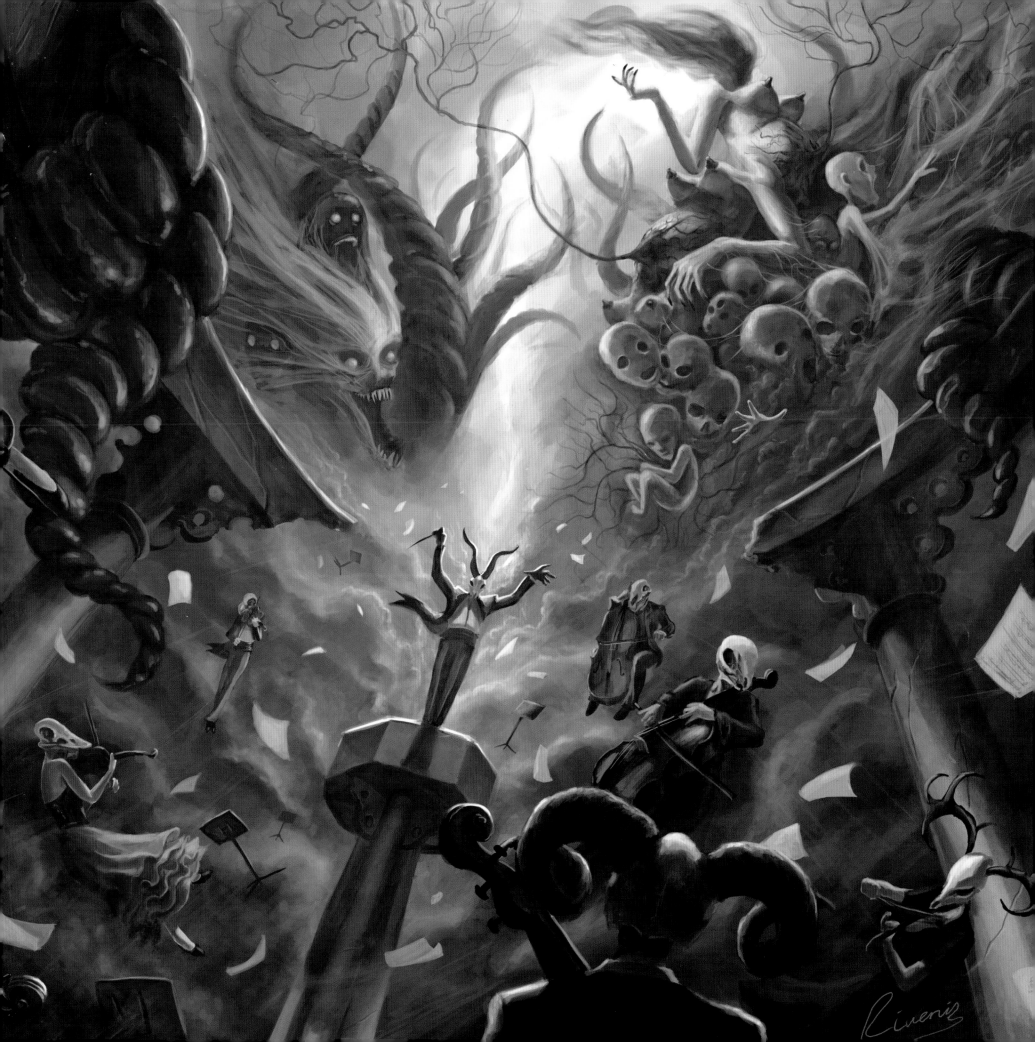

Index

Page numbers in *italics* refer to
illustration captions.

List of Artists

Caption page numbers for artists whose work is represented in this book, in order of appearance (see also the index):

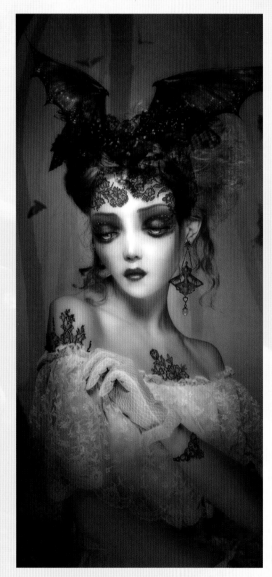

Mist and Powder by Natalie Shau © Natalie Shau
Digital media: 3D, drawing, photography, natalie-shau.com